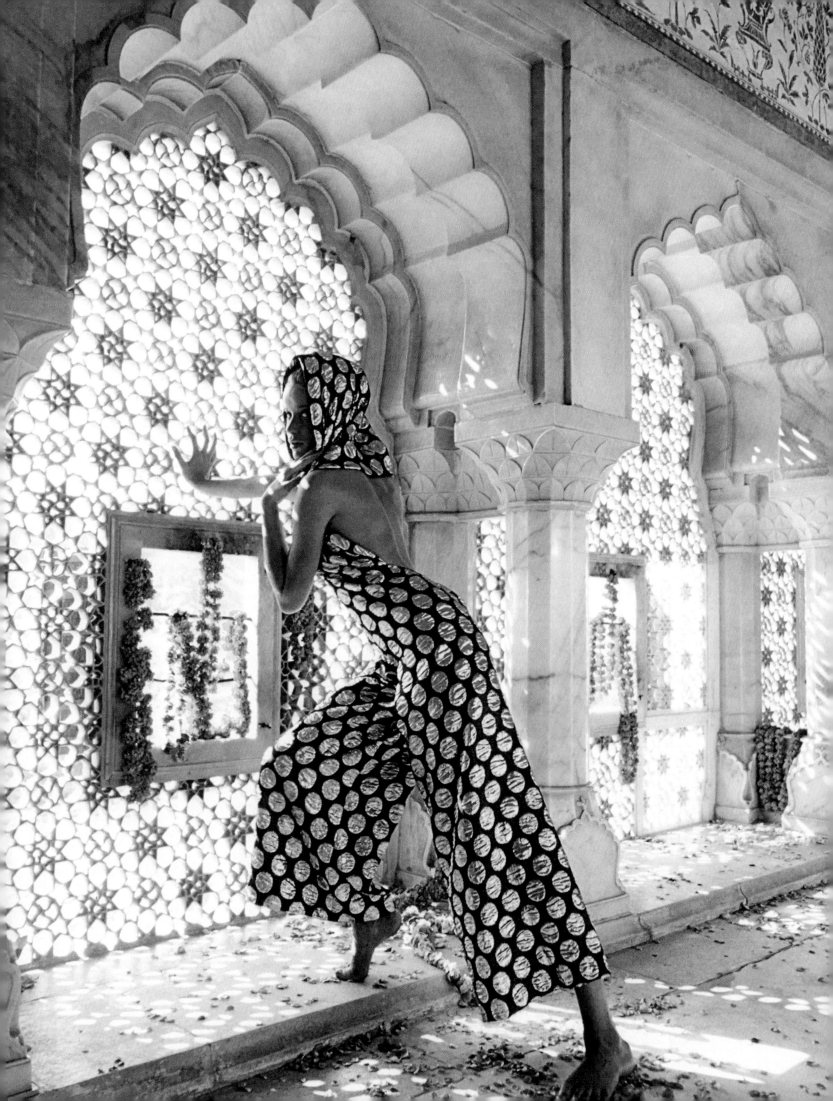

INDIA IN FASHION

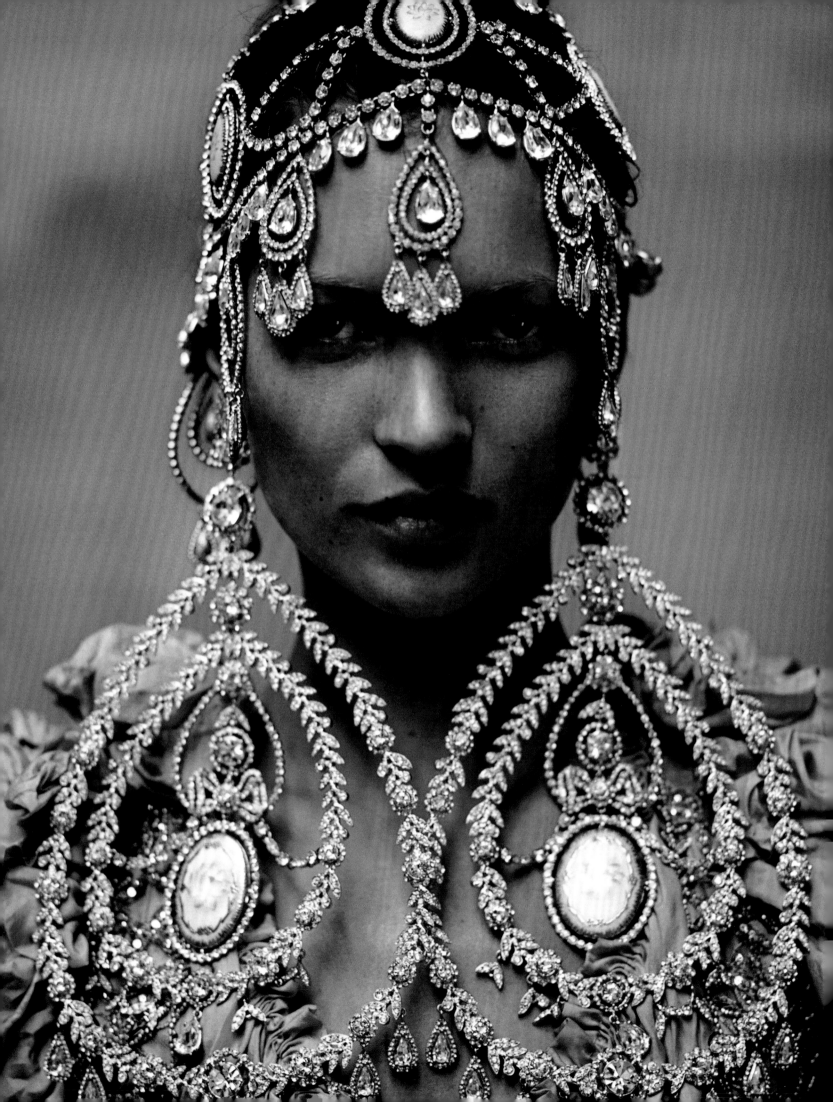

INDIA IN FASHION

THE IMPACT OF INDIAN DRESS AND TEXTILES ON THE FASHIONABLE IMAGINATION

HAMISH BOWLES

NITA MUKESH AMBANI
CULTURAL CENTRE

RIZZOLI **Electa**

CONTENTS

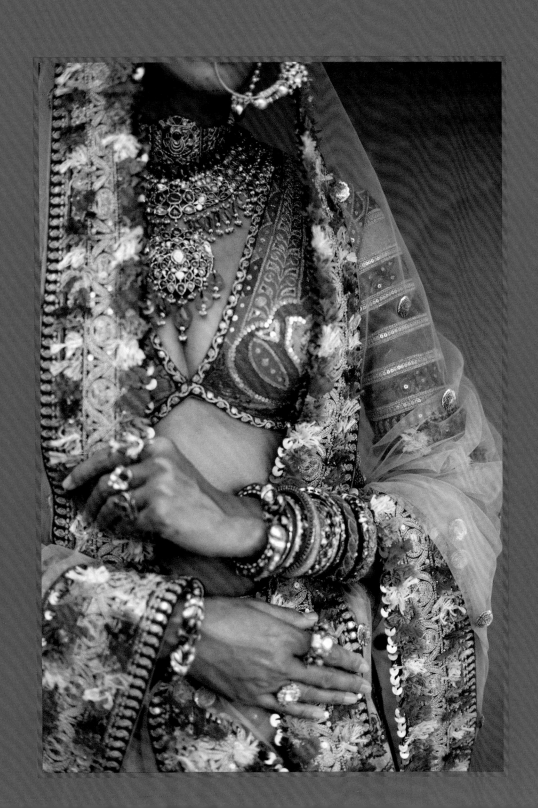

FOREWORD

INTRODUCTION

FASHION, TEXTILES, HISTORY

DESIGNER PROFILES

ACKNOWLEDGMENTS

GLOSSARY

CONTRIBUTOR BIOGRAPHIES

FOREWORD

NITA M. AMBANI

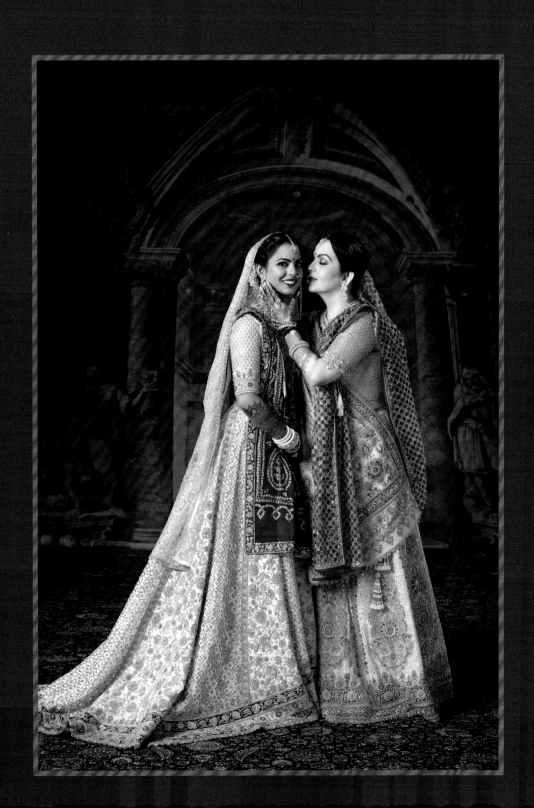

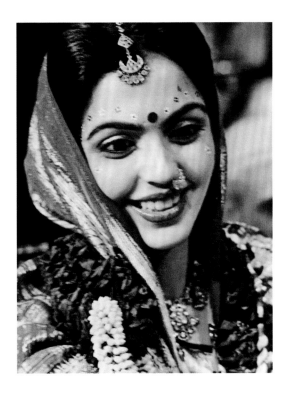

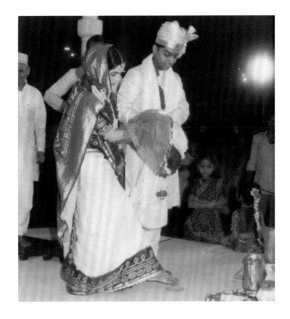

I don't remember the exact moment that sealed my lifelong love for textiles, but the sari has often starred in many special memories: watching my mother drape crisp cotton saris; choosing a red and green *Kanjeevaram* for myself the first time I wore a sari; seeing my daughter, Isha, walk down the aisle draped in my wedding sari—a traditional silk *panetar* handwoven by local artisans in the same community where my mother's and her mother's wedding outfits were woven! Fabrics for me have been an embodiment of love and legacy across generations.

This love took me on a deeply fulfilling journey of discovering the diversity of weaves across India. And that is why *India in Fashion: The Impact of Indian Dress and Textiles on the Fashionable Imagination* and everything it stands for means so much to me. The pages you hold in your hands are a celebration of Indian craftsmanship. This book is where the past, present, and future of traditional Indian textiles convene. It is therefore befitting that the publication of this volume coincides with a very significant inauguration in the sphere of art and culture.

For my family and me, the spring of 2023 will always be distinctly special. It is when we welcome the world to our Nita Mukesh Ambani Cultural Centre (NMACC): the realization of a dream, a celebration of our rich heritage, and a tribute to the arts and crafts of our great nation. Located at the Jio World Centre in Mumbai, comprising three state-of-the-art theaters and a dedicated performance and visual art space, the NMACC will be home to events and programs that will run the gamut of culture—from global to local, historical to contemporary, and conventional to street.

The NMACC builds on the Reliance Foundation's mission of preserving and promoting Indian arts. Whether it's the traditional weaves of Benaras and Paithan to art forms such as *pichwai* and *meenakari* from Rajasthan, and *pattachitra* from Odisha—year after year, the Reliance Foundation has provided our skilled *karigars* (artisans) the hope and means to keep their art forms and traditions alive. The NMACC will further extend our scope by providing a community space that ignites curiosity, nurtures ideas, initiates conversations, encourages diversity, and democratizes art.

Be it fabric, motif, or drape, the Indian design aesthetic has influenced fashion across the globe. From time immemorial, the craft of the Indian artisan has been integral and irreplaceable. So, when the team and I were conceptualizing the show, we were excited about the opportunity to showcase and celebrate this global influence of Indian arts and crafts. We wanted to bring forth the idea of "made in India," and not just in terms of manufacturing but also the imagination and artistry that it continues to inspire.

In Hamish Bowles, we found the perfect partner to bring to life an ode to this iconic journey, which led to the birth of the exhibition *India in Fashion* and this accompanying catalogue published by Rizzoli. Bowles's vision for the show has been brilliantly designed and executed by Patrick Kinmonth, exhibition design director, and Rooshad Shroff, associate designer. The exhibition and book chronicle the widespread impact that traditional Indian costumes, textiles, and embroideries have had on Western clothing and the international fashion sensibility from the eighteenth century to the present day. Documenting the history of textiles and costumes in India is a mammoth undertaking. In the pages ahead, you'll find fascinating accounts—ranging from the impact of Indian fashion on the Court of Versailles to the journey of the Kashmiri shawl to the dramatic iterations of the sari drape on global runways—along with profiles of the designers leading the contemporary Indian fashion movement.

Through these pages, I hope you get a glimpse of our heritage, and through the NMACC, we look forward to carrying ahead the legacy of Indian art for generations to come. I know firsthand how integral and enriching cultural experiences are. Art sensitizes the mind and nurtures the soul. It is my greatest wish that at the NMACC, Indian and global communities come together to inspire and be inspired.

INTROD

INDIA IN FASHION

HAMISH BOWLES

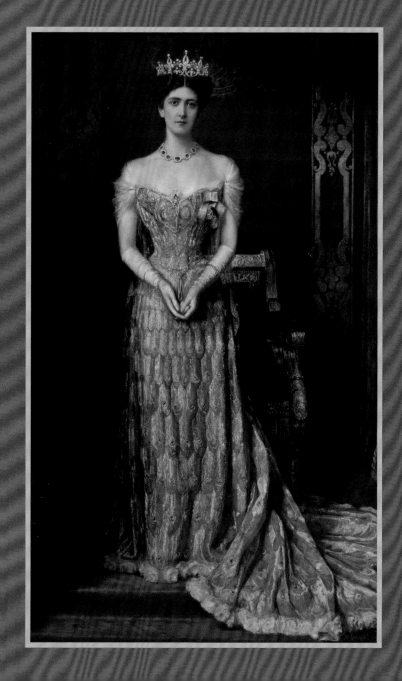

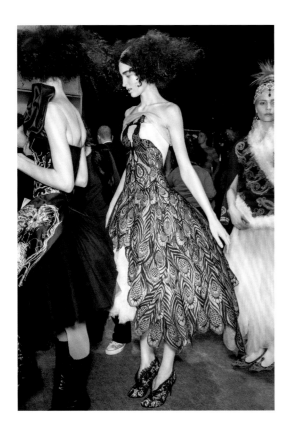

B eginning in the seventeenth century and continuing to this day, India's impact on Western fashion has been a complicated and layered history of admiration, appropriation, exploitation, and celebration. From the whimsical foliate charms of the chintzes conceived on the Coromandel Coast to the scrolling *botehs* of Kashmir's shawls, from the many varied draperies of the sari and the dhoti, to the impasto splendors of *zardozi* embroideries and the delicacy of *chikankari* work, the treasury of India's sartorial and textile traditions have provided inspiration that led to imitation at the court of Louis XVI and the couturiers of Jazz Age Paris, the sportswear designers of midcentury America, and the hippies of the Summer of Love. India's uniquely skilled craftspeople, who have generally toiled in anonymity, have furnished embroideries for British coronation robes, European haute couture garments, the collections of the twenty-first century's forward-facing design visionaries, and global fast fashion. Today, India's fashion community has laid its own legitimate claim to the traditions, skills, and inspirations of its homeland with dazzling results that celebrate and showcase the touch and artistry of the skilled hand.

At the turn of the seventeenth century, buccaneering merchants of the East India companies of the Netherlands, Britain, and, later, France began to import Indian-made textiles to Europe; however, it was the British who would have the longest and most complex relationship with India.

After realizing that it could not compete with the Dutch in the lucrative spice trade, the British East India Company decided to turn its attention to "potentially more promising sectors of the trade of Asia,"[1] especially indigo dyes and textiles, including the cottons so fine they were known as "woven winds" and delicately patterned chintzes, all of which were to be found in India.[2]

By 1608, when the British East India Company first arrived on the subcontinent, India's population was 150 million, and it was then responsible for producing about a quarter of the world's goods.[3] The country was the undisputed leader in manufactured textiles.[4] The relative stability of the Mughal Empire had allowed domestic trade to flourish. The sixteenth-century courts of Emperor Akbar and his successors, with their highly sophisticated and ever-evolving dress traditions, prized the refined regional textiles and embroideries brought to them from across the empire.[5] These luxury items carried local, symbolic, or political meaning with them and assumed diplomatic power too. The vast textile business contributed to making the "Mughal Emperor ... the richest monarch in the world,"[6] and presented a prize that the rapacious East India Company was keen to seize. By 1680, East India Company was importing more than a million pieces of chintz a year from India.

By the end of the seventeenth century, the East India Company was a uniquely powerful corporation with deep financial interests and British government connections. Bengal was the center of the Company's woven textile operations, and the capital city of Dhaka had an astonishing 25,000 weavers working to satisfy local and European demand.[7] The labor-intensive chintz fabrics that delighted Western consumers with their excitingly unfamiliar treatments of foliate motifs and their exquisite artistry were produced primarily on the Coromandel Coast.

When the Mughal Empire collapsed after the death of Aurangzeb in 1707, following a period of interdynastic conflict and wars with foreign invaders, the well-armed British East India Company seized the day with policies that were engineered to enrich its members.[8] As the Company took firm hold in the country, a systemic program of exploitation was implemented. Historian William Dalrymple stated, "the Company's conquest of India almost certainly remains the supreme act of corporate violence in world history."[9]

Throughout the eighteenth century, as India was brought under British rule, the brilliantly hued chintzes and improbably diaphanous muslins, which were often

OPPOSITE William Logsdail, *Portrait of Mary Curzon, Baroness Curzon of Kedleston*, 1909. Oil on canvas. Kedleston Hall, Derbyshire. Lady Curzon wears an evening dress of gold and silver *zardozi* embroidery on silk taffeta by Jean-Philippe Worth, 1900–02. The Peacock Dress embroidery was made at the workshop of Kishan Chand in India before being sent to the House of Worth. Lady Curzon wore the dress at the Delhi Durbar in 1903.

ABOVE Alexander McQueen, evening dress of cream tulle with peacock lace appliqué, Fall 2008, *The Girl Who Lived in the Tree* collection. Photographed by Robert Fairer. The peacock— native to India and symbolic of royalty—here references not only Lady Curzon's renowned Peacock Dress but also Queen Victoria (1819–1901), who was crowned Empress of India in 1876.

embroidered or woven in delicate patterns and sometimes threaded with gold or silver thread to coruscate in candlelight, remained coveted commodities in Europe. Once Indian textiles became fashionable and prized in Europe and North America, local manufacturers scrambled to imitate them with their own technology and deliver them to a broader customer base at more competitive prices than the costly imports. The Indian textiles, however, continued to be prized even after protectionist laws were introduced to forbid their import and wear. Indian chintzes were banned in France between 1686 and 1759, and partially banned in Britain between 1700 and 1774.[10] With the Industrial Revolution and the mechanization of looms that enabled mass production techniques, the Western imitations became increasingly more sophisticated, and the Indian exporters could not compete except at the most rarefied levels.

In Europe and North America, Indian chintzes were used for household furnishings such as bed and wall hangings, and for men's garments such as waistcoats and *banyans*. An informal and lightly structured robe worn at home, *banyans* were inspired by Eastern silhouettes, including the "Indian house gown."[11] As fashions changed, the *banyan* developed into a more fitted and constructed garment, like the Indian chintz example fashioned for the Prince Regent (late King George IV). The Prince Regent's ca. 1785 *banyan* reflects the influence of his sometime friend and style arbiter Beau Brummell, who was the era's preeminent dandy. Brummell was quoted as saying, "Come to Brighton my dear fellow ... let us be off tomorrow; we'll eat currant-tart and live in chintz and salt-water."[12]

The enthusiasm for Indian motifs extended beyond fashion. The Prince Regent commissioned the theatrically minded royal architect John Nash to build the Brighton Pavilion in fanciful Indo-Saracenic style. The Neo-Mughal-tinged Daylesford, a cottage house built by architect Samuel Pepys Cockerell between 1788 and 1793 for Warren Hastings, who was the first Governor-General of British India, and his more ambitiously Mughal-influenced Sezincote House of 1805, which was constructed for Colonel John Cockerell, who had served in Bengal for the East India Company, bear testament both to the fashion for Indian aesthetics and the staggering wealth amassed by those nabobs who had gone to seek their fortunes through the exploitation and plunder of the subcontinent.

Imported Indian Kashmir shawls were another prized and costly commodity that were favored by the Empress Joséphine and the fashionable *salonistes* of Napoleonic Paris. With minimal adaptation, the shawls could be fashioned into high-waisted, narrow dresses that were fondly felt to emulate the garments seen in ancient Greco-Roman art—a sartorial riposte to the voluminous excesses of women's garments during the *Ancien Régime*. European manufacturers were quick to imitate these Indian originals and soon were to be greatly helped by detailed studies such as J. Forbes Watson's *The Textile Fabrics of India* (1866) and *Textile Manufacturers and the Costumes of the People of India* (1867). These tomes ultimately provided blueprints for European manufacturers and contributed to the decline of the very industry that Forbes Watson had intended to memorialize and celebrate. The new mechanized looms of Paris, Lyons, and Paisley in Scotland (the latter giving the garment its popular British name) were soon producing extremely complex woven designs that closely emulated the hand-embroidered and woven Kashmir examples. Eventually, these accessibly priced and ubiquitous shawls of European manufacture destroyed the Indian market.

The voluminous shawls were adapted to accommodate the evolving fashionable silhouette through the nineteenth century. Worn folded on the bias over the full skirts of the 1850s, they were buoyed by the immense dimensions of the wire-framed crinolines of the following decade. At the end of the 1860s, the fashionable silhouette, dictated by the all-powerful British-born couturier Charles Frederick Worth, who dressed the royal courts

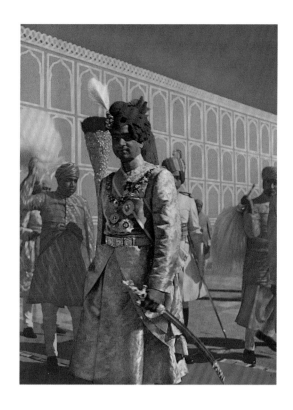

ABOVE Maharaja Bhawani Singh of Jaipur. Photographed by Constantin Joffé for the December 1948 issue of *Vogue*.

OPPOSITE Gabrielle "Coco" Chanel, tunic and breeches of mauve pink lamé with golden arabesques, Fall/Winter 1969, Haute Couture. Modeled by Marisa Berenson. Photographed by Gianni Penati for the January 1, 1969, issue of *Vogue*.

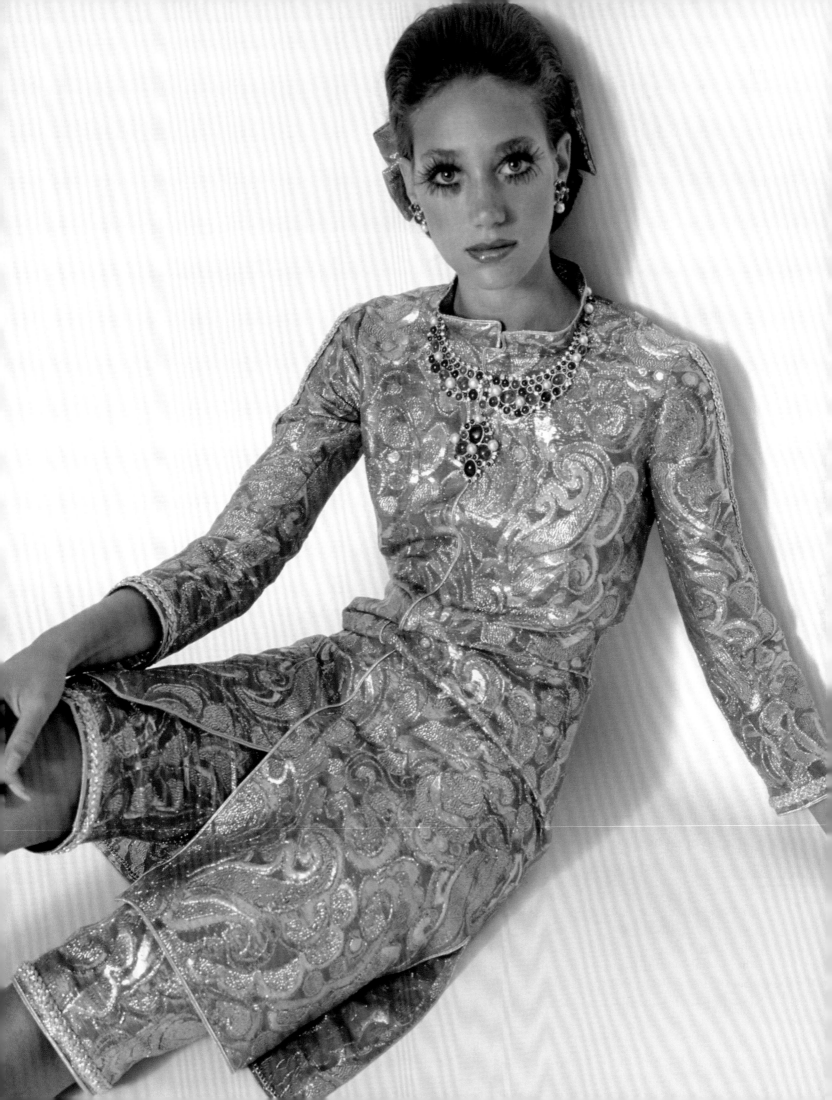

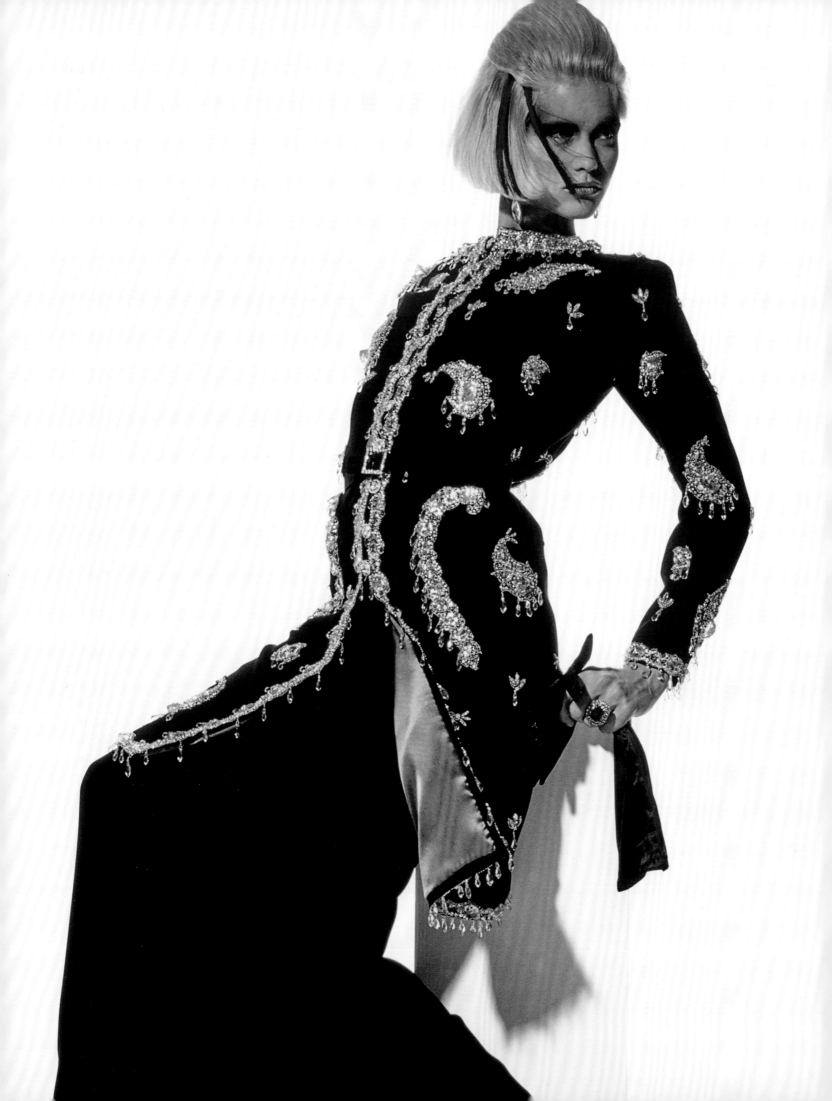

of Europe and Russia from his salons on Paris's rue de la Paix, evolved from full skirts supported by caged crinolines to the bustle, with the skirts cut and draped to fall straighter from waist to floor in front with all of the volume drawn to the back, evolving into the even more exaggerated horizontal shelf bustles that appeared in the 1880s. To accommodate the bustle, prized and valuable shawls were repurposed through seaming and tailoring into the shaped *visites* that draped over the bustle's protuberance in the back. The shawls were also used to create complete dresses, as they had been earlier in the century, for garments such as the tea gown, which was a daytime garment designed for informal wear or entertaining at home. The *boteh*, or paisley motif, was an integral element in the design of many Kashmir shawls. It was also incorporated into textile designs and printed, woven, or embroidered on fabrics from silk to wool. It remains a fashion leitmotif to this day.

In 1858, following the Indian Rebellion of the previous year, the East India Company transferred control of India to the Crown, and Queen Victoria became its Empress. Seven years earlier, the queen, along with six million of her subjects, had marveled at the Indian offerings on view at the centerpiece of the Great Exhibition of 1851. The queen acquired a sumptuous example of Benaras gold-woven brocade, which was used in a Carolean era fancy-dress costume designed for her by the French artist Eugène Lami.

With India now firmly under Britain's rule, commerce and empire were even more closely intertwined. At the height of the Raj in the early twentieth century, after Britain's industrial revolution and its mechanized imitations had decimated much of India's handloom production for export, the wardrobe of the Vicereine of India, Lady Mary Curzon, became a showcase for India's embroidery, especially *zardozi*, the ornate gold metal work that flourished during the later years of the Mughal Empire. Scholar Nicola Thomas notes that Curzon "appears to have created a wardrobe that might resonate with the Maharajas attending state functions, an audience whose own traditions were embedded in the absolute power of clothing ... by using embroidered fabrics as her mechanism, Mary was following a well-established tradition, which held particular resonance in courtly India."[13]

One of a bevy of wealthy American "dollar princesses" who swelled the coffers of European aristocrats while garnering prized titles, the unusually cultivated Mary Leiter, daughter of a wealthy Chicago dry goods magnate, would become the Vicereine of India when her husband, George Curzon, the first Marquess Curzon of Kedleston, was appointed as viceroy in 1899. Although some of Lady Curzon's viceregal wardrobe was made in India of imported European fabrics, she also patronized the greatest Parisian haute couturiers, including Worth's son Jean-Philippe, who had assumed the artistic direction of the couture house when his father retired—but even she balked at his prices.

Perhaps no other dress in Lady Curzon's wardrobe demonstrates colonial authority more than the Peacock dress, designed by Jean-Philippe Worth in Paris with embroidery created by the workshop of Kishan Chand in India, and worn by the Vicereine to the second Delhi Durbar in 1903, to honor the 1902 coronation of King Edward VII.[14] Composed of gold *zardozi* embroidery on silk chiffon, the design was intended to mimic the feathers of a real peacock. The embroidery, made in Kishan Chand's Delhi workshop, was sent to Worth's atelier, where it was fashioned into the dress and shipped back to India for Lady Curzon to wear.[15]

In India, the peacock symbolizes good luck and prosperity. Lady Curzon's dress was most obviously inspired by the Peacock Throne, the seat of power for the Mughal Empire, and encrusted with precious stones including the 105 carat Koh-i-Noor diamond, which was seized by the Persian ruler Nader Shah during the Battle of Karnal in 1739 and later set into the crown worn by Queen Alexandra for the Coronation of 1902. The dress thus symbolically equated Britain's power with that of the Mughals. Lady Curzon wore the dress to the ball at the Diwan-i-Khas, the building that originally housed the throne.[16]

Lady Curzon was also entrusted with supervising the embroidery for several dresses for Queen Alexandra, including her ethereal coronation dress, which was made in Kishan Chand's workshop and designed by Ashraf Khan. The queen deemed the results a "glorious success." It was a rare instance of a designer being acknowledged by the queen.

The queen's dresses, like Lady Curzon's, were fabricated by her preferred Paris dressmakers. The new century that her husband's reign ushered in would see the most distinguished European and American fashion talents seek inspiration from Indian prototypes.

At the turn of the century, French fashion designer Paul Poiret apprenticed at the House of Worth but railed at its conservative and traditionalist approach and clientele. When he launched his eponymous house in 1903, Poiret looked to Eastern dress forms, including the kimono and the draped *sirwal* pant, to create clothing of revolutionary simplicity that liberated women from corsetry and brought the highly colored, Orientalizing world of Diaghilev's Ballets Russes into fashionable drawing rooms. For his Spring 1924 collection, Poiret created "Lure," a sari-inspired dress that his wife and emblematic muse Denise wore. The Rani of Pudukkottai (née Molly Fink of Melbourne) was fabled for her own stylish wardrobe, which included clothes ordered from Paquin, Patou, Vionnet, Chanel, and Callot Soeurs—many of them made up in Indian textiles that she had presumably supplied.

The tradition of using Indian textiles continued. In the 1950s, Princess Lilian of Belgium brought fabrics that she had acquired in India to be made up by Christian Dior in designs from his latest collections. Twenty years later, the distinguished lecturer Rosamond Bernier had the Indophile London-based designer Zandra Rhodes do the same.

In 1934, the appearance of the orchidaceous nineteen-year-old Sita Devi of Kapurthala in Paris, where she was to order haute couture garments from such modish creators as Paquin and Mainbocher and the milliner Reboux, proved electrifying. Dubbed "the Pearl of India," Devi was applauded by *Vogue* for the "refreshing exoticism of her native clothes." The publication commissioned fashionable photographers Cecil Beaton, Horst. P. Horst, André Durst, and the illustrator Eric to record her beauty for them. In the July 1, 1935, issue of *Vogue*, the princess wrote, "I was thrilled to see that some of the dressmakers were actually inspired for their new models this year by some of the saris I wore in the summer of 1934."[17] Among those inspired were Alix (later Madame Grès), Elsa Schiaparelli (who included both sari and dhoti themes in her Spring 1935 collection), and Mainbocher.

Chicago-born Main Bocher was so enraptured with his client's Benaras saris that he continued to use the textiles in his collections through the 1960s, fashioning them into his elegantly conservative, structured Western silhouettes for such preeminent style leaders as the Duchess of Windsor, Millicent Rogers, Princess Natalia Paley, and C. Z. Guest. The Russian born and New York–based couturiere Valentina Schlee also sublimated authentic sari textiles to her own innovative but decidedly Western silhouettes.

Conversely, Alix, a sculptor by training, was inspired by the drapery and manipulation of textiles of Indian garments to indulge her notorious aversion to cutting fabric. Alix's devotion to Indian craft culminated in her 1958 visit to India on a Ford Foundation grant. She spent time in India touring handloom workshops, art centers, and museums devoted to textiles in Varanasi, Chennai, Mumbai, Delhi, and Jaipur.[18] The *New York Times* noted that the trip was "designed to bring the ancient Indian handcraft of weaving more in tune with the modern Western market."[19] Grès's collection the following year, in Spring 1959, would pay tribute to India in silhouettes reminiscent of kurtas, dhotis, cholis, and sari dresses made in vibrantly colored Indian-inspired textiles.[20]

Schiaparelli showed silk chiffon saris for Spring 1935, using a palette of vibrant Indian-inspired colors, including her celebrated "shocking pink." Meanwhile, Gabrielle "Coco"

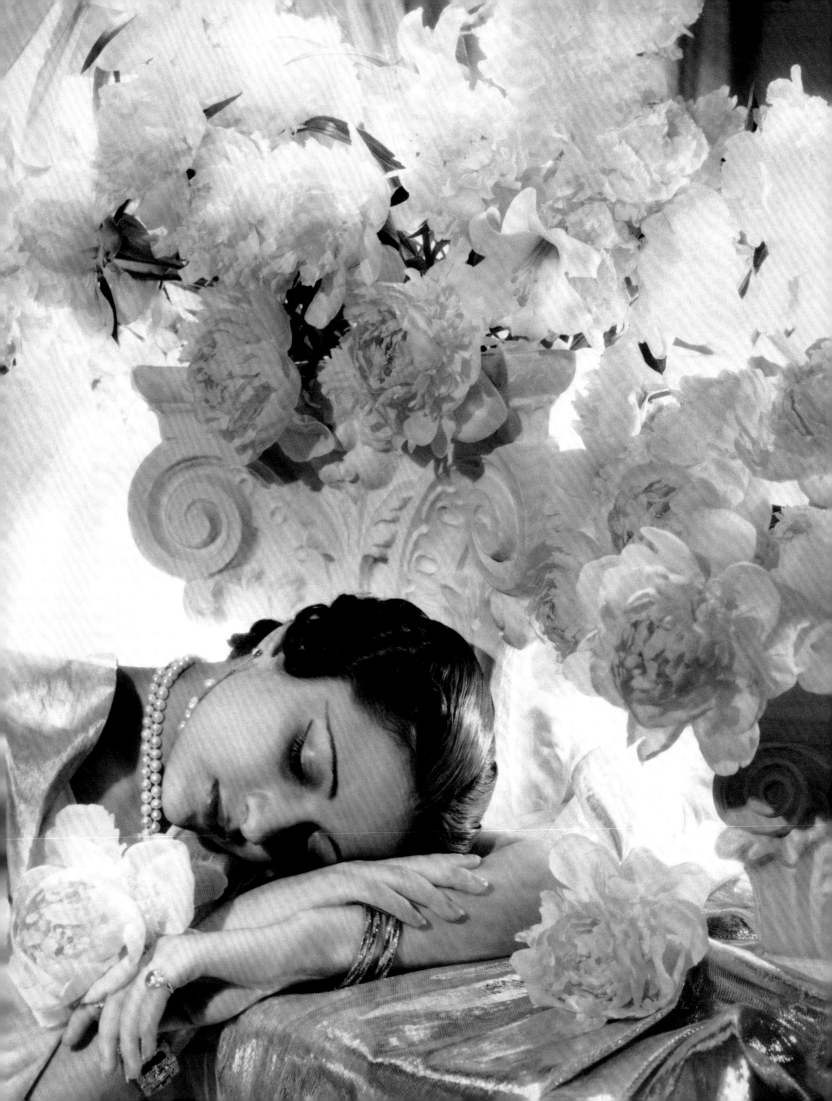

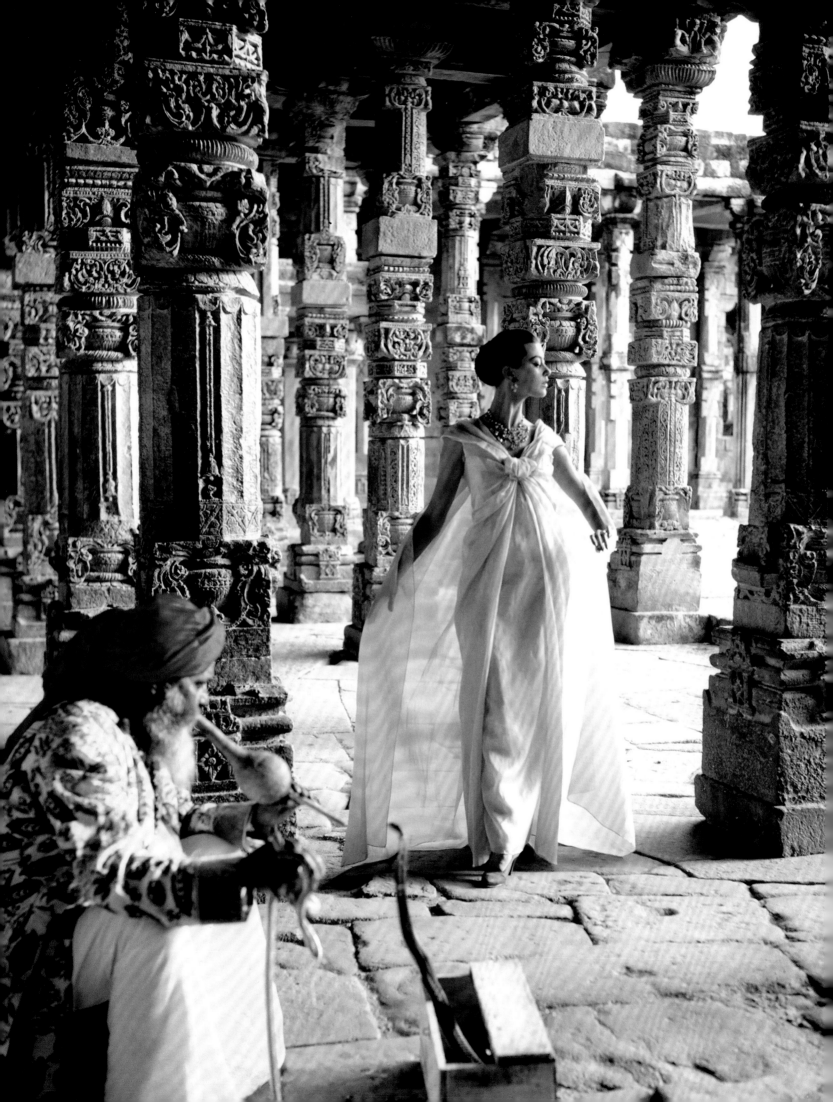

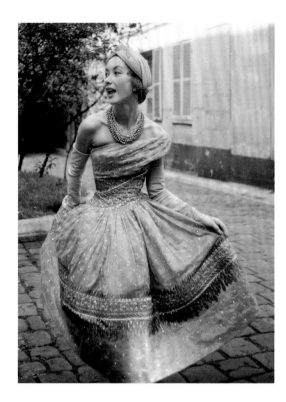

Chanel, who had been introduced to Indian myths and sacred texts in the teens by her then lover Boy Capel, showed a sari drape in her Spring 1939 collection, and designed costume jewelry that emulated princely Indian fine jewelry earlier in the decade.

Saris made of silk chiffon had been introduced by another stylish Indian royal: Indira Devi of Cooch Behar, who was "a prominent figure in the social scene that flitted between London, Paris, and Hollywood between the wars, and included Noël Coward, Jimmy Stewart, the American interior designer Elsie de Wolfe, and various louche members of the British royal family and the European aristocracy."[21] Devi worked with the Parisian textile firm Monsieur Erigua to specially make silk chiffon in sari lengths (45 inches wide by 6 yards long), delighting in the fact that the material had previously only been used for negligees.[22] Devi also loved jewelry, having stones set by her preferred houses, Cartier and Asprey, and even incorporated them into the shoes that she ordered by the hundreds from Salvatore Ferragamo.[23] In turn, European and American style leaders invited to India as the guests of the princely families returned home with precious jewels in Indian settings, creating a new vogue that was echoed in the innovative designs of houses, including Cartier, whose designer Jeanne Toussaint created "tutti frutti" jewels, incorporating tumbled and carved Indian stones, that were commissioned by fashion plates such as Daisy Fellowes, who had also ordered Schiaparelli's sari dress.

The Maharani's second daughter, Gayatri Devi (known as Ayesha), wife of Maharaja Sawai Man Singh II, and a future politician with her own glamorous friendship circle that included First Lady Jacqueline Kennedy, inherited her mother's sartorial flair and would continue to proselytize for Indian dress on the international stage. Of the silk chiffon sari that made her famous, Ayesha declared, "After all, there's nothing more lasting than six yards of material whose fashion never changes."[24]

Princess Kapurthala's son, Martand Singh, meanwhile, would inherit his mother's passion for textiles, becoming the director of the Calico Museum of Textiles in Ahmedabad, India. Singh did much to revive and preserve his country's textile traditions. He was the cocurator with Diana Vreeland of the groundbreaking 1985 exhibition *Costumes of Royal India*, presented at The Metropolitan Museum of Art.

In the aftermath of World War II, the world experienced a period of intense economic, political, and cultural upheaval, including the Partition of India in 1947. The Parisian haute couture, however, remained a rarefied world. Christian Dior launched his house with his "Corolle" line (immediately dubbed "The New Look" by *Harper's Bazaar* editor Carmel Snow) for Spring 1947. The line included Indian inspiration from that first collection that extended to the naming of his ensembles, *Benaras*, *Bengale*, and *Pondichery*, among them.

Dior's young protégée Yves Saint Laurent took up the mantle, both at Dior and subsequently at his own house. Saint Laurent's very first collection for Spring 1962 featured slim-fitting raja jackets—a recurring theme at Chanel too—and turban-inspired hats. Saint Laurent's Spring/Summer haute couture 1982 collection, inspired by his Indian model muse Kirat Young, was a paean to India. The highlights were showcased in a retrospective show held at the Purana Qila, Delhi, India, on November 12, 1989.

The revered couturier Cristóbal Balenciaga explored the sari for a sequence of evening dresses in his Fall 1963 collection. The great couturier reimagined the artful drapery of the source garment through highly complex seaming and interior structure. Balenciaga's dressmaker Madame Felisa, who had been responsible for these wonders, went to work for Saint Laurent after Balenciaga retired in 1968, and these draped sari-inspired dresses thenceforth became a recurring part of Saint Laurent's repertoire. Hubert de Givenchy, who was mentored by his great friend Balenciaga through the early years of his career, also experimented with sari-inspired dress forms.

OPPOSITE Christian Dior London, evening dress of gold lamé organza, Fall/Winter 1956. Modeled by Anne Gunning. Photographed by Norman Parkinson for the November 1956 issue of British *Vogue*.

ABOVE Christian Dior, "Soirée de Lahore" evening dress of gold lamé gauze from Pétillault with embroidery by Rébé, Fall/Winter 1955, Haute Couture, Y line. Modeled by Lia Lucas. Photographed by Mark Shaw.

OVERLEAF Federico Forquet, printed chador scarf and dhoti pants, Spring/Summer 1967. Modeled by Samantha Jones. Photographed at the Durbar Hall of Jag Mandir Palace by Henry Clarke for the June 1967 issue of *Vogue*.

Haute couture was not the only thing inspired by India. In 1955, the Museum of Modern Art staged the influential exhibition *Textiles and Ornamental Arts in India*, which incorporated contemporary fashion pieces, including a dress in a sari fabric by the American manufacturer Filcol. To coincide with the opening, a *Life* magazine article with photos by Mark Shaw presented a report on the journey of a dress with a visit to the Indian craftspeople who created the fabric—"a weaver, two helpers, two trimmers produce one sari in five days."[25]

A decade earlier, acclaimed American photojournalist Margaret Bourke-White had traveled to India, where she shot the image of Gandhi seated next to his charkha, or spinning wheel. This haunting image became symbolic of a nation on the eve of independence. The charkha was a potent symbol of both nonviolent protest and self-reliance. Khadi not only represented a rejection of British imperialism but also emphasized "Indianness." Domestically produced, the humble, hand-spun cotton became a prominent vehicle in the movement toward economic liberation. Worn, khadi served as "the Livery of Freedom, emerging out of Gandhi's sartorial experiments to de-Europeanize fashion."[26] The extraordinary importance of textiles and dress within the Swadeshi movement exemplifies the longstanding power of cloth and cloth-making in India.

Gandhi's impact on the global peace movement was profound. In the tumultuous era of the sixties, as the Vietnam War intensified, there was a renewed interest in India. In 1965, Beat poet Allen Ginsberg coined the expression "flower power," putting a name to the hippie movement. That same year, Diana Vreeland declared, "More dreamers. More doers. Here. Now. Youthquake 1965."[27] As *Vogue* fashion editor Susan Train explained, Vreeland "was completely in touch with ... the enormous cultural revolution being led by young people."[28]

"In the 1960s, everybody was dreaming about being an international traveler, and Vreeland was going to show them what it was all about," Train recalled. "With the advent of the jet plane, all of a sudden you could go to India for a week or two ... and you could get there very fast. Vreeland was inspired by the idea of travel and wanted to open up the world for *Vogue* readers and spark their imaginations."[29]

In 1956, British *Vogue* sent photographer Norman Parkinson to India with models Anne Gunning and Barbara Mullen. The team traveled from Tamil Nadu to Kashmir, scouting for shoots. The portfolio from the trip was published in the magazine's November issue. It portrayed dazzling Indian landscapes and architectural marvels, including the Taj Mahal, as backdrops to Western fashion.[30] Extended captions presented historic details on each location, but the clothes, like the *Vogue* team presenting them, were all tourists in the end. Upon seeing the image of Gunning in a pink mohair coat by Jaeger outside the City Palace in Jaipur, Vreeland famously exclaimed, "How clever of you, Mr. Parkinson, also to know that pink is the navy blue of India."[31]

Film critic Penelope Gilliatt described her astonishment of India: "The eye is stormed a million times a day: not only by colour of a full-throated kind that makes our own seem constricted, and by strangeness—a peacock pacing along a trunk road— but still more by the Indian instinct for beauty. It shows everywhere."[32]

The June 1967 issue of American *Vogue* featured a lavish, twenty-six page editorial shot by Henry Clarke in Udaipur, featuring models Samantha Jones and Simone D'Aillencourt. As it had for Parkinson in 1956, India provided an alluringly escapist backdrop for the season's latest offerings that included "India pink dresses" and dhoti-inspired pajamas by Roman couturier Federico Forquet—clothes that reflected the jet-set "hippie de luxe" looks and lifestyle championed by Vreeland.[33] This exoticizing, Orientalist vision brings to mind the words of Richard Martin and Harold Koda, then curators of The Metropolitan Museum of Art's Costume Institute. "Orientalism

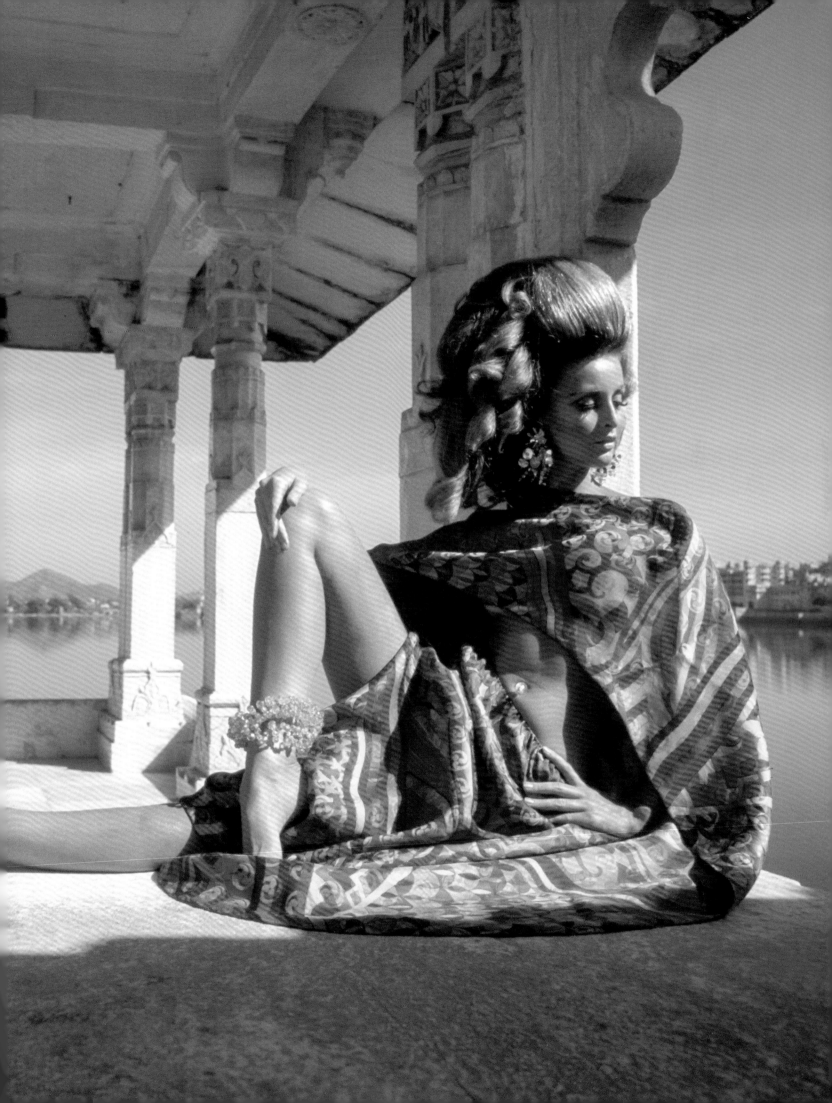

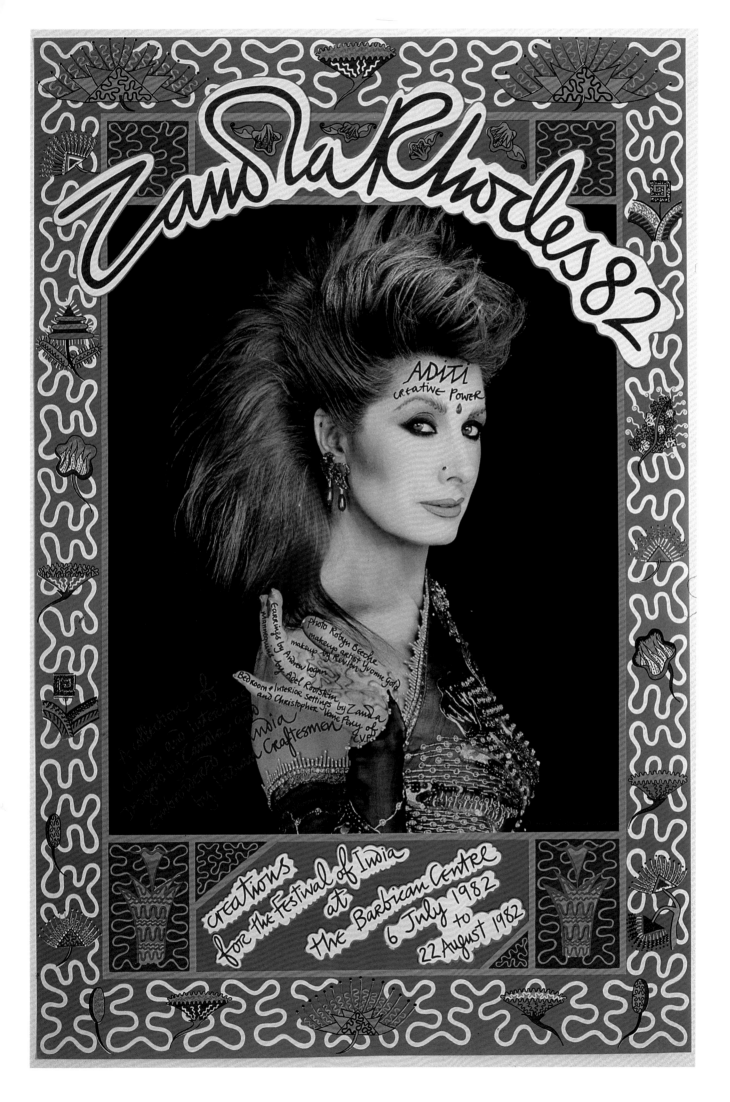

OPPOSITE Zandra Rhodes ADITI poster for the Festival of India at The Barbican Centre, London, 1982.

BELOW Schiaparelli, spiral "sari" evening dress, Spring/Summer 1935. Illustrated by Christian Bérard for the March 15, 1935, issue of *Vogue*.

is not a picture of the East or the Easts," they wrote. "It represents longing, option, and faraway perfection. It is, like Utopia, a picture everywhere and nowhere, save in the imagination."[34] First Lady Jacqueline Kennedy had presaged the look when she chose a sleeveless, green and blue print shift dress by American designer, Warhol muse, and socialite Joan "Tiger" Morse to wear when she visited the Taj Mahal during her goodwill tour of India and Pakistan in 1963. Morse owned the same dress herself and was photographed by Mark Shaw wearing it for a *Life* magazine feature titled "Businesslike Search for Style: Around the World Jet Shopper," which followed the Upper East Side Factory doyenne on her fabric buying trip to the East. Morse boasted that she had flown around the world thirteen times over three years in order to purchase textiles, such as a 22-carat gold and pure silver brocaded fabric from Benaras that took eight months to weave a single length on a handloom, for her New York boutique, A La Carte.[35]

Tiger Morse represented a uniquely American trend of women sportswear designers who incorporated ethnic influences into their collections. The 1951 Resort collection of Carolyn Schnurer, an American designer known for her culturally inspired daywear and beachwear, was called *Flight to India*. The collection included several fashions with a decided Eastern drift: the Bombay shirt, the choli, and the halter top, fabricated in sari fabrics or incorporating surface adornment such as Kutch mirror work.[36]

As a young child, fellow American designer Tina Leser spent the winter in Madras with her family. She became enthralled with the color pageantry of the maharajas. She developed a deep, abiding love of textiles and a keen sense of color.[37] She later remarked, "After seeing an elephant in India with a ruby necklace, I thought anything is possible."[38] As early as her Resort 1945 collection, Leser directly referenced India in skirts that adapted the traditional dhoti. In 1965, she realized her visionary dream of creating an international manufacturing partnership in India. "Their workmanship is better, and they need more work to allow them better standards of living," Leser explained. "I hope this will help promote the angle of international thinking and economic cooperation."[39]

Born in Jerusalem to a French missionary mother and an Arabist theologian father, and raised in Damascus, designer Thea Porter opened her shop in London's Soho during the Summer of Love in 1967. In the vein of Tiger Morse, many of Porter's designs, including her signature patchwork caftans, incorporated Indian textiles. "It's like wearing a king's raiment … they're so splendid," New York socialite and Warhol muse "Baby" Jane Holzer enthused in *Vogue*.[40] Porter would later recount that "The Beatles, all four of them—then smooth-cheeked Liverpool boys—came in to buy cushions but ordered clothes as well. They wanted to look gorgeous and were my first big spenders."[41]

That following year, The Beatles embarked on a spiritual journey to India at the ashram of Maharishi Mahesh Yogi, led by George Harrison's fascination with the country through the music of Ravi Shankar, who taught him how to play the sitar and whose ragas became the soundtrack to sixties counterculture. The lads from Liverpool returned to London rejuvenated, armed with thirty new songs—most of which would end up on the *White Album*—and a wardrobe of humble cotton kurtas.

It was not the first time that The Beatles had embraced Indian menswear. In 1965, The Beatles played Shea Stadium in New York City to a sold-out crowd of 55,600. They wore tan Nehru jackets, named after Jawaharlal Nehru, who was India's first prime minister after independence, and derived from the northern Indian achkan, or knee-length jacket usually considered court dress for Indian nobility. *Vogue* had already shone a light on Nehru's sartorial sense: "Always immaculately dressed—in white Gandhi-linen while in India, and in Bond Street suits while in England—he is a starter of styles."[42]

The revered Indian designer Ritu Kumar was in the vanguard of reclaiming India's textile and design patrimony for the country itself, liberated from imperialist ideas and the

imposition of Western dressmaking concepts under the Raj. Kumar is credited with reviving both hand-block printing in Bengal and bringing an awareness of *zardozi* craftsmanship in the seventies when her partnerships with Seventh Avenue manufacturers brought the world of Indian craft and textile aesthetics to wide European and American audiences.

Indian-American fashion designer Naeem Khan learned his fashion craft in the seventies and early eighties working alongside Halston, who defined the fashion of Manhattan's Studio 54 era. Halston's embroideries were produced in Khan's family workshop in Mumbai. Khan has brought those skills to the embellishment of the clothes in his own name collections, notably dressing First Lady Michelle Obama.

Throughout the eighties, designers including Karl Lagerfeld in his work at Chanel, Christian Lacroix, and Jean-Louis Scherrer (who apprenticed with Christian Dior alongside Saint Laurent) found abundant inspiration in India's princely dress traditions, their highly decorated, opulent homages finding favor with emerging American socialites and the women of the oil-rich Gulf states. (Long after Scherrer left the house that bore his name, Ritu Beri, the first Asian to head a French fashion house, was briefly appointed head of women's ready-to-wear.)

Karl Lagerfeld continued the house of Chanel's fascination with the splendors of Indian princely dress. Lagerfeld, who never traveled to India (he perversely declared, "it's much more inspiring not to go to places than to go"), later celebrated its sartorial aesthetics in his Paris-Bombay Métiers d'Art show of 2011–2012. Tim Blanks called it "a reminder that Europe's fashion industry has increasingly turned to India to produce extravagantly handworked pieces as it has become prohibitively expensive to make them at home."[43]

Meanwhile, contemporary designers, including Jean Paul Gaultier, Dries Van Noten, and John Galliano, as the profiles in this book reveal, have celebrated India in their collections and in practical ways too, supporting the country's artisans.

Alexander McQueen's Fall 2008 collection titled *The Girl Who Lived in the Tree* was the result of a month spent in India with his friend and collaborator, the jeweler Shaun Leane. It referenced the twilight years of the British Raj. "Alexander McQueen handed his audience a self-imagined fantasy of crinolined princesses and British colonial romance of such beauty," Sarah Mower noted, "it arguably surpassed anything he's achieved in 14 years."[44]

Following the lead of Ritu Kumar, India's design community has looked beyond the tropes of princely colonial era dressing to build its own design language—one that focuses on the extraordinary skills of their country's textile and embroidery artisans (and their well-being) as well as reimagining the country's dress forms: the sari, dhoti, *lehenga* choli, and sherwani, among so many others, in innovative ways. They may have looked to Coromandel chintzes, the muslins of Dhaka, the embroideries of Kashmir, and the silks of Benaras, but they refracted through a very different lens than that of the West's designers.

"How do we define India?" asks Raw Mango's Sanjay Garg, who has found inspiration in the art of the late-nineteenth-century artist Raja Ravi Varma's work and "the way Indira Gandhi wore the saree. ... There could be a hundred definitions. So [it is] impossible to say if we have a common aesthetic."[45] Sabyasachi Mukherjee notes, "India is such a reservoir of history, art, and culture—and I believe that for culture to be relevant it needs to be dynamic. My job is to make it dynamic for today's consumer."[46] In doing just that, the designers profiled here—Abu Jani, Sandeep Khosla, Anamika Khanna, Anuradha Vakil, Manish Malhotra, Rahul Mishra, Raw Mango's Sanjay Garg, Sabyasachi Mukherjee, and Tarun Tahiliani—have developed their own unique aesthetics, ones that, as Rahul Mishra becomes the first Indian designer to present his haute couture in Paris, and Sabyasachi opens a flagship in Manhattan and collaborates with H&M, find their place today on the world stage. India continues to impact global fashion, as it has through the centuries.

ABOVE Givenchy, embroidered silk evening dress, Spring/Summer 1962, Haute Couture. Modeled by Audrey Hepburn. Photographed by Howell Conant for the May 11, 1962, issue of *Life* magazine.

OPPOSITE Alexander McQueen, "sari" evening dress of red dupioni silk woven with silver jacquard borders and ivory silk tulle underdress, Fall 2008, *The Girl Who Lived in the Tree* collection. Photographed by Robert Fairer.

OVERLEAF Karl Lagerfeld for Chanel, "Coromandel" evening dress of spun-metal jaserant and cannetille embroidery with bead and sequin appliqué by Lesage, Spring/Summer 1996, Haute Couture. Modeled by Shalom Harlow. Photographed by Irving Penn for the April 1996 issue of *Vogue*. This dress required 1,280 hours of work—more time than any other piece to come out of Chanel—and, as a result, was the most expensive dress ever produced by the atelier up to that point.

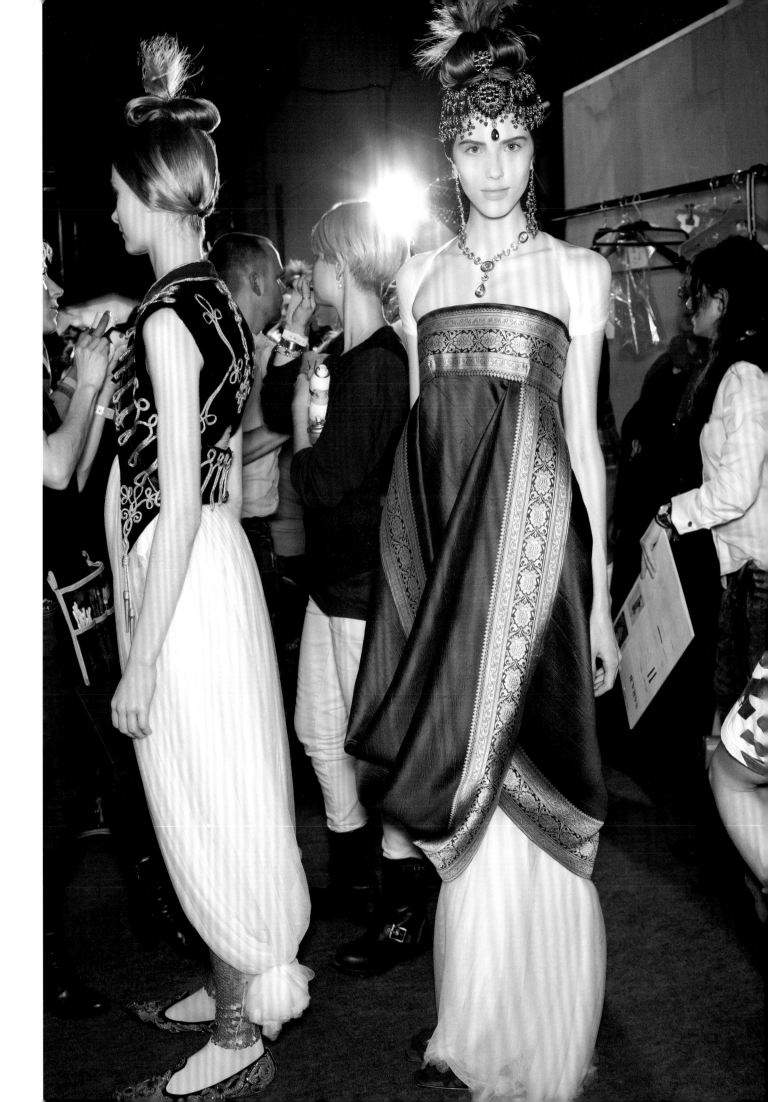

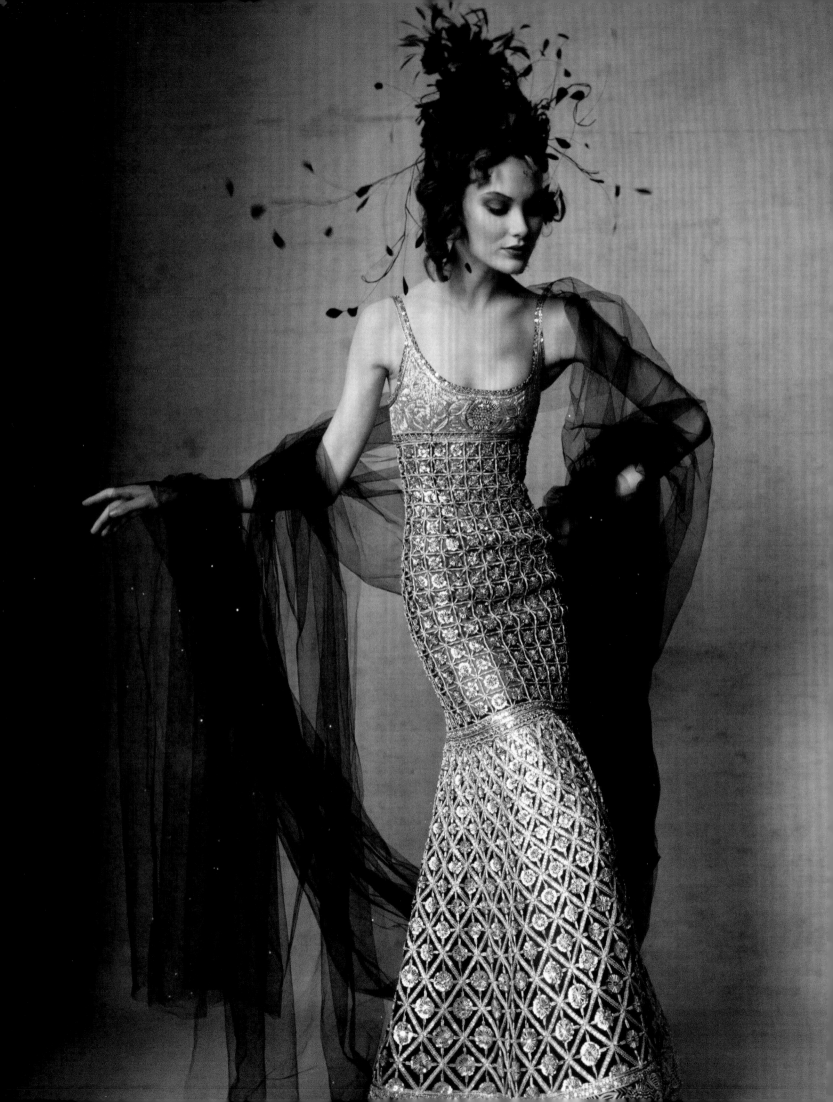

ENDNOTES

1 William Dalrymple, *The Anarchy: The East India Company, Corporate Violence, and the Pillage of an Empire* (New York: Bloomsbury Publishing, 2019), 13.

2 Dalrymple, *Anarchy*, 13.

3 Dalrymple, *Anarchy*, 14.

4 Dalrymple, *Anarchy*, 14.

5 Sylvia Houghteling, *The Art of Cloth in Mughal India* (Princeton and Oxford: Princeton University Press, 2022), pp. 11-12.

6 Dalrymple, *Anarchy*, 14.

7 Dalrymple, *Anarchy*, 25.

8 Dalrymple, *Anarchy*, 394.

9 Dalrymple, *Anarchy*, 394.

10 Sarah Fee, *Cloth That Changed the World: The Art and Fashion of Indian Chintz* (New Haven, CT: Yale University Press, 2019), 16.

11 Richard Martin and Harold Koda, *Orientalism: Visions of the East in Western Dress* (New York: Metropolitan Museum of Art, 1994), 35.

12 Captain Jesse, *The Life of George Brummell, Esq., Commonly Called Beau Brummell, Vol. 1* (London: Saunders and Otley, 1844), 353.

13 Nicola J. Thomas, "Embodying Imperial Spectacle: Dressing Lady Curzon, Vicereine of India, 1899–1905," *Cultural Geographies* 14, no. 3 (2007) : 369–400, 389.

14 Thomas, "Embodying Imperial Spectacle," 400.

15 https://www.nationaltrust.org.uk/kedleston-hall/features/lady-mary-curzons-peacock-dress

16 Thomas, "Embodying Imperial Spectacle," 392.

17 Sita Devi of Kapurthala, "Beauty in India," *Vogue*, July 1, 1935, 52.

18 "India Getting Grès' Advice," *The New York Times*, November 17, 1958, 39.

19 "India Getting Grès' Advice," 39.

20 Alexandre Samson, "The Indian Journey of Madame Grès," unpublished manuscript, 2021.

21 Lucy Moore, *Maharanis: The Extraordinary Tale of Four Indian Queens and Their Journey from Purdah to Parliament* (New York: Viking, 2004), 186.

22 Moore, *Maharanis*, 187.

23 Moore, *Maharanis*, 187.

24 "Conversations with Fleur Cowles: H.R.H. The Maharanee of Jaipur," British *Harper's Bazaar*, October 1965, 81.

25 "East Brightens West: Orient's Style Takes Over in U.S. Fashion and Gives It a Gaudy, Faraway Look," *Life*, May 16, 1955.

26 Mayank Mansingh Kaul, "Rethinking Khadi," The Voice of Fashion, January 10, 2019, https://thevoiceoffashion.com/fabric-of-india/opinion/rethinking-khadi--2041.

27 "Youthquake," *Vogue*, January 1, 1965, 112.

28 Alexander Vreeland, *Diana Vreeland: Memos the Vogue Years* (New York: Rizzoli, 2013), 202.

29 Vreeland, *Diana Vreeland*, 202.

30 Penelope Gilliatt, "India," British *Vogue*, November 1965, 82–97.

31 Norman Parkinson, *Fifty Years of Style and Fashion* (New York: Vendome Press, 1983), 56.

32 Gilliatt, "India," 82.

33 "Summer in the City of Dreams—Udaipur," *Vogue*, June 1967, 84–109.

34 Richard Martin and Harold Koda, *Orientalism: Visions of the East in Western Dress* (New York: Abrams, 1994), 13.

35 "Businesslike Search for Style: Around the World Jet Shopper," *Life*, August 3, 1962, 43.

36 "Ideas from India," *Vogue*, January 1, 1951, 144–145.

37 April Calahan, "Tina Leser: Global Vision," in *The Hidden History of American Fashion: Rediscovering 20th Century Women Designers*, ed. Nancy Deihl (London: Bloomsbury, 2018), 42.

38 Calahan, "Tina Leser: Global Vision," 42.

39 Calahan, "Tina Leser: Global Vision," 50–51.

40 "Vogue's Own Boutique," *Vogue*, November 15, 1968, 192.

41 Venetia Porter, *Thea Porter's Scrapbook* (Norwich: Unicorn Press, 2019), 33.

42 Krishnalal Shridharani, "Nehru of India— a Man to Watch," *Vogue*, September 1, 1942, 77.

43 Tim Blanks, "Chanel Pre-Fall 2012," *Vogue*, December 5, 2011, https://www.vogue.com/fashion-shows/pre-fall-2012/chanel.

44 Sarah Mower, "Alexander McQueen Fall 2008 Ready-to-Wear," *Vogue*, February 28, 2008, https://www.vogue.com/fashion-shows/fall-2008-ready-to-wear/alexander-mcqueen.

45 Chinmayee Manjunath, "Sanjay Garg Interview: The Path-breaking Designer on His Unique Approach to Fashion and Luxury," *Scroll.in*, September 12, 2018, https://scroll.in/magazine/893450/sanjay-garg-interview-the-path-breaking-designer-on-his-unique-approach-to-fashion-and-luxury.

46 Shriya Zamindar, "Sabyasachi Has a New Address in New York's West Village," *Vogue*, October 14, 2022, https://www.vogue.in/fashion/content/sabyasachi-new-store-in-new-york-west-village.

FASHIO

TEXTI

HISTO

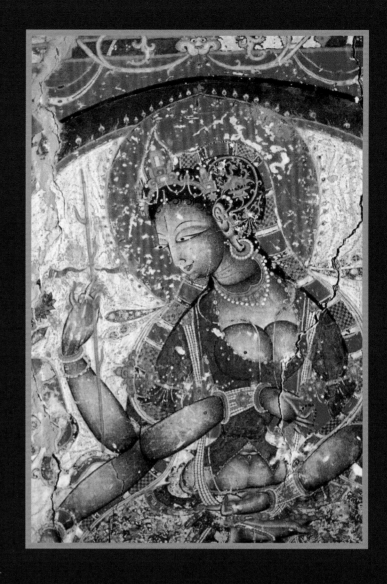

A HISTORY OF INDIAN DRESS

DRESS

RITU KUMAR

The fashion history of India cannot be defined easily or clearly to the rest of the world. Western fashion—as we know it today—is a product of an affluent environment, backed by a powerful media, a product of the twentieth century, and in the avatar of contemporary life a phenomenon that is only a few hundred years old. Today it is one of the biggest businesses in the world, owned by well-funded multinational companies that dictate the fashion choices they offer to the world, in a well-synchronized manner with its components of clothes, accessories, makeup, and perfumes, which constitute a large part of their revenue.

India, on the other hand, from the arrival of the Indo-Aryans from circa 1800 BCE to the end of the British colonial rule, has laid the foundations of its biggest industries on its textiles, produced largely by master craftspeople running highly complex guilds. At one time, most cities, towns, and villages had their own spinners, weavers, dyers, printers, and embroiderers, whose acumen was passed down from one generation to the next. These craftspeople were patronized by royalty and temples. Sartorial variations emerged as styles changed, largely dependent on one's religion, traditions, and climate, as well as tastes. India still holds on to its traditions in the continued use of the unstitched garment, the sari, and its varied usage in indigenous styles, which remains still the basis of the fashion of India.

FOUNDATIONS OF INDIAN FASHION

India perhaps is one of the few countries in the world that does not follow fashion as seen from a purely Western perspective. This is not due to any dictate by society or religion. The country's most important and democratizing garment, the sari, is worn in a myriad of ways, perhaps more traditionally by older women and more innovatively by the younger population, allowing great diversity in Indian women's wardrobes. It is important to understand from a fashion viewpoint that this garment is still worn on an everyday basis, unlike the kimono in Japan, which is now mostly worn for special occasions. The sari is India's ready-to-wear fashion, available at any price. A 500 rupee sari is as acceptable as one costing a lakh (one hundred thousand) of rupees or more, and both can be worn for the same occasion. The sari, in its choice of material and color, can easily follow the rhythm of the seasons, reflecting nature's own cycle of colors. It is also important that the garment works perfectly with India's rituals, of which weddings are an intrinsically theatrical part. The Indian calendar has festive occasions year-round, many of which are celebrated across the country.

The historical context of India's sartorial past has rarely ever been studied or written about. Colonial perceptions of India led people to believe that there was no fashion or individualistic sartorial style. This belief was largely dependent on the conclusions derived from European travelogues, guides, and paintings documenting the European experience of the region by such documenters as artist Thomas Daniell (1749–1840), who painted Indian architecture and monuments in addition to indigenous costume, which he published in a small volume (unfortunately, this book depicted only the clothing of the household staff of a British sahib). Nothing much else was recorded to reflect the wide range of garments that was, and is still, worn by India's vast population, or the profuse and varied use of India's rich legacy of textiles.

When photography was introduced to the subcontinent, it was used largely for portraiture of the maharajahs. These photographers had little or no access to women in India, who were the real repositories of the nuances of Indian fashion. There are images of dancing girls, generally portrayed with swirling skirts at evening soirees,

OPPOSITE Green Tara as Prajnaparamita. Sumtsek hall at Alchi monastery, Ladakh, late eleventh century.

and the impression remained of an unsophisticated country whose citizens, at best, were partially clothed or were, for the most part, naked. This reinforced the impression that India had little or no acumen in tailoring and cutting. There was a complete absence of the understanding of generations-old traditions: the layering of ensembles using stitched and unstitched clothing that conveyed in its nuances many social and societal traditions, the subtle use of jewelry to accompany dress, and the application of intricate embroidery, printing, and weaving, unknown to the rest of the world.

Looking back, there is little by way of evidence in paintings until about the fifth century CE, when Buddhist caves were found, which were profusely painted. A very rare and important image, showing an upper garment, is from a wall painting from the Ajanta Caves, of a dancing figure from the Mahajanaka Jataka, in grotto 1, Gupta period fifth century (see page 148). The figure is dressed in a tight-fitting tunic, the back cut high, leaving the midriff area bare. The bust is covered, but the front panel narrows at the waist and hangs loose over a skirt, which looks like an ikat loomed fabric. A similar style of tunic is worn today in the Lohar community of blacksmiths, in Rajasthan. It is a generic garment in that region and hasn't changed style for centuries. The sleeves on the garment in the cave painting seem to be made of a tie-dye fabric. A profusion of hair ornaments and jewelry is part of the dancer's toilette. The hair is styled in a large bun at the nape of her neck and decorated with carved tiaras made out of banana-tree cores. This coiffure is still used by brides in Bengal as well as in images of the goddess Durga. Very often, a complex aesthetic lasts in regional Indian fashion and survives unchanged until the twenty-first century.

Classical Indian dancing in temple courtyards was traditionally an important ritual of worship and was performed wearing costumes that were a dexterous combination of stitched and draped garments. Techniques to create accordionlike pleated finishes were achieved by using hot irons to flatten the folds of the fabric, a technique that has come down through generations in its original form to modern India.

At the monastery of Alchi in the remote Himalayan area of Ladakh (which lies thousands of miles north of the cave depiction of the dancing girl), an early eleventh-century wall painting of the Buddhist goddess known as the "Green Tara" wears a choli, one of India's primary fashion garments (see page 30). The cut of her choli—made from what looks like dyed indigo-blue fabric—is not unusual by today's standards.

To comprehend the basis of India's fashion repertoire, it is important to understand that other than the sari, the most important fashion garment of India is the small blouse known as the choli. An important upper garment using diverse patterns and styling, cholis are not undergarments; the cut, however, can often be like that of a woman's brassiere or bustier. The garment highlights the breasts and areas around a woman's curvature, fairly provocatively, and leaves the midriff bare. This style is indigenous to India and is worn in varied ways by different communities. Cholis are worn with a range of unstitched saris and multipaneled skirts, and are usually accompanied by an *odhni* (a shawl, often worn around the head, neck, or shoulders). The choli is at the core of fashion in India—its silhouette applicable to every shape and age. It is worn both casually, for daily wear, and for couture and bridalwear.

There is ample evidence in sculpture of the ancient and medieval times, where ornate sculptures of voluptuous figures are draped in the styles mentioned, commonly seen around the main temples and monuments in India. The sculptures rejoice in the beauty of the body and attempts to enhance it with textiles, rather than to cover it. In intense heat, clothing worn straight off the loom also offers cooling relief, and very rich and intricate textiles were used to accessorize more simplistic outfits, creating theatrical ensembles for both men and women. India specialized in fine lightweight and

ABOVE Tilly Kettle, *Dancers*, 1772. Oil on canvas. National Gallery of Modern Art, New Delhi.

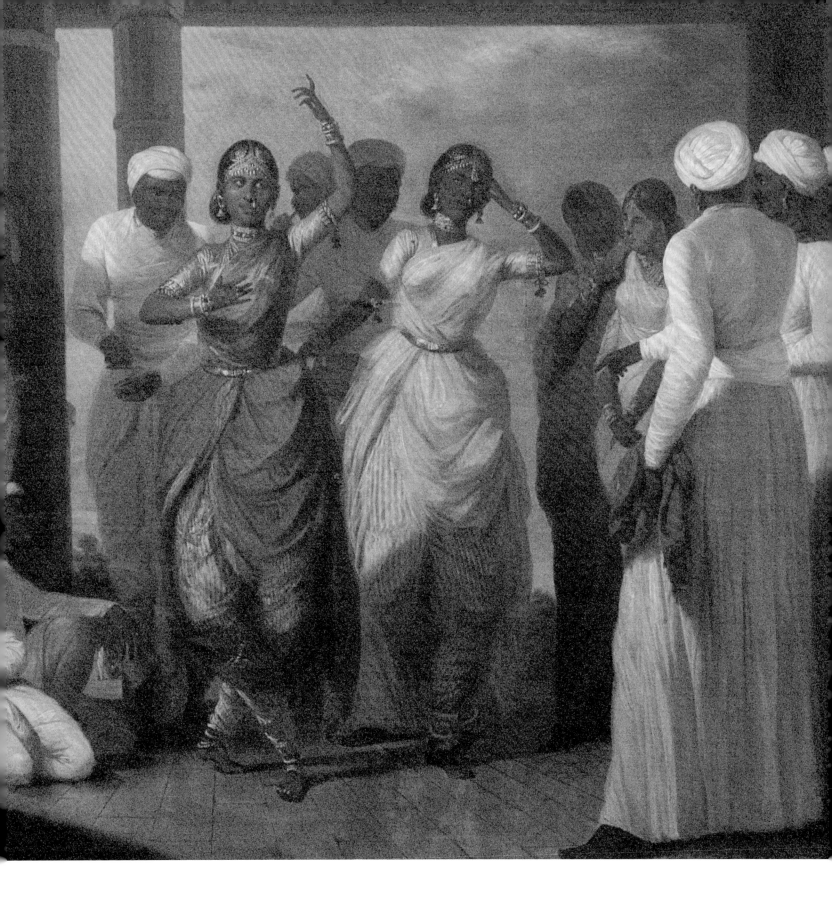

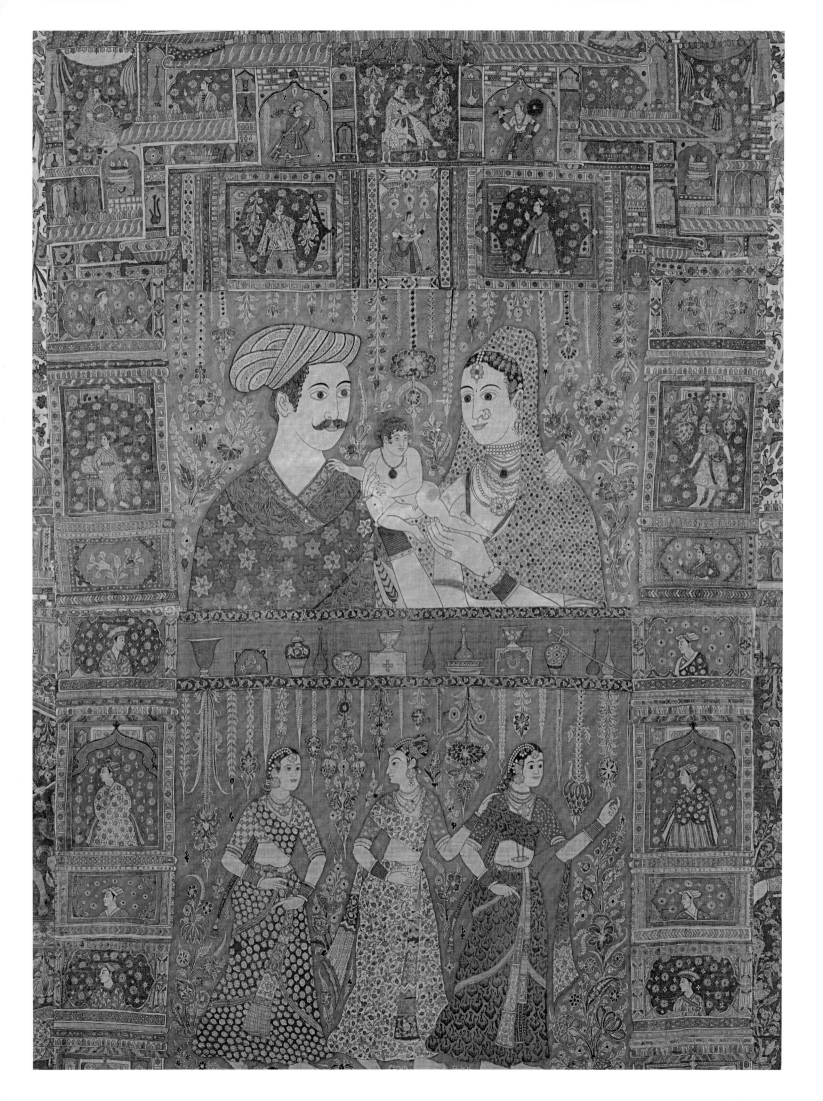

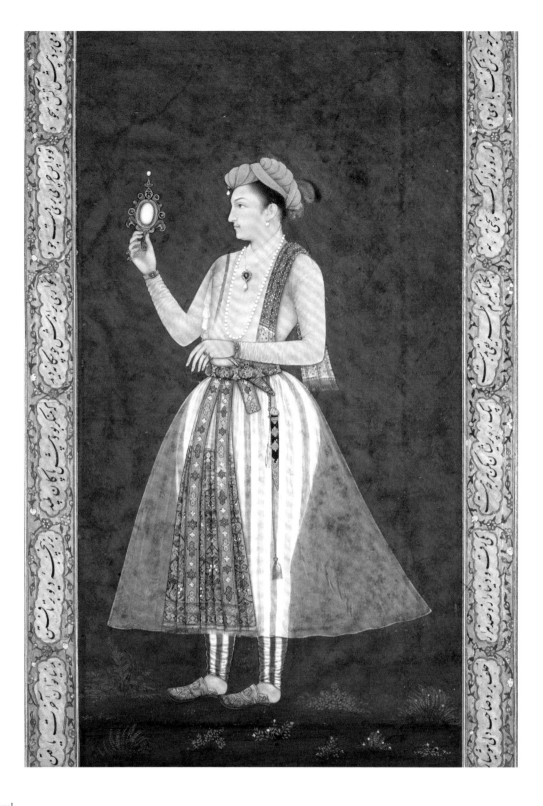

OPPOSITE *Kalamkari* hanging with figures in an architectural setting, ca. 1640–50. Cotton: plain weave, mordant-painted and dyed, resist dyed. Attributed to Deccan, India. The Metropolitan Museum of Art, New York. The central couple is wearing fabrics typical of the Deccan style. The man wears a patterned *jama*, a hand-painted floral *dupatta*, and a striped turban, while the woman wears a choli and patterned *odhni*.

ABOVE Bichitr. Prince Salim (later Emperor Jahangir), from the Minto Album, ca. 1630. Mughal Empire. Opaque watercolor on paper. Victoria and Albert Museum, London. The prince is wearing a style typical of the Mughal period. The sheer muslin *jama* is worn over a woven striped pajama. The highlight of the ensemble is the ornate *patka* worn around the waist.

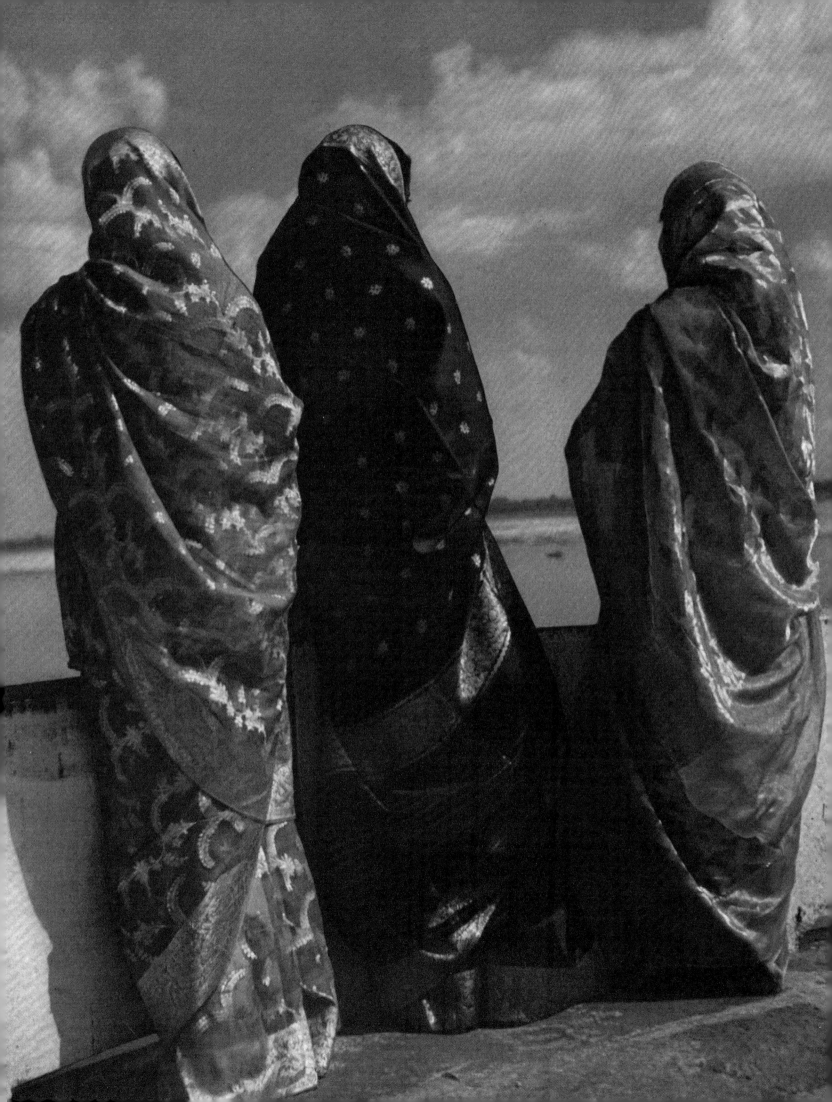

gossamer fabrics that formed an intrinsic part of the outfit and were used mostly as scarves, turbans, and skirts, identifying the status of the wearers in a definitive way.

ESTABLISHING STYLES

The emergence of Islam was to have far-reaching sociocultural influences on the fashions of India. The sultans of the Mamluk dynasty controlled northern India for most of the thirteenth century. Foreign rulers in a predominantly Hindu land, they initially tried to retain their Islamic traditions, as did the indigenous Hindu population, and it was not until sometime around the fourteenth century when an assimilation of cultures and styles began. This was due to a number of marriages between sultanate nobles and Hindu princesses, where a unique handwriting in fashion was carved, creating ensembles using an assortment of stitched garments, layered one on top of the other with unstitched garments making up the accessories.

The culmination of this cultural renaissance created a true synthesis of the best in Persian and Indian sensibilities in the main centers of power in India. This led to the creation of refined textiles, which were subtle, rich, and opulent. The use of real gold and silver threads, in use to decorate textiles since before Indo-Islamic kingdoms, and a variety of precious stones, pearls, rubies, sapphires, garnets, and emeralds, added a sculpted three-dimensional look to the embroideries embellishing robes called *khalats*. These were used much like jewelry and were considered prestigious gifts for dignitaries. India's love for gold, both as an ornament and as an investment, made these garments precious.

Wardrobes in the palaces were varied, large, and rich, with ateliers catering to the daily needs of the royalty and nobility. The splendor and refinement of the Mughal emperor Humayun's court was matched by the Indian royalty choosing colors fitting for the seasons: for instance, yellow in spring, burgundies and olives during the monsoons. Special sections in all palaces, called *tosha khanas*, were repositories of royal costumes for both men and women.

EXPORTING TRADITIONS

From the sixteenth century to the eighteenth, India was perhaps the greatest exporter of textiles that the world had ever known. India introduced a new vocabulary to the world that is still in common usage—words such as *khaki, chintz, shawl, calico, pajamas, gingham, dungarees*, and *bandanna* are all of Indian origin. By the turn of the century, however, the fate of India's indigenous handmade textiles—and its vast textile heritage that had been passed down through generations—seemed all but lost.

Ultimately, the export of such large volumes of textiles was to have a serious impact on the economies of Europe. The Industrial Revolution made it possible for Indian cotton thread and textiles to be copied by European machines, which was to have a devastating effect on the livelihood of the Indian craftsperson. In 1866, J. Forbes Watson published a substantial study where he listed the most important textiles of India, accompanied by seven hundred fabric samples that were then distributed to the textiles cities of Britain for reproduction.

Crippling trade policies imposed under nineteenth-century British colonial rule exposed the Indian market to cheap, industrially made foreign textiles while imposing tariffs and taxes on both exports and domestic trade in Indian-made textiles. This had a devastating impact on Indian crafts, particularly hand-spinning, printing, and weaving.

OPPOSITE Women wearing Benarasi saris in Varanasi (formerly Benaras), India. Photographed by Constantin Joffé for the December 1948 issue of *Vogue*.

This state of affairs continued until India got its independence and Mahatma Gandhi (1869–1948) started a movement to revive these suffering industries.

Gandhi, the revered revolutionary and anti-colonial nationalist, gave the process of independence a symbol: khadi fabric, the humble cloth hand-woven and hand-spun on charkhas in thousands of modest huts all over the country. It was a direction toward self-sufficiency and the creation of a brilliant, yet unusual, fashion symbol. Bonfires were made of fabrics from Britain and France—imported chiffons and velvets, in addition to any foreign textiles, were burned in city squares as a symbolic rejection of anything not made in India.

A nascent country set out to repair damage done to its craftspeople and its ethos of textile excellence. Under the guidance of social reformers and freedom activists Kamaladevi Chattopadhyay and Pupul Jayakar, cultural disciples discovered and revived what they could of the dying textile arts. This led to spectacular nationwide displays such as the Vishwakarma series of exhibitions that displayed long-forgotten techniques of textile design. These exhibitions formed the basis of the international festivals of India, which were mounted across the world and put India on the international fashion map.

India moved from a country of famines to one where its people enjoyed its excellence in handcrafted textiles. This revival created fresh documents in embroideries and hand-block printing, which today remain the bedrocks of the fashion of India and the international world beyond. India, in the twenty-first century, boasts a healthy and organic fashion identity, which is catalyzed by Indian designers who cater largely to an Indian identity of dress.

"The history of India may well be written with textiles as its leading motif"— these are the words of India's first prime minister, Jawaharlal Nehru (1889–1964). The sentiment is even more relevant today, more than seventy-five years after India's independence, than it was in 1947. Nehru, as well as his contemporary compatriots, would find the present situation miraculous—a country in which almost every traditional craft has been revived.

ABOVE Mahatma Gandhi and his spinning wheel. Photographed by Margaret Bourke-White for the May 27, 1946, issue of *Life* magazine.

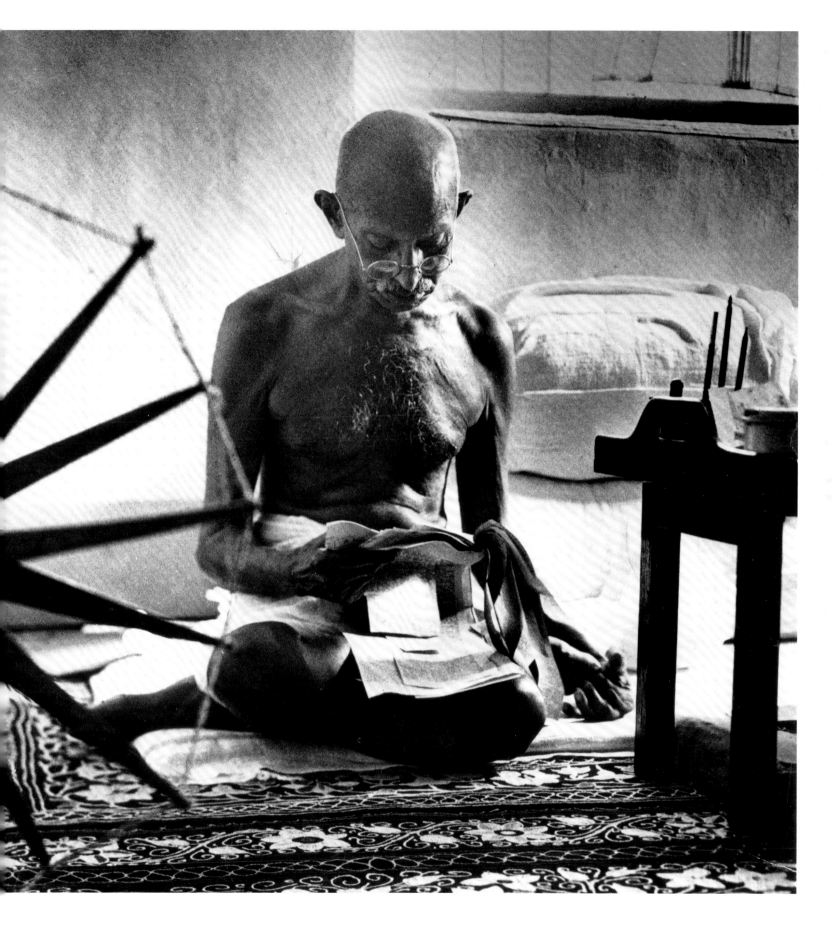

WEARING A GARDEN AND WEAVING AIR

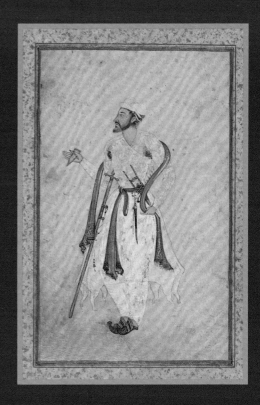

FASHION IN THE MUGHAL EMPIRE

SYLVIA HOUGHTELING

In the 1590s, Abu'l Fazl, the court historian for the Mughal emperor Akbar (r. 1556–1605), paused to praise the support that the emperor had given to the textile manufacturers that were flourishing in the lands over which Akbar ruled. "His majesty himself acquired in a short time a theoretical and practical knowledge of the whole trade; and on account of the care bestowed upon them, the intelligent workmen of this country soon improved. All kinds of hair-weaving and silk-spinning were brought to perfection; and the imperial workshops furnish all those stuffs which are made in other countries. A taste for fine material has since become general, and the drapery used at feasts surpasses every description." It was not only Akbar's court historian who recounted the fineness of South Asian textiles that rivaled foreign imports in the late sixteenth century. In snippets of imperial documents, merchant accounts, and poetry that survives, the same themes recur: fashions in the Mughal Empire were both particular to South Asia, but also absorbed into their diversity the styles of many peoples. As Abu'l Fazl wrote, the "variety of fashions which now prevail ... astonish experienced travelers."[1]

Though intended to glorify Emperor Akbar's patronage, Abu'l Fazl's claim held great truth. The array of garments, fabrics, dye colors, and forms of embellishment that can be found on extant Mughal textiles, and that ornament the far more plentiful evidence for Mughal fashion that appears in paintings from the period, suggests that there was no one singular Mughal style of dress. Instead, the clothing worn by both non-elite and courtly figures in sixteenth- and seventeenth-century South Asia now appears stunning for its variation, its mixing and matching of a panoply of dress types, its relative flexibility in terms of gendered garments, and its wide range of materials.[2]

At the Mughal court of Emperor Akbar, textiles made from fibers unique to South Asia flowed in from the far reaches of the empire. Shawls and waist-ties crafted from cashmere, the soft underhair of a high-altitude mountain goat, were treasured at the court; the present-day name of "cashmere" derives from Kashmir, the site where the textiles were woven, although the cashmere goat hair and the goats themselves came from farther north in present-day Ladakh and Tibet in the Himalayan plateaus.[3] The water in the rivers of Kashmir, where the woven pashmina textiles were then washed, was known to give extra suppleness to the fabric; cloths washed in the plains of India were never as soft.[4] Consumers throughout the Mughal Empire also purchased furnishings and tent panels made from silk spun by a variety of wild silkworms (muga, tasar, and eri) that fed on castor leaves and the champa tree and that produced lustrous, golden-yellow, and honey-colored fibers that could exceed in strength and durability the standard: white *Bombyx mori* silk from China.[5]

Yet it was the fine and thin cotton cloth (mulmul) for which South Asia, and particularly Bengal, was known that distinguished the dress worn throughout the Mughal Empire. Sources ranging from Gujarati literature, Deccani paintings, accounts of European and Persian travelers, to the records of the imperial court suggest the value of this fabric. Although diaphanous cotton textiles were woven in Gujarat, in the Deccan, and throughout South Asia, the most renowned cloth from Bengal was made from a short-staple cotton plant, *Gossypium arboreum* var. *neglecta*, that grew along the Meghna River.[6] The imperial court hundreds of miles away could detect small differences in the location of where the cloth was then processed—it was not only the cotton plants, but also the water where the textiles were washed and bleached, that affected their overall appearance. The weaving center of Sonargaon, from which Emperor Akbar received his cotton textiles, boasted a particular water reservoir nearby that yielded the most crisply white textiles.[7] Whereas his contemporaries in the Safavid Empire dyed fine cotton cloth a brilliant range of colors, Emperor Akbar wore the cotton cloth white, and with the extreme fineness of the spun threads, it often appeared translucent.

OPPOSITE A Mughal courtier in a six-pointed *chakdar jama*, ca. 1575. Gum tempera and gold on paper, mounted with gold-sprinkled borders. Cleveland Museum of Art.

BELOW *Patka* (waist sash), Kashmir, late eighteenth century. Pashmina goat hair. Chhatrapati Shivaji Maharaj Vastu Sangrahalaya, Mumbai.

The Mughal rulers reigned over a multifaith empire, and in pre-Islamic dress, the ruler's inner qualities were said to radiate through the skin.[8] The sheer nature of the cloth allowed the emperor's smooth, lustrous skin to be seen even when he was dressed. In poetry, these cotton garments were praised for being as thin as the "skin of the moon"; in Latin texts, the cloth was called "woven air."[9]

This diaphanous cotton material appeared across male and female dress. For men, the white cloths were worn as a *jama*, a simple, long-sleeved garment that crossed at the chest and flared into a skirt. The garment was fastened either under the right or left arm, depending on whether the wearer was Muslim or Hindu, respectively.[10] A particular variant of the *jama*, known as the *chakdar jama*, had a hem punctuated by four or six long, pointed edges, and it became particularly fashionable at the end of the sixteenth century. The *chakdar jama* had a sense of movement to it as the triangles of cloth dangled alongside the legs, mirroring the triangular crossing sections of the upper part of the *jama*. In a painting of a strapping Mughal courtier, the translucent *jama* stretches tightly across the man's broad chest, revealing his physique, his body hair, and potentially, in the dark marks under his arms, the scent of musk on his skin.[11] Elite women also wore thin cotton muslin, often in the form of a garment called a *peshwaz*, which fastened down the center and could be affixed as a long, sheer skirt to a *choli* blouse, or worn loosely over a blouse and brightly colored trousers.[12] There were differences in the tailoring of these white cotton garments for men and women, with the men's garments crossing at the chest and expanding out in a starched skirt and the women's garments gathered into a longer, more formfitting lower silhouette. However, the basic components of male and female Mughal dress as depicted in paintings were largely consistent and composed of mulmul cotton garments for the upper body and bright trousers below.

The white cotton *jama* and *peshwaz* accentuated the vibrancy of what was worn beneath: *salwar*, or pajama trousers (the latter term from the Persian, *payjama*: *pay* for feet or limbs, and *jama*, for a garment or covering) were made from lime green, pomegranate red, and saffron-colored *mashru* textiles, the name for a warp-faced fabric that combined silk and cotton and yielded a satiny finish.[13] Wrapped around the waist were pleated or folded sashes (*patkas*) that served a practical function as a place to affix small possessions in the absence of pockets. The courtly style during Akbar's reign favored geometric designs for these sashes—stripes, diamond, and chevron patterns— while other *patka* sashes included both *bandhani*, or tie-dyed cotton cloth with a pattern of dots, and later, naturalistic floral ornamentation.[14] Jewelry and clothing mixed and complemented each other. Strands of pearls encased necks, studded shawls, and dangled from ears. Thin veils, edged in gold, allowed precious metal threads to seemingly float in the air when those who wore them danced.

Further layering emerged in the garments innovated by Emperor Jahangir (r. 1605–27), the son of Akbar, whose aesthetic inclinations are evident in his patronage of painting and in his confessional autobiography, where he details the forms of dress that he credited himself with having invented. One novel garment was the *nadiri*, a knee-length, sleeveless robe that could be worn over a thin *jama* or layered on top of a thicker garment. While Mughal attire mixed sumptuous silk fabrics with seemingly simpler textures, such as cotton and wool, for his sons, the princes of the realm, Jahangir encrusted *nadiri* robes in gems, pearls, and gold and silver embroidery. Jahangir's powerful wife, Queen Nur Jahan, gave to the future Emperor Shah Jahan a *nadiri* "adorned with jeweled flowers and precious pearls." The value of these garments, studded with gems and covered in luxurious metal embroidery, exceeded any woven textiles in cost and could approach millions in contemporary prices. Jahangir gifted these most valuable garments

OPPOSITE Govardhan, Abu'l Fazl presents Akbar with the second volume of the emperor's biography, from the *Akbarnama*, Mughal Empire, 1603–05. Opaque watercolor, ink, and gold on paper. Chester Beatty Library, Dublin.

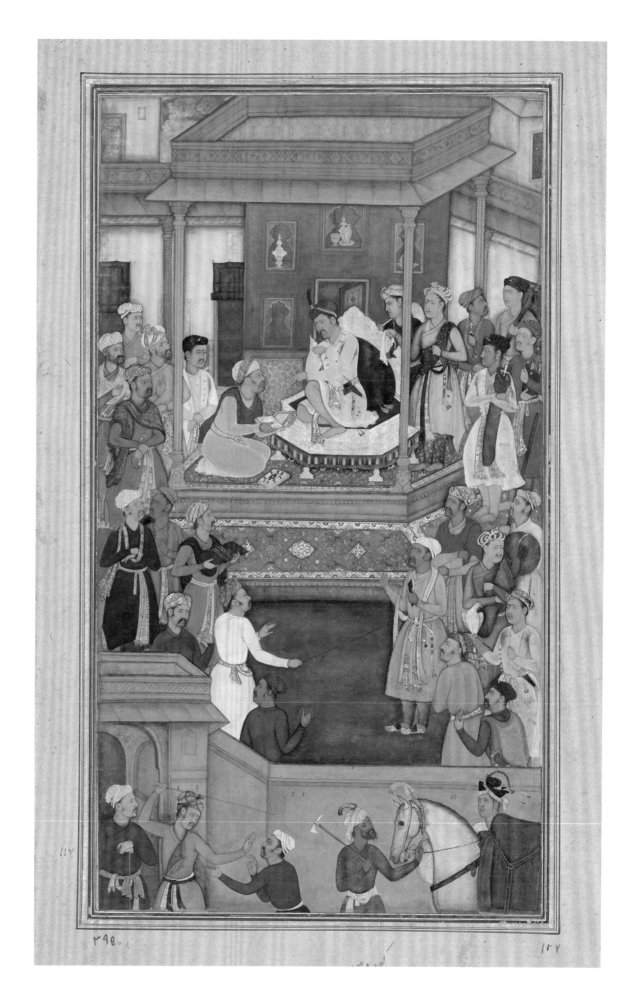

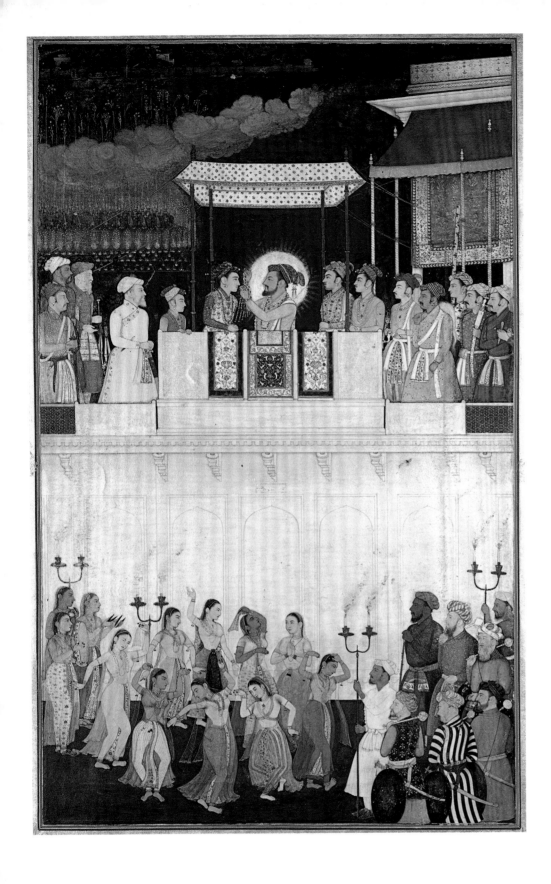

ABOVE Bulaqi, Shah Jahan honoring Prince Dara Shikoh at his wedding, from the *Padshahnama*, Mughal Empire, ca. 1635–50. Opaque watercolor, ink, and gold on paper with decorative incising on paper. Royal Library at Windsor Castle. Royal Collection Trust.

OPPOSITE Manohar, Jahangir and his vizier, I'timad al-Daula, folio from the *Shah Jahan Album*, Mughal Empire, ca. 1615. Opaque watercolor, ink, and gold on paper. The Metropolitan Museum of Art, New York.

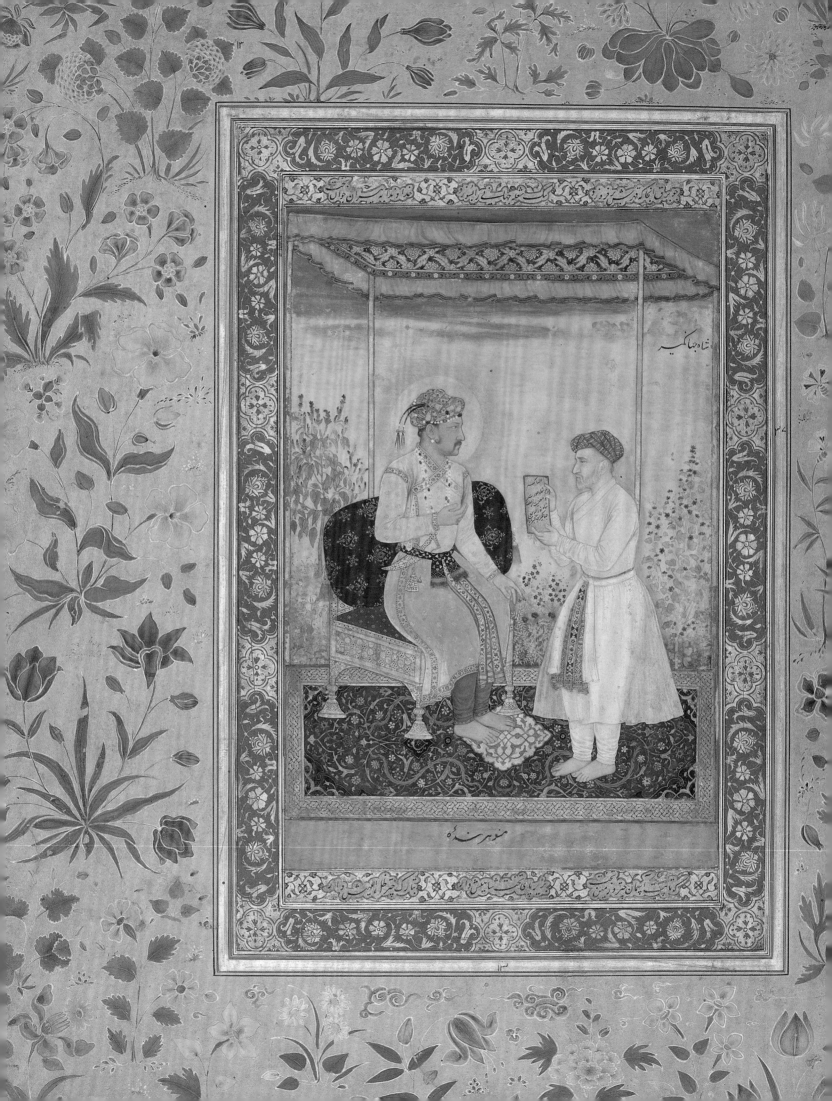

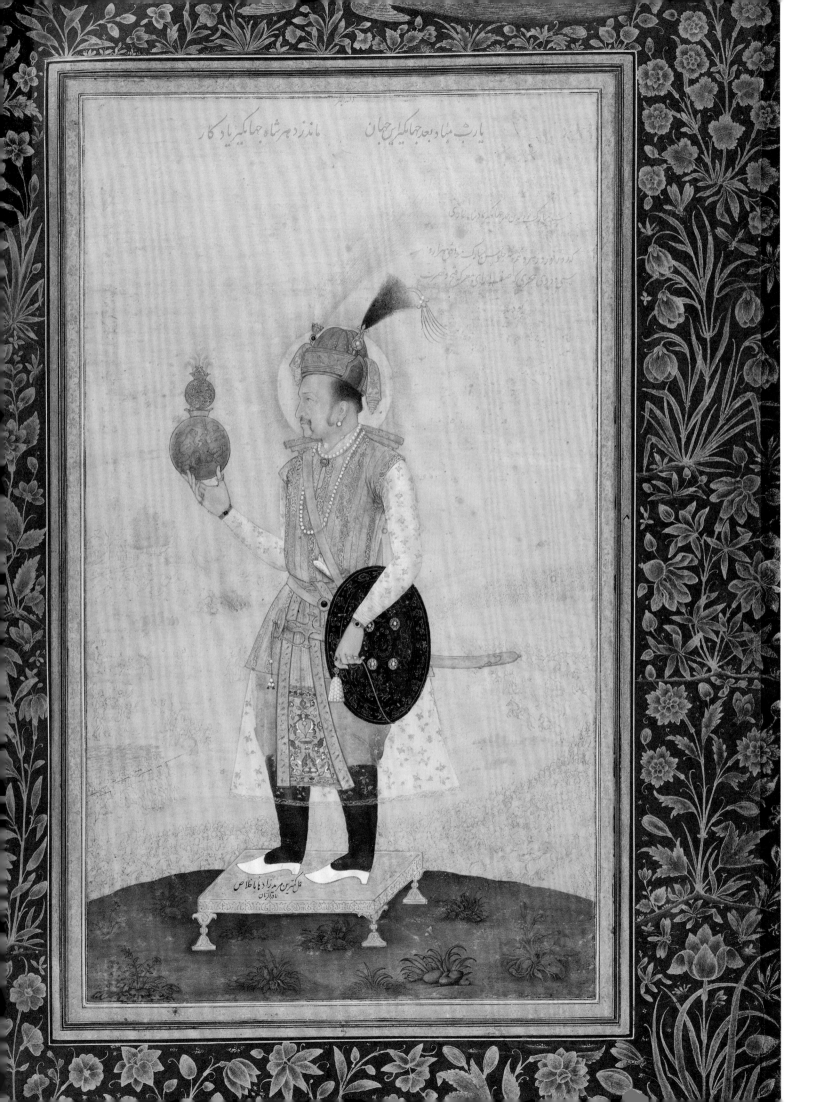

only to his nearest kin and invested these gifts of robes with sentimental significance. Upon sending a jewel-covered garment to his son Prince Khurram (later Emperor Shah Jahan), Jahangir told the messenger to note that he had been wearing the robe when his son set off for a military victory in the southern region of the Deccan.[15]

Embroidery also adorned the footwear that has been attributed to Jahangir's time. In paintings made during his reign, Jahangir can be seen barefoot but also wearing a variety of shoes and high equestrian boots. While the style of the boots derived from Central Asia, a form of slippers with upturned toes and decorated with metal thread has been popularly known as the *salim shahi* (King Salim) slippers, named after Emperor Jahangir, who held the name Salim before ascending to the throne.[16]

Historical records suggest that embellishment through elaborate embroidery held particularly high value among Jahangir's family, including Queen Nur Jahan. European visitors to the Mughal court had been confounded by what to take the emperors, who seemed to have everything and learned that embroidered goods were welcome. According to Sir Thomas Roe, a British envoy to the Mughal court, Nur Jahan made a special request for British-made embroidery, such as gold-embroidered sweet bags, embroidered pillows and cases, bobbin lace, and toys made from "fine needlework."[17]

The most visually recognizable fabrics of the Mughal court contain patterns of naturalistically rendered flowers that appear in symmetrical, orderly rows. This floral style, which emerged during the reign of Emperor Shah Jahan (r. 1628–58), not only ornamented robes, carpets, and tent hangings, but also appeared in manuscript borders. Floral patterns were inlaid using semiprecious stones onto the walls of the Taj Mahal.[18] This meant that the patterns adorning garments worn by high-ranking Mughal officials and Rajput kings, such as those seen on the robe of Raja Ram Singh of Amber, recur on floor coverings and tent wall hangings, linking the dress of the figures with the spaces that they inhabited. Weavers incorporated these stylized patterns of brightly colored flowers into silken fabrics, and painters used rich dyes to bring color to the poppy and peony flowers adorning cotton cloths.[19] The shawls of Kashmir, which previously appeared in paintings as delicate, but relatively plain in their ornamentation, began to bear rows of elegantly bending flowers at each end. Embroiderers in Chanderi in Madhya Pradesh produced intricate floral stitchwork on translucent white cotton cloth that was used for summer dresses at Shah Jahan's court.[20] With a fish-glue gum, cloth printers stamped the repeated rows of flowers onto cotton cloth and then affixed golden foil. If the garments were made of cotton, as they often were, the floral cloth was then treated with wax and burnished, giving it a luminous surface.

The profusion of flowers on textiles and carpets, jewels, gems, and palace walls took form metaphorically in the poetry of the period in which writers extolled the paradisial beauty of gardens particularly in the region of Kashmir.[21] In poetic verse but also travelers' accounts, lush carpets and monumental tent hangings were likened to gardens, bursting with flowers, while poets compared actual fields of flowers to luxury cloth. Emperor Jahangir wrote of seeing "apricot and peach trees [that] had blossomed by the field and clothed themselves in blooms."[22] A tent hanging's flowers seemed so lifelike to the French traveler François Bernier that they resembled parterres, the beds of flowers arranged in formal gardens.[23]

The connection between cloth and flowers extended beyond metaphor: many of the finest garments were also dyed using the fruits and petals of local trees and plants. Although likely used sparingly, precious saffron appears in contemporary dye books as a colorant used to produce reddish-yellow garments, or to bring a bit of warmth to a camel-colored cloth. The dye colorant safflower (*kasubha*), though more ubiquitous in the period and less valuable, is today not well known. The petals of this thistlelike

OPPOSITE Abu'l Hasan, *Jahangir holding a globe*, Mughal Empire, 1622–23. Opaque watercolor, ink, and gold on paper. Freer Gallery of Art, Smithsonian Institution, Washington, DC.

flower produce a range of hues, from a searing bright pink to a softer orangish yellow, and the color produced by safflower was particularly popular during springtime festivals in Rajasthan and throughout South Asia.[24] A range of purples, from violet to the color of poppy seeds, emerged from indigo mixed with red dyes, which came from a variety of roots. Pomegranate rinds produced green, while turmeric imparted to cloths a bright yellow. For Diwali in Jaipur, Rajasthan, turbans and garments were dyed a deep indigo blue, like the color of the dark night sky.[25]

Although some of these dyes were known to be quickly fading, they brought brilliance to festival gatherings and yearly entertainments.[26] And just as the colors faded, fashions changed. At the court of Emperor Aurangzeb (r. 1658–1707), the ruler returned to the simplicity of the white cotton *jama*. Paintings from the seventeenth and eighteenth centuries suggest that a novel style emerged for cotton *jamas* dyed from only the chest upward. In some paintings, the garments are dyed brown on the upper body; in other places, such as the Rajput court of Mewar, the garments worn during festivals are white on the bottom and bright orange on the upper body, giving the impression of a robe half submerged into the bright pigment of the dye vat. The effect speaks to the uniqueness of these garments—the simplicity, geometry, and the skill of the dyers who gave vibrant colors to the cloth.

Precious few actual examples of Mughal fashion remain from the seventeenth century. Despite South Asia's status as the largest exporter of textiles worldwide by the late seventeenth century, present-day collections in India, Pakistan, and Bangladesh hold only a small number of textiles known to have been used in the Mughal realm. The warm climatic conditions hinder preservation, and the waves of disruption that the Mughal administration and its imperial collections underwent in the eighteenth and nineteenth centuries led to dispersal and destruction. In the intervening years, gold brocaded cloths were mined for their precious metals, while the silk was discarded or burned. During the period of British colonialism, the indigenous short-staple cotton plants once used to grow the finest cotton, and the wild roots that produced brilliant red dyes, were replaced by higher-yield cash crops. The gloriousness of Mughal textiles derived from the virtuosity of their makers, but also the unique environmental conditions of their materials. Continuing in the vein of Mahatma Gandhi's early twentieth-century movement for khadi cloth, recent scholarly researchers and sustainable enterprises have sought to recover and cultivate the cotton, silk, and woolen fibers, as well as indigo and natural red-root dyes in ways that avoid environmental harm and empower cultivators and textile artisans.[27] In doing so, these initiatives have sought to effect tangible change. They have also recaptured the ephemeral beauty achieved by Mughal textiles: the mystery of the night sky and the breezy touch of woven air.

OPPOSITE Bhima Ram and Kesu Ram, *Maharana Ari Singh Attending Celebrations in His Palace at Night* (detail), Udaipur, 1764. Opaque watercolor with gold and silver on paper. Freer Gallery of Art, Smithsonian Institution, Washington, DC.

ENDNOTES

[1] Abu'l Fazl, *Āʾīn-i Akbarī*, trans. Henry Blochmann, Vol. I (Calcutta: Asiatic Society of Bengal, 1873), 88.

[2] This essay is based on *The Art of Cloth in Mughal India* by Sylvia Houghteling (Princeton University Press, 2022). For further discussion of the diversity of fibers in the Mughal Empire, see Houghteling, "Landscapes of Cloth in the Mughal Empire," in *The Art of Cloth*, 27–69.

[3] Janet Rizvi and Monisha Ahmed, *Pashmina: The Kashmir Shawl and Beyond*, second edition (Mumbai: Marg, 2017), 28–35.

[4] Simon Digby, "Export Industries and Handicraft Production under the Sultans of Kashmir," *Indian Social and Economic History Review* 44 (2007): 419.

[5] Lotika Varadarajan, "Silk in Northeastern and Eastern India: The Indigenous Tradition," *Modern Asian Studies* 22 (1988): 564, 568; Richard S. Peigler, "Wild Silks of the World," *American Entomologist* 39 (1993): 152; Rahul Jain, *Indian Lampas-Weave Silks in the Collection of the Calico Museum of Textiles*, Woven Textiles: Technical Studies Monograph no. 3 (Ahmedabad: Sarabhai Foundation, 2013); Rosemary Crill, *The Fabric of India* (London: V&A Publishing, 2015), 20–23.

[6] Saiful Islam, *Muslin: Our Story* (Dhaka: Drik Picture Library Ltd., 2016), 38–49.

[7] Sylvia Houghteling, *The Art of Cloth in Mughal India* (Princeton, NJ: Princeton University Press, 2022), 50.

[8] Sylvia Houghteling, "The Emperor's Humbler Clothes: Textures of Courtly Dress in Seventeenth-Century South Asia," *Ars Orientalis* 47 (2017): 98–99.

[9] Sonia Ashmore, *Muslin* (London: Victoria and Albert Museum, 2012), 11.

[10] B. N. Goswamy, *Indian Costumes in the Collection of the Calico Museum of Textiles* (Ahmedabad: Sarabhai Foundation, 1993), 27.

[11] Houghteling, *The Art of Cloth*, 60.

[12] Goswamy, *Indian Costumes*, 156.

[13] Avalon Fotheringham, *The Indian Textile Sourcebook* (London: Thames & Hudson and the Victoria and Albert Museum, 2019), 156.

[14] Steven Cohen, "Textiles, Dress, and Attire as Depicted in the Albums," in *Muraqqaʿ: Imperial Mughal Albums from the Chester Beatty Library, Dublin*, edited by Elaine Wright (Hanover, NH: Distributed by University Press of New England, 2008), 181–84.

[15] Houghteling, *The Art of Cloth*, 78.

[16] Ritu Kumar, *Costumes and Textiles of Royal India* (Suffolk: Antique Collectors' Club, 2006), 273.

[17] Ellison Banks Findly, "Nur Jahan's Embroidery Trade and Flowers of the Taj Mahal," *Asian Art and Culture* 92 (1996): 13–14.

[18] Ebba Koch, "The Taj Mahal: Architecture, Symbolism, and Urban Significance," *Muqarnas* 22 (2005): 145; Robert Skelton, "A Decorative Motif in Mughal Art," in *Aspects of Indian Art: Papers Presented in a Symposium at the Los Angeles County Museum of Art, Oct. 1970*, edited by Pratapaditya Pal (Leiden, The Netherlands: E. J. Brill, 1972); Cohen, "Textiles, Dress, and Attire," 184–85.

[19] Rahul Jain, *Rapture: The Art of Indian Textiles* (New Delhi: Nyogi Books, 2011).

[20] Harit Joshi, "The Politics of Ceremonial in Shah Jahan's Court," in *The Mughal Empire from Jahangir to Shah Jahan*, edited by Ebba Koch and Ali Anooshahr (Mumbai: Marg, 2019), 115.

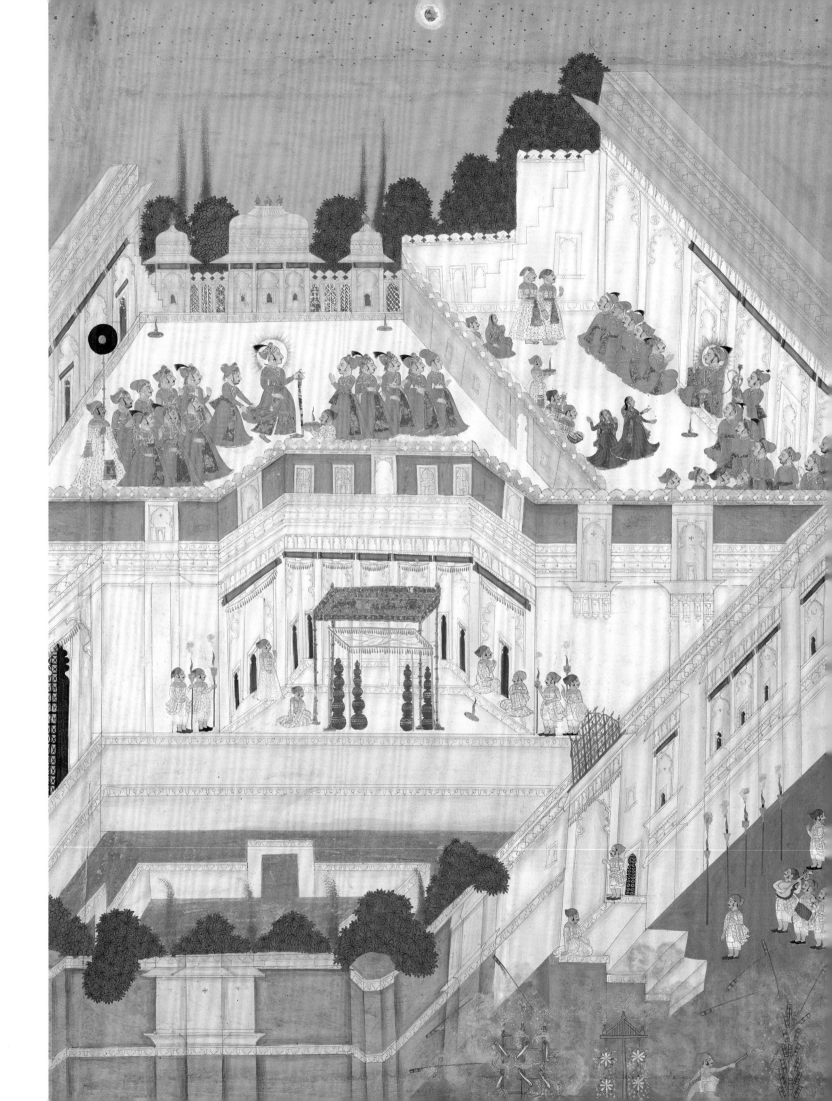

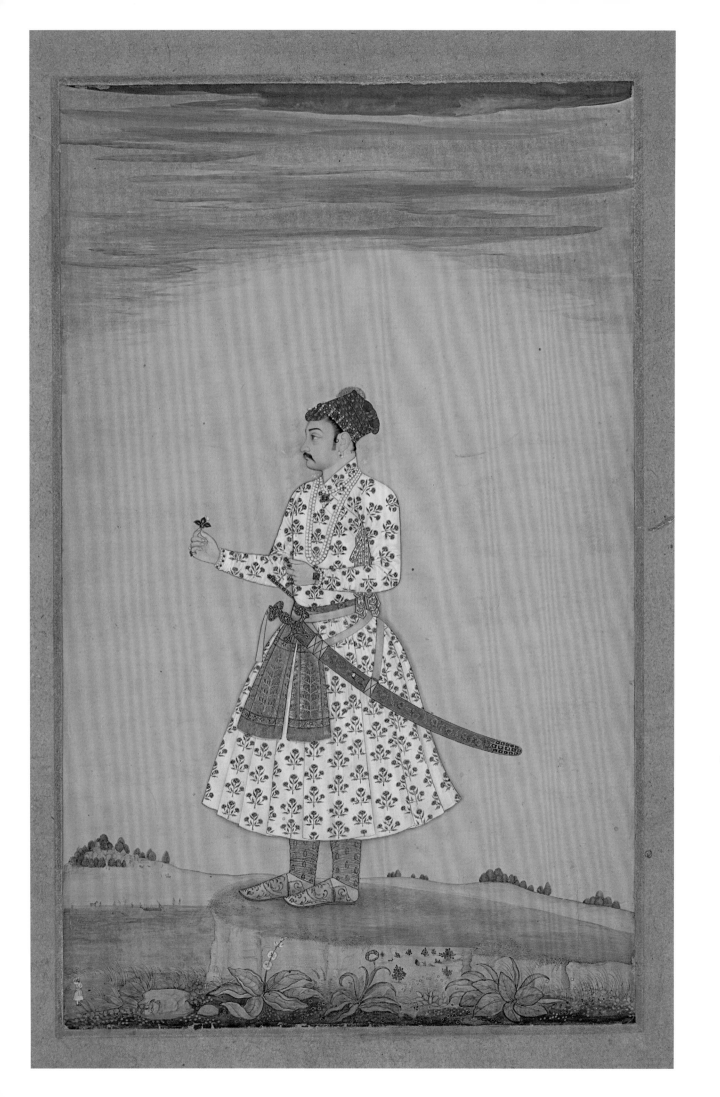
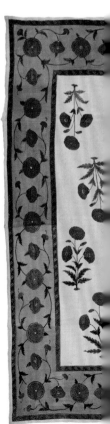

ENDNOTES CONTINUED

21 Sunil Sharma, *Mughal Arcadia: Persian Literature in an Indian Court* (Cambridge, MA: Harvard University Press, 2017); Anubhuti Maurya, "Of Tulips and Daffodils: Kashmir Jannat Nazir as a Political Landscape in the Mughal Empire," *Economic and Political Weekly* LII, no. 15 (April 15, 2017): 37–44.

22 Jahangir, *The Jahangirnama,* trans. and ed. Wheeler Thackston (Washington, DC: Freer Gallery of Art, Arthur M. Sackler Gallery, Smithsonian Institution, 1999), 323.

23 Houghteling, *The Art of Cloth,* 151.

24 Sylvia Houghteling, "Dyeing the Springtime: The Art and Poetry of Fleeting Textile Colors in Medieval and Early Modern South Asia," *Religions* 11 (2020): 1–19. https://doi.org/10.3390/rel11120627.

25 Veronica Murphy and Rosemary Crill, *Tie-Dyed Textiles of India: Tradition and Trade* (New York: Rizzoli in association with the Victoria and Albert Museum, 1991), 67.

26 Dipti Khera, "The Joys of Bonding," in *Visions of Paradise: Indian Paintings in the National Gallery*, edited by Wayne Crothers (Melbourne: National Gallery of Victoria, 2018), 108–17.

27 Uzramma, "The Indian Loom, Climate Change, and Democracy: Introducing the Malkha Enterprise," *Comparative Studies of South Asia, Africa and the Middle East* 39 (2019): 233–40; Islam, *Muslin*; Pramod Kumar in conversation with Rahul Jain. From the exhibition publication for *Pra-Kashi: Silk, Gold & Silver from the City of Light* (New Delhi: The National Museum, 2019).

OPPOSITE Maharaja Ram Singh (I) of Amber, Mughal Empire, ca 1660. Opaque watercolor with gold on paper. The Museum of Fine Arts, Houston.

BELOW Floorspread, possibly Burhanpur, ca. 1650. Cotton, plain weave, hand painted, mordant and resist dyed. Victoria and Albert Museum, London.

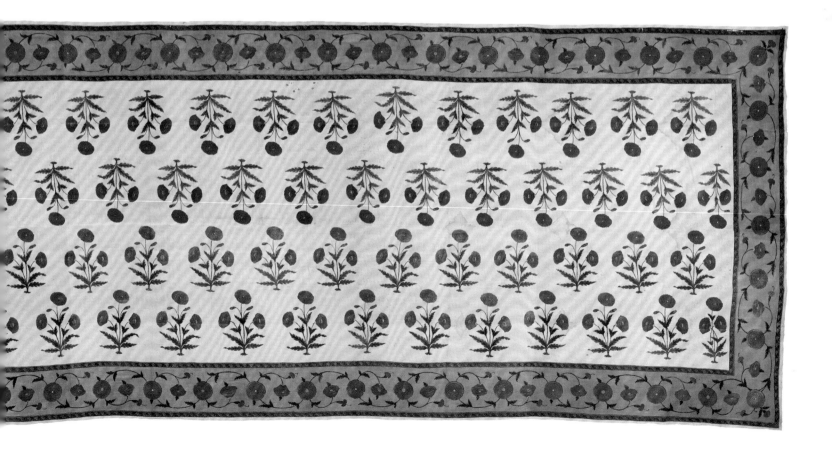

INDIA'S
INFLUENCERS
AT THE
COURT OF
VERSAILLES

KIMBERLY CHRISMAN-CAMPBELL

Marie Antoinette is remembered as a fashion icon, and Paris as the capital of *la mode* in the eighteenth century. Though the French may have been famous for setting trends around the world, they had to look increasingly farther afield for inspiration. As the *Magasin des modes nouvelles* observed in January 1787: "No one can deny that our French Ladies have made the Ladies of almost all the other Kingdoms adopt their fashions; however, we must admit that in almost every case they are simply paying them back. Haven't they borrowed ... from the Polish, the English, the Turks, the Chinese?"[1] A year later, the magazine predicted: "This year Fashion will travel to all the climates, all the Kingdoms, all the Provinces, and all the Countries of the world." Subsequent issues featured fashions evoking a seemingly random assortment of regions, including Sweden, Russia, and Greece.[2]

India was notably absent from the list, but not for long. In June 1788, three ambassadors from Tipu Sultan of Mysore—Mohammed Dervish Khan, Mohammed Osman Khan, and Akbar Ali Khan—and their large entourage arrived in France, staying three months. The sultan hoped to persuade Louis XVI to join a military alliance against the English; the mission was a diplomatic failure but a fashion phenomenon.

Diplomatic visits were not just instruments of policy but also opportunities to exercise soft power in the form of exotic spectacle. The comte d'Hézecques, a page at the French court, noted: "These ambassadors who arrive from the extremities of the earth always excite curiosity, and often they make history, out of the rarity of the event rather than the importance of their negotiations." Fashions and textiles à la Turque and à la Chinoise had long been worn in France as part of *le goût asiatique*, the "Asiatic taste" that manifested in many forms of popular culture. But it was unusual to see real Asian dress—or people, for that matter—up close. "The morals, the habits, the costumes of these Indians were for a long time the subject of our conversations, the model for our fashions," Hézecques testified. "Indomania" replaced "Anglomania" as the style buzzword of the day.[3]

While they waited for their royal audience, the Indian visitors behaved like any other tourists, visiting Notre-Dame, the Comédie-Italienne, and the Palais-Royal. Elisabeth Vigée Le Brun saw the ambassadors at the Opéra and requested permission to paint their portraits. In her memoirs, the artist left a description of their "robes of white muslin, scattered with flowers embroidered in gold. ... These robes, a kind of tunic with large, turned-up sleeves, were held in place by elaborate belts."[4]

Indeed, many French artists were inspired by the ambassadors, leaving a rich visual record of their visit. Claude-André Deseine produced a bust of Mohammed Osman Khan, capturing the folds of his turban and the asymmetrical fastenings of his robe in precise, three-dimensional detail. Waxworks impresario Philippe Curtius created a life-size tableau depicting the ambassadors.[5] The Sèvres porcelain factory sold souvenir teacups decorated with their portraits.[6] And Charles-Eloi Asselin's panoramic gouache memorialized their visit to the Parc de Saint-Cloud, where the Indians were swarmed by curious crowds.

When they finally had their audience with Louis XVI in August of 1788, the ambassadors wore "loose trousers and gowns of muslin or cotton cloth, fairly fine," Hézecques recorded. "I have not seen any gold embroideries except on their shawls, with which they wrap themselves more or less, according to the temperature. Their turbans are not as high as those of the Turks, but they are much wider. The slaves wear turbans in the shape of our round hats, which, placed on the side of the head, look very well."[7] The entire French court assembled to greet and gawk at the visitors, along with mobs of Parisians who had traveled to Versailles to witness the occasion.

OPPOSITE Paul Cornu, illustration from *Galerie des Modes et Costumes Français, Dessinés d'Après Nature*, 1778–87. Los Angeles County Museum of Art.

ABOVE Portrait of Tipu Sultan, Mysore, ca. 1790. Opaque watercolor on paper. Victoria and Albert Museum, London.

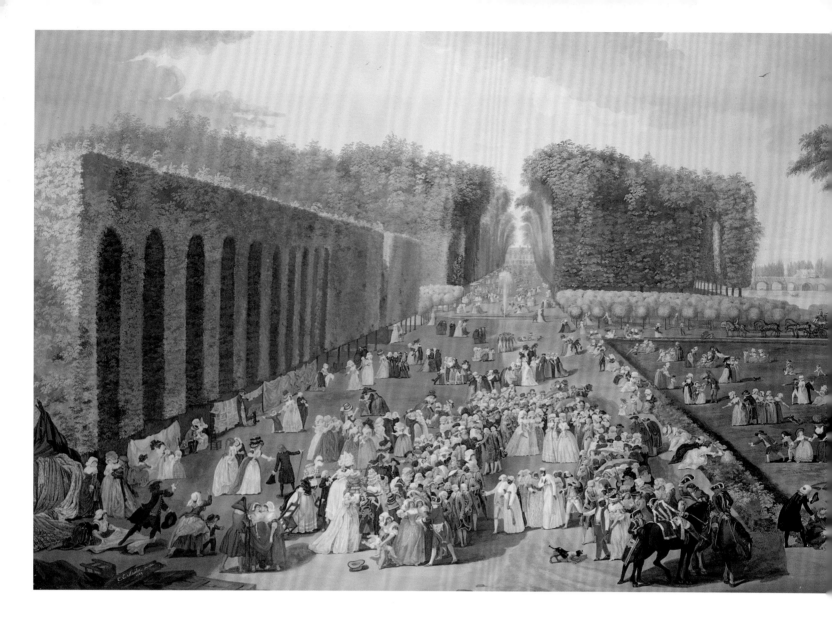

ABOVE Charles-Eloi Asselin, *Reception for Ambassadors of Tiphoo-Sahib or Tipu Sultan in the Saint-Cloud Park*, August 18, 1788, organized by Marie Antoinette, 1755–93 Queen of France, 1788. Musée national de Céramique, Sèvres, France.

OPPOSITE Elisabeth Vigée Le Brun, *Mohammed Dervich Khan*, 1788. Oil on canvas. Private collection.

The ambassadors came bearing gifts of precious Indian clothing, jewels, and textiles: a muslin gown, lengths of "very beautiful" muslin, and a box of pearls for Marie Antoinette, and ornamental weapons and a large ruby for the king.[8] They presented Madame du Barry, mistress of the late Louis XV, with "some pieces of muslin, very richly embroidered in gold." She later gave one to Vigée Le Brun: "superb, with large detached flowers, of which the colors and the gold are perfectly blended." The painter kept this rare textile for many years, eventually having it made into a ball gown.[9]

It was inevitable that the ambassadors themselves would set fashion trends. Elegant turbans and gold-embroidered shawls soon appeared on fashionable ladies. The next issue of the *Magasin des modes nouvelles* featured gowns "à la Tippoo-Saïb" and "à l'Indienne." Far from resembling Indian dress, however, the new fashions were Indian in name only, as the editors admitted: "We don't want to say that the Indians invented the fashions; but they made us think of the shapes & the names."[10] Over the next two months, the magazine featured a turbanlike bonnet "à l'Indienne" and a "bonnet à la Pondichérie." The editors even attributed a passing vogue for brown ribbons to the ambassadors' influence: "Everyone knows that cacao comes from India, & that cacao is used to make chocolate; Tippoo-Saïb's Ambassadors have surely caused the fashion for chocolate-colored ribbons."[11] France's fashion leaders would not soon forget their taste of India.

ENDNOTES

[1] *Magasin des modes nouvelles* 6 (January 10, 1787): 41.

[2] *Magasin des modes nouvelles* 11 (February 29, 1788): 83.

[3] Comte F. d'Hézecques, *Souvenirs d'un page de la cour de Louis XVI* (Paris: Didier et Cie, 1873), 229.

[4] Elisabeth Vigée Le Brun, *Souvenirs*, ed. Claudine Herrmann (Paris: Des femmes, 1986), 1:61. Only the portrait of Mohammed Dervish Khan survives today, in a private collection.

[5] Jean Adhémar, "Les Musées de cire en France, Curtius, le 'Banquet Royal,' les têtes coupées," *Gazette des Beaux-Arts* 92 (December 1978): 203–14.

[6] Anne Buddle et al., *The Tiger and the Thistle: Tipu Sultan and the Scots in India, 1760–1800* (Edinburgh: National Galleries of Scotland, 1999).

[7] Hézecques, *Souvenirs d'un page de la cour,* 233–34.

[8] Hézecques, *Souvenirs d'un page de la cour,* 235; Jeanne-Louise-Henriette Campan, *Mémoires de Madame Campan, première femme de chambre de Marie-Antoinette*, ed. Jean Chalon (Paris: Mercure de France, 1988), 15.

[9] Vigée Le Brun, *Souvenirs,* 1.125, 2.102.

[10] *Magasin des modes nouvelles* 36 (November 10, 1788): 284–85.

[11] *Magasin des modes nouvelles* 31 (September 20, 1788): 245.

LEFT Defraine/Duhamel, "Robe à la Tippoo-Saïb et à l'Indienne," *Magasin des Modes Nouvelles*, 29e Cahier, pls. 2–3, August 30, 1788.

OPPOSITE Elisabeth Vigée Le Brun, *The Marquise de Pezay and the Marquise de Rougé with Her Sons Alexis and Adrien*, 1787. Oil on canvas. National Gallery of Art, Washington, DC.

INDIA AS DESIGNER TO THE WORLD

AVALON FOTHERINGHAM

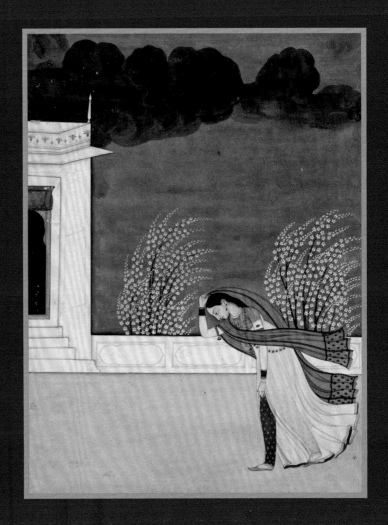

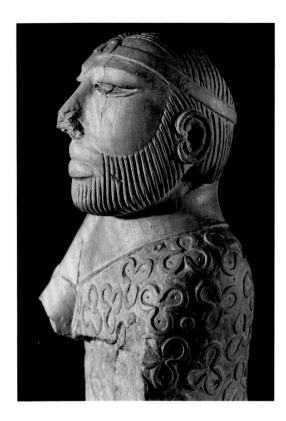

Buoyed by an expanding international market, by the late eighteenth century India accounted for roughly 25 percent of the world's textile output as a whole.[1] An extraordinary volume and variety of textiles were being produced by millions of artisans spinning, weaving, printing, dyeing, and embroidering all across South Asia, justly earning India its position as the globe's foremost source of fabric.

Although the forces of colonialism and industrialization would shortly undercut this lead, India's historic primacy in the textile trade had already fundamentally altered dress practices stretching from the Caribbean to Japan. The legacy of India's contributions to global dress reflects its role as much more than a fabric warehouse. Rather, a full accounting of India's influence must acknowledge its impact as an influencer of tastes, styles of pattern, modes of dress, and approaches to design—in short, the impact of India as an exporter of fashion.

The sartorial debt the world owes to India can be traced back to the ancient past. The textile and dress history in India, home to an extraordinarily rich array of natural fibers and dyes, encompasses millennia of skilled cloth and clothing production. Evidence suggests widespread cotton spinning was taking place as early as 6000 BCE; mordant dyeing was taking place from about 2500 BCE; wild silks were being reeled and spun as early as 2450 BCE; and methods of patterning clothes were already in development by circa 2000 BCE. Certainly by the first centuries of the Common Era, both plain and patterned Indian fabrics were not only being produced but widely traded, the beginnings of a process of "Southernization" in which "the cultivation of cotton as well as related processes and technologies spread from the Indian subcontinent to other parts of Asia and eventually the entire globe."[2] Discoveries of ancient fragments of Indian cloth along ancient Silk Roads align with literary texts and records of the ancient world, which document wider global desires for fashionable Indian fabrics. These desires drove millennia of Indian textile consumption, rooting India deep within global vocabularies of fashion; from *indigo*, a word that comes from the ancient Greek *indikon*, meaning "blue dye from India," to *cashmere*, after the regional home of pashmina fabrics, Kashmir.

Of course, the techniques and technologies that supplied these ancient export markets were not developed solely for trade. It was the demands of India's courts, its fashion capitals, that drove the production of its most exquisite fabrics. Centuries of visitors to India marveled at the richness and beauty of Indian courtly dress. Especially admired were the delicate muslins favored by generations of Indian rulers, whose expensive tastes demanded the sheerest, lightest cloths. The ancient Greek ambassador Megasthenes described the "flowered garments made of the finest muslin" worn by the Mauryan emperor Chandragupta and his court,[3] and over a thousand years later Marco Polo recorded similar amazement at the muslins of South India, which were so fine "they look like tissue of spider's web."[4] Frenchman François Bernier was likewise astounded at the muslins of the Mughal court, which were so fine as to last only a few hours of wear and yet were worn in tremendous quantities at exorbitant cost.[5] The expense of these fabrics was a consequence of the excessive care required to produce even a single length of plain muslin cloth—a process that took months of careful work under conditions of perfect humidity to prevent the breaking of the cobweblike threads during spinning and weaving. Its production was so magical as to give rise to legends "of a cloth made by mermaids, water nymphs and fairies."[6] The technique of *jamdani*, in which slightly heavier cotton threads are hand-brocaded into muslin to create patterns that seem to float on air, or of *chikankari*, in which muslins are embellished with delicate white-work embroidery, only served to emphasize the beauty of India's most delicate cloth.

Having perfected the art of weaving and wearing muslin at home, India then exported muslin fashions abroad. Global fashions for Indian muslin—from the styles

OPPOSITE Woman in a white muslin *peshwaz* and Kashmir shawl, Punjab Hills, ca. 1780. Opaque watercolor and gold. Ackland Art Museum, The University of North Carolina at Chapel Hill.

ABOVE Seated male. Excavated from Mohenjo-daro, Pakistan, ca. 2000 BCE. Carved steatite with remnants of pigment. National Museum, Karachi.

of ancient Rome or Regency England—drew on established heritages of Indian dress. By the early nineteenth century, European women's dress was emulating even the decoration and accessorizing of Indian muslin fashions; neoclassical gowns were not only styled out of *jamdani* and *chikan*-patterned Indian muslins but also decorated with sparkling silver, precious stones, pearls, and beads—techniques already long popular in Indian muslin fashions across the subcontinent.

Even in the pairing of muslin gowns with Kashmir shawls, European consumers were replicating Indian fashions. Kashmir shawls first became popular accessories to courtly muslin *jamas* and *peshwaz* during the Mughal Emperor Akbar's reign (r. 1556–1605). By the mid-seventeenth century they began to be patterned with rows of naturalistic flowers worked in *kani*, or tapestry weave, in accordance with general fashions for floral patterns across all varieties of textiles at the Mughal court. By the mid-eighteenth century, the popularity of these floral-patterned Kashmir shawls in Indian fashion was such that every well-to-do person in India was expected to own a pair or two.[7] In adopting Kashmir shawls as companions to muslin gowns (as well as appropriating Kashmiri floral motifs into the European design canon as the "paisley," named for the Scottish town that produced imitation Kashmir shawls), late eighteenth- and nineteenth-century European dress drew on preexisting Indian fashions in dress and accessories.

In contrast with muslin and Kashmir shawls, which were the more highly valued in Indian fashion for how little they weighed, the heaviness of Indian silver- and gold-patterned silks was a direct indication of their value, as their weight reflected just how much precious material the textile or garment contained. Measuring the quantity of silver and gold in a fabric was an exact science; especially since finely drawn silver or silver-gilt wire might be no thicker than the width of a hair, and yet when worked in large enough quantities on cloth, it could result in terrifically heavy pieces. As art forms, embroidering and weaving with gold and silver have been Indian specialties for centuries, with various centers across the subcontinent developing reputations for certain styles and techniques.

Among the most renowned was Varanasi, or Benaras, a city famous for its gold- and silver-brocade silks. Produced as opulent saris, *dupattas* (a shawl or headcover), yardage for tailored dress, and more, garments made of Varanasi brocade were a must for nineteenth-century India's fashionable elite. Once again, visitors to India expressed wonder at the richness of Indian style: Helen Douglas Mackenzie, a British woman writing of her visit to Varanasi in 1847, observed how "the most magnificent gold and silver stuffs," called *kincob*, were used for garments there. While she acknowledged that no "European brocades [are] equal to them," Mackenzie believed Benaras brocades to be "almost too heavy for any articles of European dress" of her era.[8] Yet little over half a century later, these splendid brocades—especially the richness of Benarasi brocade saris—were beginning to fire the imaginations of Western couture designers. From Paul Poiret, Mainbocher, Simonetta, Dior, and Balenciaga to Marchesa and Alexander McQueen, many of Europe's and America's most acclaimed and influential designers of the twentieth and twenty-first centuries have drawn inspiration from Benarasi textiles.

But it is India's influence on everyday dress that is the true measure of its impact on global fashion. Beyond costly muslins and gold brocades, it was brightly dyed and patterned cottons that were the most impactful of India's fashions to influence dress abroad. Printed and painted cottons, or chintz, have long been mainstays of Indian fashionable dress, and over centuries of design evolution, expansion, trade, and exchange, different styles of chintz patterning developed. From the joyfully strewn blossoms of South Indian hand-drawn and dyed *kalamkari* flowers to the more restrained elegance of stenciled and block-printed northern Indian floral styles, chintz reflects a rich heritage of innovation, experimentation, and hybridity. Even within distinct pattern types and techniques,

OPPOSITE Length of *kamkhwab* (kincob). Woven by Bakshu in Varanasi in Uttar Pradesh, 1855. Silk brocaded with silk, silver, and silver-gilt wrapped thread. Victoria and Albert Museum, London. Indian weavers were usually not credited for their work, but this textile includes the embroidered name of the weaver: Bakshu.

BELOW LEFT Shawl, Kashmir, ca. 1820. Twill-tapestry woven pashmina. Victoria and Albert Museum, London.

BELOW RIGHT *Kalamkari* hanging (detail) showing South Indian–style all-over floral patterns on dress. Coastal southeast India for a Nayaka court, ca. 1625–35. Cotton, hand-drawn outlines, mordant and resist dyed; painted details. Achdjian Gallery, Paris.

PAGE 62 Portrait of Itimad ad-Daula and Nawab Zamar ad-Din Khan, Minister to Emperor Muhammad Shah, both in floral-printed cotton jamas. Delhi, ca. 1745. Victoria and Albert Museum, London.

PAGE 63 George Haité, design for a paisley shawl, Britain, ca. 1850. Watercolor and gouache. Victoria and Albert Museum, London.

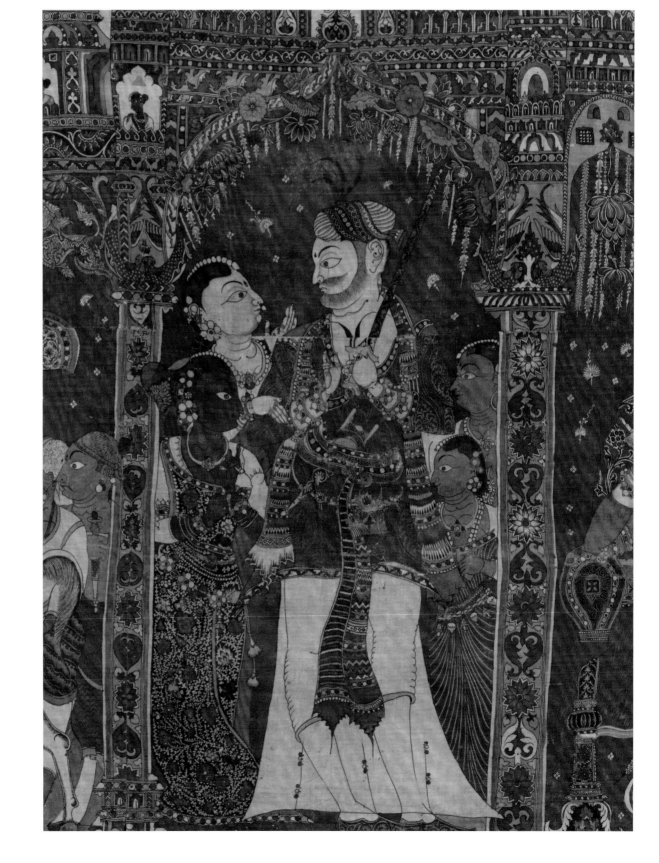

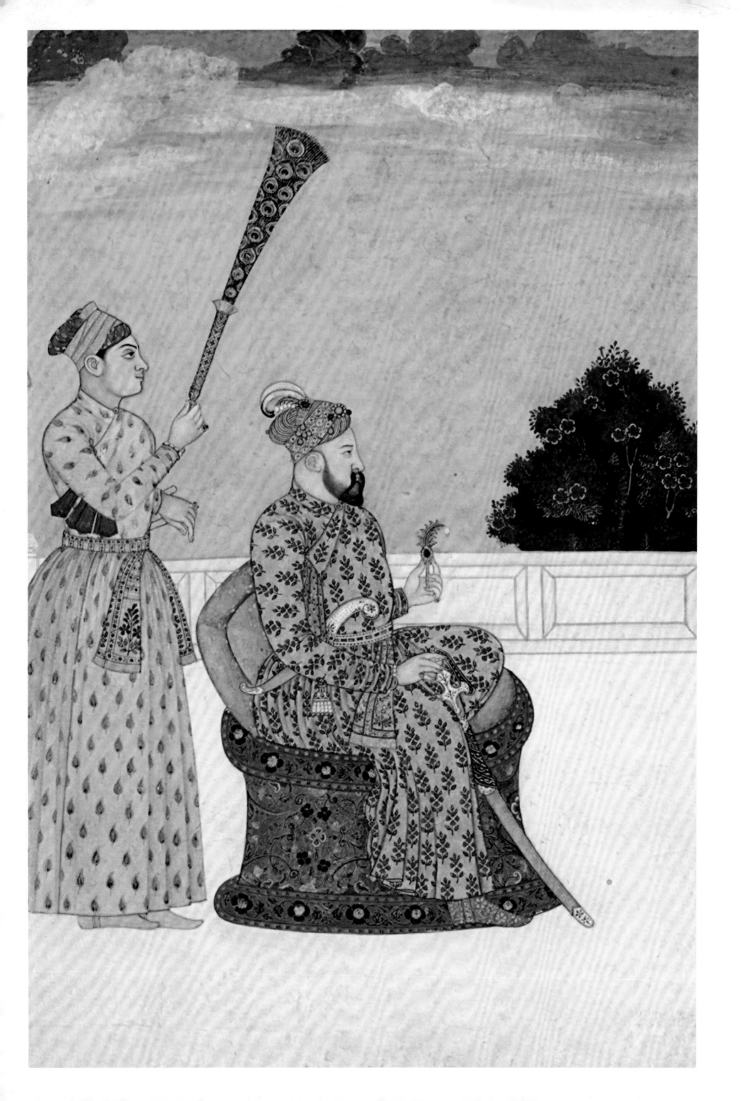

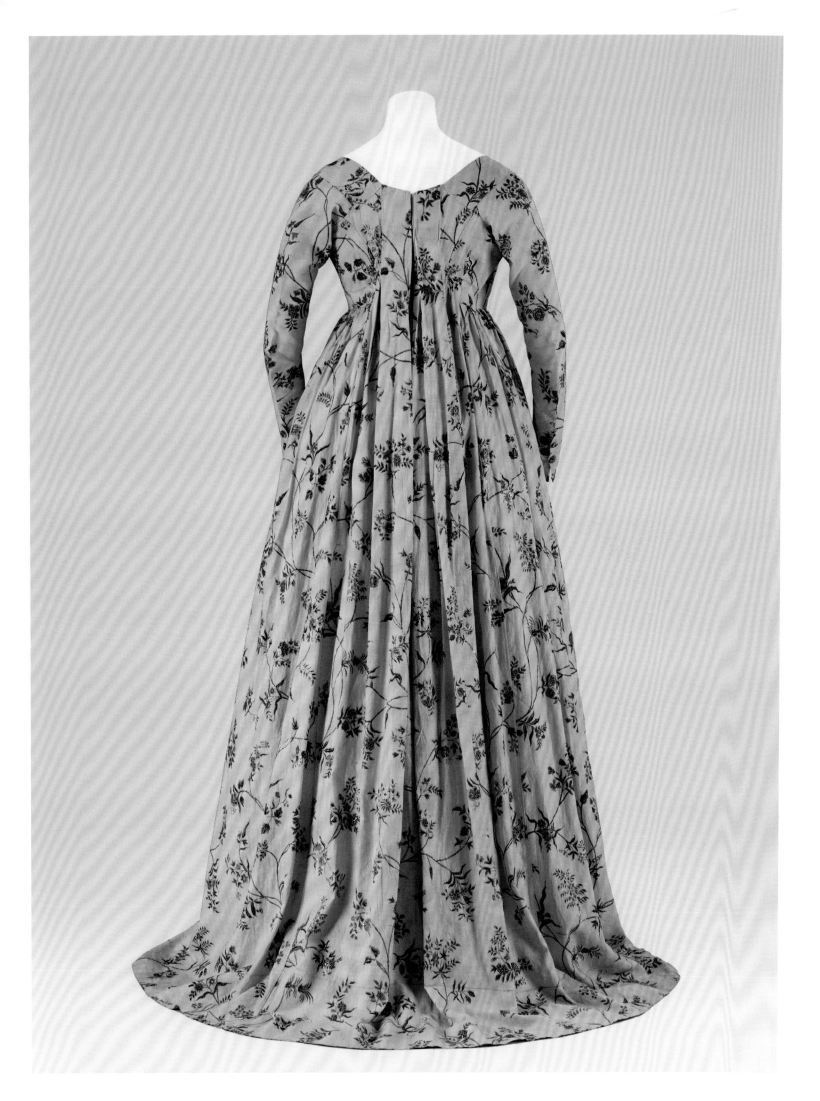

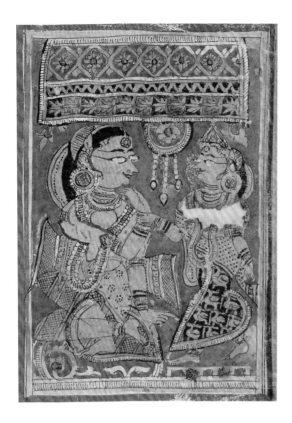

variations developed, and domestic Indian consumer discrimination was high; according to one story, a Raja slain in battle in 1763 was recognized solely by the discovery of his severed arm, still clothed in a sleeve of "Multan chintz, of exquisite beauty"—the product of his local block-printing center. [9]

India's supremacy in fixing dyes on cotton made its brightly colored cottons popular with fashion consumers far beyond India itself. Fragments of printed cottons from Gujarat dating from the early first centuries of the Common Era through to the twentieth century have been found at dig sites in Egypt, the remains of centuries of fabrics discarded after use. Likewise, precious lengths of printed yardage and ceremonial cloths from Gujarat have been found in Southeast Asia, dating from as early as the fourteenth century on. Importantly, many of the patterns on these Egyptian and Southeast Asian market fabrics are consistent with the styles of those depicted on the dress of figures in west Indian art over the same period, which suggests that to some extent Gujarat's exports reflected its own domestic market's tastes in patterned dress.

With the establishment of sea routes around the Cape of Good Hope, chintz also began being traded directly to Europe, and by extension to West Africa, the Americas, and Japan, expanding India's export market reach beyond its immediate overland and Indian Ocean networks. By the 1680s the Dutch East India Company was taking over a million lengths of Indian cotton back to Amsterdam, and the English East India Company was taking over 1.5 million back to London. [10] These imports included chintz hangings worked in designs amalgamating European, Indian, and wider Asian styles to suit European consumer tastes for chinoiserie patterns—a process that relied heavily on Indian artisans "Indianizing" the patterns they were commissioned to produce. Early East India Company records document frequent instructions sent to suppliers specifying that Indian artisans should be left "to work their own Fancyes, which is always preferable before any Patterns we can send you from Europe." [11]

Swiftly the popularity of Indian chintz furnishings saw the fabrics reused as dress yardage, and orders were made for lengths of chintz to be made up into clothing. By 1683, chintz had become "the ware of Gentlewomen" in Holland, and the fashion swiftly spread to England, where by 1686 it was "the Ware of Ladyes of the greatest quality." [12] The popularity and comparative affordability of Indian chintz began to threaten domestic European textile industries, and several nations implemented protectionist prohibitions banning its import and use. But anti-chintz legislation did nothing to quell demand; European fashion markets were already too enamored with chintz to stop buying it, and smuggling was rife, such that in 1720 English shopkeepers noted that "the Running of Said Prohibited Goods is Increased to that Degree that Wee have Dayly great Quantities of Patterns brought to our Shopps." [13] Indeed, the majority of surviving Indian chintzes found in Europe today date from the period of their outright prohibition.

Like chintz, affordable fashion was a key factor in the success of yet another category of Indian trade good that changed global dress. Named for *bandhani*, or tie-dye, the Indian technique used to pattern it, the bandanna originated in Bengal but became a must-have accessory for fashion consumers all over the world. Attractive, cheap, and much larger than the handkerchiefs of today at approximately a yard square, Bengali silk bandannas were first imported into Europe by the Dutch in the 1680s. By the time the English East India Company began ordering their own shipments of bandannas in the 1720s, the Dutch were regularly importing tens of thousands of individual bandannas a year. [14] And despite yet again falling squarely within the category of banned Indian imported goods, Bengali bandannas were among the most smuggled of prohibited silk fashion fabrics. [15] As a result, they can found depicted in hundreds of European artworks of the eighteenth and nineteenth centuries, most often tied around the necks of

OPPOSITE Overdress retailored from an older *robe à la française* during the period of chintz prohibition. Chintz fabric from Coastal Southeast India, 1760s. Tailoring done in Britain, 1790s. Victoria and Albert Museum, London.

TOP *Kalpasutra* manuscript page showing a maid-servant dressed in a *hamsa*-patterned cloth (detail), Gujarat, India, late 1400s–early 1500s. Ink, paint, and gold on paper. Victoria and Albert Museum, London.

ABOVE *Hamsa*-patterned ceremonial cloth (detail), Gujarat, India for the Indonesian market, ca. 1470–1550. Block-printed and mordant-dyed cotton. Victoria and Albert Museum, London.

jailers and sailors, the shoulders of maids and widows, and even draped over beggars, eventually becoming entrenched in Western fashion culture as an emblem of the working class. Long after the Bengali silk bandanna industry was supplanted by European industrially printed cotton imitations, bandannas still carry these associations, just as the name itself still attests to its Indian origin.

Indeed, it could be argued that Indian handkerchiefs, including the bandanna, were the first truly global fashion accessories. While Bengal supplied bandannas, South India supplied madras—large, colorful, checked cotton kerchiefs that formed critical elements of dress for fashion consumers around the world. Once again, the checked patterns of madras kerchiefs drew on well-established traditions of checked garment fashions in South India, as evidenced by artwork dating as early as the 1500s showing colorfully checked saris, lungis, and rumals in use. Over centuries of trade, madras became a highly valued trade commodity and important article of dress for consumers globally, both cut into single squares for use as handkerchiefs, neckerchiefs, and headwraps or used in lengths of multiple squares as yardage for wrapped and tailored dress.

As a result of madras's popularity, trade records indicate that by the early nineteenth century, it was being produced to dozens if not hundreds of unique subcategories of design and manufacture to meet the specific demands of a global market.[16] Consumed practically everywhere by everyone, madras took on multiple meanings and associations over the eras. Among other regions, in Japan madras helped supply Edo fashions for checked garments under the trade name *matafū-jima* (from Madras); in Britain and France it enjoyed particularly heightened popularity during vogues for "Creole" and "Highland" fashions in the late eighteenth and early nineteenth centuries; and in communities in the Caribbean, West Africa, and the Netherlands, madras became a critical part of traditional cultural dress and is still in use today.

Muslins, shawls, brocades, chintz, bandannas, and madras are only a handful of examples of India's immeasurable contributions to global dress. Much more than simply an exporter of fabrics, India undoubtedly played a profound role as an exporter of fashion, changing how people dressed in ways that are still visible today, from the global dominance of cotton to the evergreen popularity of the paisley. *India in Fashion* investigates this impact by positioning India in its historic and rightful place as both supplier and tastemaker—India as designer to the world.

ENDNOTES

1 Giorgio Riello and Tirthankar Roy, *How India Clothed the World: The World of South Asian Textiles, 1500–1850*. Global Economic History Series, Vol. 4 (Leiden, The Netherlands: Brill, 2009), 331.

2 Giorgio Riello and Prasannan Parthasarathi, *The Spinning World: A Global History of Cotton Textiles, 1200–1850* (Oxford: Oxford University Press, 2009), 2.

3 Gillian Vogelsang-Eastwood and Willem Vogelsang, *Encyclopedia of Embroidery from Central Asia, the Iranian Plateau and the Indian Subcontinent* (London: Bloomsbury Visual Arts, 2021), 59.

4 Moti Chandra, S. P. Gupta, K. N. Dikshit, Vinod P. Dwivedi, and Shashi Asthana, *Costumes, Textiles, Cosmetics & Coiffure in Ancient and Mediaeval India* (Delhi: Oriental Publishers on Behalf of the Indian Archaeological Society, 1973), 141.

5 François Bernier, *Travels in the Mogul Empire* (London: William Pickering, 1826), 294.

6 Saiful Islam, *Muslin Our Story* (Dhaka, Bangladesh: Drik Picture Library Limited, 2016), 82.

7 Janet Rizvi with Monisha Ahmed, *Pashmina: The Kashmir Shawl and Beyond* (Mumbai: Marg, 2009), 202.

8 Helen Douglas Mackenzie, *Life in the Mission, the Camp, and the Zenáná: Or, Six Years in India* (New York: Redfield, 1853), 71.

9 Christopher Rowell, Mildred Archer, and Robert Skelton, *Treasures from India: The Clive Collection at Powis Castle* (London: Herbert Press, 1987), 94.

10 *The Cambridge Economic History of India: Volume 1, ca. 1200–ca. 1750* (Cambridge: Cambridge University Press, 1982), 401.

11 P. J. Thomas, *Mercantilism and East India Trade* (London: Taylor & Francis, 2019), 40. This volume was originally published in 1963.

12 K. N. Chaudhuri, *The Trading World of Asia and the English East India Company: 1660–1760* (Cambridge: Cambridge University Press, 2006), 281.

13 Jonathan Eacott, *Selling Empire: India in the Making of Britain and America, 1600–1830* (Chapel Hill: University of North Carolina Press, 2016), 95.

14 Cargo lists for only two ships arriving in Amsterdam in 1725 totaled 6,060 pieces, each of which would have been a length of a minimum of seven handkerchiefs, totaling upwards of 42,420 bandannas. See *Europische mercurius*, Volume 36 (Amsterdam: Andries van Damme, 1725).

15 William Farrell, "Smuggling Silks into Eighteenth-Century Britain: Geography, Perpetrators, and Consumers," *Journal of British Studies* 55, no. 2 (2016), 279.

16 See Alexandre Legoux de Flaix, *Essai historique, géographique et politique sur l'Indoustan; avec le tableau de son commerce* (France: Pougin, 1807), for a summary of some of the major categories and their characteristics.

LEFT Philip James de Loutherbourg, *Portrait study of a sailor, possibly Christian Promonder*, ca. 1740–1812. Watercolor over graphite. The British Museum, London.

OPPOSITE Uncut length of bandanna, Berhampur, India, before 1881. Tie-dyed silk. Victoria and Albert Museum, London.

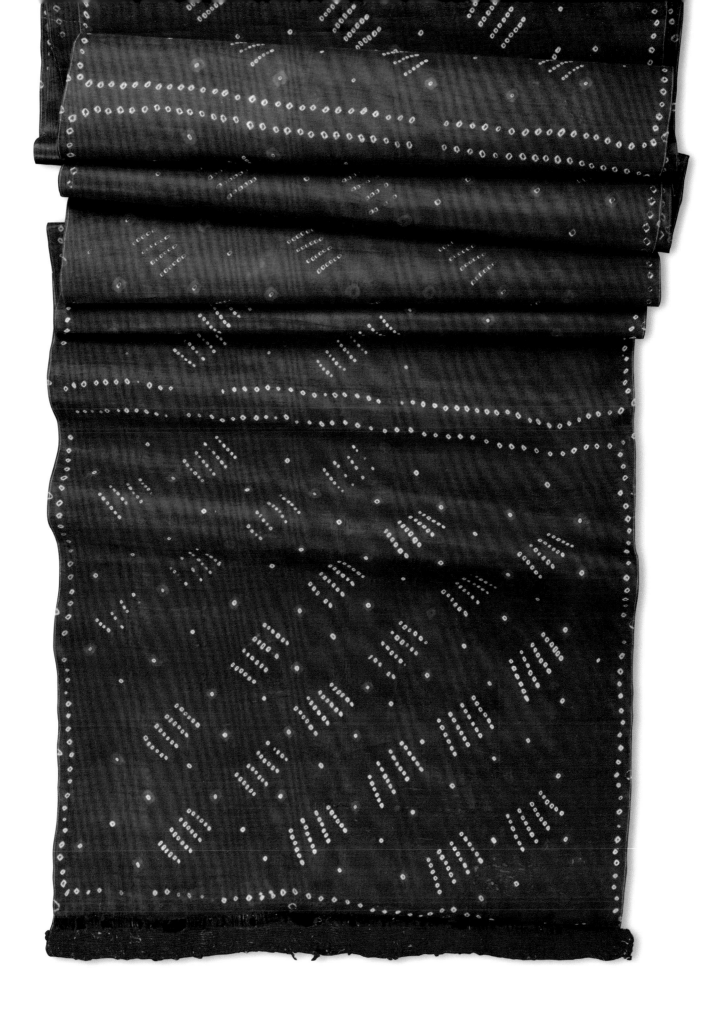

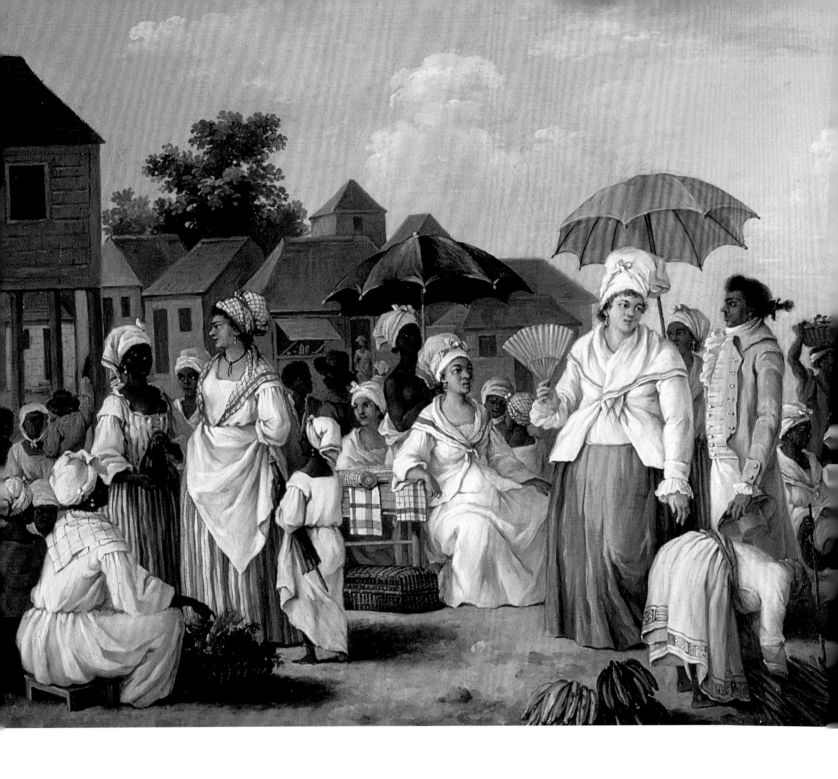

ABOVE Agostino Brunias, *The Linen Market in Santo Domingo*, ca. 1775. Oil on canvas. Private collection.

OPPOSITE Mural painting featuring a woman in a checked sari, Lepashki, Andhra Pradesh, India, sixteenth century.

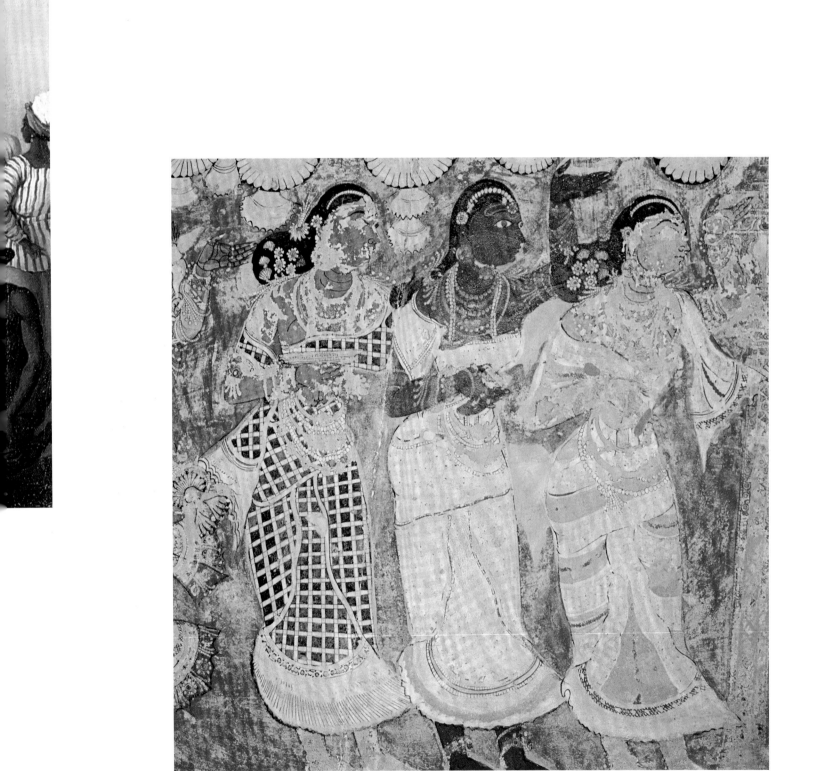

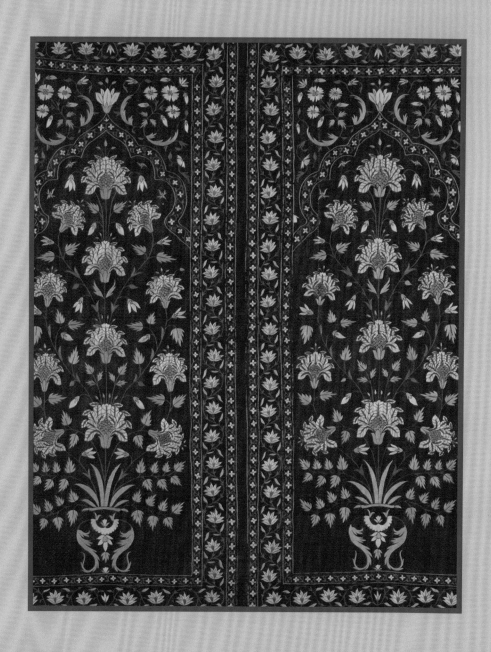

VANDANA BHANDARI

INDIAN
EMBROIDERY
IN FASHION

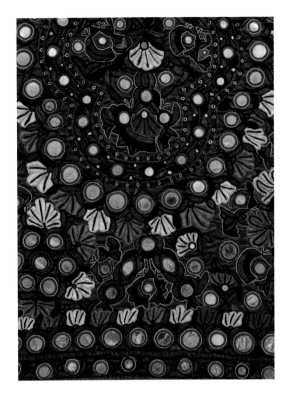

The spinning and weaving of cloth were considered a basic necessity in ancient civilizations. The use of ornamentation such as embroidery, however, was a reflection of an advanced society with well-developed craftsmanship where people valued exclusive and luxurious products. This text addresses just a few of the styles most popularly seen in fashion, for instance forms of gold and silver work, western Indian domestic styles and Gujarati *aari* embroidery, and Lucknowi *chikankari*.

Ancient civilizations always used draped clothing, and bronze needles excavated from the Indus Valley Civilization (ca. 3000 BCE) support the early use of embroidery in India. The historical practice and development of embroidery in India can be appreciated through a study of geographical location, trade routes and invasions over centuries, and the social and cultural practice of the people.

India is internationally recognized for fine workmanship and is home to the most versatile styles of embroidery, which is found in its varied forms throughout the country. The stitches, motifs, and interpretations reflect local cultures and traditions. The outstanding handwork skills of embroidery have been passed down from generation to generation and have flourished in the country for thousands of years.

Indian designers and the apparel and textile industry rely heavily on the rich tradition of embroidery techniques. The excellence and identity of Indian designers is an amalgamation of the effective fusion of their creativity and the handicrafts and handlooms employed by them. Leading designers have interpreted traditional embroideries in a modern way, and this usage has made such techniques fashionable and aspirational for consumers, while sustaining and conserving a rich cultural heritage. International couture has also employed Indian embroideries and showcased these on the world stage.

Embroidery in India has been practiced for both professional and domestic usage. Professional work was mainly done by men and made either for a patron, such as a court or a temple, or commercially for local trade or export. Domestic work, done by women, was closely associated with family life, social customs, and reflected cultural traditions. Today more and more women are working on embroideries for commercial purposes. A sampling of some of the Indian embroidery traditions closely tied to the world of fashion is described in the paragraphs below.

METALLIC EMBROIDERIES: Indian ceremonial textiles have long been a canvas for the use of silver and gold. Garments adorned with gold and silver metallic wires are written about in various ancient texts, including early travelogues of visiting scholars. Referred to as one of the eight auspicious objects in ancient Hindu texts, gold was used to adorn the garments of kings and priests.

Metal embroidery is classified into different styles. Each has subtle differences that are unique to the region where they are practiced. Local terminology and techniques influence the art to develop indigenous styles. Gold and silver embroidery came to be called *zardozi* in Delhi, Hyderabad, Bhopal, Lucknow, and other parts of Uttar Pradesh; *kamdani* or *badla* in Lucknow; *danka* and *gota-patti* in Rajasthan; *tilladoz* in Jammu and Kashmir; and *marori* work in Gujarat.

Each of these styles differs in the way the raw materials, tools, and embroidery are brought together. Most of these embroideries are done while holding the cloth in one hand while the other is used for the handwork. An *adda*, or wooden frame, however, is now increasingly being used, which allows the craftsperson to use both hands to embroider a prestretched piece of cloth and to simultaneously manipulate the thread from above and below. Embroidery styles such as *tilla*, *zardozi*, and *gota* are generally worked on a wooden frame.

OPPOSITE Tent hanging, Mughal, probably Gujarat, early eighteenth century. Quilted cotton and silk chainstitch embroidery. Victoria and Albert Museum, London.

ABOVE Child's dress (detail), Megwhar community, Sindh, Pakistan, mid-twentieth century. Cotton faced with silk, embellished with mirrors and embroidered with silk in open chain, fly, herringbone, and cretan stitch. Victoria and Albert Museum, London.

ZARDOZI AND ZARI/AARI WORK: A migratory craft from central Asia, believed to have reached India in the twelfth century and patronized by Mughal rulers, *zardozi* translates to "gold embroidery" and traditionally used pure gold and silver metal wires embroidered on opulent velvet, brocade, and satin textiles. The technique combines sequins, beads, precious and semiprecious stones, and pearls. *Zari zardozi* is practiced across India in clusters, with several regional variations.

In the *zardozi* technique, a flattened wire known as the *badla* is wrapped around a cotton or silk thread. This composite thread, known as the *kasab*, is flexible and available in different thicknesses in two main colors: gold (*sunheri*) and silver (*rupheri*). The *kasab* is skillfully molded by hand or machines to make wide-ranging embroidery embellishments.

This style commonly uses motifs such as vines punctuated with flowers, geometric shapes, and overall patterns like *jaal* (lattice work), *chudi* (circular designs), animal motifs including peacocks and parrots, and the paisley. The heavier pieces were traditionally embroidered with depictions of tigers, horses, and lions.

The main difference between *zardozi* and *zari/aari* work is that in *zardozi* the stitch is applied to the cloth (couched) whereas in the latter, the stitch is applied through the cloth. The *zari/aari* technique mainly uses chain stitch, produced by the hooked aari needle (awl/hook), although this tool can also be used to add sequins and beads to the design.

TILLADOZ: Tilla embroidery is primarily recognized as a contribution of Jammu and Kashmir in northern India. The work derives its name from gold and silver wire, in its flat form or wrapped around silk or cotton thread. It creates an ornamental effect as it is couched on the surface of the fabric using cotton or silk thread of the same color. A centuries-old craft, *tilla* is part of the many crafts that flourished under Mughal patronage in undivided India. With a Persian lineage, the design aesthetics are dominantly inspired by elements of nature local to Kashmir.

RAJASTHAN AND GUJARAT: The regions of Rajasthan and Gujarat in western India share craft practices, creating one of the richest heritages of embroideries in terms of stylistic variations.

Each style is a distinct combination of stitches, patterns, and colors, and the rules for using them have been shaped by historical, socioeconomic, and cultural factors.

These distinctions also mark the identity of communities, and each of them expresses it through their own vocabulary of motifs, stitches, colors, and so on.

Embroidery styles are identified by different criteria: the type of stitches used, the communities that practice them, and the regions where they are practiced. The distinctive styles also serve in identification of community, and even particular artisans.

The particular technique practiced has traditionally supplied specific names for the style. As an example, the colorful, mirrored embroidery practiced by the Meghwal (or Meghwar) community is either *kaccho* (interlacing stitch) or *pakko bharat* (chain and buttonhole stitch), which reflects the type of stitches used.

The embroideries of Gujarat, which were exported to Europe in the eighteenth century and were done with straight needles, became commercial at an earlier stage probably because trading was done from the region. Conversely, the handwork of Rajasthan remained as a domestic practice for a longer time. Embroideries done on leather using the chain stitch found traction for commercial use under the patronage of royalty. The cobbler's awl used on leather over time was modified for cloth embroidery, which was executed in silk thread using a hook and created soft furnishings, court dresses, floor spreads, and canopies—all of which became popular trade items. This embroidery was done by men and is known as *aari bharat* or *aari*.

ABOVE Dress piece (detail). Worked by students at Hobart School for Girls, Chennai, Tamil Nadu, ca. 1880. Gauze embellished with couched silver-gilt *kalabattun*. Victoria and Albert Museum, London.

OPPOSITE Robe (detail), Amristar, Punjab, ca. 1855. Wool and *zardozi* embroidery. Victoria and Albert Museum, London.

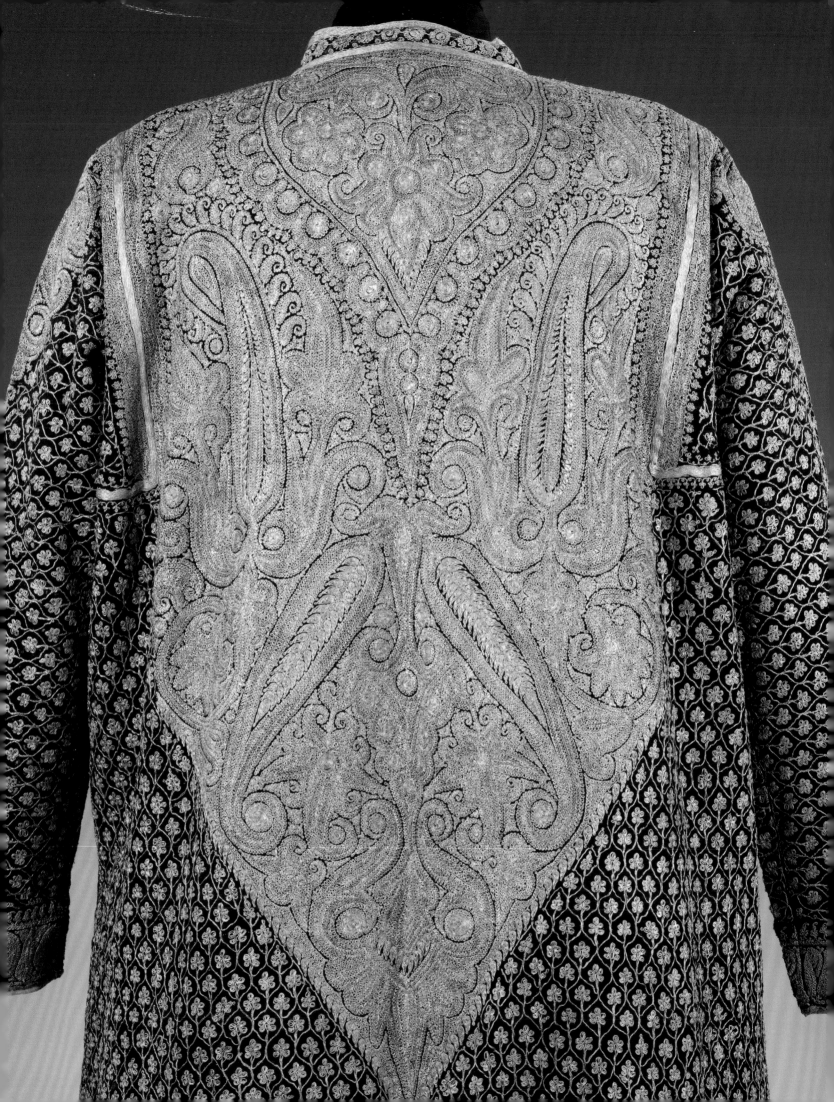

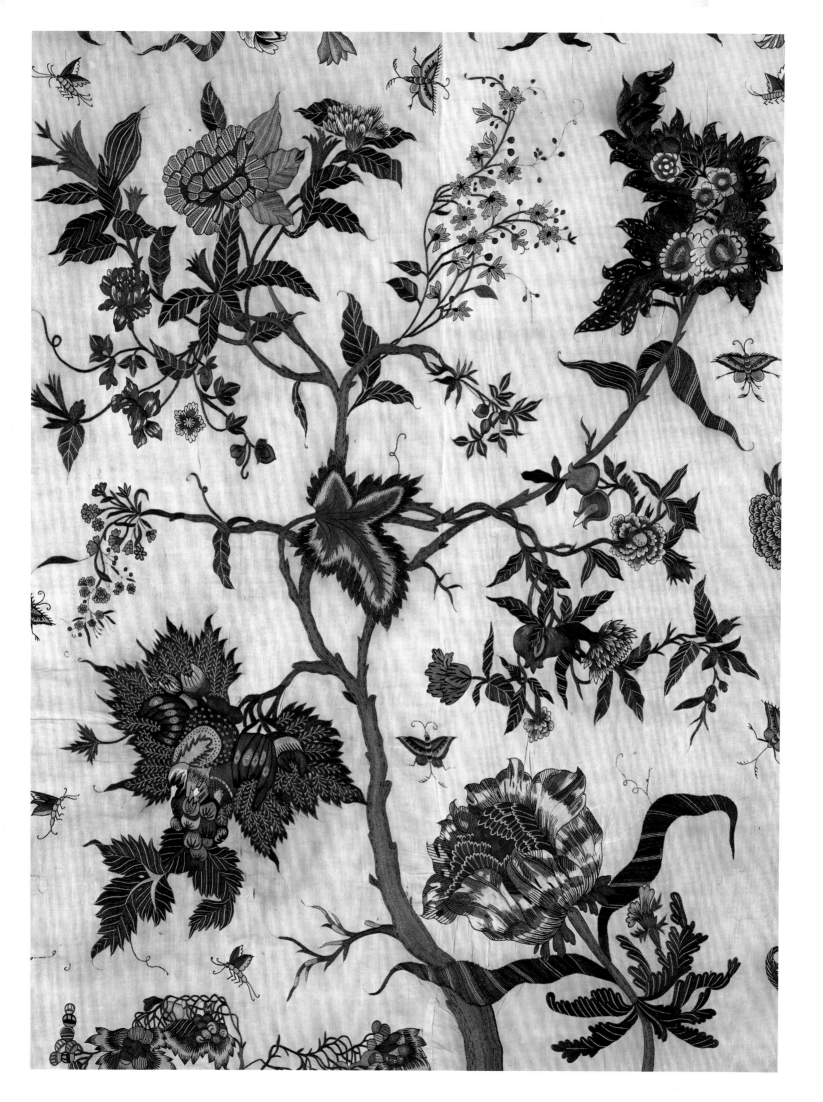

The entire array of vibrant colors—including blue, red, and golden yellow—on cotton and silk can be seen in western India. Multiple types of stitches, such as satin, line and back stitch, beadwork, buttonhole and chain, and inverted chain, are used as the techniques of adornment.

CHIKANKARI OF UTTAR PRADESH: The fine and delicate white-on-white *chikankari* embroidery is practiced in Lucknow, in Uttar Pradesh—which was and is the center of *chikan* embroidery, renowned for its timeless grace and its gossamer delicacy.

A city known for its *tehzeeb* (refined etiquette), Lucknowi *chikan* is characterized by the exquisite fineness of its workmanship. How the technique first developed there is uncertain; some believe it was adapted from a pre-existing Persian tradition and others that it migrated to Lucknow from Bengal.

Embroidery is just one stage in the making of a *chikankari* product, and the production process involves a group of people having various responsibilities: cutting, sewing, printing of the design, embroidering, washing and finishing, and marketing of the final product. The ecosystem that exists in Lucknow for the multiple processes makes it possible for the embroidery community to flourish in the region.

Originally, *chikan* embroidery was done with untwisted white thread on soft, white cotton fabric such as muslin or cambric. Needles were used, but traditional embroidery frames were not. *Chikan* embroidery has a repertoire of about forty stitches and can be broadly classified into three variations: flat, embossed, and open-trellis work, or *jali*.

Flat stitches are worked close to the surface of the fabric and include *tepachi* (stem stitch); *bukhia* (herringbone); and *katav* (a type of appliqué). The *bukhia* is the most popular stitch used in *chikan* and is worked from the reverse side to create a shadow-like effect. The embossed stitch gives a raised effect and includes the *murri* (rice shaped) and the *phanda* (millet shaped).

The warp and weft are teased aside with the needle and thread to create a netlike effect, and through variations like *bulbul chasm*, *chattai*, and *siddhaur*, the *jali* stitch is the finest and most delicate stitch worked in *chikankari* embroidery. The motifs are inspired by nature and include floral and leaf forms along with the paisley pattern.

Hand embroidery is practiced from rural communities to urban centers in India. The types presented here are only a selection of India's phenomenally rich array of embroidery styles and techniques, each of which has its own equally fascinating history. Fashion embroidery has a place in luxury products and is used widely by designers both in Indian and international markets. Preserving and reviving the legacy of Indian hand embroidery through innovations sustains the craft seamlessly into the future.

OPPOSITE Palampore (detail), Mochi community, Kutch, Gujarat, 1700–20. Cotton and silk chain-stitch embroidery. Victoria and Albert Museum, London.

ABOVE Dress (detail), England, ca. 1805. Cotton muslin and *chikankari* embroidery. Fashion Museum, Bath, UK.

FRANK AMES

THE KASHMIR SHAWL

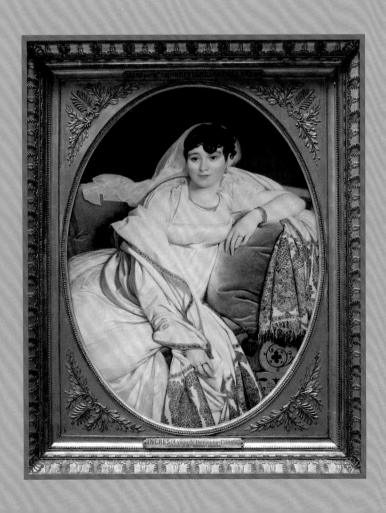

India's Kashmir shawl has stood for centuries unrivaled as a symbol of nobility, wealth, and status. It remains one of the most coveted textiles of the East. It first arrived in the West via the late eighteenth-century Raj, and it quickly became fashionable in London. At the start of the nineteenth century, Norwich weavers produced the first "imitation" Kashmir shawl, woven on the harness loom. Production in Edinburgh soon followed.[1] By 1818 the town of Paisley in Scotland took the lead, dominating in the production of inexpensive imitations that sold as far off as Turkey, Persia, and India. Paisley's imitations succeeded so well that the town's name became synonymous with the Indian patterns themselves.[2]

But the true rise to fame of the Kashmir shawl began with the return of French officers from Napoleon's Egyptian campaign (1798–1801). Among the souvenirs they brought with them were the precious Kashmir shawls, often worn as waistbands. It became a symbol of their distinguished service and a reminder of the battles fought against the Mamluks. Indeed, Napoleon's personal Kashmir shawl waistband (*patka*) is still on view at the Château de Malmaison.

Imagine the Paris fashion industry when it discovered that the Indian shawl was woven by a complex technique that had been until then the unique reserve of their famous tapestry ateliers such as Aubusson, Beauvais, and Gobelins. While the British chose the harness loom for their production, the French, fascinated by the complexity of the weave, first began dissecting it with the goal of reproducing it exactly. By 1800, French weavers succeeded in replicating the double-interlocked twill tapestry weave and began producing fine shawls in the Indian style using domestic wool.[3] By 1815, Joseph-Marie Jacquard invented the mechanical loom, and the race was on to churn out inexpensive imitations to meet the burgeoning French demand.

Empress Joséphine Bonaparte, besides possessing a notoriously large collection, also had an unparalleled passion for all the arts, including horticulture, which likely inspired her attraction to the botanical nature of the Indian shawl. As empress of France, she set the trend—and all followed in her footsteps.

From the diary of Madame de Rémusat—a lady-in-waiting who was Joséphine's personal attendant—we learn that her mistress owned between three hundred and four hundred shawls. Some were reconfigured into gowns, bed quilts, and even cushions for her dog. Napoleon, preferring to see his wife's bare shoulders, often grabbed her shawls and flung them into the fire. The empress then calmly sent to her wardrobe for another.[4]

Many of the shawls in her collection were purchased for upwards of 12,000 francs (today's value of about $40,000). Bonaparte's second wife, Marie-Louise, was given an allowance of 80,000 francs solely for the purchase of "les châles en dentelles."[5]

The fashion element for these romantic weavings is clearly evident in Benjamin Zix's 1810 painting of the imperial wedding procession of Napoleon's second marriage. Women parade across the Grande Galerie with shawls draped like trophies over their arms. Louis-Gabriel-Eugène Isabey's painting (1817) depicting this great edifice, now the Louvre, illustrates not only a *défilé de mode* in Paris's obvious place-to-be-seen but also France's obsession with the Kashmir shawl. The sensuously diaphanous swathe of pashmina soon became the ne plus ultra accessory that few women of social stature could do without—the perfect accoutrement to the sheer negligee style that was de rigueur.

With Napoleon's court artists—including David, Ingres, and Gros—France's sartorial splendor was celebrated in their virtuosic brushstrokes, capturing the spirit of Romanticism as in the poetry of Lamartine or Ingres's painting of Madame Rivière, adorned in a luminescent pashmina that flows rhythmically around her like a river and is a brilliant metaphor for her name.

OPPOSITE Jean-Auguste-Dominique Ingres, *Portrait of Madame Rivière, Wife of Philibert Rivière*, 1806. Oil on canvas. Musée du Louvre, Paris.

ABOVE Louis-Gabriel-Eugène Isabey, *The Grand Staircase of the Museum*, 1817. Watercolor on paper. Musée du Louvre, Paris.

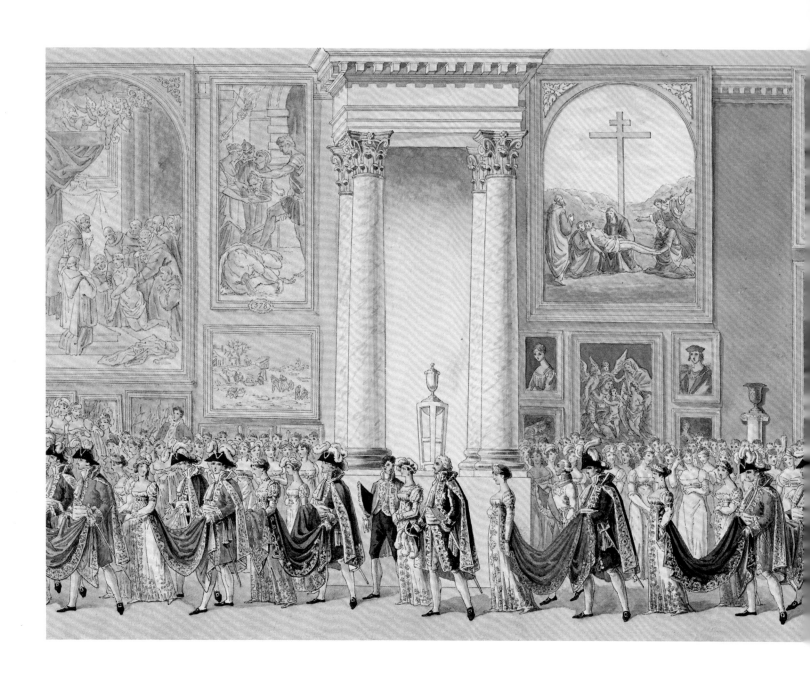

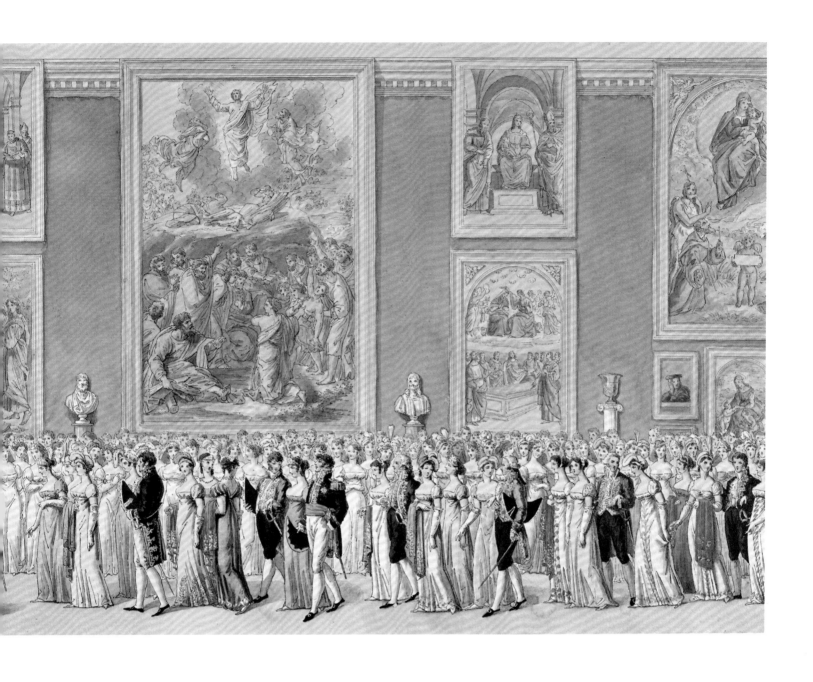

Akbar the Great (r. 1556–1605), as the most powerful ruler in the Orient for a half century, not only set fashion trends according to his own dictates but also personally orchestrated their creation. Abul Fazl, his court chronicler, wrote: "In former times shawls were often brought from Kashmir. People folded them up in four folds, and wore them for a very long time. Nowadays, they are generally worn without folds and merely thrown over the shoulder. His Majesty has commenced to wear them double, which looks very well."[6]

This was the beginning of the *dochalla* fashion, or shawls worn as pairs, sewn back-to-back thus hiding the threads of the reverse sides. There is much evidence to corroborate Fazl's statement. He noted that Akbar experimented with dyes and attempted to dye wool red. Pashmina shawls were held in such high esteem by the emperor that he changed their name to *parmnarm*, which translates to "perfectly soft." They were often gifted as *khil'a* to visiting dignitaries and to his military commanders.

During Akbar's reign, the Kashmir shawl was plain and without pattern. It was not until the Shah Jahan period (r. 1628–58) that the shawl began to exhibit floral bouquets or *botehs*.

We learn of its style, how the shawl is wrapped and displayed, not from Mughal paintings per se but mainly from miniatures of the Deccan, from the opulent courts of Bijapur, Golkonda, and Ahmadnagar.[7] The shawl's floral *pallu*, or decorative end panel, is carefully draped around and over the shoulder to display its series of floral bouquets. It is obvious the wearer did not simply toss it around himself. In order to set the shawl's pink *boteh* extremity vertical, it had to be carefully folded, most likely by a servant.

But as it landed on the shores of Europe, what exactly was it about the Kashmir shawl that made it so attractive and mysterious? First, let us look at its wool. The fine hairs derive from the inner coat of goats that graze at the extreme altitudes of the Himalayas, usually above twelve thousand feet. With a fiber measurement of fifteen microns, it is extremely fine. Such rare fiber was unknown to Europe. By comparison, the finest merino wool is eighteen microns. *Pashm* is in a class of its own. This quality renders the fleece easier to spin and imbues the woven fabric with greater lightness and warmth. Normal sheep fibers are scaly with hollow centers. Dyes take unevenly to them. But the hairs of *pashm* are of solid keratin and have the ability to absorb dyes better than any other wool.[8]

We know that pashmina goes back to antiquity. French excavations at the Egyptian necropoli sites of Palmyra and Antinoöpolis yielded "cachemere" wool fragments. Yet its mysterious origins remained for centuries hidden within the cloak of the Himalayas. It took nearly two millennia before its European discovery.

Note the strange enigmatic motifs of palms (*botehs*/paisleys) decorating the borders of the shawl. Are they heraldic icons of the Oriental nobility? Do they symbolize a ceremonial status or rank within the military? Whatever the case may be, they invariably evoke a time-honored sense of royalty, wealth, and exoticism.

While the paisley shape is of ancient Iranian descent, only during the eighteenth century when it was incorporated into the Kashmir shawl did it experience a rebirth. As its popularity spread westward, it found its most enthusiastic audience in Iran. Under Karim Khan Zand (r. 1751–79), Shiraz became the "regional center of the Persian heartland." A new era of prosperity was stirring, and the arts flourished. Paintings, depicting both court culture and private life, became essential features to the bustling architectural activity. Kashmir shawl fabrics, seen in coats, tunics, pants, and jackets, were exalted in every shape and sartorial manner as captured in dazzling displays by the period's great court painters such as Muhammad Baqir and Muhammad Sadiq.

ABOVE Rose boteh *palla* fragment, Mughal, seventeenth century. Private collection.

OPPOSITE Antoine-Jean Gros, *Josephine Tasher de la Pagerie, Empress of the French, Gazing at a Bust of Her Son Eugene de Beauharnais at Malmaison*, 1808. Oil on canvas. Musée d'Art et d'Histoire, Palais Massena, Nice.

OVERLEAF John Singer Sargent, *Cashmere*, 1908. Oil on canvas. Private collection. The painter's niece Reine Ormond, wrapped in a cashmere shawl, is depicted in seven poses.

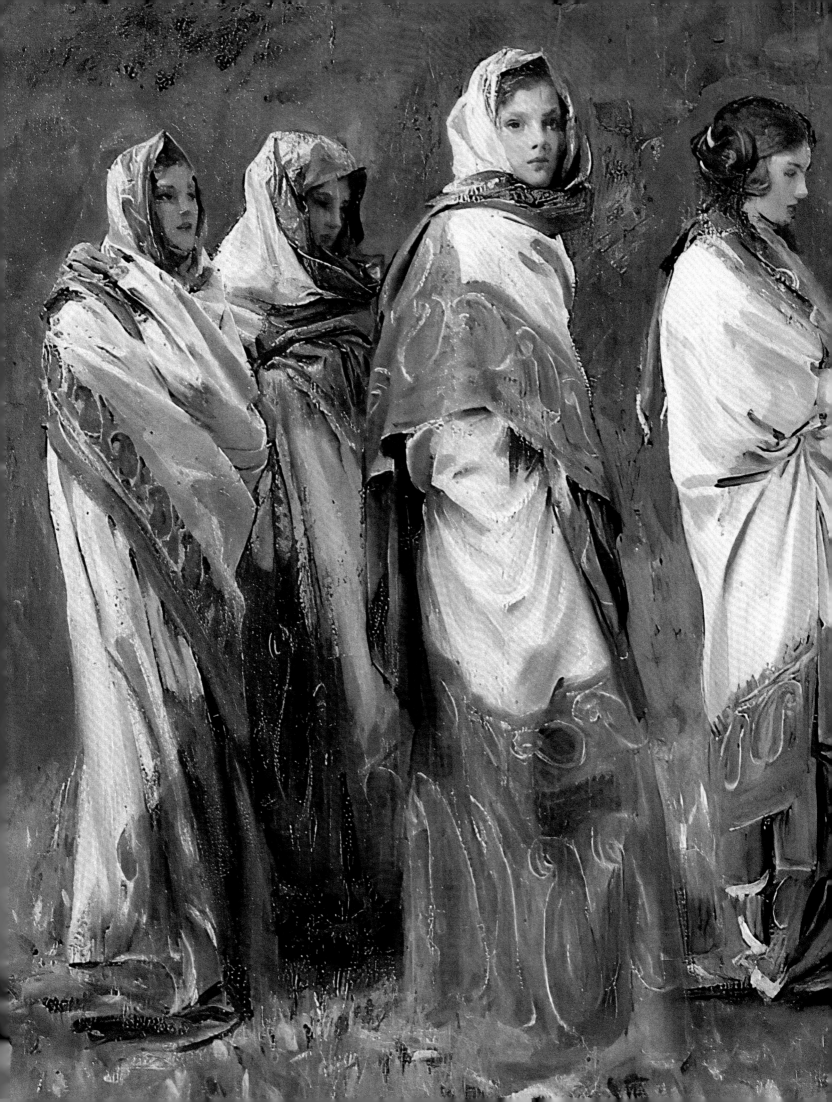

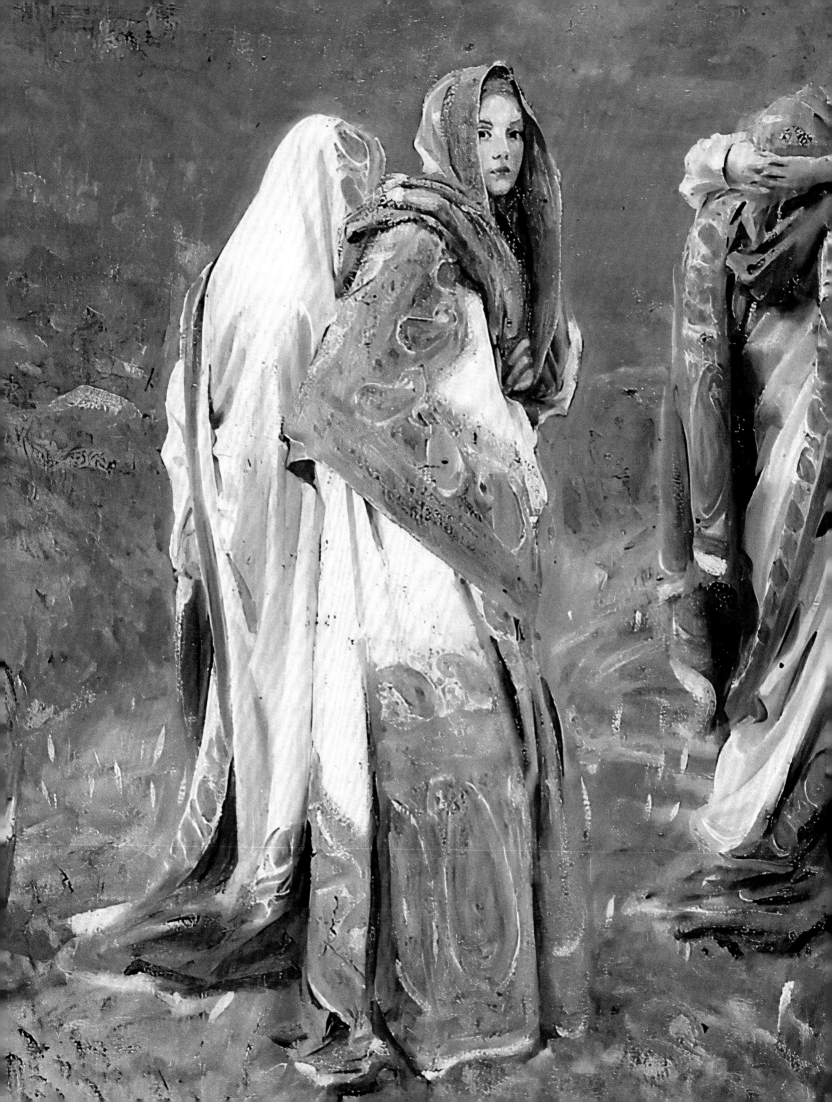

Iran's diplomatic corps adapted the Kashmir shawl to wrap their impressively tall "beehive" turbans, while nobles, perhaps of lesser importance, appeared in their paintings wearing their domed felt caps with a more modest shawl wrap.

As seen in the paintings, these majestic turbans are meticulously crafted to display a portion of the *boteh* at the top while the shawl's *hashysia* swirls luxuriantly around the exterior.[9]

Whether the "schal" or shawl was woven in Kerman—a center for shawl weaving (*termeh*) of lesser quality—or in Kashmir, it was often considered by the Persians as cloth to be cut or reconfigured into clothing. It seems that the shawl was not worn in Persia as a shoulder mantle.

Fueled by the Industrial Revolution and new loom technologies in the first half of the nineteenth century, leading French designers popularized fashion based upon the imitation jacquard shawl. Early nineteenth-century French national and universal exhibitions celebrated them as works of art. While the French manufacturers continued to fixate on the representation of natural flowers in their shawls, Kashmiri designers paid little heed to France's obsession. They had other stylistic ideas in mind.

Under the rule of Maharaja Ranjit Singh (r. 1801–39), Kashmir shawl production was controlled by the Sikhs from 1819 until 1846. During this period, a new style was born, one that broke away from the simple *boteh* repeats one normally encountered at the extremities of the shawl. The whole shawl became almost covered in pattern save for a small plain center. The designs were bizarre, exotic, and often architectonic. The shapes and forms appear to derive from the Khalsa culture of the Punjab. The motifs assail our senses and tax our abilities of interpretation. A new design language, albeit mysterious, was born. Although the French manufacturers disliked the designs, they had no choice but to emulate them, such was the public demand for the genuine Indian article.[10]

There is little question that French designers dictated the fashion in Europe for the imitation jacquard shawls, attracting agents from all over Europe. Buyers from Paisley, Norwich, and Edinburgh made frequent visits to Paris for the latest patterns in shawl fashion. Setting the stage for France's domineering success was industrialist Guillaume Ternaux (1763–1833). When asked by Napoleon's interior minister, Comte Jean-Pierre Bachasson de Montalivet, to supply twelve shawls for the Imperial Court, Ternaux immediately turned to the miniaturist Isabey (mentioned above) to create designs of a decidedly French look. On the eve of the New Year 1812, the Empress Marie-Louise distributed them as gifts to her ladies-in-waiting, keeping a few for herself.[11]

France's burgeoning shawl industry, struggling to compete with the relentless demand for the Indian shawl, benefited greatly from this royal patronage. French industrial designers such as Amédée Couder, Anthony Berrus, and Frédéric Hébert continued the forward momentum from there, producing prizewinning shawl patterns for major weaving companies Duché Aîné & Cie, Fortier & Maillard, Frédéric Hébert & Fils, Berrus Frères & Cie, Biétry, and more. Berrus's designs were sold to weavers in Lyon and Nîmes as well as to Scottish and Austrian manufacturers. During the period 1849–51 his dense jungle-foliage patterns comprising exotic floral sprays and zoomorphic leafy vines gripped the public's attention; his deployment of color nuancing was absolutely beautiful if not kaleidoscopic.[12]

Amédée Couder, on the other hand, flaunted his inimitable architectural prowess by producing several masterpieces that could only have been woven using the advanced loom technology engineered by the likes of Eck and Denierouse. In his *Nou-Rouze* (Farsi for New Year) of 1839, Couder expressed his affinity for Persian culture and combined it with Gothic art filled with colonnades and spires and featuring a world of

ABOVE Kashmir shawl, France, ca. 1870.
OPPOSITE Kashmir shawl, Sikh Period, ca. 1835.

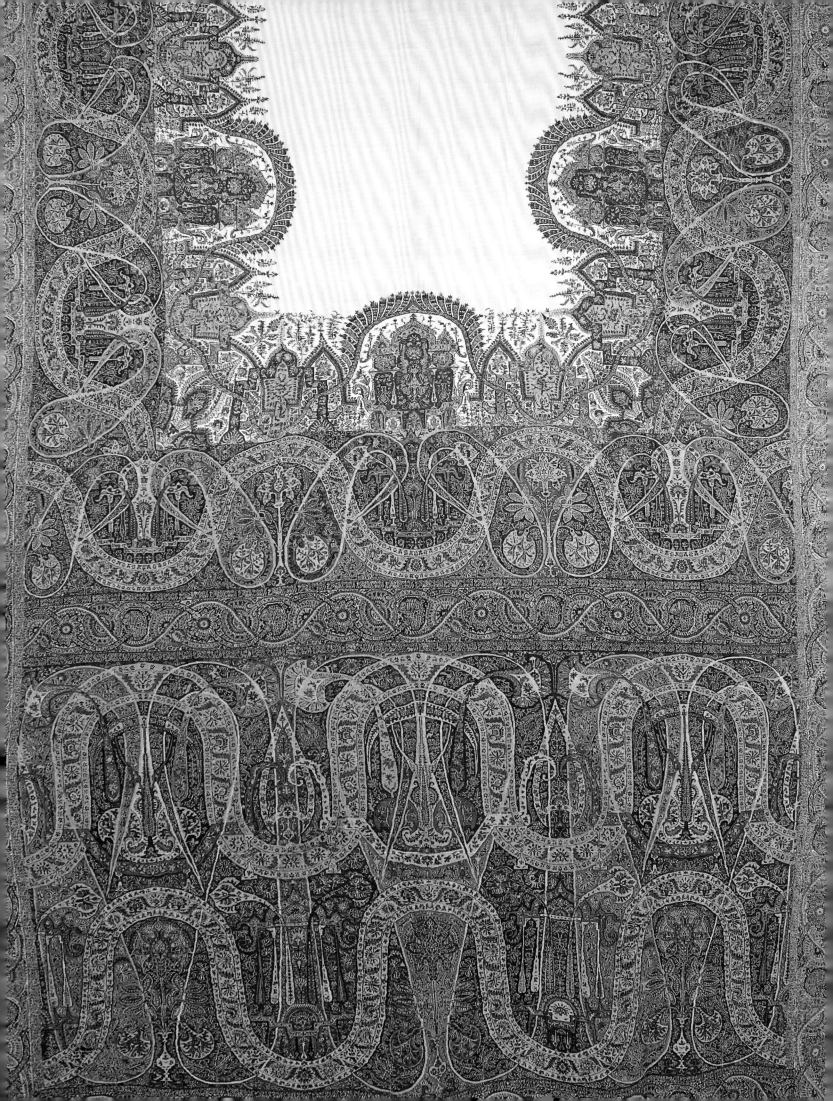

people celebrating on a stage of massive architectural proportions.[13] Over one hundred thousand jacquard cards were required to weave it.

A big challenge in the study of the European jacquard imitations is determining who was the artist. If French archives are replete with enticing stories and effusive praise of their manufacturers, they are less forthcoming—except in rare cases—as to who actually drew their designs. For some, such as Couder, Berrus, and Victor Delaye, we are able to consult their extant sketch albums.

The turning point in European-influenced patterns on shawls woven in India comes in 1851, following the Great Exhibition of London. Srinagar was flooded with European agents who arrived with their own design albums, and huge quantities with swirling paisley patterns were soon dispatched to Europe.

The huge, steel-hooped cage crinoline (at times six yards in diameter), so extremely popular during the 1850s and 1860s, gave way to the bustle. The large jacquard shawls, measuring as much as 160 by 350 cm, could no longer be properly donned, and consequently many were cut into square shawls. And the coup de grâce of course was the Franco-Prussian War of 1870–71, which put an end to commerce. Fashion for the shawl dropped precipitously. It marked the end of three-quarters of a century of a thriving European industry, one that brought fame to manufacturers and designers, and one that promoted the paisley design (Indian patterns) across a vast media of textile weavings, prints, carpets, clothing, wallpaper, and more.

ENDNOTES

[1] Pamela Clabburn, "British Shawls in the Indian Style," in *The Kashmir Shawl and Its Indo-French Influence*, ed. Frank Ames (Woodbridge, UK: Antique Collectors' Club, 1997), 237.

[2] Clabburn, "British Shawls."

[3] See "Shawl Weaving in France," in *The Kashmir Shawl and Its Indo-French Influence*, ed. Frank Ames (Woodbridge, UK: Antique Collectors' Club, 1997), 135–62.

[4] John Irwin, *Shawls: A Study in Indo-European Influences* (London: Her Majesty's Stationery Office, 1955), 32.

[5] Irwin, *Shawls*, 33.

[6] Abul Fazl (1551–1602), *The Ain i Akbari*, ed. Heinrich Blochmann (Calcutta: C. B. Lewis at the Baptist Mission Press, 1872), I:92.

[7] Realistic depictions of the Kashmir shawl are found mostly in miniatures of seventeenth-century Deccani paintings. An exception is Nizam ud-Din Awliya. See Stephen Cohen, ed., *Kashmir Shawls: The Tapi Collection* (Mumbai: The Shoestring Publisher, 2012), 16.

[8] For a detailed discussion of wool fiber, see Steven Cohen, "What Is a Kashmir Shawl," in *Kashmir Shawls*, 16–27.

[9] For a detailed discussion of the Zand period, see "Persia and Kashmir," in *Woven Masterpieces of Sikh Heritage*, ed. Frank Ames (Woodbridge, UK: Antique Collectors' Club Publishing Group, 2010), 205.

[10] Ames, *Woven Masterpieces of Sikh Heritage*. See chapter 3, "The Development of the Sikh Style," 43.

[11] Irwin, *Shawls*, 33–34.

[12] The Louvre Museum library contains many volumes of Berrus's designs. Etro of Italy has the most extensive collection of shawls designed by Berrus, Couder, Hébert, and others.

[13] Couder appears to have been influenced by the then-prominent and prolific German architect and painter Karl Friedrich Schinkel, who was particularly active in creating designs for Berlin's theatrical stages. For further study, see *Vorbilder für Fabrikanten und Handwerker*.

OPPOSITE Gustave Janet, day ensemble with paisley motif detail, *La mode artistique*, 1874–75. Musée Carnavalet, Paris.

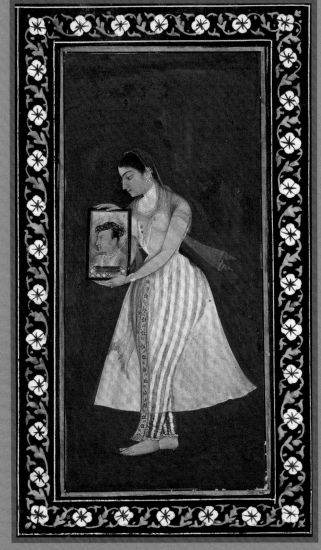

THE
LONG
SHADOW OF
MUSLIN

SONIA ASHMORE

"Fashion is truly termed a witch ... the dearer and scarcer any commodity, the more the mode. Thirty shillings a-yard for muslins, and only the shadow of a commodity when procured." So grumbled a British clothier in 1696 of a "Trade which exhausted our Bullion to support our Pride and Luxury."[1] Similar complaints had begun in Roman times, continuing into the nineteenth century. What was the shadow that caused such ire? The plainest, and most delicate, of woven cotton cloths, a fabric that clothed royalty, upset economies, formed great wealth and caused extreme poverty, the stuff of legend, fortunes, and high fashion in Asia, Europe, and America.

Muslin is a plain weave cotton fabric, made by handloom weavers in Bengal with extreme dexterity acquired over generations. Numerous names for muslin relate to the degree of fineness of its weave, which varies with the quality of yarn used. Among them have been *abrawan* (running water), *shabnam* (evening dew), *alaballee* (very fine), *sangati* (for presentation), and *mulmul khas* (special muslin), usually reserved for the king. *Jamdani* muslin, with intricate motifs hand brocaded in the loom, was perhaps the greatest achievement of muslin weaving.[2] Geography was the foundation of Bengal's muslin. In the delta lands around what became Kolkata (Calcutta) and Dhaka (Dacca, now in Bangladesh), rich alluvial soils, particularly by the Meghna River south of Dhaka, encouraged the growth of a particular variety of tree cotton, *Gossypium arboreum* var. *neglecta*, known as *Phuti karpas*.[3] Hand spinning of the short fibers resulted in a slight unevenness in the yarn where the filaments joined, contributing to the "mossiness" or downy nap of the finished cloth.[4]

Muslin was, and still is, woven in modest rural conditions: a thatched hut or now tin-roofed shed contained looms made of bamboo or timber; a pit below enabled the weavers to work the heddles with their feet. Specialized processes were involved in growing and preparing the raw cotton and the warp, loom reeds and heddles before weaving. Humidity was necessary to prevent the fibers from breaking. Finishing tasks followed, and some muslins were then hand-embroidered or otherwise embellished. Historically, hand spinners and weavers achieved thread counts of twelve hundred or higher.[5] Even by 1851, when quality had supposedly declined, a ten yard [9.1 m] length shown at the Great Exhibition weighed just over 3 ounces [85 grams] and "may be passed through a wedding ring."[6] Usually woven in lengths twenty yards by one yard (18 x 1 m), the finest pieces could take two men six months to weave.

Despite lack of archaeological evidence, records of muslin have appeared for over twenty-four hundred years, in description, poetry, and legend, and depicted in Indian paintings and sculpture.[7] Travelers from the Greco-Roman world, medieval North Africa, and Arabia marveled at Indian muslins. The seventh-century Chinese monk Yuan Chwang (Xuanzang) described dancing girls wearing muslin "soft and transparent like the fleecy vapours of dawn."[8] Indian muslins were evidently worn across the subcontinent and known to the world beyond. "There is in Bengale such a quantity of cotton and silks, that the kingdom may be called the common storehouse for those two kinds of merchandise, not of Hindoustan or the Empire of the Great Mogul only, but of all the neighbouring kingdoms, and even of Europe," noted a seventeenth-century French physician at the Delhi court.[9]

India, producer of the most varied and sophisticated textiles in the world, developed a textile trade with Southeast Asia, Arabia, and North Africa well before the arrival of European merchants.[10] Armenians took Indian cloth overland to the Middle East and central Asia. Muslin was traded via Egypt to the Roman Empire where it was known as "woven wind," yet its source, Bengal, was largely ignored by Europeans until the early seventeenth century.[11] King James I's ambassador to the court of Emperor Jahangir attempted to interest English East India Company officials in trading with

OPPOSITE Bishandas, *Nur Jahan Holding a Portrait of Emperor Jahangir*, Northern India, Mughal court, ca. 1627. Gum tempera and gold on paper. The Cleveland Museum of Art. This portrait shows Nur Jahan holding a portrait of her husband, Jahangir, both apparently dressed in muslin.

TOP AND ABOVE Muslin, India, probably Dhaka, nineteenth century. Cotton. Victoria and Albert Museum, London.

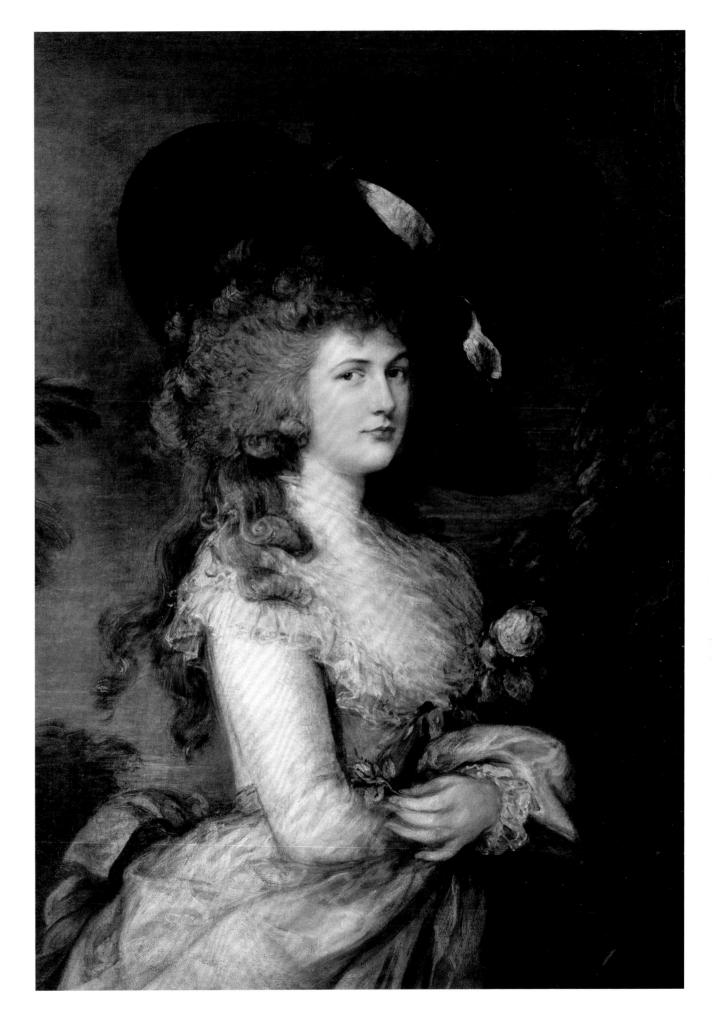

Bengal, noting that its "fine" cloth was already traded by the Portuguese. The company doubted it would sell in cooler climates. Two centuries later, the firm had conquered Bengal by force, dominated her trade, and was regularly shipping tens of thousands of lengths of muslin cloth.[12]

Muslin weaving was a cottage industry, although the finest muslins were made exclusively in *karkhanas*—workshops owned by the Mughal courts. Other weavers were taxed by local rulers, contributing to the wealth of the Mughal Empire's richest state. As Mughal power declined and the company became more aggressive, it took control of muslin production. Weavers became bound to the East India Company, and "Rural production came to be monitored by an elaborate system of supervision and control."[13] Ultimately this resulted in debt bondage for the weavers and contributed to the decline of muslin weaving.

In India, muslin was worn by both men and women, notably at the Mughal and Deccani courts, fashioned into elegant *jamas*, *angarkhas*, turbans, sashes, and *peshwaz* for men, and saris and shawls for women. It was suited to a hot climate, indicated status, and showed off the body beneath, whether male or female. Emperor Akbar favored costly muslins as much as silk in his own wardrobe.[14] In the West, muslin came to be seen as a feminine fabric, cut into flimsy, classically inspired dresses worn across the fashionable world and by influential tastemakers such as Marie Antoinette, Joséphine Bonaparte, and Georgiana Cavendish, Duchess of Devonshire, whose "chemise" gown, sent to her by the French queen, heralded a radically unstructured style of dress that was enabled by the availability of almost weightless Bengal muslin. English "nabobs" and their families returning from India would bring and occasionally wear Indian clothing at home. Among surviving examples is the Indian muslin gown (*jama*) worn by Captain John Foote of the East India Company in his portrait by Joshua Reynolds; both portrait and gown survive at the York Museums Trust.[15] However, it was the systematic marketing of Indian textiles by the European East India Companies, particularly in Britain, that launched chintz textiles from southeast India and then Bengal muslins on their domestic markets, transforming Western clothing practices. By the late seventeenth century, muslin was "the general wear in England," remaining fashionable in the West for over two hundred years despite changing dress styles.[16] Yet the success of Indian cottons brought the wrath of British cloth manufacturers and resistance to company monopolies. Industrial producers learned to imitate Indian textiles and saturated the Indian market with their copies. India became a source of ideas, raw materials, and markets, not textile perfection.

PAGE 90 Muslin, with *chikan* work embroidery, probably Dhaka, nineteenth century. Cotton. Victoria and Albert Museum, London. A more refined version of *chikan* was developed in Lucknow.

PAGE 91 Thomas Gainsborough, *Portrait of Georgiana, Duchess of Devonshire*, ca. 1785–87. Oil on canvas. Devonshire Collection, Chatsworth, UK.

OPPOSITE *Peshwaz* (woman's court dress), Mughal empire or Deccan, late eighteenth or early nineteenth century. Muslin with applied tinsel, spangles, and foil. Victoria and Albert Museum, London.

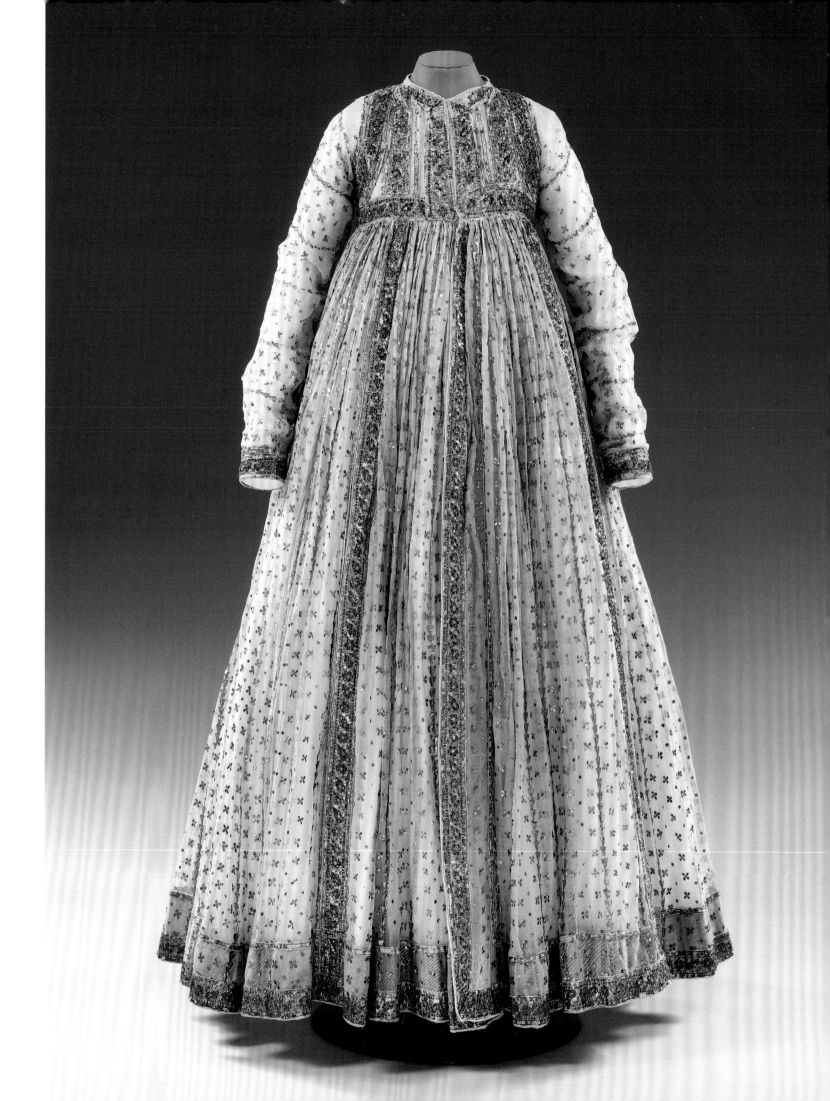

1 John Blanch, *The Naked Truth, in an Essay upon Trade* (London: n.p., 1698), 13.

2 *Mulmul khas* "is generally made in half pieces, each measuring 10 yards by 1, and there are usually 1000 to 1800 threads in the warp," according to John Taylor, *The Cotton Manufacture of Dacca* (London: n.p., 1851, 43). Taylor, a surgeon and "Resident," or EIC commercial agent, at Dhaka, wrote the most comprehensive account of muslin production for years to come, much relied on by other writers.

3 It was wrongly identified by cotton experts from the early nineteenth century onward as *Gossypium herbaceum*, which led this writer to perpetuate the mistake in *Muslin* (2012). *Gossypium arboreum* was almost extinct, but efforts are now being made to revive it.

4 "The celebrated Dacca muslin ... is very irregularly twisted, and appears in the microscope like an ill-made hair rope bristling with loose strands ... the filaments appear from 1/1000 to 1/1500 of an inch [less than 1 mm or 25 microns] in diameter, and consisting of groups of ribbons intermixed with flattened cylinders." Andrew Ure, *The Cotton Manufacture of Great Britain Investigated and Illustrated*. 2 vols (London: n.p., 1861) I, 112. Andrew Ure was a nineteenth-century Scottish physician and scientific polymath.

5 Yarn count is calculated according to how many 840 yard (770 meter) hanks make one pound (0.45 kg) in weight; thus, 240 count means 240 hanks of yarn per pound. Thread count refers to the number of threads per square inch in a finished fabric, so a finer yarn count produces a high thread count.

6 Taylor, *The Cotton Manufacture of Dacca*, viii. The Bengal muslins "excited the special wonder and admiration of Her Majesty and Prince Albert."

7 While the climate of Bengal does not lend itself to the preservation of ancient textile fragments, excavations at Mehrgarh, one of the Indus Valley Civilization sites, now in Pakistan, suggest that cotton was grown there in similar alluvial conditions in at least 5000 BCE. Furthermore, it seems likely that *Gossypium arboreum* originated in Asia.

8 Thomas Watters, *On Yuan Chwang's Travels in India 629–645 AD* (London: Royal Asiatic Society, 1904) 287.

9 François Bernier, *Travels in the Mogul Empire A.D. 1656–1668* (London: n.p., 1891) 339.

10 From ancient times, before traders worked their way up the eastern coast as far as Bengal, Barygaza (Bharuch) in Gujarat was India's main port, a trade hub for Africa, the Middle East, and Europe.

11 The Dutch, Portuguese, Danes, and French all had their own trading companies and established trading settlements in Bengal from 1615 onward.

12 Bengal's great wealth also derived from silk, saltpeter, indigo, and opium.

13 Hameeda Hossain, "Working Conditions of the Company's Weavers in the Dacca Arangs 1790–1817," in *Oxford University Papers on India* 1: 2, ed. J. J. Allen (Delhi: Oxford University Press India, 1987), 97–125.

14 Akbar, the third Mughal Emperor, ruled from 1556 to 1605. The importance of textiles in his administration was recorded in the *Ain-i-Akbari*. For recent interpretation see Sylvia Houghteling, "The Emperor's Humbler Clothes: Textures of Courtly Dress in Seventeenth-Century South Asia," *Ars Orientalis* (2017) 47: 91–116.

15 Other surviving examples include muslin dresses embroidered with silver and gold thread brought from India by the Whinyates family and now in the Wilson–Cheltenham Gallery & Museum, UK, and a wedding dress of 1801, made of a length of Indian muslin bought in Bombay by an American sea captain for his betrothed, Sally Peirce, in the Peirce-Nichols House, Peabody Essex Museum, Salem, Massachusetts.

16 Blanch, *The Naked Truth*, 13.

OPPOSITE Joshua Reynolds, *Portrait of Captain John Foote*, 1761–65. Oil on canvas. York Museums and Gallery Trust, UK.

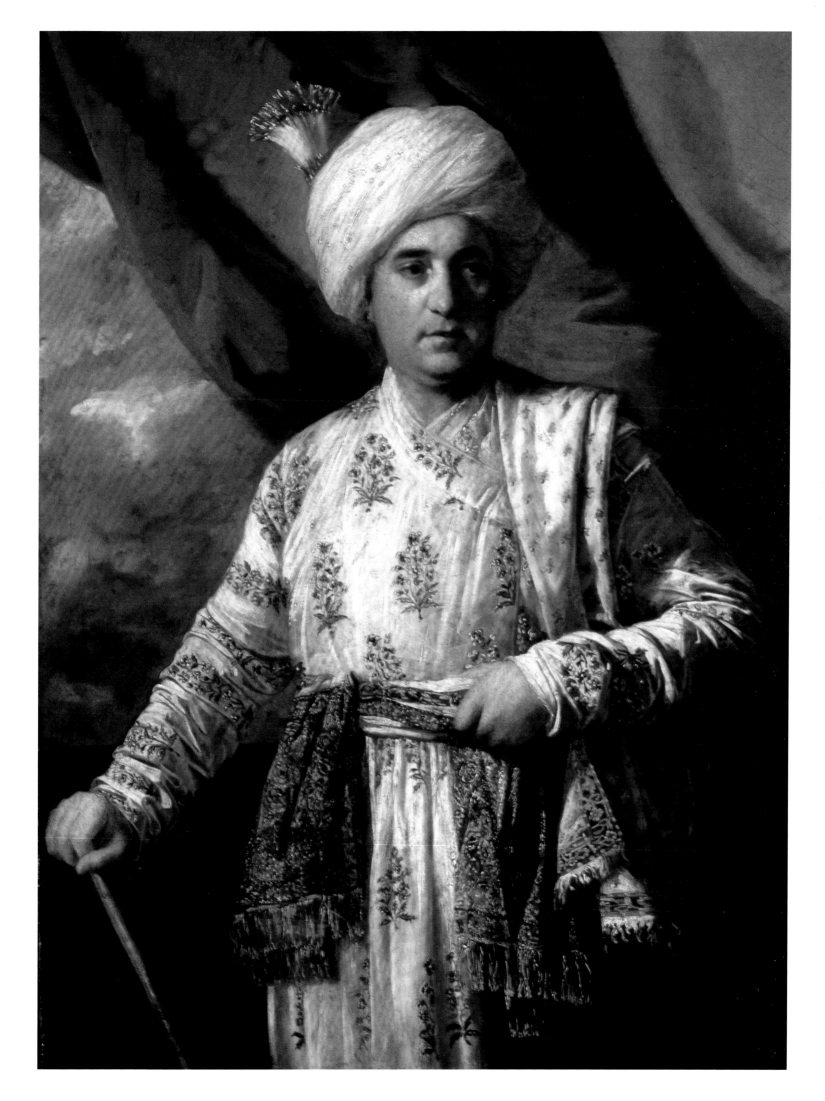

CHANGING GLOBAL FASHION FOREVER

INDIAN CHINTZ AND INDO-EUROPEAN ENTANGLEMENTS[1]

SARAH FEE

For millennia, Asia was at the heart of the world's fashion industry. China's silks and India's cottons dressed elites across Afro-Eurasia and drove trade between the regions. In ancient times, all roads by land and sea led to India, which lay midway between Rome and China. Roman ships sailed there in search of luxury goods found nowhere else: pepper, gemstones, and cotton cloth. It was, above all, India's unequaled mastery of cotton and the global desire to dress in it that forever changed fashion systems and human history—ultimately inspiring the Industrial Revolution, the factory system, and European colonization of India—with reverberations still with us today.[2]

By at least five thousand years ago in India, farmers had domesticated the only Asian cotton species, women had perfected spinning cotton so fine that no modern machine could rival it, male weavers wove it into an incredible range of textures, while dyers mastered three potent indigenous dye plants: *Indigofera tinctoria* leaves for blue, chay root for red, turmeric for yellow. With bamboo pens or carved wooden blocks, painters and printers applied complex dye agents (mordants) and wax or mud resists to create extraordinary designs and subtle shades, ranging from mesmerizing geometries to naturalistic scenes of court life, from lilac purples to deep black.

From 2000 BCE, the great Indus Valley Civilization shipped cotton cloth to Mesopotamia, and soon thereafter to all the cosmopolitan ports of the Indian Ocean. Archaeological fragments of Gujarati printed cottons from the second century testify to the cloth's unequaled deep colors and intricate patterns. Bengal and the Coromandel Coast were also by this time equally renowned for their cottons.

In the medieval era, as the Roman Empire collapsed and Europe slumped into a backwater, Indian chintz continued to flow to the great Islamic centers of Asia and Africa, and to the wealthy ports and courts of the Indonesian archipelago, which then enjoyed the world monopoly on cloves, mace, and nutmeg. It was in search of these rare and profitable spices that Europeans again set sail for the Indian Ocean, the Portuguese arriving in 1498. This time, they sailed around the tip of southern Africa, opening new maritime routes. East India trading companies from the Netherlands, Britain, Denmark, Sweden, and France soon followed.

If Europeans set out in search of Indonesia's spices, they stayed for Indian cottons. European companies found themselves beholden to Indian Ocean fashion and trade patterns. Indonesia's spice merchants and Africa's gold and ivory traders typically released their goods only in exchange for Indian cotton cloth. Europeans thus located their trading posts near India's great textile production areas—Gujarat, Bengal, and the Coromandel Coast. The Dutch made much of their fortune in selling Indian cottons to Indonesia. The British abandoned the spice trade when they found they could make better profits taking Indian cottons—above all painted chintz—back to Europe.

By 1650, Indian chintz had become a fashion sensation in Europe, known as "the calico craze." Cotton at the time was novel in Europe, which depended on linen, wool, or silk, and embroidery and weaves for patterning. The washability of Indian chintz, its bold colors, and exuberant free-flowing designs of florals, animals, and landscapes fascinated consumers. At first, Europe's elites delighted in large Indian chintz furnishing fabrics—carpets, wall covers, bed-curtains. Soon, the colorful, washable fabric was embraced as fashionable dress. Women had the precious fabrics sewn into fashionable silhouettes *à la française* or *à l'anglaise*, while elite men commonly wore it for leisure, as "banyan" morning gowns, a T-shaped garment itself inspired by Asian robes. Cheaper than silk, Indian chintz soon brought colored pattern to many social strata, creating the first mass fashion.

OPPOSITE Overdress of a woman's *robe à l'anglaise* (detail), ca. 1760. Textile made in coastal southeast India for the European market, dress likely constructed in Britain. Chintz: cotton tabby, painted mordants, and resist. Royal Ontario Museum, Toronto.

TOP Scarf fragment, India, late third century–early fifth century CE. Resist-dyed cotton. Cotsen Textile Traces Study Collection, Washington, DC.

ABOVE Hand-painting cotton cloth, India, 1822. Hand-colored engraving published by Ackermann, London.

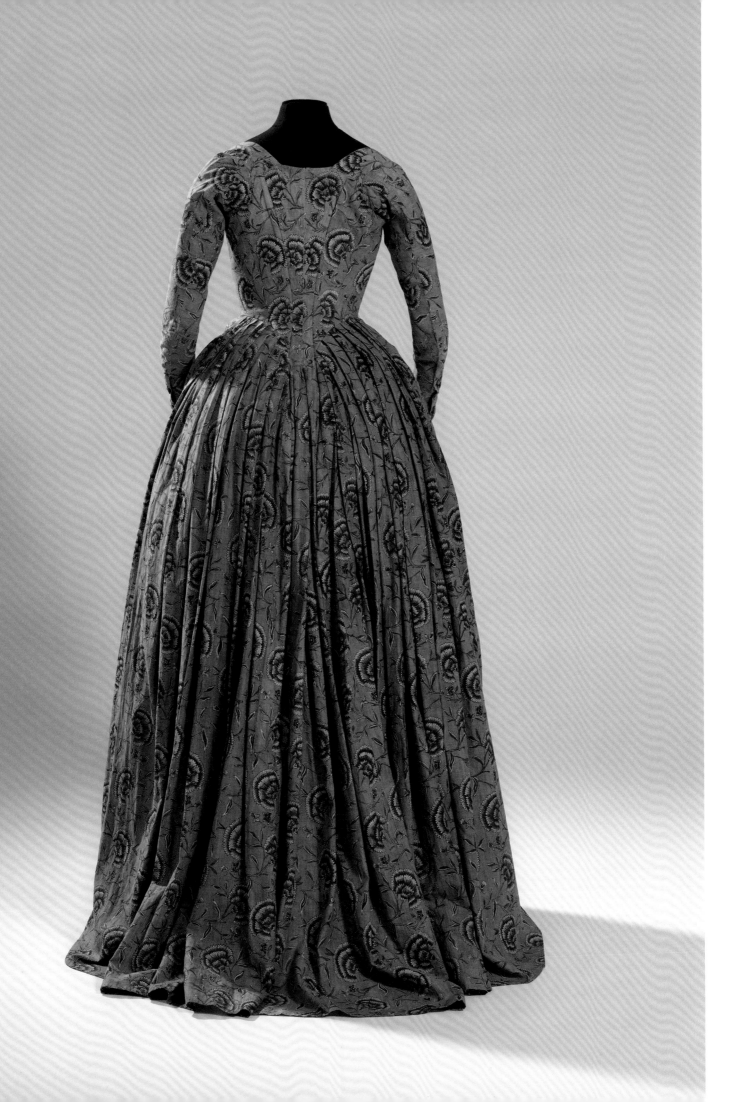

At the trade's peak in the 1680s, 57 percent of French cargo from India consisted of Indian chintz, while the British East India Company annually imported one million pieces of Indian cotton. Europe's own weavers of silk, linen, and wool were not pleased. They rose up in protest and even rioted against foreign cotton. Governments in France and England implemented a series of bans from 1686 to 1774 forbidding importing or dressing in Indian chintz. But threats of fines, imprisonment, or even death could not tame the force of fashion; smugglers continued to import it, and women brazenly wore it.

With bans in Europe, East India trading companies increased trafficking Indian cotton to Africa, the Pacific, and the Americas, where it was eagerly sought by indigenous and settler communities. Although each market developed precise design tastes, and tailored it differently, the net result was that Indian chintz had become a truly global fashion. An iniquitous four-stop trade arose: Europeans carried Indian cotton to Africa, which they traded for enslaved captives whom they took to the Americas to cultivate transplanted crops—sugar, indigo, and cotton—for consumption in Europe; the proceeds were then taken to India for the purchase of textiles and other goods. At the same time, West Asia and Southeast Asia continued to consume enormous quantities of India's painted and printed cotton.

Struggling to meet escalating global demand for Indian chintz, Europeans adopted strategies that further disrupted long-standing patterns of the global fashion industry and trade. They attempted to monopolize Indian weavers and painters or relocate them to European trading posts. These were now concentrated along the Coromandel Coast, where the best Indian chintz was made: the French at Pondicherry (now Puducherry), the Dutch at Masulipatnam, and the British in Madras (now Chennai). Ultimately the British East India Company, backed by its private army, colonized large parts of India, beginning with its major textile-producing areas. More impactful on a global scale was a parallel strategy: imitating the cloth back in Europe.

Historians today emphasize that Europe's growing control of the global trade in cotton and its mechanization of textile manufacture set in motion the so-called Industrial Revolution. In fact, it was more an "evolution," as it required centuries of learning.[3] Initially, Europeans adopted Indian craft-based materials and processes: hand-carved wooden blocks, madder and indigo dyes, river washing, bleaching with sun and dung. They gained some know-how through industrial espionage in India, and some through Armenian and Turkish chintz block printers who settled in southern France.

A great advantage for Europe's printers was immediate knowledge of local seasonal fashion trends, whereas Indian cottons took a year or more to reach Europe by sail. Ultimately, Britain emerged as Europe's dominant textile printer, the result of many entangled policies and practices. By the 1740s, Atlantic markets were increasingly accepting British block-printed cloths in place of Indian originals. Simultaneously, labor-saving printing technologies were developed: engraved copper plates for repeat patterns (by 1752) and engraved rollers (by the 1790s).

Europe had mastered printing but was yet unable to produce the plain cotton base cloth, remaining dependent on imports from India or on locally made inferior cotton-linen blends (fustian). Efforts to weave its own cotton cloth became the stimulus for Britain's burst of technological inventions from 1770 to 1830: machines to spin cotton warp yarn (1769), mechanized looms to weave cotton cloth, and then steam engines to power them (1830s), leading to the first wave of factories and mill towns.

All this activity in turn increased demand for reliable supplies of raw cotton, especially American cotton species, which were best adapted to machinery. The result was the "great cotton rush": the massive planting of cotton first in the West Indies, then

OPPOSITE Man's banyan. Textile made in coastal southeast India, constructed in the Netherlands, early 1700s. Chintz: cotton tabby, painted mordants, and resist. Royal Ontario Museum, Toronto.

in the southern United States, with the tragic state-sponsored removal of indigenous American populations. To plant, tend, and harvest the cotton, Europeans imported enslaved Africans in ever-increasing numbers.

Next, British cotton cloth printers from 1820 set their sights on the large Indian market. In a drastic reversal, factories in Manchester and Glasgow mass-produced roller-printed cottons for India. Their success lay partly in their new bright dyestuffs, the results of government-funded science-industry collaborations: pencil blue, chrome yellow, lead green, and scaled-up "Turkey red," followed in 1856 by synthetic dyes. In 1869, German chemists synthesized the red colorant alizarin, which naturally exists in India's endemic chay plant, which for millennia had greatly contributed to Indian chintz's success.

It is little wonder that India's nationalists seeking to end British rule—most famously Mahatma Gandhi—put cotton at the center of their economic and political actions, urging the boycott of imported British cloth, and the revival of India's home industries. Their wish was ultimately realized: European and North American dominance of cotton cloth production lasted a mere two centuries, ending around 2000. Today, Indian artisanal handprinted cotton is enjoying a successful renaissance, while industrial cotton manufacturers are based in Asia.

For the purposes of the condensed story above, "Europe" and "India," "British" and "Indian," appear as stark binaries. Yet the realities were more fluid. Especially before 1850, Indo-European entanglements within India occurred on personal and professional levels, and fashion influences flowed in many directions. Prior to the eighteenth century, European men often took Indian wives, their children dressing in novel hybrid ways. One little-known entanglement was the employment of Europeans by Indian rulers. Despite treaties and laws that sought to limit the practice, Portuguese, French, Swiss, Italian, and British men served princely states as soldiers, tutors, chefs, gardeners, clerks, and much else besides; European women worked as nurses and governesses or joined harems. Rulers might require foreign employees to "outwardly adopt the local culture," from eschewing beef to growing beards.[4] Famously, E. M. Forster served as private secretary in 1921 to Tukojirao III, the ruler of Dewas, posing for photographs wearing turbans or *angarkha*. More infamously, a century earlier, was George Harris Derusset, also known as the Barber of Lucknow.

Trained as a hairdresser in England, George Harris Quigley immigrated to India in the late 1820s. Despite changing his surname to Derusset to add cachet, he was unable to find work in Calcutta as "a Barber and Hair dresser ... for one rupee."[5] As numerous other "supplicants from near and far ... in hopes of profit," he was drawn upcountry to Lucknow, seat of the Awadh (Oudh) kingdom, a successor to the Mughals in wealth and pomp.[6] There, he was soon hired by King Nasir-al-din Haidar. By 1832, Derusset had become a main attendant and palace manager, as master of boats and pleasure craft, the stables, the "Kitchen and Cellar," and "the Royal Robes (European)." Already a blend of late Delhi-Mughal and Persian dress, Awadhi royal wardrobes from 1801 further included European-style crowns and the blue cape of the East India Company; Nasir's predecessor had ceded half his territory to the company and taken the title of King.[7] George Harris ordered for his king English-style silk jackets and breeches from an English tailor in Calcutta, and created a tailoring shop on-site.[8] In time, the wider male Indian population and tailors gradually adopted and adapted the European suit-coat, fusing it with local silhouettes, to ultimately create the sherwani coat, a story also now well told.

Miraculously, one of George Harris Derusset's own outfits from his time at the court of Awadh has survived, as well as one belonging to his brother William Henry, also a hairdresser, who briefly joined the court staff. The cut of their double-breasted

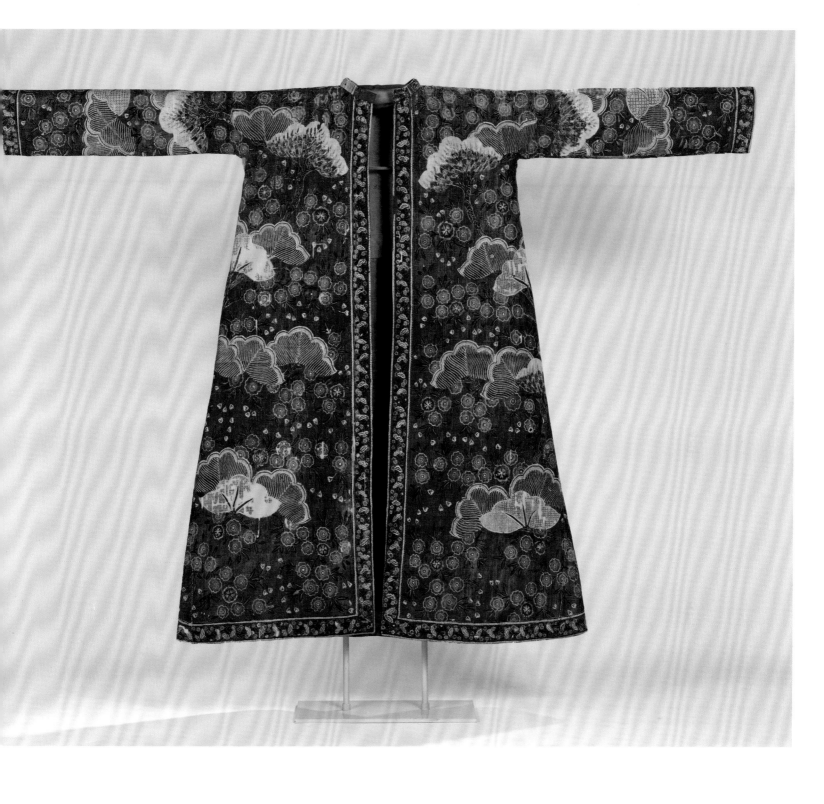

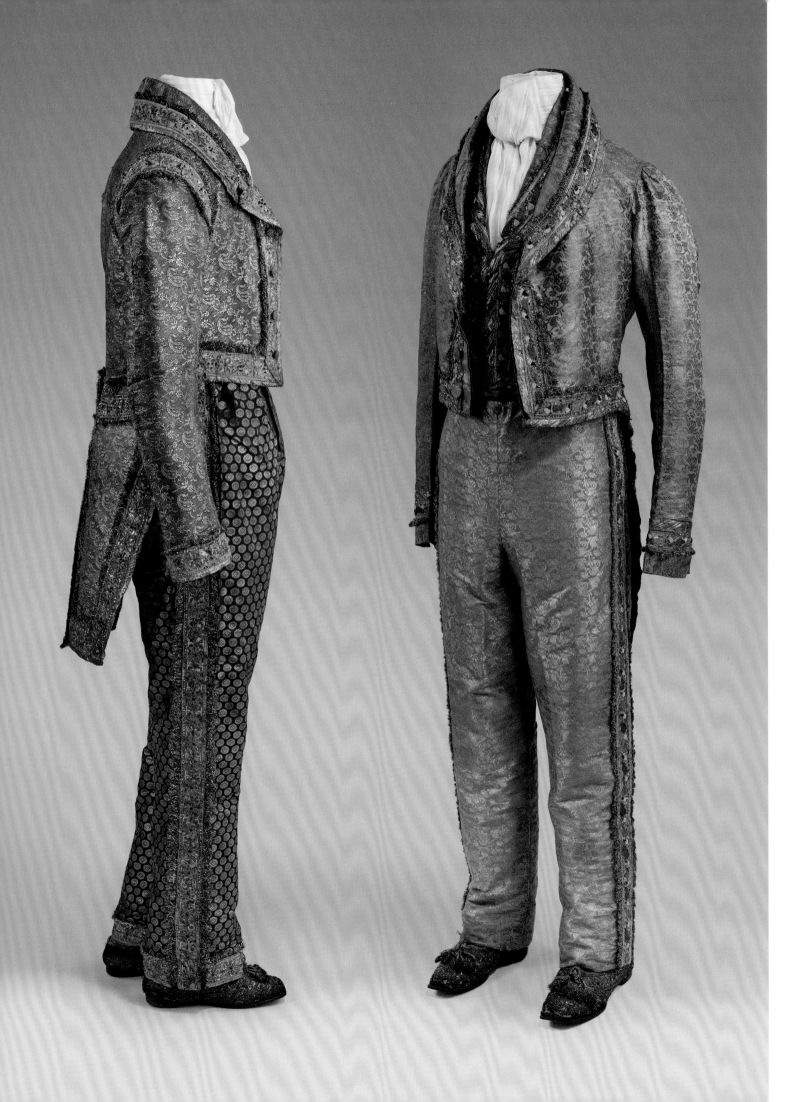

ENDNOTES

1 For their help with various aspects of this chapter, I thank Rosemary Crill, Jason Cyrus, Janet Dewan, Deepali Dewan, Kristiina Lahde, Karla Livingston, Alexandra Palmer, and Berta Pavlov.

2 For more on these topics, see Giorgio Riello, *Cotton, The Fabric that Made the Modern World* (Cambridge: Cambridge University Press, 2013); Sven Beckert, *Empire of Cotton: A Global History* (New York: Alfred A. Knopf, 2014); Helen Bieri Thomson et al. eds., *Indiennes: Un Tissu Révolutionne le Monde!* (Prangins, Switzerland: Château de Prangins / Musée nationale suisse, 2018); Sarah Fee, ed., *Cloth That Changed the World: The Art and Fashion of Indian Chintz* (New Haven, CT: Yale University Press / Royal Ontario Museum Publications, 2020); Giorgio Riello and Prasannan Parthasarathi, eds., *The Spinning World: A Global History of Cotton Textiles, 1200–1850* (Oxford: Oxford University Press, 2009).

3 Riello, *Cotton, The Fabric that Made the Modern World*.

4 Elizabeth Anderson, *Clothe: A Fateful Compromise with the Cotton Trade* (n.p., 2020).

5 Rosie Llewellyn-Jones, "The Barber of Lucknow: George Harris Derusset," *Asian Affairs* 27, no. 1 (1996), 64.

6 Stephen Markel, "The Dynastic History of Lucknow" in *India's Fabled City: The Art of Courtly Lucknow*, ed. Stephen Markel. (Los Angeles: Los Angeles County Museum of Art, 2010), 16.

7 Rosemary Crill, "Textiles and Dress in Lucknow in the Eighteenth and Nineteenth Centuries" in *India's Fabled City: The Art of Courtly Lucknow*, ed. Stephen Markel. (Los Angeles: Los Angeles County Museum of Art, 2010), 228–29.

8 Rosie Llewellyn-Jones, "Lucknow and European Society," in *India's Fabled City: The Art of Courtly Lucknow*, ed. Stephen Markel. (Los Angeles: Los Angeles County Museum of Art, 2010), 54–67.

9 Ritu Kumar, *Costumes and Textiles of Royal India* (London: Christie's Books, 1999), 140.

10 George Harris recorded that a shoemaker named Buckshee made shoes for the family. Men named Punnahally and Fyzoolah were paid, respectively, for embroidery and the making of "splendid gold tassles." Account Books, Fisher Library, University of Toronto, Folio 49.2

11 See man to the right of the door in the watercolor by unknown artist, 1820–22. Ghazi ud-Din Haidar, seventh Navab (r. 1814–27), entertains Lord and Lady Moira to a banquet in his palace. Opaque watercolor. The British Library, London.

12 Jayne Shrimpton, "Dressing for a Tropical Climate: The Role of Native Fabrics in Fashionable Dress in Early Colonial India," *Textile History* 23, no. 1 (1992), 56.

13 Prasannajit de Silva, *Colonial Self-Fashioning in British India, c. 1785–1845: Visualising Identity and Difference* (Newcastle upon Tyne, UK: Cambridge Scholars Publishing, 2018), 28.

OPPOSITE Men's court suits of brocaded silk and *zardozi* embroidery embellished with sequins, glass stones, beads, and tinsel. Shoes with *zardozi* embroidery, India, 1830s. Left: worn by William Henry Derusset; right: worn by George Harris Derusset. The shoes belonged to William and are featured with both suits for photographic styling purposes.

RIGHT Turban of brocaded silk (*left*) and skullcap with *zardozi* embroidery (*right*), India, 1830s.

tailcoats and trousers are preeminently British late Regency. But the luxurious colorful silk fabrics and the trim and accessories are anything but. The tailcoats, waistcoats, and trousers are fashioned from Indian kincob of red or citron-yellow silk, with *buta* and medallion patterns woven in gold thread. Most strikingly, all cuffs, lapels, tails, hems, side seams, and pockets are lavishly trimmed with *zardozi*—gold-thread embroidery encrusted with sequins, glass stones, and beads, further edged with tinsel, the hallmarks of Lucknow. The Lucknow palace was famous for its extensive workshops "of tailors, jewellers and embroiderers" drawn from across India.[9] William's ensemble includes shoes, square-toed in European fashion, but similarly covered in *zardozi* and tassels.[10] George's ensemble was passed down through the family with several pieces of Indian male headgear: an embroidered red skullcap and a coiled turban of white and silver. The latter is sometimes seen in paintings of the Lucknow court settings, in one instance worn by what appears to be a European servant.[11] But whether George wore the turban with his tailcoat—or wore it at all—remains unknown.

The Derusset brothers' outfits were in some ways not unusual. Until 1830, European men, from high officials to sailors, might on occasion dress in both Indian fabrics and cuts, most famously Europeans serving at Mughal and Awadhi courts. More usually, British residents of India retained British dress cuts. While employing British-made flannels for certain garments or occasions, they also adopted Indian-made fabrics—above all cottons—for their superior suitability to the climate, and wider availability. Some relied on Indian tailors.[12] In a portrait painted back in Britain, after George left Oudh with a small fortune in 1836, but before he died bankrupt in 1861, he wears an Indian silk brocade waistcoat.

In their particular fusion and flamboyancy, the Derussets' court costumes remind us of the heterogeneity of fashion paths, and of an earlier alternative or more fluid scenario of Anglo-Indian relations, particularly for non-elites.[13] From the late 1850s especially, following the annexation of Awadh and the onset of British crown rule, colonial and racial boundaries hardened as did classifications and narratives of what constituted "British" or "Indian" dress. Even so, the two-way fashion fusions of the long, entangled eighteenth and nineteenth centuries that forever changed the world live on, their traces still visible in the sherwani and in the printed cotton florals still cyclically fashionable today.

ALEXANDRA PALMER

THE INFLUENCE OF INDIA

ON EIGHTEENTH-CENTURY EUROPEAN FASHION

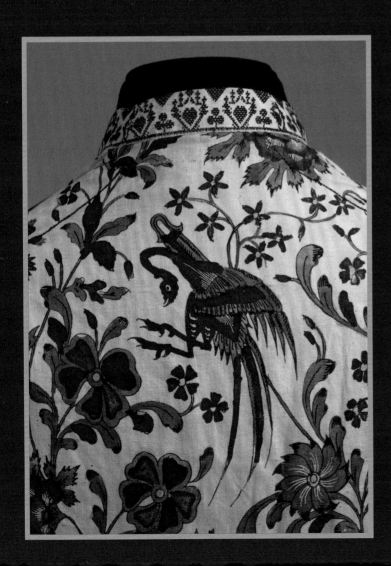

Visually, economically, and physically, India had an enormous impact on eighteenth-century fashion in Europe. Textiles composed 40 percent of the Indian cargo exported to Europe, including raw silk as well as cotton and silk textiles in various weaves and embroideries.[1] Most recognizable were the colorful painted and printed textile lengths for fashionable chintz described by John Fryer in 1698 as "an accomplishment in the Art of Staining Calicuts."[2] India's flexible processes responded to partnerships with European trader-designers; Indian merchants; factory owners; and skilled *karigars*, or artisans—who together produced goods commissioned for specific cultural tastes. Colors were adjusted to suit Dutch preference for chay reds in Amsterdam and Hindeloopen fashions. Solid greens astonished, because Europeans could not print a clear green. Patterns were transferred, modified, and newly created with white porcelain grounds or blues favored by English and French clients, and made even more luxurious when glazed, silvered, and gilded so the textiles glistened in candlelight.

In Europe, weaving to shape luxurious men's coats and waistcoats, as well as women's petticoats and gowns, required a complex, time-consuming, and costly loom setup. Indian-made versions emulated this in chintz and embroidery techniques that easily accommodated design placement and reduced waste, making Indian production efficient and cost effective. Distinguishing elements were integrated borders, pockets, cuffs, and buttons that framed the wearer, making these garments so desirable. Once in Europe, the semi-made Indian garment could be interlined with wool for warmth and lined with Indian or East Asian silk, enabling the cotton fashion to slip over the body. A man's cotton waistcoat with printed narrow stripes could be enhanced with a silver chain-stitch meander at the borders and pocket flaps, coordinated buttons, and strewn with motifs of sprigs, butterflies, and insects. Such details clearly signified the ultimate in imported Indian luxury fashion.

At the end of the century, sheer, white cotton gauze textiles, the finest from Bengal, replaced rococo colors.[3] The new style suited the postrevolutionary political climate with delicate, symmetrical designs that were light on the eye and body. Indian muslin had long been used for accessories—fichus, aprons, and cravats—and competed with European linen lace. In 1678, Tavernier had tantalizingly reported muslins so fine "that when on the person you see all the skin as though it were uncovered."[4] Muslins were various, with plain or varied self-woven stripes. Some were delicately and colorfully embroidered in vertical meanders or elegant sprigs and could be embellished with metal thread that added weight and drape. Modern European families dressed toddlers in washable and easy-to-wear Indian muslin gowns in response to the writings of John Locke (1632–1704) and Jean-Jacques Rousseau (1712–1778), which focused on child-rearing that encouraged freedom of movement. India also sent out prized, lightweight silver- and gilt-embroidered muslins for evening dress and finely worked single, continuous chain-stitch embroidery with colored threads. This technique, called *ari* work, was accomplished with a fine hook, working the design with texture and shaded cotton threads in a beautiful painterly technique.

By the end of the century, *chikan* muslins, embroidered white on white, were de rigueur and worn with the finely woven wool shawls, made so fashionable by Empress Joséphine. Muslins were also embroidered to shape for European dress. The popularity of one design, demonstrating the skill and the ease of India's continuing flexible production, is seen in three versions embroidered with a central panel of paired circles and leaves. Each has a long train, two with a deep border worked with grape leaves on a vine around the hem, one with a Greek stepped pattern, and a third variation has been worked with a different border at the hem. India's masterful craftspeople, traders, brokers, and intermediaries accommodated shifting tastes and were essential to the fabrication of elite European fashion.

OPPOSITE Woman's jacket (*wentke*) (detail). Textile made in coastal southeast India, constructed and trimmed in the Netherlands; used in Hindeloopen, Friesland, 1700–99. Chintz: cotton tabby, painted mordants, resist, and dyes, glazed, silk lining, silk trim. Royal Ontario Museum, Toronto.

ENDNOTES

[1] Om Parkash, "From Market-Determined to Coercion-Based Textile Manufacturing in Eighteenth-Century Bengal," in *How India Clothed the World: The World of South Asian Textiles, 1500–1850*, eds. Giorgio Riello and Tirthankar Roy (Leiden, The Netherlands: Brill, 2009), 219.

[2] John Fryer, *A New Account of East-India and Persia, in Eight Letters Being Nine Years Travels, Begun 1672 and Finished 1681* (London: n.p., 1698), 31.

[3] Tirthankar Roy, *India in the World Economy: From Antiquity to the Present* (Cambridge: Cambridge University Press, 2012), 48, 147.

[4] Valentine Ball, *Travels in India, Volume 1 by Jean-Baptiste Tavernier* (London: Macmillan and Company, 1889), 56.

BELOW François Pascal Simon Gérard, *Madame Bonaparte in her salon*, ca. 1811. Oil on canvas. Musée National du Château de Malmaison, Rueil-Malmaison, France.

OPPOSITE Overdress of a *robe à la française*. Textile made in coastal southeast India for the European market, dress likely constructed in France, ca. 1770. Chintz: cotton tabby, painted mordants, resist, and dyes, glazed, silk lining, silk trim. Royal Ontario Museum, Toronto.

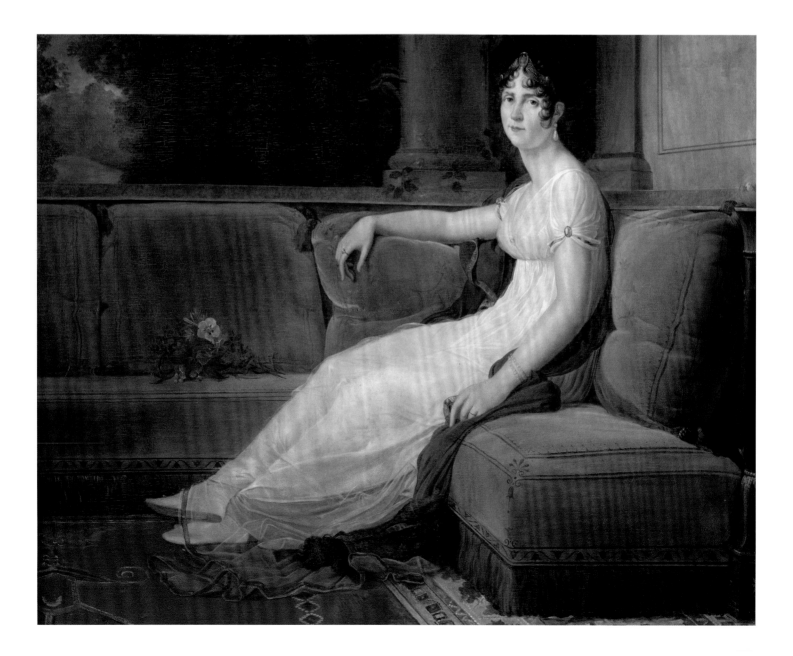

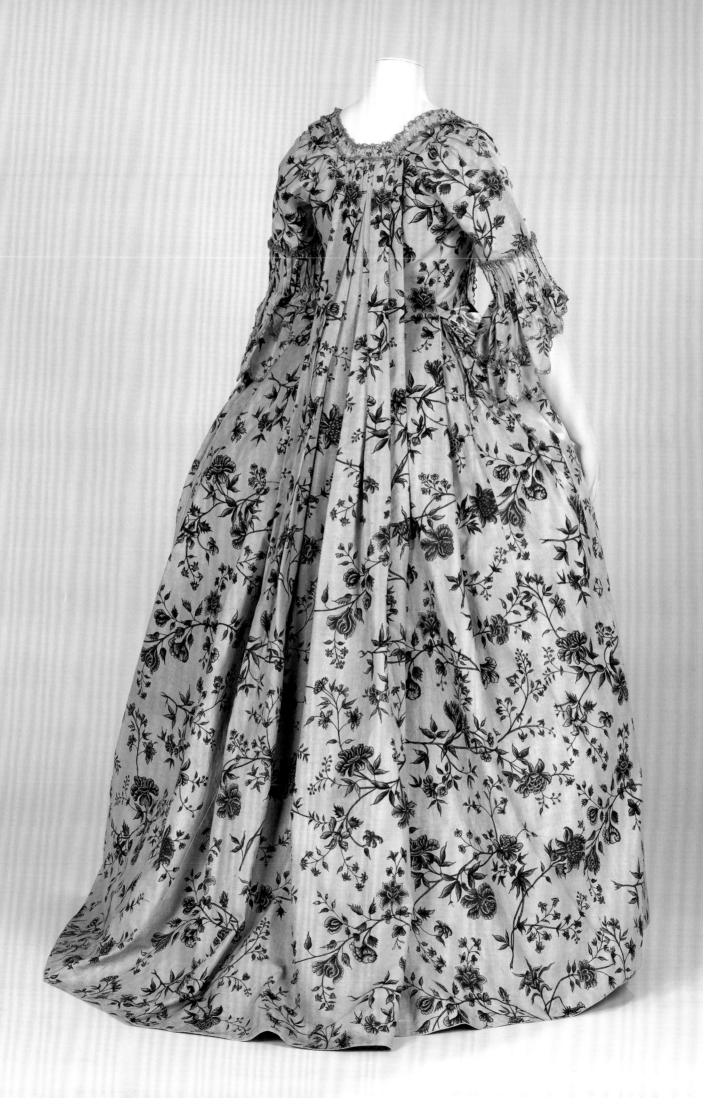

INDIA
AT THE
GREAT
EXHIBITION
OF 1851

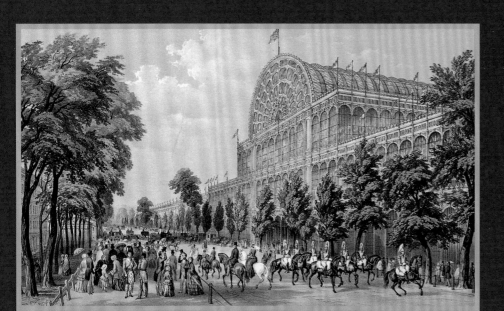

OPPOSITE Phillip Brannan, *View of the South Side from Near the Princes Gate, Looking West*, 1851. Color lithograph. Victoria and Albert Museum, London.

ABOVE Sari, Varanasi, ca. 1850. Silk woven with silver-gilt-wrapped thread. Victoria and Albert Museum, London. One of the Indian textiles from the Great Exhibition illustrated in Owen Jones's book *The Grammar of Ornament* (1856).

In May 1851, in London's Hyde Park, Queen Victoria opened the Great Exhibition of the Works of Industry of All Nations. The show, the largest and most impressive of its time, was housed in a vast glasshouse three times the size of St. Paul's Cathedral.[1] This was not the first industrial exhibition, but was effectively the first world's fair, a precedent for a series of increasingly large international shows. The exhibition hall, named the Crystal Palace, was a pioneering modular construction built in nine months from cast iron and sheet glass, and by the time the show closed in October of that year, six million people had visited the exhibition, generally emerging overwhelmed by the 100,000 objects on display.[2] Nevertheless, the young artist and designer William Morris refused to enter this temple of industrial vulgarity. Morris had a point: a fundamental tension between commerce and culture underlay the exhibition. Britain was then the world's leading industrialized nation, yet economic depression had prompted a critical assessment of its financial progress. The exhibition organizers had many agendas but recognized the need to improve both technical and artistic education as well as the taste of producers and consumers. India became a key element in this program.

India was in the last throes of British East India Company rule.[3] Displaying India in 1851 expressed conflicting British attitudes to the culture of the subcontinent, making it clear that as "owner" of "an estate which we have to improve," Britain was increasingly greedy for her material resources.[4] The company sourced products exemplifying resources of the four presidencies under its rule—Bengal, Bombay, Madras, and Agra.[5] The coordinator of the Indian section, John Forbes Royle, admired India as one of the oldest civilized nations with supremely skilled craft workers, yet characterized them as backward and ignorant, who "practice arts of which they know not the principles."[6]

Regarded as "the Koh-i-noor of the British Crown,"[7] India was placed at the center of the exhibition, a position that emphasized her perceived value to Britain, allocated 2,800 square meters of space, more than any other foreign country, and flanked by the Refreshment Court, Steam Engines, and Fine Art. Of the thirty classes of exhibits representing India, seven were textile related. These probably had the greatest long-term impact, beyond the immediately sensational sights of a caparisoned stuffed (African) elephant, an ivory throne from Travancore, two very big diamonds, a silver bedstead from Kashmir hung with fine shawls, and another plated with gold and silver, decorated with emeralds, and hung with gold embroidered muslin. Few of the objects were in glass cases. Fabrics were draped on walls and hung from balconies; a tent was constructed with sumptuous hangings and carpets. Examples of dyeing, printing, weaving, and embroidery; ikat, *mashru*, chintz, "tinsel printing," muslins, and other woven cottons, kincobs (or *kinkhwab*), *chikan*s and *jamdanis*, cashmere and other shawls, turbans, dhotis, *lunghis*, and a variety of costumes were among many textile objects seen for the first time by the British public. Commentators found it hard to match the dazzling craftsmanship with the condition of the makers. "Look into the glittering pavilion; you will fancy yourself in fairyland," yet, looking at the clay models of Indian craftsmen, "you will dream of a horde of squalid, starved barbarians."[8]

The architect and design reformer Owen Jones considered that the Great Exhibition as a whole displayed "a fruitless struggle to produce in art novelty without beauty—beauty without intelligence; all work without faith," while the Indian work showed "all the principles, all the unity, all the truth, for which we had looked elsewhere in vain."[9] He devoted most of his influential work, *The Grammar of Ornament*, to non-Western design. It was partly intended as an inspirational guide for manufacturers and included images of Indian textiles shown at the exhibition subsequently acquired for the Museum of Manufactures that was to form a core of the future Victoria and Albert Museum. Nearly a quarter of the government's acquisition budget for the new museum was spent

on Indian objects from the exhibition. A small committee including Jones selected these objects with the intention of improving public taste by example. Harmony of design and brilliant use of color were often noted by design reformers. "Europe has nothing to teach, but a great deal to learn" from Indian dyeing and printing techniques, noted Royle in the official catalogue.[10] The brocaded silks of Varanasi and Ahmedabad were particularly admired. Indian textiles accounted for 65 of the 139 items purchased from the display. Many were toured to schools of art and manufacturing centers; the rest were either returned to their owners, acquired by the Queen, or auctioned for modest prices.

From the early seventeenth century, textiles became an important element in the material relations of the empire. After 1851, Indian textiles were given increasing prominence in international exhibitions, and elaborate "Indian" palaces were constructed in which to display the fruits of the empire.[11] Yet the sense of imperial ownership of Indian products went hand in hand with a nostalgic and protective attitude to Indian-handcraft production. Valued by design reformers, Indian textile motifs were appropriated by British manufacturers and absorbed into the vocabulary of Western textiles. British manufacturers were penetrating the Indian market, often with copies of Indian textiles. Removed from their indigenous contexts, Indian textiles were also appropriated as set dressing for the theater of empire, and worked into the costume of state occasions, everyday clothing, and even fancy dress.

On June 13, 1851, a costume ball held at Buckingham Palace evoked the reign of King Charles II. Queen Victoria's elaborate "Stuart" dress, designed by French artist Eugène Lami, incorporated kincob (or *kinkhwab*) from Varanasi, silk brocaded with gold- and silver-wrapped thread. "Mine was of grey moiré antique, ornamented with gold lace," the Queen recorded. "The petticoat, showing under the dress, which was all open in front, was of rich gold & silver brocade, (Indian Manufacture) richly trimmed with silver lace. Wore diamonds & pearls, & 4 very large Indian emerald drops … "[12] Similar brocades were shown at the Great Exhibition, although the source of this particular piece is not known. An almost identical sample was bought for the Victoria and Albert collections in 1883, and Indian fabrics continued to be incorporated into both ceremonial and fancy dress by the British royal family.

ENDNOTES

[1] The Crystal Palace measured some 564 by 138 meters with 92,000 square meters of exhibition space.

[2] For an analysis of responses to the exhibition see Geoffrey Cantor, "Emotional Reactions to the Great Exhibition of 1851," *Journal of Victorian Culture* 20 (2015): 2, 230–45.

[3] The East India Company had moved from being a trading company to asserting military and political control over most of the subcontinent. India came under formal British government rule in 1858 and acquired an English empress, Queen Victoria, in 1877.

[4] J. Forbes Royle, "The Arts and Manufactures of India," *Lectures on the Results of the Great Exhibition of 1851* (London: David Bogue, 1852), 441–538. John Forbes Royle (1798–1858) was an economic botanist and East India Company employee.

[5] The presidencies were administrative areas extending far beyond the cities they were named after, encompassing hundreds of thousands of square miles. Agra became part of North-Western Provinces.

[6] J. Forbes Royle, *Papers Referring to the Proposed Contributions from India for the Industrial Exhibition of 1851* (London: n.p., 1849), 2.

[7] Robert Hunt, *Handbook to the Official Catalogues of the Great Exhibition* (London: W. Clowes and Sons, 1851), 760. The Koh-i-Noor, or "Mountain of Light," was the world's largest known diamond, appropriated from the boy king of Punjab, Duleep Singh; it was one of the most popular attractions of the India exhibition. The Daria-i-Noor, a large and very rare pale pink diamond, was also displayed.

[8] "Indian and Indian Contributions to the Industrial Bazaar," *The Illustrated Exhibitor: Guide to the Great Exhibition* (London: John Cassell, 1852), 319.

[9] Owen Jones, *The Grammar of Ornament* (London: Day & Son, 1856), 159.

[10] *Official Descriptive and Illustrated Catalogue of the Great Exhibition of the Works of Industry of All Nations* (London: William Clowes and Sons, 1851), 917.

[11] There is extensive literature on the Great Exhibition. For studies of the cultural transmission of imperialism in Britain see, for example, John M. Mackenzie, *Propaganda and Empire* (Manchester, UK: Manchester University Press, 1984); Saloni Mathur, *India by Design: Colonial History and Cultural Display* (Berkeley: University of California Press, 2007).

[12] Queen Victoria, Journal Entry: Friday, June 13, 1851. www.queenvictoriasjournals.org.

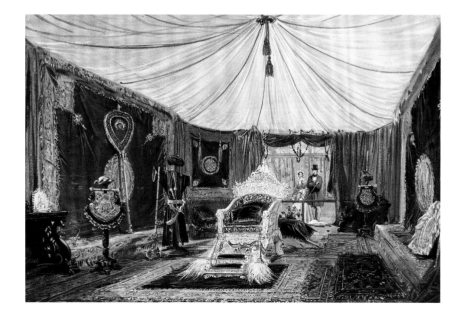

LEFT Joseph Nash, *The Great Exhibition: India No. 1*, 1851. Watercolor and bodycolor over pencil. Royal Collection Trust. The painting depicts the Ivory Chair of State and footstool presented to the Queen by the Raja of Travancore. Behind it is the crown of the King of Oudh. The costume of the Raja of Bundi is displayed on the left.

OPPOSITE Joseph Nash, *The Great Exhibition: India No. 4*, ca. 1851. Pencil, watercolor, and bodycolor. Royal Collection Trust.

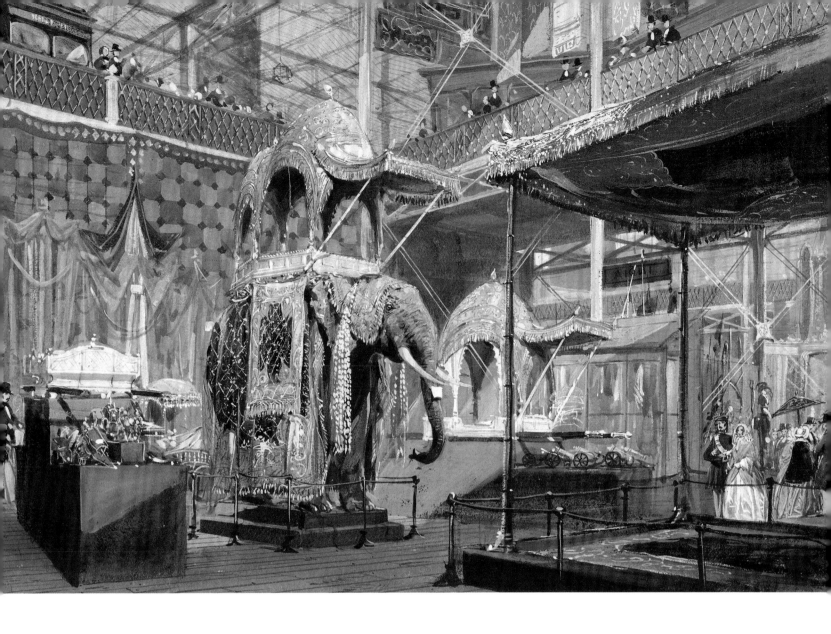

PAGE 112 *Mashru* (warp-faced silk and cotton), Aurangabad Maharastra, ca. 1851. Silk and cotton. Victoria and Albert Museum, London. This cloth could be worn by Muslims as it had a hidden cotton weft that would be worn next to the skin; pure silk was not permitted. This textile was illustrated in Henry Hardy Cole's 1874 *Catalogue of the Objects of Indian Art Exhibited in the South Kensington Museum* as an example of good design. It was also featured in *The Grammar of Ornament*. The regular repeat and discreet colors were greatly admired.

PAGE 113 Skirt length, Kutch, ca. 1850. Satin-woven silk with silk embroidery. Victoria and Albert Museum, London. One of the Indian textiles from the Great Exhibition illustrated in *The Grammar of Ornament*. In the 1880s, F. Steiner & Co. of Manchester produced roller-printed versions of similar textiles for export to India.

BELOW LEFT Eugène-Louis Lami, Queen Victoria's costume for the Stuart Ball, 1851. Silk, lace, gold braid, silver fringing, seed pearls. Royal Collection Trust. The most glamorous of all Queen Victoria's surviving clothes, this costume was inspired by the court of Charles II. The rich brocade of the underskirt was woven in Benaras. The lace of the berthe is a copy of seventeenth-century Venetian raised-point needle lace, probably made in Ireland and perhaps acquired at the Great Exhibition.

BELOW RIGHT Eugène-Louis Lami, textile detail of Queen Victoria's costume for the Stuart Ball, 1851. Varanasi woven silk brocaded with gold and silver-wrapped silk thread, lace, gold braid, silver fringing, seed pearls. Royal Collection Trust.

OPPOSITE Eugène-Louis Lami, sketch for Queen Victoria's costume for the Stuart Ball, 1851. Watercolor. Royal Collection Trust.

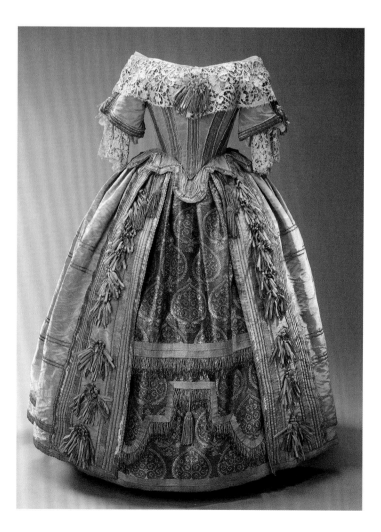

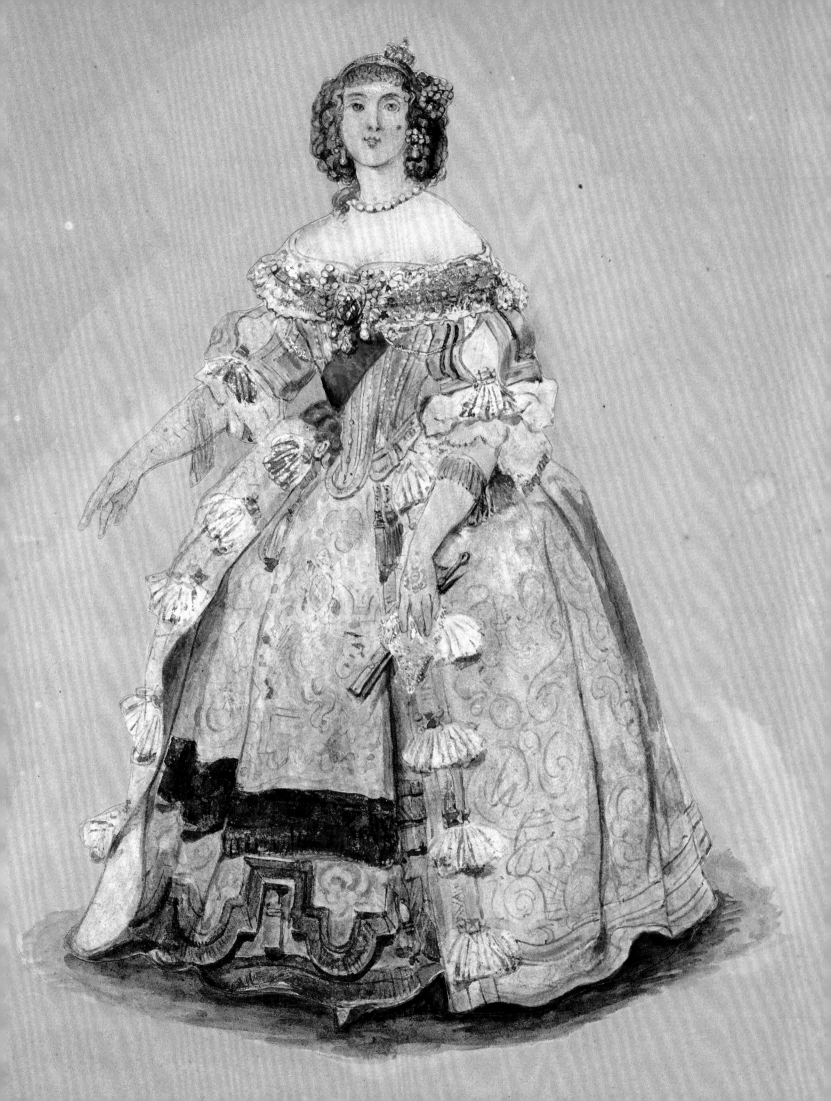

JEWELS, SARIS, AND SHOES

INDIAN ROYALTY AND WESTERN LUXURY HOUSES UNDER THE BRITISH RAJ

AMIN JAFFER

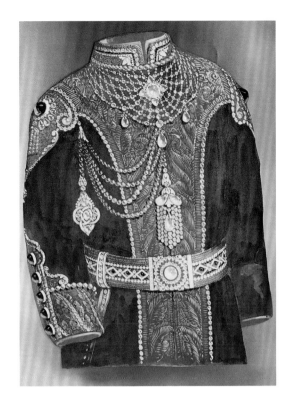

During the British Raj, elite society in India was inspired by fashion trends from the West, which affected both modes of dress and adornment. The adoption of European-style jewelry, textiles, clothing, and accessories among Indians was no doubt in part motivated by an appreciation of the novelty that has long defined fashion across cultures. But within the colonial context, the appropriation of Western styles in clothing situated the Indian wearer in relation to the British overlord, endorsing the imperial order and signaling a sense of the superiority of tastes disseminated from Europe.

The shift in personal adornment was perhaps first seen in the realm of jewelry. Under colonial rule Indian royals showed themselves to be remarkably receptive to the work of European jewelers, eagerly commissioning them to reset precious stones in the latest Western styles. This represented a departure both in material and technique. The Western preference for platinum and open claw settings replaced traditional gold jewelry with *kundan* work, in which stones were firmly set into a closed setting. The importance placed on jewelry by Indian royals and their appreciation of Western designs meant that they were ideal clients for European jewelers interested in expanding into overseas markets. By the second half of the nineteenth century a steady supply of Western-made jewelry was already being sent to the subcontinent specifically for an elite Indian clientele. Of both Western and Indian form, these pieces were designed specifically to appeal to Indian tastes. In Calcutta, the two leading retailers of this class of material were Hamilton & Co. and Garrard's.[1]

While vicereine from 1884 to 1888, Hariot, Marchioness of Dufferin and Ava (1843–1936), visited what was probably one of these firms and recorded her observations: "The jewels set in Europe for the Eastern market are a curious mixture of splendour and childishness: watches encrusted with diamonds, and such complicated interiors that, besides telling you all you can possibly want to know about the time of the day or of the year, they play you a tune, and give you a representation of a conductor waving his baton as he sits somewhere on the face, mixed up with the seconds and the hours. Then there are ornaments for turbans, on which the diamond flowers, being wound up, whirl round and round till you can no longer see their shape."[2]

Jewelry from Western outlets in India was supplemented by pieces acquired by the royals on their forays to Europe. Rajaram of Kolhapur (r. 1866–70) was among the first princes to buy jewelry in Europe, recording in his diary a shopping trip to Bond Street in 1870 where he "went to Hunt and Roskell's, where I bought some watches, earrings, &c."[3] The royals also commissioned pieces. The Paris firm of Cartier took the lead in soliciting orders, in 1909 sending Jules Glaenzer and M. Prieur on a seven-month-long speculative trip to the East to source pearls and precious stones and to establish links with potential clients. The pair enjoyed only limited success, but two years later the firm dispatched Jacques Cartier (1884–1942), head of the London branch, to further investigate the possibility of establishing relationships with Indian gem dealers and potential clients. Cartier's meetings with maharajas reveal not only that the royals appreciated the aesthetic of contemporary European jewelry but also that they were eager to reset their own stones in the latest Western tastes.[4] For example, Sayajirao III, Gaekwad of Baroda (r. 1875–1939), entrusted Cartier with the task of reworking all of his jewelry into platinum, but local jewelers from Baroda who resented the young Frenchman's influence ultimately prevented him from proceeding with the job.[5] Cartier was not the only firm to enjoy Gaekwad's patronage. In 1911, for the engagement of his daughter Indira Devi (1892–1968) to Madho Rao Scindia, Maharaja of Gwalior (r. 1886–1925), he purchased jewelry from the Parisian firm Chaumet, and records indicate that in the same period he was also buying stock items from Boucheron.[6] When she traveled to

OPPOSITE Bernard Boutet de Monvel, *Portrait of Maharani Sanyogita Devi of Indore in Indian Dress*, 1934. Oil on canvas. The Al Thani Collection.

ABOVE Joseph Chaumet, design for a ceremonial coat embellished with precious stones, ca. 1910. Watercolor and gouache on paper.

the West, Gaekwad's wife, Chimnabai (1872–1958), took her jeweler with her to advise on her purchases from European firms.[7]

Cartier's archives reveal that, as was the case with other luxury goods, selling to Indian princes was a long and complex affair. Transactions were sometimes conducted in London and Paris, but most often it was the company's agents in India who executed orders, undertaking to visit rulers, to supply them with designs and models from Europe for their approval, to take charge of their precious stones, and to collect payments. Commissioning jewelry at such a distance was not always easy, as is indicated by Sayajirao's order from Cartier of three pairs of diamond bracelets. In spite of considerable correspondence and the use of models (the first set of which arrived damaged), the bracelets were the wrong size and had to be made again.[8] As was the case with the furnishers Maple & Co., Cartier's local agents approached royal families that would be celebrating marriages and jubilees, hoping to secure business from them at a time when princes planned to impress their relations and guests with their lavish spending.[9] Although the patronage of Indian princes was great in volume, profit usually came not from selling stones, but in the labor involved in resetting existing jewels.[10] Cartier's forays into the Indian market were not only to find clients, but also to source precious stones and to purchase from dealers such as Imre Schwaiger and Indian Arts Palace in Delhi, old and new Indian jewelry, which they resold in Europe.[11] Exposure to Indian jewelry ultimately inspired the firm's own Eastern-style creations; just as maharajas admired Western settings in platinum, Western clients also developed a penchant for the decorative effects of Indian jewelry, particularly the flamboyant mixture of colored stones, marketed at Cartier under the label "tutti frutti," and the effect of multistrand ropes and tassels of pearls and jewels.

Although numerous commissions were executed by European jewelers for Indian princes, it is invariably the most spectacular that are remembered. Among these is a celebrated emerald turban ornament made by Cartier's Paris workshop in 1926 for Jagatjit Singh, Maharaja of Kapurthala (r. 1877–1949). The ruler was highly Westernized, spent as much time as possible in France, and married European women as his fifth and sixth wives. As is evident from his diary, he was a keen shopper and from his first trip abroad admired the work of European jewelers. For example, he spent the morning of June 12, 1893, "in visiting jewelers and the shops in the Rue de la Paix, a very attractive street."[12] The Cartier turban ornament, commissioned in time for the ruler's Golden Jubilee, was not his first order from a Parisian jeweler; in 1905 he had asked Boucheron to create a turban ornament with diamonds that he supplied from his treasury.[13] But such commissions pale in significance compared with the jewels reset by Parisian jewelers Boucheron and Cartier for Bhupinder Singh, Maharaja of Patiala (r. 1900–38). Baron Fouquier recorded how in 1928 the ruler caused a sensation in Paris with his retinue of forty servants and twenty dancing girls.[14] Among his luggage were six iron chests of precious stones, which were sent to Louis Boucheron (1874–1959), whom the maharaja had met in 1926 while the jeweler was in India scouting for business. As well as numerous sapphires, rubies, and pearls, the collection included over seven thousand diamonds and more than fourteen hundred emeralds. These were worked into 149 pieces of jewelry. Among them were traditional designs such as *bajubands* (armlets) and *sarpeches* (turban ornaments) as well as more universal forms such as necklaces and earrings, all designed with clear Indian references, but executed in an art deco style. According to Fouquier, Patiala was so delighted by Boucheron's jewelry that to mark the occasion he gave a party to which he invited the community of Indian royals passing through Paris at the time.

BELOW Maharaja Jagatjit Singh of Kapurthala and his traveling party in Europe, ca. 1893.

PAGE 120 *Maharaja Yadavendra Singh of Patiala Wearing the Patiala Necklace*, ca. 1938. Gelatin silver print. John Fasal Collection.

PAGE 121 *Maharaja Bhupinder Singh of Patiala*, 1911. Modern print from an original glass negative. Photographed by Vandyk.

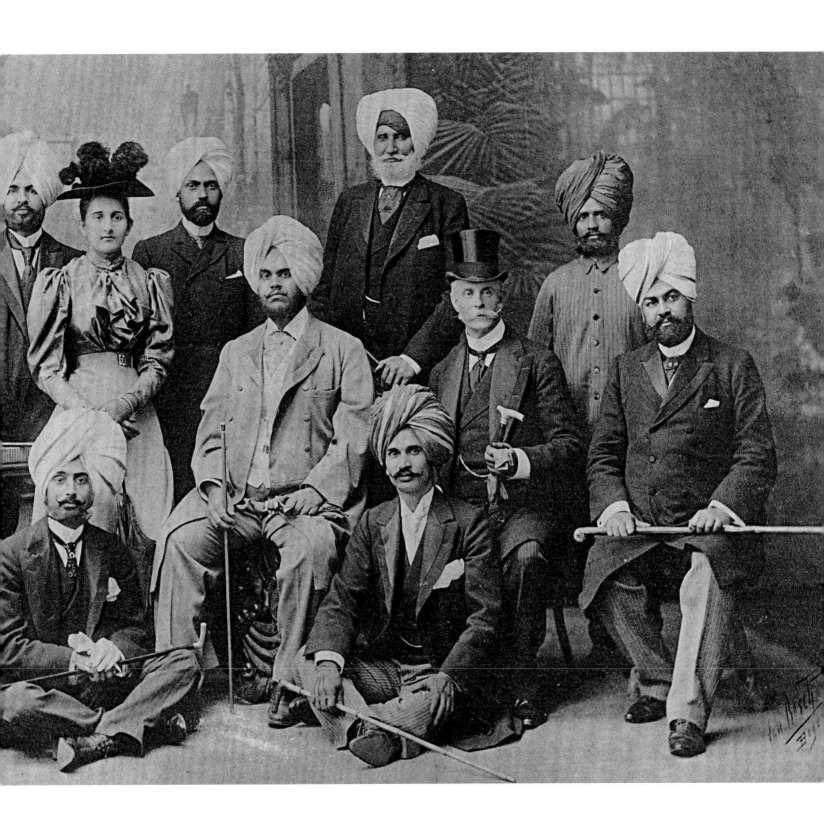

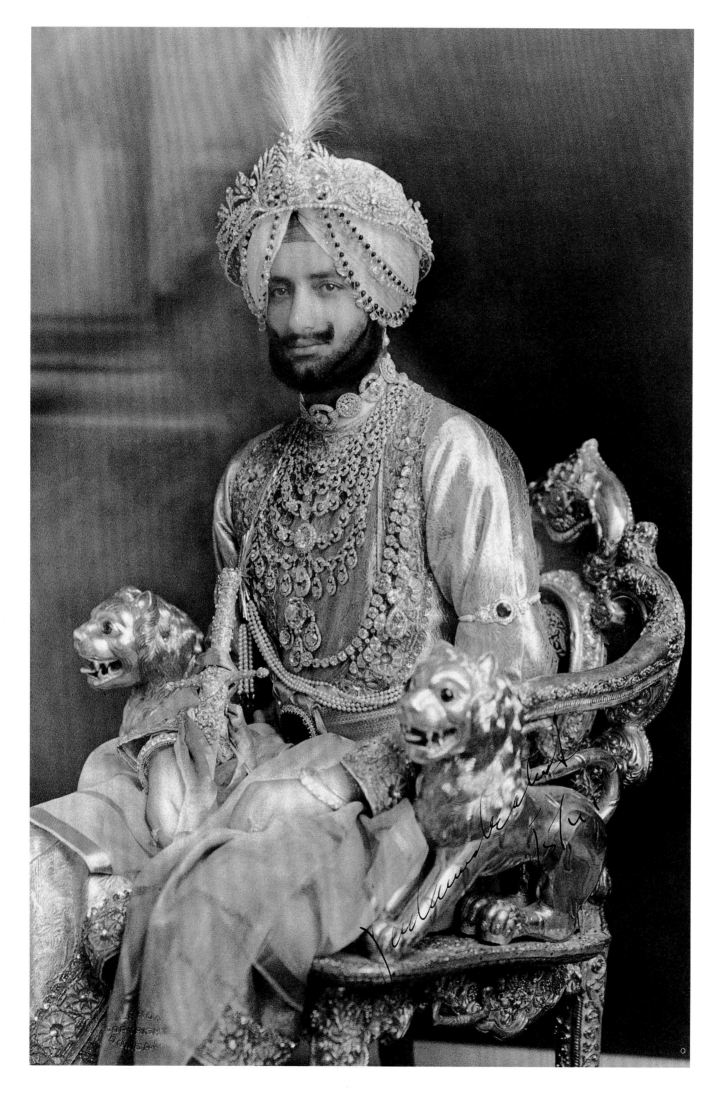

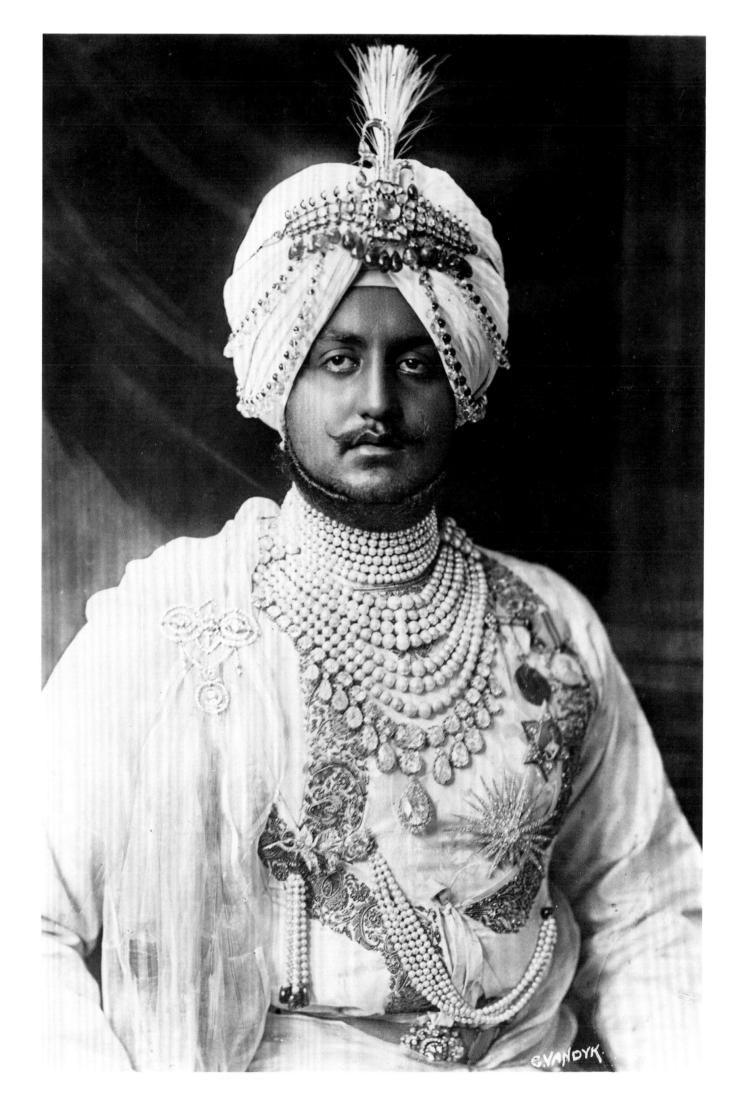

Louis Boucheron must have been surprised to learn soon after he had received the Maharaja of Patiala's order that Cartier was staging an exhibition at Rue de la Paix of "Crown Jewels" that they had reset for the same prince! This substantial order had been placed in 1925 and included a variety of forms, both Indian and Western. Among the pieces were two enormous diamond necklaces. The first consisted of three strands of large uncut diamonds embellished with diamond pendants. The second consisted of five strands of substantial diamonds, with the light yellow 234.69 carat De Beers diamond as its central pendant. The exhibition was an instant success. In the words of a contemporary writer: "At Cartier's dreams take shape, we are in the world of *One Thousand and One Nights*, and the beauty, and the extent of his collection surpasses the imagination."[15] In quantitative terms, the Patiala order is the largest single commission that Cartier has ever executed, although in value the firm clearly made greater profits when supplying stones as well as settings. Information about the Patiala's accounts indicate that Bhupinder Singh was financially stretched; by 1930 he had not yet paid Boucheron and Cartier and was petitioning the government for a loan in order to settle his enormous debts.[16] The accounts must have been settled without much further delay, as Cartier accepted another order to reset a substantial number of the maharaja's stones in 1935.

Cartier was also central in forming the jewelry collection of Ranjitsinhji, Maharaja Jam Saheb of Nawanagar (r. 1907–33). The ruler had been educated at Trinity College, Cambridge, and attained worldwide fame as a champion batsman for the All-England cricket team, winning the affectionate nickname "the Black Prince of cricketers." A lover of the English way of life, Ranji nevertheless understood that the possession of great jewels was an integral aspect of Indian kingship, and with this in mind, on his accession to the throne, he set about enriching the Nawanagar treasury. Over the course of his life, Ranji developed a keen appreciation of jewelry and was regarded internationally as an authority on precious stones. His biographer reveals that "like many collectors, he was terrifyingly casual in the care of his jewels. He traveled with several suitcases full of rings, watches and ornaments, besides the most important items in the State collection."[17] In his rooms "drawers and wardrobes were full of pieces of jewelry, apparently lying haphazard, but in reality carefully card-indexed both in his own mind and that of his servant, who followed him everywhere for thirty-seven years with the devotion of a spaniel."

The Jam Saheb acquired the renowned 136.25-carat cushion-shaped Queen of Holland diamond (later recut to 135.92 carats), renamed the Ranjitsinhji, which Jacques Cartier mounted for him in a spectacular multistrand necklace, using an exceptional group of white and colored diamonds. Ranji also commissioned from Cartier a fine emerald and diamond necklace with a matching turban ornament. Both pieces were conceived in an angular art deco style, the necklace with a recently acquired 70-carat emerald and the turban ornament with an emerald of 40 carats "remarkable for its fire."[18] Ranji's successor Digvijaysinhji (r. 1933–66) continued this relationship with Cartier, commissioning in 1937 an extraordinary necklace to show off a total of 118 rubies from the Nawanagar treasury. The firm also supplied him with a remarkable 61.50-carat whiskey-colored diamond, which Cartier set in 1937 as a turban ornament that converted into a brooch.[19]

The princely house of Indore also made big purchases of jewelry through European firms. Before the First World War, Tukoji Rao Holkar III (r. 1903–26) bought from Chaumet a pair of exceptional pear-shaped Golconda diamonds, subsequently known as the "Indore Pears." When his successor Yeshwant Rao (r. 1926–61) came of age in 1930, he too began buying jewelry, but turned to the Parisian firm of Mauboussin, which sold the prince the 56.40-carat Porter Rhodes diamond in 1937. Yeshwant Rao's loyalty to Mauboussin was partly inspired by his close friendship with employee Jean Goulet, who

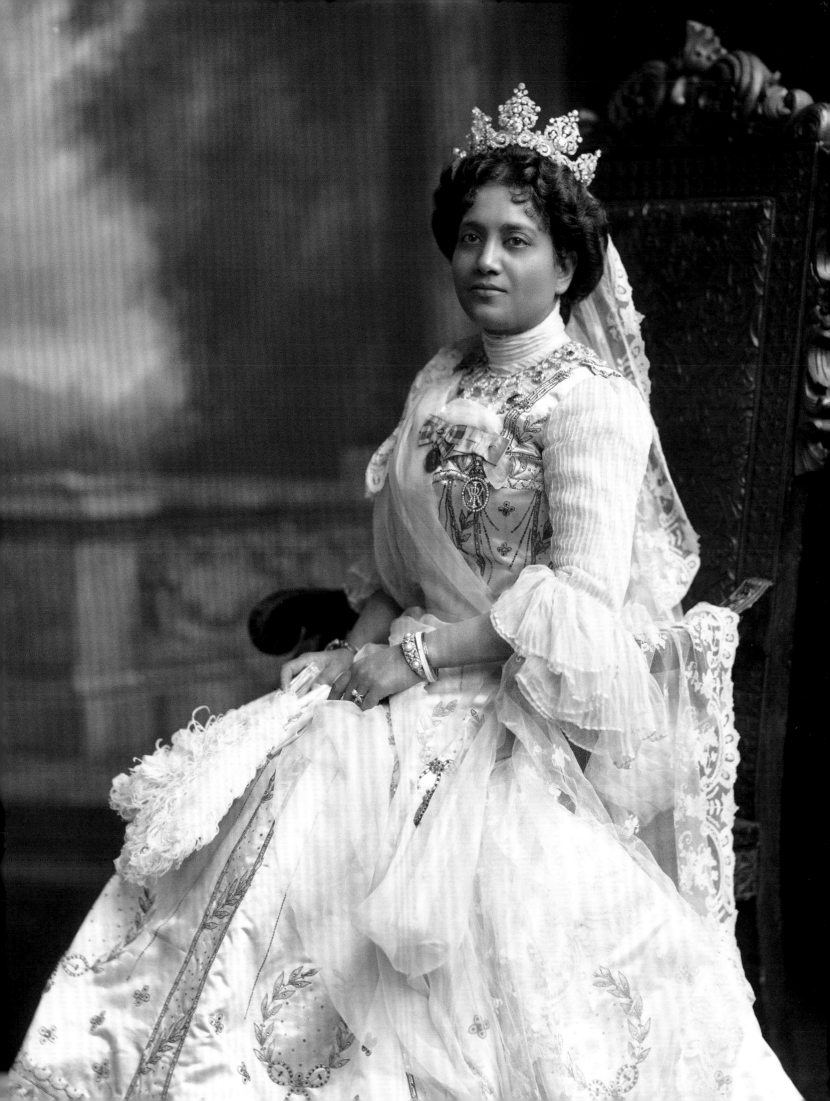

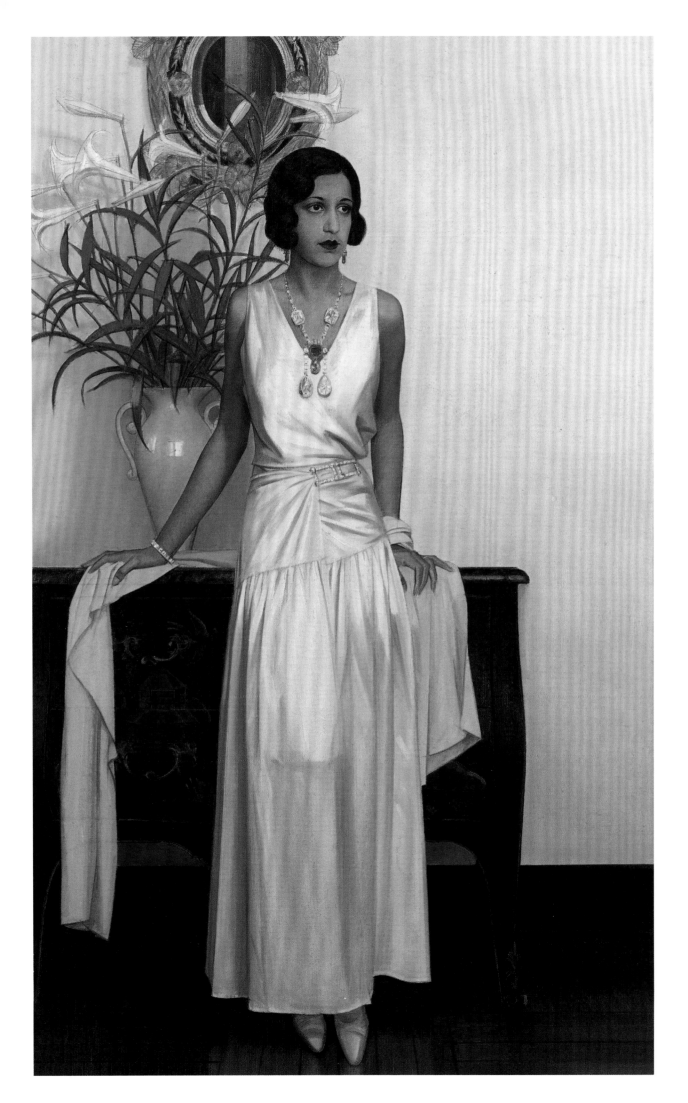

was the same age as the prince and shared his interest in Indian religions. He appointed the firm his official jewelers and invited Goulet to Indore to catalogue and appraise the treasury, a task that took two months to complete. Among the works commissioned from Mauboussin were a *sarpech* and *turra* (turban tassel), both of traditional form, but set in platinum and fashioned in a distinctly deco idiom. The firm provided the prince with a number of pieces of jewelry and suggested various designs for the Indore Pears, finally setting these spectacular diamonds into an elegant, rather restrained necklace in 1937. The prince's orders could not have come at a better time; the collapse of Wall Street in 1929 led to the Great Depression and with it a downturn in the demand for luxury goods. At this time, Indian princes were critical in sustaining a number of luxury houses.

The wearing of Western-set or Western-style jewelry posed less of an issue for Indian royals than did wearing Western dress. In a colonial context the choice of clothes worn by an Indian situated him both socially and politically. This was particularly true in light of early nineteenth-century East India Company policy, which aimed to demarcate the British as rulers and Indians as the ruled. The distinction between the races was reinforced through a series of regulations that forbade Indians below a certain rank from wearing shoes and boots in the presence of Europeans.[20] The importance of shoes as markers of Western civilization is evident from the comments of Hariot, Marchioness of Dufferin and Ava, who noted on receiving Sunity Devi, Maharani of Cooch Behar (1863–1932), that she wore "native dress, but has very smart shoes and stockings, while her sisters and sisters-in-law had bare feet."[21] One generation later, Maharani Indira, Devi of Cooch Behar (1892–1968), although raised in Western clothes, pointedly chose to appear in traditional Indian bare feet when paying homage to Queen Mary at Buckingham Palace as a symbol of her Indian heritage.[22]

Sartorial segregation reflected the perception about the superiority of all things European, including garments.[23] For some Indians, wearing the "clothes of the Ruling Race"[24] symbolized both modernity and a pro-British ideology. The artist E. M. Merrick (b. 1842) encountered a concrete example of this attitude in the widow of Vijayarama Gajapathi Raju, Maharaja of Vizianagram (r. 1845–79):

"I thought the old Maharanee was rather curiously dressed for an Indian lady, but she told me that when she was painted she wished to look like Queen Victoria, and had therefore dressed herself in English costume. She was wearing a purple pork-pie hat trimmed with three diamond stars, and a white veil covered with gold spangles hanging down the back; a purple velvet dress with a broad lace collar fastened by a large brooch, and open sleeves lined with white satin and edged with a ruche. As the velvet dress was made quite tight, and it was ninety-five in the shade, she must have been extremely uncomfortable. She asked me if I did not think the dress very handsome, and, not liking to disappoint her, I said it was."[25]

The maharani was not the only Indian princess to imitate the appearance of Queen Victoria (r. 1837–1901). An official portrait of Sunity Devi taken in London at the time of the coronation of Edward VII (r. 1901–10) reveals an even closer parallel with images of the ruler, both in posture and attitude (see page 123).

The dress worn by Sunity Devi had been made for her by a French milliner, although her usual London dressmaker was Madame Oliver Holmes.[26] European tailors and couturiers were naturally much in demand among Westernized Indian royals, who ordered clothes and uniforms while they were in Europe and supplemented their wardrobes by mail order once they returned home. Firms such as Henry Poole & Co. and Ede & Ravenscroft catered to an international clientele and kept details of measurements from which they were able to cut new garments for commissions from around the world. The shoemakers John Lobb & Co. likewise retained foot measurements for the same

purpose. The accounts of Maharaja Ganga Singh of Bikaner (r. 1887–1943) and his successor, Maharaja Sadul Singh (r. 1943–50), are replete with references to the purchase of clothes and shoes from London firms. A list of "things to be ordered immediately in England" include khaki socks, silk ties, starched collars, silk handkerchiefs, a motoring cap, an opera hat, flannel trousers, suiting fabric, suits, complete morning dress, "Nice Tennis or Polo Sweater," and accessories for uniforms.[27] Transactions were rarely simple, with details verified back and forth between Bikaner and London. For instance, Peal & Co.'s invoice of August 1948 for shoes, which listed no fewer than twenty-two items ordered by Maharaja Sadul Singh, met with protracted correspondence from the Master of the Household about the exact material used for the soles of certain of the shoes.[28]

Whether or not in purdah, some Indian royal women began wearing Western clothes and ordering their trousseaus in Europe. Begum Kaikhusrau Jahan of Bhopal (r. 1901–26), for instance, often wore European clothes under her burka.[29] Indian princesses sometimes commissioned the leading designers of the day. Among them was Indira Devi. In his autobiography, Salvatore Ferragamo (1898–1960) recalled her order for more than one hundred pairs of shoes, among them a pair made with pearls and diamonds supplied by the princess herself: "I made one pair of shoes in green velvet with a spiral of pearls running up the heels and one in black velvet with a diamond buckle and two straight rows of diamonds running down the heel."[30] For another, unnamed Indian princess, Ferragamo used the feathers of a hummingbird to create the rarest and most highly priced shoes of his career.[31] Rani Sita Devi of Kapurthala (1915–2002) and Australian-born Rani Molly of Pudukkottai (1894–1967) ordered clothes from the latest French designers, among them Callot Soeurs, Jeanne Paquin, Jean Patou, Madeleine Vionnet, Elsa Schiaparelli, Edward Molyneux, Coco Chanel, and Jeanne Lanvin. It wasn't only Western-style clothes that were custom-made in Europe for Indian royals. Monsieur Erigua of Paris produced fashionable chiffons in sari lengths for Indira Devi, and Parisian firms such as Sarees Inc. specialized in creating for elite Indian women rare sari materials in the latest Western fabrics and patterns.[32]

Wearing European clothes became increasingly common among Western-educated Indian princes, although traditional headdress was sometimes retained. When Man Ray (1890–1976) photographed Sultan Mohamed Shah, Aga Khan III (1877–1957), he expected to find "a vision of Oriental splendor with silks and turbans, pearls, emeralds and rubies." Instead, the Aga Khan appeared "wearing a yellow woollen sweater, doeskin trousers and—a pair of boxing gloves on his hands. He explained that since he spent so much of his time in Europe and England, his subjects would be most impressed to see him in a Western outfit."[33] Man Ray likewise observed that during his photo session with Yeshwant Rao II, the prince wore only "Western clothes—sack suits and formal evening dress."[34] His wife posed in "French clothes, and a huge emerald ring. The Maharaja had bought it for her that morning while taking a walk."[35] Not every prince was convinced that adopting Western ways was the best way forward. Venkata Swetha Chalapathi Ranga Rao, ruler of Bobbili (r. 1887–1926; raised from Raja to Maharaja in 1899), for instance, produced a volume aimed at the "Indian Aristocracy," in which he stressed the importance for Indians of maintaining their cultural integrity, including their own style of clothes. Western dress, he wrote, was not unattractive, "but it is purely European, and so unfitted for [Indians]."[36] For others it was comfort, rather than any point of principle, that mediated against wearing Western clothes. Meherban Narayanrao Babasaheb, Chief of Ichalkaranji, found simply that it was "difficult to understand the utility of stiff collars and tight-fitting boots and shoes. Whatever may be the reason for them (and they serve a really useful purpose no doubt), there is no denying their discomfort, which Europeans themselves admit. I know of nothing more

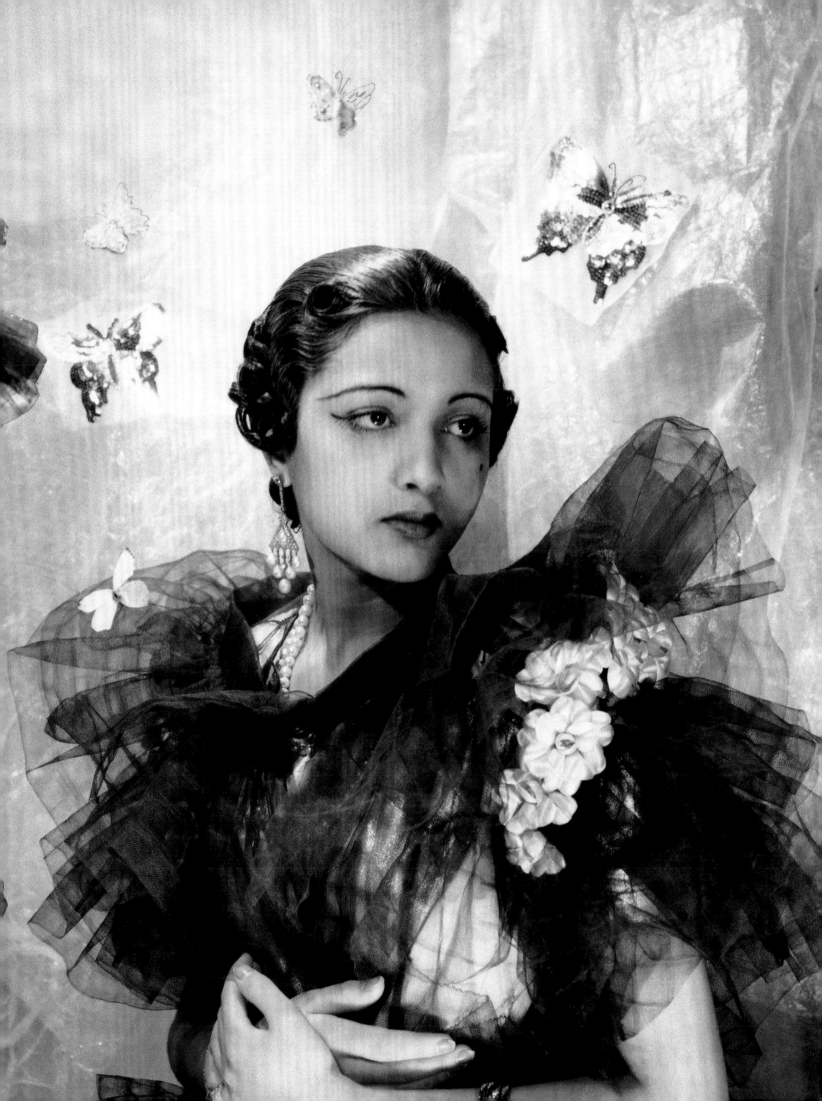

calculated to upset one's equanimity than the struggle involved in the adjustment of a new and highly-glazed English collar, unless it be the ordeal of becoming accustomed to the torture of narrow boots."[37]

For some Indians during the British Raj, the discomfort associated with Western clothes was not just a physical one. Appropriating the dress of the colonial master demonstrated support for an imperial system in which people of the subcontinent played the role of second-class citizens. While many wore Western dress and accessories as a reflection of the latest taste, for others, incorporating Western attire into one's wardrobe represented a moral and political position. As a freedom fighter, Mahatma Gandhi saw the refusal to wear Western dress as a critical element of the rejection of British political dominion over India. His economic policy of undermining the British textile industry underlined a deeper message, that of reclaiming Indian sartorial identity and India's position as a producer and exporter of fabrics. Within a political context, therefore, the wearing of Western attire among Indian elites was much more than just adopting the latest styles from abroad.

ENDNOTES

[1] Charlotte Gere and John Culme with William Summers, *Garrard, The Crown Jewellers for 150 Years* (London: Quartet Books, 1993), 57–58.

[2] The Marchioness of Dufferin and Ava, *Our Viceregal Life in India: Selections from My Journal 1884–1888* (London: John Murray, 1889), 48–49.

[3] Capt. Edward West, ed., *Diary of the Late Rajah of Kolhapoor, During His Visit to Europe in 1870* (London: Smith, Elder & Co, 1872), 13.

[4] Hans Nadelhoffer, *Cartier, Jewellers Extraordinary* (London: Thames & Hudson, 1984), 159.

[5] Harry Fane, "Cartier and the Indian Heritage," The Bowrings Lecture, [unpublished article], (March 2003), 10.

[6] Katherine Prior and John Adamson, *Maharajas' Jewels* (Paris: Assouline, 2000), 110; Boucheron Archives, "Personnalités Historiques Maharadjahs," n.d., 4.

[7] Prior and Adamson, *Maharajas' Jewels*, 116.

[8] Judy Rudoe, *Cartier 1900–1939* (New York: Abrams / Metropolitan Museum of Art, 1997), 36.

[9] Rudoe, *Cartier 1900–1939*, 34.

[10] Rudoe, *Cartier 1900–1939*, 31–32.

[11] Rudoe, *Cartier 1900–1939*, 156, 162–63.

[12] His Highness The Raja-i-Rajgan Jagatjit Singh of Kapurthala, *My Travels in Europe and America 1893* (London: George Routledge and Sons, Ltd, 1895), 86.

[13] Prior and Adamson, *Maharajas' Jewels*, 146.

[14] Le Baron Fouquier, "Reflets d'Orient," *Reflets*, May 1938, 34.

[15] From *L'Illustration*, cited in Fane, "Cartier and the Indian Heritage," 14.

[16] Oriental and India Office Collections at the British Library, R/1/1/1881.

[17] Roland Wild, *The Biography of Colonel His Highness Shri Sir Ranjitsinhji* (London: Rich and Cowan, Ltd, 1934), 240.

[18] Wild, *The Biography of Colonel His Highness*, 324.

[19] Nadelhoffer, *Cartier, Jewellers Extraordinary*, 86.

[20] D. Dewar, *A Handbook to the English Pre-mutiny Records in the Government Record Rooms of the United Provinces of Agra and Oudh*, n.d, 198, 269, 453; E. M. Collingham, *Imperial Bodies* (Cambridge: Polity, 2001), 57, 186.

[21] Dufferin and Ava, *Our Viceregal Life in India*, 62.

[22] Lucy Moore, *Maharanis* (London: Viking, 2004), 188.

[23] *The Journal of Mrs. Fenton 1826–1830* (London: E. Arnold, 1901), 82.

[24] Michael Madhusudan Datta, cited in Emma Tarlo, *Clothing Matters: Dress and Identity in India* (London: Hurst & Co., 1996), 23.

[25] E. M. Merrick, *With a Palette in Eastern Palaces* (London: S. Low, Marston, 1899), 138–39.

[26] Sunity Devee, *The Autobiography of an Indian Princess* (London: John Murray, 1921), 123, 173.

[27] Bikaner Royal Archives, undated list.

[28] Bikaner Royal Archives, letter of August 12, 1948.

[29] Yvonne Fitzroy, *Courts and Camps in India Impression of Viceregal Tours 1921–1924* (London: Methuen, 1926), 290.

[30] Salvatore Ferragamo, *Shoemaker of Dreams* (London: George G. Harrap & Co., 1957), 217.

[31] Ferragamo, *Shoemaker of Dreams*, 92–94.

[32] Moore, *Maharanis*, 187.

[33] Man Ray, *Self Portrait* (Boston: Little, Brown & Company, 1963), 171.

[34] Ray, *Self Portrait*, 172.

[35] Ray, *Self Portrait*, 172.

[36] Maharaja of Bobbili, *Advice to the Indian Aristocracy* (Madras, India: Addison and Co., 1905), 31.

[37] Meherban Narayanrao Babasaheb, *Impressions of British Life and Character* (London: MacMillan and Co., Limited, 1914), 204.

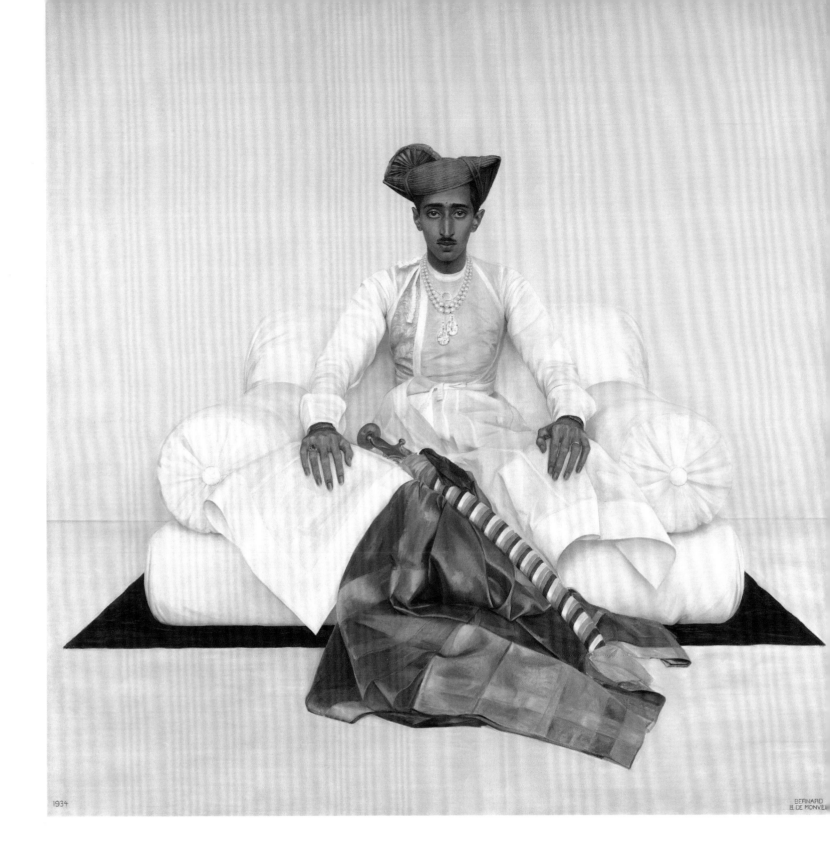

ABOVE Bernard Boutet de Monvel, *Portrait of Maharaja
Yeshwant Rao Holkar II of Indore in Indian Dress*, 1934.
Oil on canvas. The Al Thani Collection.

A BRIEF
HISTORY
OF SARIS

RUJUTA VAIDYA

The sari remains an irreplaceable symbol of identity for Indian women—a position that is both historically important and free-form in its interpretation. The garment transforms as you traverse the country: the way the fabric is draped, the motifs that form the patterns, the weaves that bring it to life, the hands that craft it. More importantly, it has endured changing rulers, geopolitical borders, and recently the impact of Western culture—where minimalism means forgoing detail, and time equals money.

Legends and history intertwine to tell the story of this garment. In the south, it is said that Kanjeevaram weavers are descendants of Makarand[1] who wove saris for the gods themselves. Most academic texts refer to the *Rig Veda*[2] as the earliest documentation of the sari (3000 BCE). The origin of an uncut piece of cloth used as a means not just to protect the wearer from climatic conditions but also to express personal style can be traced back to the once flourishing Indus Valley Civilization, 2800–1800 BCE.

Despite the fact that the framework of the country comprises various cultures, languages, communities, and class distinctions, the sari is common to all. In its present form, the sari is typically worn with a blouse and an underskirt, but that wasn't always the case. Under the influence of the Mughal rule (early sixteenth to mid-eighteenth century), the Benarasi sari in particular gained prominence. Characterized by ornate motifs woven with silk or metallic threads of gold and silver, the Benarasi sari is an example of exquisite craftsmanship. When commissioned by the royal court, *zardozi* embroidery was added to further enhance each piece. The Mughals were known for their elaborate stitched garments and therefore the blouse as a garment for the upper body evolved, although paintings from this era show that it was worn with a *gharara*, or a bifurcated bottom resembling flared pants for women.

There are over a hundred different ways a sari can be worn. In rural India, where communities are largely agrarian, the sari is worn in a utilitarian fashion. The Koli drape from Maharashtra is typically seen on women from the fishing communities that dot the coastline. This drape is achieved by wrapping the inner end of the sari between the legs, almost fashioning pants at the lower end of the sari. The top half of the *pallu* is usually tucked in at the waist to offer maximum mobility under active working conditions. The Kunbi drapes are worn by women working on farms in Goa. This calf-length drape features front pleats that offer more give at the bottom, allowing women to hike up the sari as needed. *Mohiniattam* dancers can practice their classical art form in a drape that fans out at the waist. Dancers today wear a prestitched form of a similar design. Drapes were, and still are, indicative of wealth and status. The Maar Kachha drape from Kerala is a delicate one to maintain and hence worn by upper-class women. This drape was created with the *mundum neriyatum*[3] and worn close to the body with little give, which restricted movement. While some of these drapes are still seen, the nuances are disappearing. The Nivi drape characterized by front pleats and a long *pallu* over the right shoulder is the most commonly worn across the country.

The arrival of the British colonial forces in the early nineteenth century led to regulations on traditional garments; later, modesty was defined by Victorian standards. Wearing blouses was mandatory for women to enter social spaces frequented by the British. Given the new restrictions, prominent socialite Jnanadanandini Tagore, wife of Satyendranath Tagore—the elder brother of polymath Rabindranath Tagore, who influenced social reforms and had an everlasting impact on Indian literature—began popularizing blouses. The Tagores were a highly respected family in Bengal with gentry roots, and people took notice. Jnanadanandini Tagore draped the sari in a manner similar to the style preferred by the Parsi community, which was closest to the drape commonly worn in Gujarat that eventually evolved into the Nivi drape.

OPPOSITE Maharani Gayatri Devi of Jaipur, 1954.

ABOVE Raja Ravi Varma, *Nagercoil Ammachi*, 1868. Oil on canvas.

In an early case of influencer style, Tagore is known to have advertised her novel drape in local publications, urging young women to follow her style.

Post-Independence India saw the third prime minister (and the first female) Indira Gandhi taking charge in crisp starched saris. Gandhi was dedicated to her promotion and protection of Indian weaves. At the opposite end was the famed beauty Maharani Gayatri Devi[4] of Jaipur, whose pastel chiffons exuded a more delicate power. The emergence of the film industry saw actors in the 1960s modifying drapes to suit the screen and inadvertently defining how an entire generation of young women styled themselves. The body-hugging drape worn by Mumtaz[5] in *Brahmachari* (1968) is among the most referenced film costumes in Bollywood history.

Over time, handlooms lost the patronage they once had. Rising prices of raw materials, the emergence of new jobs, and migration of the workforce to larger cities impacted the weaving clusters of India. The sari has always been evocative of nature and customs in different states. While red and yellow are typical bridal hues, the Khatri[6] community in Gujarat wears black and red *bandhani* called *chandrokhani*—alluding to the beauty of the moon and the bride herself. Baluchari saris worn in West Bengal and Bangladesh have entire epic sagas woven into the *pallu* and sometimes the body of the sari. Dhakai *jamdanis*[7] of Bangladesh (once a part of undivided India) are known for detailed floral motifs woven into featherlight muslin cloth. The value of a *jamdani* is comparable to that of a Benarasi—both are woven on jacquard looms with a complex mechanism of cards. Ikat weaves—with resist dyeing and dizzying geometric accuracy that depict fish, dancing figures, birds, and more—can take up to three months to weave.

In the past decade, we've seen various iterations and innovations of the sari, courtesy of a new crop of design talent. Tarun Tahiliani's modernized predraped pieces have continued to be a mainstay while younger names such as Gaurav Gupta and Amit Aggarwal have pushed boundaries, drawing from abstract forms to serve as futuristic expressions of the sari. Interestingly enough, the past ten years have also seen the design community in India consciously leading consumer mindsets back toward handwoven textiles; puritans Sanjay Garg of Raw Mango, Gaurang Shah, and Ritu Kumar are among those who can be credited with this trend.

The sari can be identified as an unstitched fabric that serves as a garment itself—but it is so much more. Transcending boundaries, cultures, and religions, it has attained the iconoclastic position of a national garment.

ENDNOTES

[1] Sage Makarand wove the first fabric ever from lotus fiber and is considered to be the weaver of the Hindu gods.

[2] The *Rig Veda* is one of the four sacred canonical Hindu texts known as the Vedas.

[3] The *mundum neriyatum* is the oldest remaining form of the sari that resembles the *antariya uttariya*—a modesty piece and a loincloth worn in 600 BCE.

[4] After Independence, princely states in India were abolished. Maharani Gayatri Devi entered politics and joined the Swatantra Party. She was a vocal critic of the former Prime Minister Indira Gandhi.

[5] Mumtaz Askari Madhvani is a prominent Bollywood actor. She is the recipient of a Filmfare Award and the Filmfare Lifetime Achievement Award for her contributions to Hindi cinema.

[6] A mercantile community from the Indian subcontinent that is predominantly found in India, but also in Pakistan and Afghanistan.

[7] Sari woven from fine muslin that originates from Bangladesh and gets its name from Dhaka, the capital of Bangladesh.

BELOW Amit Aggarwal, predraped sari with metallic plissé palla and hand-embroidered bodice, 2022 Couture.

OPPOSITE Raw Mango, striped "Mashru" sari, 2019 *Angoori* collection. Photographed by Ritika Shah.

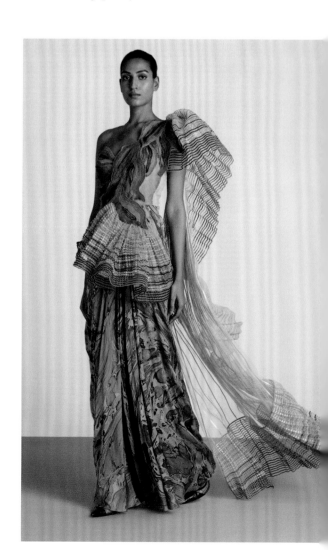

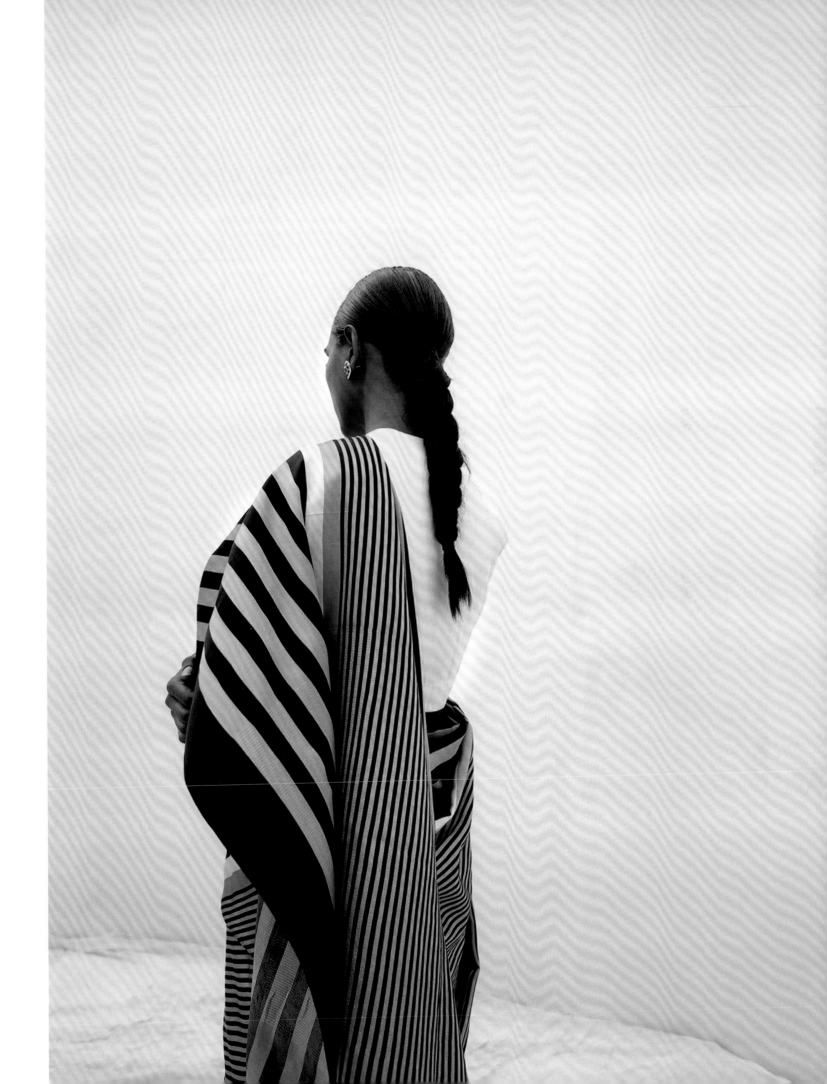

THE SARI
IN WESTERN
HIGH
FASHION
DURING THE
TWENTIETH CENTURY

CAROLINE RENNOLDS MILBANK

It was during the twentieth century that the aesthetic of the Indian sari, the oldest continually worn garment in history, exerted its strongest influence over the constantly changing and evolving fashions of Europe and the United States. This influence occurred intermittently in French and Italian haute couture and more continually and to a much broader degree in the United States.

In Europe, the appeal of the sari was especially mesmerizing during the interwar period. The height of glamour and elegance there at the time was to be found wherever Indian royalty were seen: at the races at Ascot, Longchamp, or Auteuil; at the Paris Ritz, the British royal court, or attending the fabled Parisian costume balls. Although couturiers—particularly those with eyes already trained toward an eclectic East of the imagination—had occasionally dabbled with aspects of Indian clothing and textiles, interest intensified, resulting in such a confluent moment as the sari starring simultaneously in the spring 1935 haute couture collections of Schiaparelli and Alix (the future Madame Grès). "What completely stunned the Western world were draped [Indian] evening dresses," reported *Vogue* in April 1935. By July, the Honorable Mrs. Reginald Fellowes, among a handful of the chicest women in the world, gave the Paris sari her priceless imprimatur when she appeared, along with her daughter the countess A. de Castéja, clad in Schiaparelli saris, sketched in watercolor by Cecil Beaton in Paris *Vogue*.

The influence of the sari begins with the role of a spiral-draped length of cloth in the development of a less structured—and thus more modern—Western silhouette. Also influential were the separate components of the sari ensemble, such as the choli, adapted to midriff-baring styles found most often in sportswear and at-home designs, and the fabric itself, in particular the distinctive Benaras silk distinguished by scattered motifs, a border, and the use of metallic thread woven into the design. For the most part, it is the sinuous winding of a sari as worn that has most strongly influenced the Paris haute couture, which since the age of Worth (mid-nineteenth century) has been all about a silhouette in flux, while it is the textiles that have most inspired American designers.

POIRET AND CALLOT SOEURS DURING THE 1910S AND 1920S

Not surprisingly, Indian influences in Paris were first seen in the designs of the two most intensely Orientalist *maisons de couture*: Poiret and Callot Soeurs. Although Paul Poiret is most closely associated with the near-Eastern looks derived from his absorption of a Ballets Russes cross-cultural aesthetic, a smattering of Poiret garment names suggests the range of his sources: Timbuktu, Muscovite, Hong-Kong, Chinois, Marrakech, Kazan, Persane, Ispahan. Poiret experimented both with sari fabric and with the spiraling of fabric for several designs particularly around 1924, a time when the tubular chemise silhouette was cresting and a designer might be especially interested in branching out beyond such a truncated style. From the personal wardrobe of Poiret's wife and muse, Denise, is the dress "Lure," from 1924, the sleeveless ankle-length chemise in gold textured material wrapped as a sari is, with a red and gold panel that serves to animate the tubular silhouette.

The Maison Callot was founded in 1895 by four sisters who had a strong background in the textile arts. As couturieres, they would be known not so much for moving the fashion needle forward but for interpreting the going silhouette in a lush collage of fabric, lace, and embroidery. Usually when Asian inspiration appears in Callot from the 1910s and the 1920s, it is in the form of panels suggestive of the *ruyi* bands of antique Chinese robes applied tabardlike to the fronts and backs of chemise dresses, the shaped

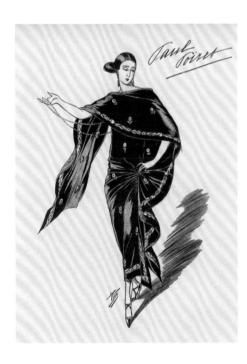

panels providing a surface for silk or bead embroidery. Designs that incorporate sari silk or sari elements represent a departure; such pieces as a spiraling brocade dress at The Metropolitan Museum of Art with a scarf panel that can be worn draped over the head, and a little black dress at the Museum at the Fashion Institute of Technology made striking with the graphic placement of metallic gold sari borders, are the most streamlined and modern examples of Callot's oeuvre.

During the 1920s and 1930s, Royal Indian style setters Princess Brinda of Kapurthala, Princess Karam of Kapurthala, and Princess Niloufer enchanted Paris, dazzling equally whether dressed in their native saris or in Paris fashions from Mainbocher, Paquin, Caroline Reboux, and photographed by Horst and Cecil Beaton or drawn by fashion illustrators for *Vogue* and *Harper's Bazaar*. When Elsa Schiaparelli debuted sari-form dresses in 1935, *Vogue* wrote that she was invoking "a memory of … Princess of Kapurthala." In Schiaparelli's work, sari elements act as another theme. Alix (Madame Grès), haute couture's truest sculptor of fabric and sari drapery, provided another opportunity to explore the relationship of flat fabric to the undulating female figure. She would return to this form of spiral wrapping again and again.

Fabric shortages in occupied Paris during the Second World War may explain why sari draping doesn't surface again in haute couture until 1948, when fabric could flow more freely. Pierre Balmain used such draping for a dramatic tailored day costume of black wool edged with a narrow band of leopard. Although numerous couturiers referenced saris in the postwar years, Balmain, who revisited the form in 1957, was rare in that he applied the spiraling effect not just for cocktail/evening styles but for day clothes as well.

For centuries, French-produced textiles, protected and promoted by the government, dominated Paris couture; in *Sixties Fashion,* Jonathan Walford discusses the role governmental financial incentives played in ensuring that French textiles composed 90 percent of what was used in haute couture. When these ceased in the early 1960s, "couturiers now looked to other sources—predominantly Switzerland and Germany, but also Thailand, for slubby shantung silks and cotton sarongs, Burma and Japan for brocades, and India for gilt-thread-embroidered saris." That such fabrics were already popular in America—France's biggest client—added to their appeal, and during the 1960s and 1970s the distinctive metallic-tinged Benaras silk appeared in draped designs by Madame Grès and Cristóbal Balenciaga Spring/Summer 1965.

THE SARI IN U.S. FASHION

During its comparatively short existence the United States has been in complete thrall to imported textiles. This dependence on fabrics produced by artisans around the world goes hand in hand with the pivotal role textiles have played in trade for millennia. From before the American Revolution such stuffs as Spitalfields or Lyon brocaded silks, Chinese silks and embroideries, the fabrics of India—woven, printed, and embroidered—were sought-after imports, so much so that women's clothing tended to be relatively simple in silhouette: the better to showcase a valued fabric. This was as true in the age of Martha Washington as it was in 1962, when *Life* magazine profiled jet traveler and boutique designer Tiger Morse shopping in Benaras, India, for saris to make into designs of the "simplest shapes and lines." Morse, as typical of American designers, separated a Benaras sari into discrete elements of field, narrow border, and wider border, reassembling them patchwork-style into an otherwise simple dress.

OPPOSITE Schiaparelli, sari-draped silk chiffon evening dresses. Worn by the Honorable Mrs. Reginald Fellowes and her daughter, the Comtesse A. de Castéja. Illustrated by Cecil Beaton for the May 1, 1935, issue of *Vogue.*

PAGE 138 Traina-Norell, silk sari-cloth dinner dress. Modeled by Sunny Harnett. Photographed by Richard Rutledge for the October 1, 1953, issue of *Vogue.*

PAGE 139 Filcol, sari dress of silk, cotton, and pure gold thread, 1955. Photographed by Mark Shaw at New York's Museum of Modern Art's exhibition on Indian textiles for the May 16, 1955, issue of *Life* magazine.

The first instance of saris influencing American fashion occurred in 1921, in Jessie Franklin Turner's tea gowns for high-end department store Bonwit Teller. As fashion historian Jan Glier Reeder has written, Turner was one of the designers chosen to participate in a First World War–era "Designed in America" campaign aimed at developing Paris-independent styles. The campaign was spearheaded by Morris De Camp Crawford, the fashion editor of *Women's Wear* newspaper but also an anthropologist specializing in Peruvian textiles at the American Museum of Natural History. Crawford promoted his idea widely and, along with Stewart Culin, the influential early curator of ethnography, textile, and fashion, created instructive programs and made actual museum holdings available as non-European sources of inspiration for textile and clothing designers. Although Turner's participation in this project resulted in designs directly inspired by textiles of the Americas, she also found influences farther afield, as she had previously while working as a European and Asian buyer for Bonwit Teller, when she explored the gamut of textiles from museum collections to artisan workshops. The December 1921 issue of *Vogue* featured a Jessie Franklin Turner tea gown made from an Indian sari, a look the designer would show intermittently until she shuttered her business in 1942.

MAINBOCHER AND THE SARI

The designer to most consistently use the Benarasi sari was Chicago-born Mainbocher, who had been, during his decade helming a Paris couture house, closely associated with dressing Indian royalty and who relocated his establishment from occupied Paris to New York in 1940. From New York he would reign as the preeminent American custom designer during the 1940s through the 1960s. A fairly well-publicized specialty of his were the unique sari evening dresses he made for inner-circle clients—the crème de la crème of the best-dressed list. For uber chic Millicent Rogers (who had worn an actual Indian sari to a Southampton fete while in her twenties in the 1920s), Mainbocher not only made entire dresses or ensembles but also interpreted one of his most clever ideas—the apron, or "glamour belt," that can transform a simple black dress—using sari silks.

Likely influenced by Mainbocher, the majority of American high-end custom designers made sari evening dresses throughout the late 1940s into the 1960s: Muriel King, Hattie Carnegie, Sophie of Saks, Valentina Schlee, the custom salon at Bergdorf Goodman. In 1947, three of the pinnacles of the best-dressed list—the Duchess of Windsor, Mrs. Gilbert Miller, and Mrs. Wolcott Blair—were sketched by René Bouché for *Vogue*, each wearing a sari evening dress custom made for her by Antonio del Castillo, then house designer at Elizabeth Arden in New York.

During the Second World War, not just the aesthetic but the generous six-plus yardage of a sari appealed when other fabrics were being rationed. Whether discovered on one's travels, a gift from a friend who had been to India, or sourced from shops selling Indian goods, saris were often taken to dressmakers in order to be transformed into dresses. Ann Lowe, the Black couturier who had made Jacqueline Kennedy's wedding dress, is just one example of a custom dressmaker branching out from wedding and debutante dresses to craft an evening dress from a sari for a private client. The countrywide practice of having such dresses made remained strong for decades but waned with the decline of home sewing and the neighborhood dressmaker in the 1970s. More recently, in the early twenty-first century, New York–based custom designer Lee Anderson was asked to transform a priceless sari gifted by a maharaja into an evening dress for a high-profile client.

ABOVE Paul Poiret, "Lure" evening dress of figured gold lamé with gold-brocaded orange silk crepe "sari" wrap, Spring 1924. Photographed by Sasha.

OPPOSITE Schiaparelli, evening dress of striped taffeta threaded with gold. Illustrated by Carl Oscar August Erickson (Eric) for the April 1, 1935, issue of *Vogue*.

GILDING THE SHIRTWAIST: THE SARI IN AMERICAN READY-TO-WEAR

Sari-inflected designs in American ready-to-wear, sportswear, and resort clothes surged beginning in the 1940s. Just as in the days of M. D. C. Crawford's "Designed in America" campaign, the Second World War necessitated that U.S. designers turn to sources such as museum archives for inspiration, because travel to Paris was impossible. An example, although hardly alone in the practice of archival research, was ready-to-wear and resort designer Tina Leser who, as fashion historian April Calahan has written, "expanded her base of inspiration to include the history of both art and fashion. She studied resources offered by the costume collections at both the Brooklyn Museum and the Costume Institute at the Metropolitan Museum of Art." Leser's methods shifted in 1949 when she accompanied her new husband, a Pan Am pilot, around the world, making use of the opportunity to study regional dress, collect textiles, and establish relationships with artisanal suppliers. During the Second World War, designer Carolyn Schnurer took off on what the *New York Times* would call her "fashion safaris," with several of her collections based on her travels in India.

Sari spiraling and the use of a narrow decorative border were employed by ready-to-wear designers of formal day and evening clothes—Nettie Rosenstein, Madame Eta, Adele Simpson, and Bruno. Typical were versions of long dinner or evening dresses in rayon crepe encircled by a band of glittery embroidery. Sourcing actual sari fabrics could prove challenging in ready-to-wear, which was produced in large quantities, although designers such as Adele Simpson did make use, in the 1950s, of saris still being made by hand in artisans' homes, appreciating that no two were exactly alike. American fabric manufacturers, often in collaboration with designers such as Leser, developed sari-inspired textiles in sturdy rayons and cottons (Dobeckmun made a bright metallic yarn that didn't tarnish), and thus Benarasi-inspired mass-produced fabrics found their way not just into evening and late-day dresses but also into swimwear, sporty playclothes, underwear, and dresses made for teenagers and even for little girls.

JACQUELINE BOUVIER KENNEDY AND SARIS

As a trendsetter for many twentieth-century fashions, Jacqueline Kennedy played a role in further popularizing American sari fashions. For its April 21, 1958, cover, *Life* magazine featured a color photograph of Senator and Mrs. John F. Kennedy and their daughter, Caroline. The glamorous senator's wife wore a dress of pale aqua and gold sari silk with a fitted bodice, round neck, and short sleeves, an interesting choice that signaled sophistication and elegance and yet was quite accessible. It could have been made by any number of ready-to-wear designers at a spectrum of price points, offered as an in-house design by a department store such as Peck & Peck or Lord & Taylor, ordered custom from a high-end designer, made up by the dressmaker around the corner, or sewn at home using a pattern specially designed for saris.

In 1962, the *New York Times* reported on the fashion impact of Mrs. Kennedy's trip to India and Pakistan. As style writer Charlotte Curtis wrote, the now First Lady "bought several saris and then approached at least one designer about having them made into dresses. That was in April. Reports of Mrs. Kennedy's activities were hardly printed before importers began to sell more saris than ever before. By May, Seventh Avenue was unveiling Westernized sari fashions and New York stores were placing their orders. What had been a limited audience now is almost as common as the mink stole and sometimes just as expensive." By October 1962, sari dresses were being

prominently featured in the popular nationwide touring show "Ebony Fashion Fair: With an Oriental Flair."

During the eighteenth and nineteenth and into the early twentieth centuries, the Western taste for clothes that paid homage to non-Western cultures broadcast an interest in world history, the arts, literature, and travel. This was true of men but perhaps even more apropos for women, whose access to formal education and opportunity to shine intellectually were limited. World textiles were originally an acquired taste, abetted by wealth through education and exposure. By the postwar period, however, Western designs made from Benarasi silks had been fully absorbed into every aspect of American female dress, worn in press photos by Hollywood stars such as Elizabeth Taylor and Eartha Kitt, to debutante balls, and at White House and embassy events in Washington, DC; promoted in 1950s and 1960s advertisements for airlines, Coca-Cola, Soft-Weve toilet paper, and record players; and featured in the Tetley Tea pavilion at the 1964 New York World's Fair. For Americans, the metallic-gold-splashed sari had become its own kind of logoless brand, exotic yet recognizable, fashionable yet timeless, glamorous yet accessible.

BELOW Antonio Castillo for Elizabeth Arden, fuchsia and gold dinner dress made from sari fabric. Worn by the Duchess of Windsor. Illustrated by René Bouché for the July 15, 1947, issue of *Vogue*.

OPPOSITE Jacqueline, Caroline, and Jack Kennedy on the cover of *Life* magazine, April 21, 1958. Mrs. Kennedy wears a dress of pale aqua and gold sari silk.

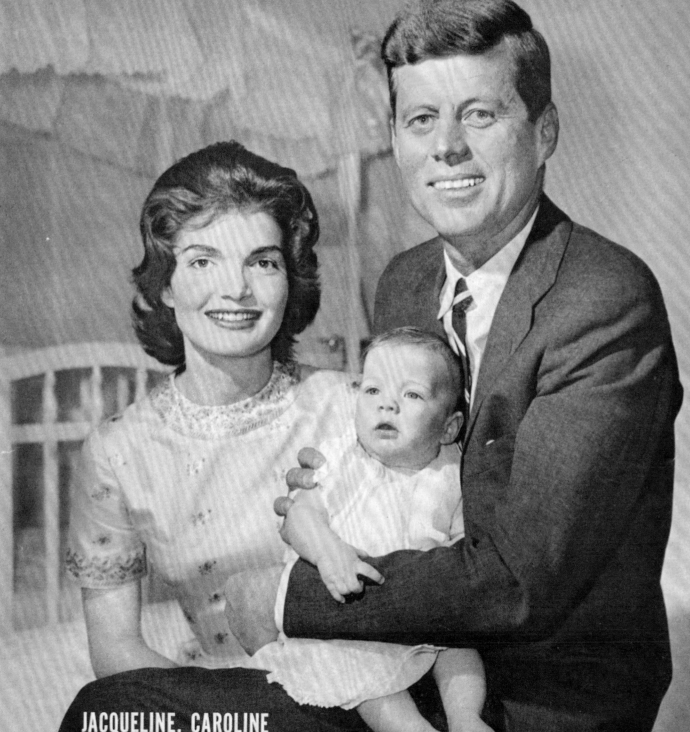

LIFE

A STAGGERING JOB OF REORGANIZATION
NEIL McELROY'S PENTAGON
HOW A FAMILY GUIDES ITS CHILDREN
TO GET A KICK OUT OF LEARNING

JACQUELINE, CAROLINE
AND JACK KENNEDY

G. U. S. PAT. OFF.

APRIL 21, 1958 **25** CENTS

THE IMAGINARY INDIA OF YVES SAINT LAURENT

AURÉLIE SAMUEL

AN IMAGINARY INDIA

India has long been a source of fascination for Europeans—and especially for artists. Yves Saint Laurent is no exception to this rule. Heir to a venerable tradition, he offered a very personal and wholly imaginary vision of India based in part on the many publications available to him in the studio of his *maison de couture* as well as on artifacts in the collection that he assembled with Pierre Bergé. The works of reference that he consulted include *Historic India*[2] and *Ancient Indian Costume*[3] as well as many specialist publications, notably those published by the Calico Museum of Textiles in Ahmedabad. Going beyond simple inspiration or reappropriation, Yves Saint Laurent understood the primordial role of clothing in India as social marker and corporeal ornament. He seized upon this reality and designed clothing that, more than merely covering the body, adorned it, producing in the viewer a sense of beauty and an emotion approximating the one designated in Sanskrit as *rasa* (literally, "savor" or "relish").[4] One is even prompted to wonder whether the 1965 dress immortalized by the photographer Irving Penn was not inspired by the pose and costume of the celebrated dancing girl in Cave 1 at Ajanta.[5]

From his earliest years, Saint Laurent developed a taste for precious gold-brocaded silks, raised metallic embroidery, and jeweled buttons, as evidenced by the sublime robe decorated with *zardozi* (a characteristic Indian embroidery that originated in Persia) designed for Baroness Marie-Hélène de Rothschild, as well as by the plumed turbans that figured in the wardrobes of Mughal princes and maharajas. The ensemble worn by Loulou de la Falaise at her marriage in 1977 is very close to this exclusively masculine tradition, which Saint Laurent successfully adapted to suit Western taste in female dress.

FROM 1962 TO *THE PINK PANTHER*

From as early as the Spring/Summer 1962 collection, the influence of India was apparent in Saint Laurent's reinterpretation of overcoats, turbans, jewelry, and long tunics made of sumptuous silks commissioned from the Lyon-based firm Bucol or the Swiss company Abraham and decorated with embroidery, most of which was executed by Mesrines, Lanel, or Rébé: "There were many nods to the Orient, for example impressive embroidery with turquoise and coral, turbans, hats *à la chinoise*, and evening gowns inspired by Indian saris."[6]

Floral motifs are omnipresent and continued to evolve throughout Saint Laurent's career, for he liked to create the illusion of a luxuriant garden that one could wear. He derived this image of the ideal garden from the art of the Mughal emperors, where it is ubiquitous: "I traversed the expanses of pink lotus in Srinagar, sparkling under the full moon."[7] He also took inspiration from the stylized palm motif, originally from Kashmir, known as the *boteh*, which he used in embroidery, gold appliqué, and jewelry—for example, the famous "Heart" pendant, commissioned from the House of Scemama in 1962, a unique piece that Saint Laurent often had his favorite model wear at his runway shows from 1979 to the end of the couture house in 2002.

OPPOSITE Yves Saint Laurent, evening ensemble of jacket in silver lamé silk gauze, silver embroidery trim with rhinestones and pearls from Rébé and skirt in silver lamé silk gauze from Abraham. Fall/Winter 1962, Haute Couture. Modeled by Lubieka. Photographed by Shahrokh Hatami.

ABOVE Yves Saint Laurent, evening ensemble of coat dress in green silk brocade from Abraham embroidered with rhinestones and pearls from Mesrines. Fall/Winter 1962, Haute Couture. Modeled by Lubieka. Photographed by Shahrokh Hatami.

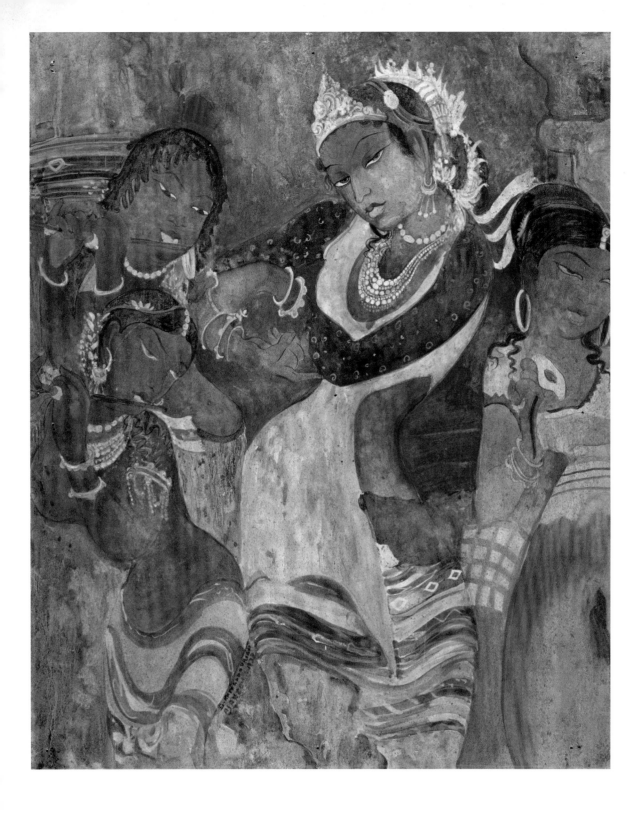

ABOVE *Dancing Girl with Musicians*, fresco painting, Ajanta Cave 1, Maharashtra, fifth century CE.

OPPOSITE Yves Saint Laurent, evening gown of crêpe de soie from Abraham and jet brocade. Fall/Winter 1965, Haute Couture. Photographed by Irving Penn for the September 1965 issue of *Vogue*.

PARIS: DÉGAGÉ SPLENDOUR BY SAINT LAURENT AND CARDIN

Saint Laurent's sensational black crêpe, *right*, bared at the sides, across the back…tricorne point on the midriff, jewelled. High cowl neckline, tied in back. Dress, in Abraham crêpe. In America at I. Magnin. Shoes by Roger Vivier. This coiffure, coifs on the preceding twelve pages, by Alexandre. *Far right:* Feathers flying at Cardin—bias black crêpe with a tricorne hem of black ostrich lifted to the back of the knee… bias blouson plunged down the back…all swirl and movement. Coiffure by Carita.

For the Fall/Winter collection that same year, he seems to have drawn inspiration from an elaborate metalwork ensemble depicting the throne room of Grand Mughal Aurangzeb, fabricated by Johann Melchior Dinglinger and reproduced in a book that was in Saint Laurent's studio library.[8] The coat, made of green Abraham silk with gold embroidery by Mesrine and accessorized with a turban, is a feminine variation on antecedents from the Mughal tradition. Saint Laurent also looked to the movies for inspiration, as evidenced by the resemblance between Greta Garbo's silhouette in *Mata Hari* (1931), directed by George Fitzmaurice, and the one imagined by the couturier in 1962, as photographed by Shahrokh Hatami. One senses the same influence in the costumes that he designed for Claudia Cardinale in *The Pink Panther* (1963), directed by Blake Edwards. Some of these gowns came directly from the 1962 collections or were inspired by them, like the model in purple shantung with a neckline of embroidery incorporating coral fabricated by Rébé, while others were designed especially for the film.

THE FALL/WINTER 1969 COLLECTION AND THE ORIENTAL BALL OF BARON DE REDÉ

The Fall/Winter 1969 collection, presented in July, bears witness to a prodigious creative impulse with multiple sources of inspiration. India is represented by "pyjama" ensembles composed of tunics and pants, distant echoes of the traditional Indian costume consisting of tunic (kurta) and pants (*payjama*). Saint Laurent looked to Indian models from the early twentieth century, when British influence first made itself felt with the introduction of buttons on certain articles of clothing—for example, sherwani coats and long achkan jackets. That year's ensembles are made from sumptuous fabrics embellished with gold embroidery: "Saint Laurent's white and gold lamés are very successful ... The wholes are incontrovertibly elegant, and their apparent simplicity dissimulates impeccable tailoring. The evening pyjamas consist of frogged tunics and assorted pants."[9]

When Saint Laurent designed this collection, he was also making costumes for the Oriental Ball of Baron de Redé (1922–2004), which took place at the Hôtel Lambert on the Île Saint-Louis in Paris on December 5, 1969. The baron, an art afficionado and collector, decided to organize this soirée after having acquired a small Indian handkerchief of embroidered silk, which also served as a model for the cardboard invitations.[10]

On the day of the ball, *Women's Wear Daily* published a spread of several of the ensembles that Saint Laurent had designed for it. For Mrs. Arturo López-Willshaw, he created "gold and silver lamé pyjamas"; for Mrs. Patrick Guinness, a "black organza caftan seamed in gold, topaz, and pearls"; for the Baroness Philippe de Rothschild, "aigret plumes over flesh-colored organza pants."

None of the costumes designed for this occasion are in the Musée Yves Saint Laurent. Its collection does, however, include a few related drawings—for example, studies for the headdresses of the Baroness de Rothschild and Guinness. Other surviving drawings, although not identified as such, were classified in the archives of the *maison de couture* as studies for the ball. It seems likely that drawing no. 2019.05.11.1, which recently resurfaced in the archives,[11] is a sketch for the gown worn by Guinness. The headgear and outfit of López-Willshaw (identified as such on the photocopy of a lost drawing), which Saint Laurent characterized as that of a Persian princess, and which corresponds to a watercolor by Alexandre Serebriakoff,[12] closely resembles the gold and silver lamé pajama pantsuits in the 1969 collection. Some of the silhouettes designed for the Oriental Ball reappear in the 1970 collection, notably in its long, buttoned coats made of printed fabric or lamé.

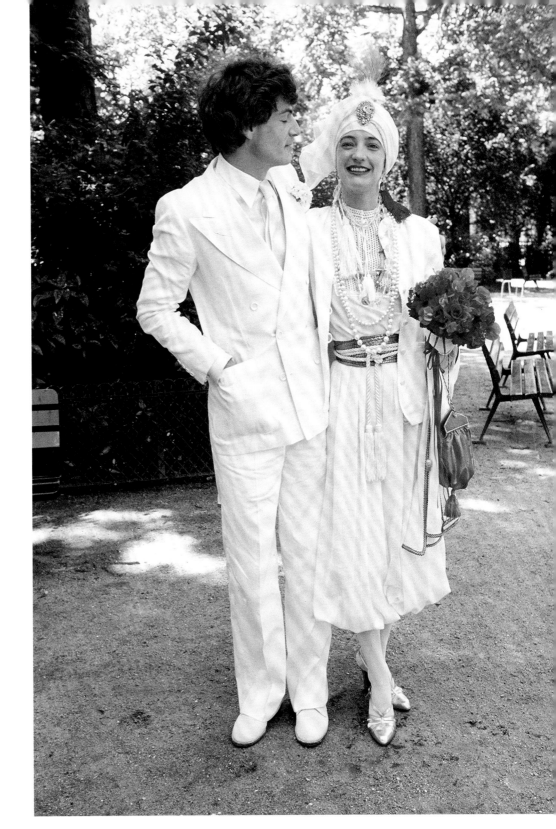

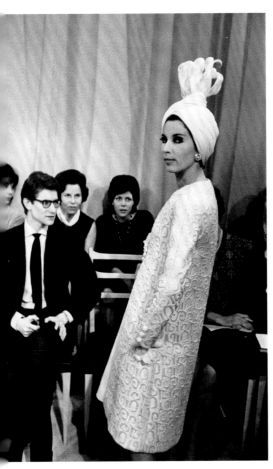

OPPOSITE ABOVE Yves Saint Laurent, evening coat of white quilted silk from Bucol embroidered with pearls by Lesage. Spring/Summer 1962, Haute Couture. House sketch.

OPPOSITE BELOW Yves Saint Laurent, evening coat of white quilted silk from Bucol embroidered with pearls by Lesage. Spring/Summer 1962, Haute Couture. Modeled by Victoire. Photographed by Pierre Boulat.

LEFT Yves Saint Laurent, evening coat of white quilted silk from Bucol embroidered with pearls by Lesage. Spring/Summer 1962, Haute Couture. Modeled by Victoire. Photographed by Pierre Boulat.

ABOVE Yves Saint Laurent, wedding ensemble. Worn by Loulou de La Falaise for her marriage to Thadée Klossowski de Rola, June 30, 1977. Photographed by Mete Zihnioglu.

Robe de cocktail
en gros shantung
violet
Encolure brodée
de corail

YVES SAINT LAURENT
CROQUIS N° 22

Miss Claudia Cardinale

TOP LEFT Yves Saint Laurent,
cocktail dress of shantung from
Hurel, neckline embroidered with
coral by Rébé. Spring/Summer 1962.
House sketch.

TOP RIGHT AND BOTTOM LEFT
Claudia Cardinale, wearing Yves
Saint Laurent, in *The Pink Panther*
(1963), directed by Blake Edwards.

BOTTOM RIGHT Yves Saint
Laurent, long tunic with
embroidered neckline to be worn
by Claudia Cardinale in *The Pink
Panther*. House sketch.

OPPOSITE Yves Saint Laurent
with Victoire during a fashion show
at 30 *bis* rue Spontini, Paris, January
1962. Photographed by Pierre Boulat.

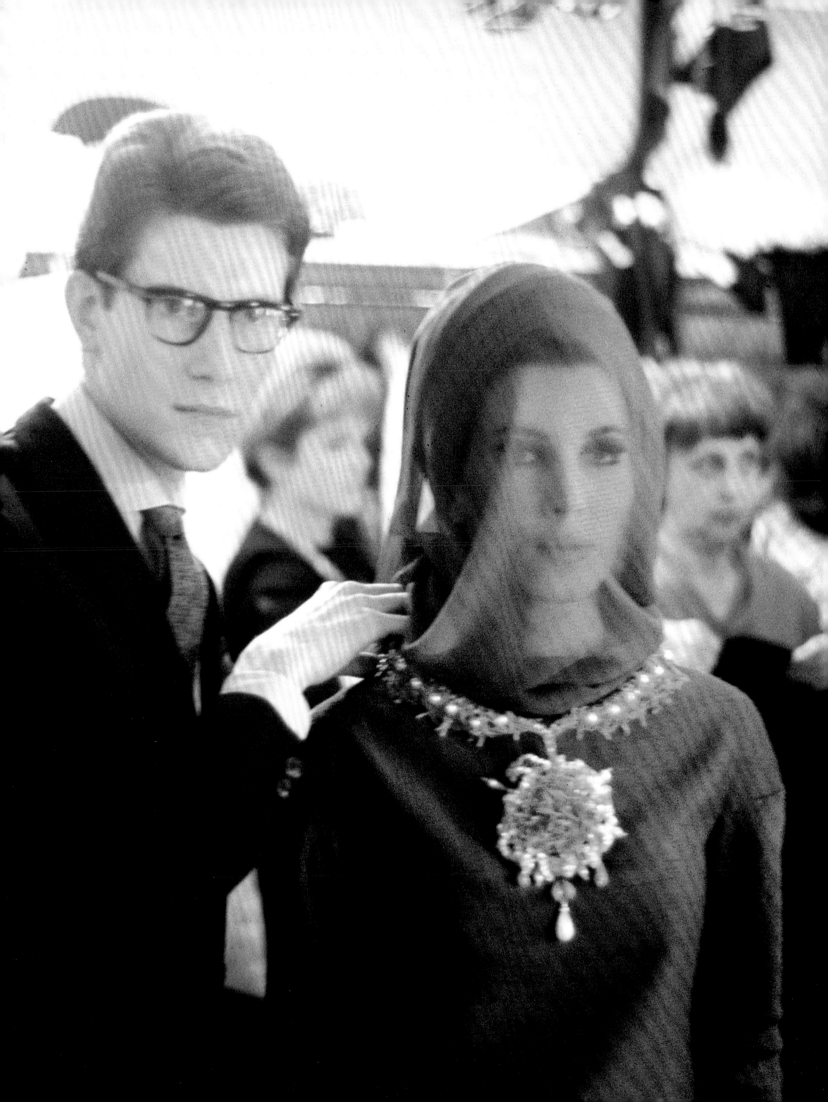

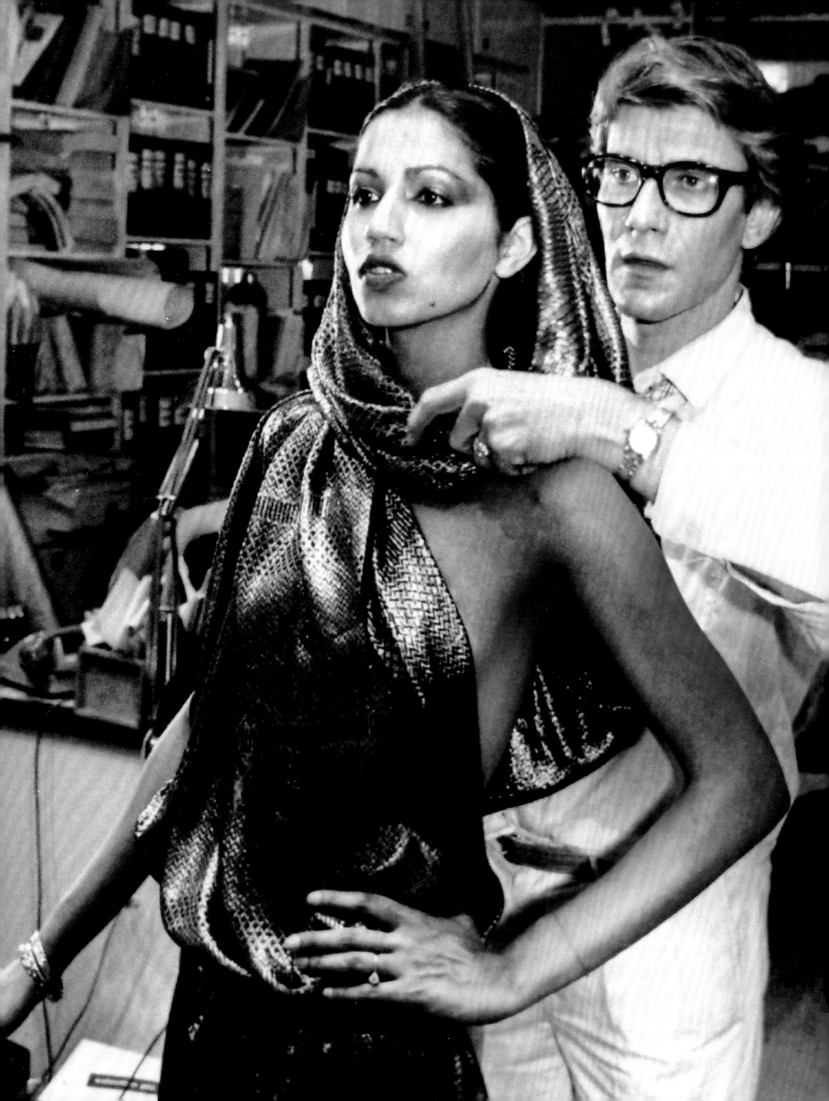

THE INDIAN COLLECTION OF 1982

The 1982 collection[13] included more than twenty evening ensembles of Indian inspiration. Saint Laurent delivered what was, in effect, his personal take on the *jama* coat worn at the Mughal court[14]: an ensemble consisting of a faille skirt and moiré silk top, accompanied by a bolero jacket richly embroidered by Lesage with pearls and artificial stones, crowned by a heavy turban, evoking northwestern India. This ensemble also borrowed from the classic female Indian silhouette consisting of a skirt (*ghaghra*) or *payjama* and a kurta, a short tunic tailored close to the body.[15]

Saint Laurent's use of turbans, and his approach to them, indicates how closely he studied Indian miniatures and maharaja portraits, down to the details of their jewels. In effect, he had his models wear turbans decorated with the *sarpech*, an ornament symbolizing royal power. Among draped garments, the turban, a masculine accessory, occupies a place apart. Its knotting can be complicated, a means of indicating the region of origin, religion, or social and familial status of the man who wears it.[16] Kirat Young, a particularly favorite model of Saint Laurent's and a woman of Indian descent, remembers her astonishment when, in 1982, he had all his models wear this masculine headgear.[17] Incidentally, Young brought Saint Laurent textiles and objects that she acquired during her sojourns in India. He was especially fascinated by the country's vibrant palette. This taught him that, when the proportions are right, the juxtaposition of complementary colors—for example, bright blue and orange—can produce a silhouette that is strong, balanced, and magisterial.

THE SARI

In India, two types of clothing coexist: garments made of several pieces of fabric sewn together, and garments consisting of a single piece of fabric that is draped over the body. Over time, women added a "breast cover" that evolved into a brassiere called a *choli*, worn principally with the sari, the Indian garment par excellence. Saint Laurent, apparently familiar with the various ways the sari could be worn,[18] devised refined variations made of the sheerest muslin, whose subtle transparency suggests the bodily forms beneath without exposing them, as well as of fluid and sensual silk satin and imitation gold lamé, lighter than the standard version, the suppleness of which he could exploit: "Gold because it is purity and flows like a spring that clings to the body until it makes from it but a single line."[19]

There can be no doubt about his having also been influenced by the designs of his master, Christian Dior, who paid homage to the sari in a gown from his Fall/Winter 1955 collection, draped over the bust "in the Indian manner" and accessorized with a turban.

OPPOSITE Kirat Young and Yves Saint Laurent during a studio fitting at 5 avenue Monceau for the presentation of the Fall/Winter 1977 haute couture collection. Photographed by André Perlstein.

ABOVE Saint Laurent Rive-Gauche, evening ensemble of hooded top and dress, both in gold silk lamé from Abraham. Fall/Winter 1991.

FASHION SHOWS IN INDIA

On February 3, 1989, the Year of France in India, a multicity festival ceremonially overseen by Francis Doré, the French ambassador to India, officially commenced in Bombay (now Mumbai). Many events were organized under its auspices, including several fashion shows of Saint Laurent's work.[20] The first took place on Sunday, November 12, before the arcaded gate of the Purana Qila, the old fort of Delhi, built by Sher Shah Suri (1486–1545). India was represented by dazzling gowns and ensembles of multicolored and embroidered silk satin. On Sunday, November 19, before the Gateway of India in Mumbai, looking out over the Arabian Sea, a second fashion show took place under the direction of the choreographer Bernard Trux. Forty local models were selected for the occasion. They moved to the strains of Ravi Shankar's sitar and music by the American composer Philip Glass: "Their sounds are perfect for the wardrobe that attempts to capture the Indian spirit of today. ... Indian materials, fabrics and colours have always inspired Mr. Saint Laurent," Trux commented to the *Indian Post*.[21]

Saint Laurent was among the first Western fashion designers to use models from India in his runway shows, thereby recognizing their allure and contributing to the trend of acknowledging non-European canons of beauty. This artist-couturier succeeded in devising a syncretic vision of India, a country that he never visited but whose essence he somehow came to understand.

ENDNOTES

[1] Article in *L'actualité*, July 15, 1991.

[2] Lucille Schulberg, *Historic India* (New York: Time Life Books, 1969).

[3] Roshen Alkazi, *Ancient Indian Costume* (New Delhi: Art Heritage Books, 1983).

[4] Codified in the *Natya Shastra*, a treatise on theater, dance, and music attributed to Bharata; see esp. *Rasa: Les neuf visages de l'art indien* (Paris: Galeries nationales du Grand Palais, 1986).

[5] Schulberg, *Historic India*, 87.

[6] Dino Buzzati, "L'A Solo' di Saint Laurent chiude la prata della moda," *Corriere della Sera* (May 30, 1962): 2.

[7] Press dossier for the perfume Opium.

[8] *À la cour du Grand Mogol* (Leipzig: Edition Leipzig, 1967). This elaborate ensemble, commissioned by Frederick Augustus II of Saxony for his palace in Dresden, was made by Johann Melchior Dinglinger and his two brothers, Georg Christoph and Georg Friedrich, in 1701–8.

[9] *L'Officiel*, October 1969.

[10] Jean-Claude Daufresne, *Fêtes à Paris au XXe siècle: Architectures éphémères de 1919 à 1989* (Sprimont, Belgium: Mardaga, 2001).

[11] Rediscovered by Domitille Eblé, curator of the graphic arts collection, Musée Yves Saint Laurent.

[12] Watercolor reproduced in Hugo Vickers, *Baron de Redé: Souvenirs et portraits* (Paris: Éditions Lacurne, 2017).

[13] Introduced January 27, 1982.

[14] From the reign of the Mughal Emperor Akbar (r. 1556–1605), masculine dress customarily consisted of pants and a high-waisted coat whose lower portion was an ample skirt called either a *jama* (when it fell from the armpit) or an *angarkha* (when it fell from the chest), always secured at the waist by a belt known as a *patka*.

[15] B. N. Goswamy, *Indian Costumes in the Collection of the Calico Museum of Textiles* (Ahmenabad, India: The Museum, 1993), 136.

[16] Rosemary Crill, *Hats from India* (London: Victoria and Albert Museum, 1985), 19.

[17] Interview conducted April 26, 2018.

[18] Perhaps from perusing these books: Kamala S. Dongerkery, *Jewelry and Personal Adornment in India* (New Delhi: Indian Council for Cultural Relations, 1971); Roshen Alkazi, *Ancient Indian Costume* (New Delhi: Art Heritage Books, 1983).

[19] Yves Saint Laurent, manuscript letter.

[20] The major events of the festival were organized by Martand Singh, secretary of the Indian National Trust for Art and Cultural Heritage. The first took place at the Oberoi Hotel in New Delhi on Friday, November 10.

[21] "Marching Behind the Saint," *Indian Post*, November 24, 1989.

OPPOSITE Yves Saint Laurent, sari-gown ensemble for evening, consisting of a sheath dress and a draped wrap, both in gold lamé Chantilly lace from Hurel. Fall/Winter 1990. Modeled by Tatiana.

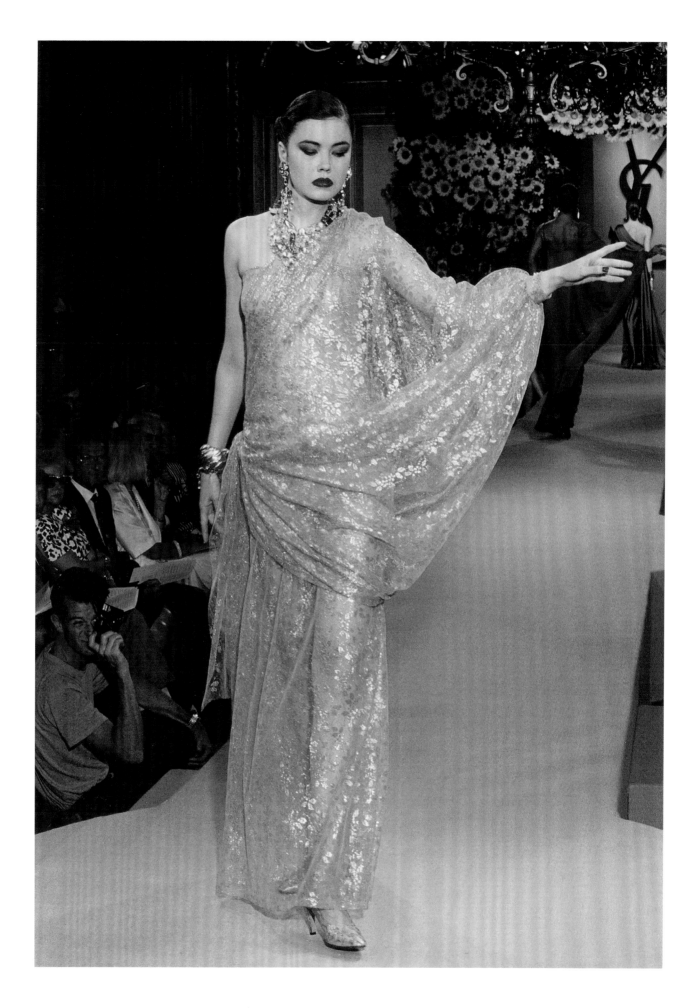

LEFT Alexandre Serebriakoff, *Baron Alexis de Redé's Le Bal Oriental*, 1969. Watercolor.

BELOW Yves Saint Laurent fashion show at the Purana Qila, Delhi, India, November 12, 1989.

OPPOSITE Yves Saint Laurent, evening ensemble of bolero jacket in grosgrain silk from Abraham embroidered with pearls and cut glass by Lesage and bustier bodice in grosgrain silk from Abraham, dress in faille moiré from Taroni, belt embroidered with synthetic stones from Leroux, turban in shantung with "shooting star" brooch of metal and rhinestones from Sabbagh. Spring/Summer 1982.

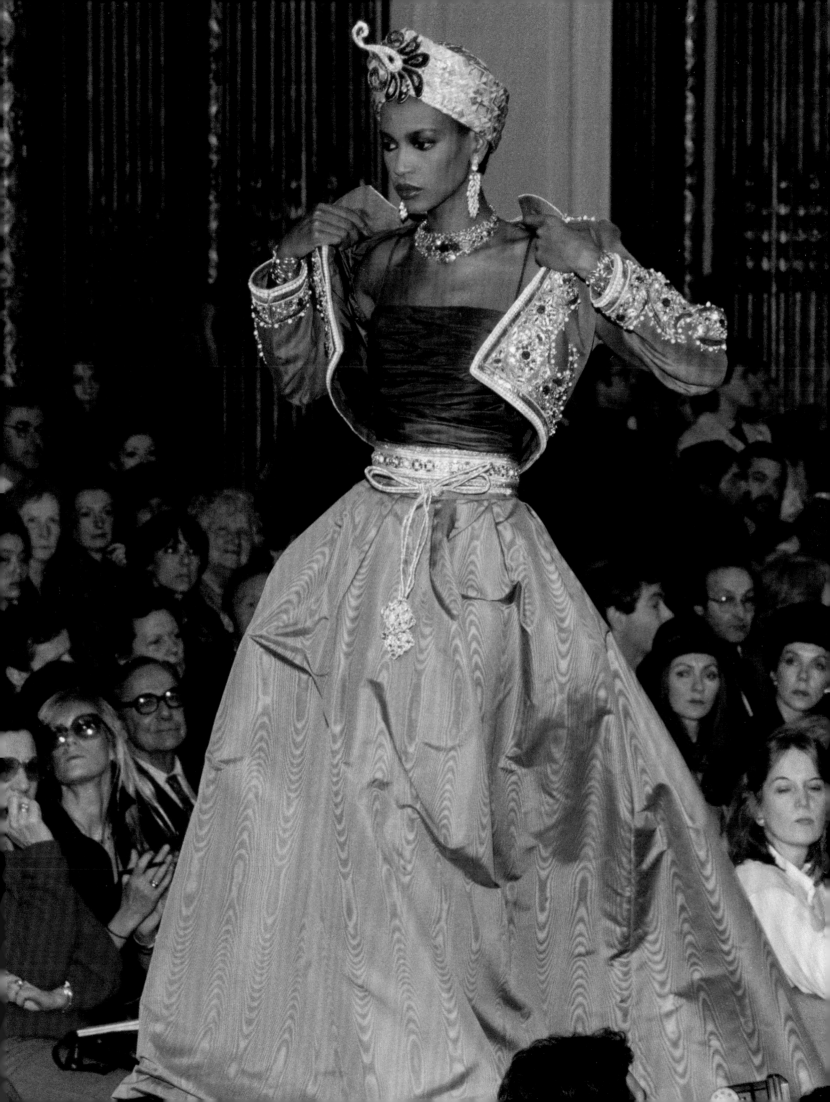

THREADS AND STITCHES

LAILA TYABJI

Textiles are the warp and weft of the Indian subcontinent—the culture and aesthetics embedded in its handloom threads, rooted in the landscape and community. They are not just functional fabrics for furnishings or clothing, dictated by market forces or need. They tell stories, contain clues of who people are and where they come from.

Their materials, colors, and motifs reflect geography, gender, creed, community, class, and caste—even marital status. Until recently, fashion trends had little influence on weaves and patterns, colors, or styles of draping. The weather, class, and community were the influencers.

In northern Karnataka, for instance, for centuries rural women all wore checked or striped Ilkal saris with decorative maroon borders. The body of the sari came in a handful of standard colors ranging from indigo blue and red through green, mustard, and gray. From the color one could tell whether the wearer was unmarried, a wife, a mother, or a widow. In other parts, the wearing of silk satin next to the skin was prohibited for those not of royal birth. Ingeniously, to circumvent this restriction, *mashru* and *himroo* weaves were developed with the silk threads on the surface of the fabric and cotton on the underside. In Kutch, the ornate mirrored silk and gold embroidery of the region was the prerogative of the rich, so embossed lacquer *rogan* work and tinsel printing replicated the look without the expense.

In Kutch, Sind, and parts of Rajasthan, a woman's embroidery, part of her dowry, was essential evidence not only of her domestic skills but also her creativity and identity. Today, sadly, women are so busy embroidering for a living that some communities have forbidden them to embroider for themselves. Nevertheless, each Kutchi village and community, even those a few miles away from each other, have their own distinctive style and stitches, instantly recognizable as being Rabari, Ahir, Jat, Mochi Bharat, Meghwal, and Sodha Rajput. Dispelling the notion that embroidery traditions remain timeless and unchanging, a craftswoman can date a piece of embroidery to within a decade from its colors, design, and the way traditional motifs such as peacocks and elephants are portrayed. Sometimes they can even recognize their grandmother's or mother-in-law's hand in the combination of stitches. Often the base fabrics are recycled old fabrics, adding yet another layer of textural memory. In Bengal they quilt together their old saris and embroider with the colored threads from the woven borders.

As the world changed, so did India, and today both urban and rural consumers are influenced by international trends and advertising projected 24-7 on their television screens and phones, on TikTok and Instagram. An example is the increasing popularity of black, hitherto not part of either male or female attire in India (and not an ideal choice in our hot climate), the exception being the all-black costumes of Rabari tribeswomen in Kutch. Even for mourning, white is the traditional hue.

At the heart of Indian textile design is color, often carrying symbolic meanings as significant as the motifs. Blazing rani pinks and oranges; the vivid glow of indigo, turquoise, and emerald greens; singing saffron and lemon yellows—the palette does not change every season according to the whim of some distant fashion forecaster. There are seven identified shades of white—each with its own poetic name, linking it to the moon, to flowers, to clouds. For these cultural reasons, adapting to the shifts and changes of the urban market can be difficult.

While I was working with Ahir embroiderers in Kutch in the 1980s, the women liked my interpretations of their classic stitches and motifs but deplored my choice of colors. "Laila *ben* knows a lot about embroidery, but her color sense is awful," said one, hating my earth tones and "boring," muted shades. Interestingly, as their eyes adapted,

OPPOSITE Sona, an Indian artisan, stitches embroidery in Hodka, a village in the Kutch district of eastern Gujarat state. Kutch is world renowned for its mirrored embroideries, traditionally stitched by village women for a multitude of applications including garments and decorative objects.

they began to enjoy playing with subtler combinations. One even worked a mirrored blouse in whites and creams for her daughter's trousseau.

Using ancestral memory and the inherent skill of their hands as a means of earning was an extraordinarily liberating experience for these rural embroiderers, giving identity and independence to women hitherto solely known in relationship to their husbands or fathers. This new reality has enabled them to become decision makers in both home and community, to have their own bank accounts, to purchase more efficient gas cookers for the home, and to give their daughters and sons an education.

In other parts of India, it was traditionally men who were the master artisans—the embroiderers of Lucknow creating white-on-white *chikankari*, the workers in gold *zardozi*, or the artists of Kashmir with their *ari* and *sozni*—and they worked for the market rather than for themselves. Their patrons were kings, courtiers, and temples—not their peers.

It is important to remember that Indian textiles may occasionally be identified as fine art, but they are primarily a traditional craft and livelihood. The textile industry is the largest single source of employment after agriculture, geared to producing a demand-driven consumer product. Weavers, along with spinners, printers, and embroiderers, form India's second largest employment sector, whose numbers range in the countless millions. They are professionals whose knowledge systems and skill sets are unique to India, are unparalleled in the world, have a minimal carbon imprint, and are perfectly suited to local conditions and production systems.

Though its creators are anonymous, the motifs, techniques, and styles are incredibly diverse—woven, waxed, embroidered, appliquéd, brocaded, block-printed, painted, patchworked, tie-dyed, tinseled. The fabrics are equally varied—silk, satin, *tussar*, *eri*, cotton, linen, goat and sheep wool, and now banana, nettle, and water chestnut fabric. Fabrics that vary from sheer eight hundred count muslin as soft as spun clouds and pashmina that passes through a ring to thick textured tweeds, *tussars*, and raw silks—India produces them all. These fabrics are woven on looms that vary from region to region, suited to the yarn and traditional weave of each area. There is concern now that these fragile skill sets and knowledge systems may not survive the onslaught of industrialization and globalization.

Kabir, the beloved fifteenth-century Indian mystic weaver-poet, said that God Almighty is also a weaver. The spinning of yarn and weaving of handloom cloth is a metaphor used in India over the ages: for creation and for the interplay of genders, cultures, communities, and skills that make up our universe. The message in these verses is that the mingling of multiplicity and diversity leads to unity and strength, and that when different strands come together, they create a fabric that is not only beautiful but also resilient and durable. This is a vital message for the world today, in these increasingly divisive times.

François Pyrard de Laval wrote in the seventeenth century, "Everyone from the Cape of Good Hope to China, man and woman, is clothed from head to foot in the product of Indian Looms." Five million yards of cloth were dispatched annually from just one port in Coromandel, and India grew fabulously rich on the proceeds. As we rediscover the beauty of handmade and handwoven, of slow rather than mass-produced fashion, that day may come again.

OPPOSITE Women wearing the traditional *ghagra* and *odhni* in Rajasthan, India.

ABOVE Women folding saris that have dried in the open air at a sari factory in Rajasthan, India.

INDIA AND ITS
CRAFTS

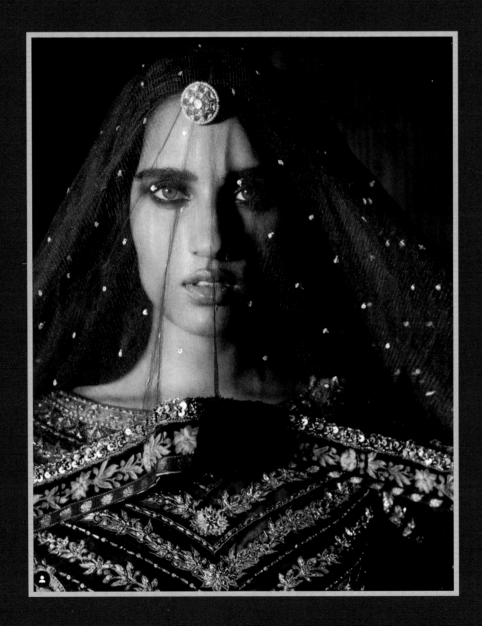

PRIYANKA R. KHANNA

I t could be said that it was a stroke of serendipity that led to the birth of the Indian fashion designer and the Indian fashion industry as we know it today. The catalyst: a museologist and art historian named Ritu Kumar, who stumbled upon a printing unit in an old mansion in Serampore, in West Bengal.

To have Kumar tell the story of her fashion label is to be drawn back into a newly independent India. A handwoven fabric, khadi, had become the symbol of the country's Freedom Movement, and in the decades that followed, fashion shows hosted by textile mills such as Calico and Hakoba traveled the length and breadth of the country to showcase their fabrics; the role of a fashion designer was nonexistent. Most of the country, reliant on mill-made polyester and synthetic cottons to outfit their wardrobes, was known to make their way to the neighborhood tailor, with magazine tear sheets and film posters, in hopes of re-creating pieces from *Vogue*.

"When I hear it said that the Indian fashion industry is nascent, I just smile," Kumar told me. "It's been there for thousands of years; you just had to bring your design perspective to the discipline of craft." For any study of India and its craft traditions, it's important to first define craft in today's context. Author, curator, and textile expert Mayank Mansingh Kaul has dedicated his career to delineating the differences in craft and design. "Is everything handmade craft? No. In my opinion, it's the processes that cannot be replicated by machine, where you can see the visible intervention of hand—*that* defines craft."

For Kumar, the first two decades of her career were spent in a process of discovery and in fashioning a new cultural identity that took pride in indigenous aesthetics. From that introduction to printing on silk in the Danish settlement of Serampore to the art of *zardozi*, embroidery done with metallic threads, in the interiors of Bengal, where paved roads and electricity did not exist, she traversed the country learning a wealth of techniques and traditions.

"I started with polka dots. I had no reference points, no visual vocabulary. I found a family of old block makers, who miraculously had kept their blocks—most others had used theirs for firewood—and I put together a collection of saris that I then sold out of a small garage," she said about her accidental foray into hand-block printing. The wooden blocks would become the most important tool in Kumar's sartorial arsenal, defining her legacy. "It [block printing and vegetable dyeing] is an alchemy. I learned, under trees in remote villages, which herbs give you yellow, how to get the perfect green. Every time I went to another school of printing, in another state, on another riverbank, they had a different repertoire. It's India's precious secret." Soon, she was expanding from block printing to *bandhani* and to the use of a finer *zardozi*, incorporating it in bridal silhouettes, making her the wedding designer of choice for decades.

Over the past six decades, Kumar's label—entirely, by her own admission, built on craft—has expanded into five labels, with nearly ninety stores across the country, catering to multiple segments of the market.

While it was Kumar who reminded a country of its forgotten legacy, and in the process became a household name, it took until the late 1980s and 1990s for "made in India" to be recognized as a badge of creative expression rather than just as a manufacturing label. Thanks to government incentives, India's export apparel industry (valued at $85 billion in 2021) was gathering steam; incidentally, its surplus product was often sold locally, creating its own retail footprint.

The mid-1980s saw, in a first-of-its-kind crossover, designer Asha Sarabhai come together with Issey Miyake on a label called Asha by Miyake Design Studio, with a focus on the best of Indian craftsmanship. In 1986, the government established the National Institute of Fashion Technology (NIFT), modeled on the Fashion Institute

OPPOSITE Ritu Kumar, black and gold embroidered blouse and *dupatta*, 2019 RI Ritu Kumar collection.

of Technology (FIT) in New York. That same year, the National Institute of Design, set up in 1961 on the recommendation of designers Charles and Ray Eames, introduced an apparel design course. A year later, Ensemble, the first multi-designer store (conceptualized by the late designer and industry pioneer Rohit Khosla along with Sal and Tarun Tahiliani, and still standing today), opened its doors. Design in India was finally gaining momentum.

The country's consumption patterns were also changing. There were the cottage industries that promoted Indian handicrafts and weaves while a hybrid Indianized Western wear was promoted by a few boutiques in Mumbai and Delhi. But a bridge was slowly being built. Abu Jani and Sandeep Khosla were crafting a fashion narrative, inspired by the vastness of India, bringing it to the women they dressed in a contemporary form. While the duo experimented initially with fabric techniques—*bandhani*, crushed silk, *jamdani*—they found their metier in *chikankari*, the embroidery form said to have been developed under the patronage of Nur Jahan, but which consequently fell out of favor, its artisans left in an abysmal state.

After much trial and error, Abu Jani and Sandeep Khosla created their own stamp, by intervening with the number of wooden blocks (traditionally one or two were used, while the duo used up to twenty-five), to create complex forms and motifs, many soon recognizable as a signature. They popularized the use of chiffon, organza, and georgette as a base fabric; added embellishments in the form of crystal, *zardozi*, and sequins; and used silhouettes that spanned saris, *lehengas*, and jackets. Even today, the duo work with *karigars*, mostly women, who specialize in this technique, in villages near Lucknow. "Our biggest driver has been the craft. Every embroidery *khakha* has been drawn by Abu, and then translated by our craftsmen. The magic has always been in creating heirloom pieces and to have the *karigars* interpret the techniques of their ancestors," says Khosla.

As Khosla succinctly notes in Abu and Sandeep's book *India Fantastique*, "We feel that the artisan is better than the design student."

Students of design were growing, and by the mid-1990s, the first batch of graduates from NIFT were testing the waters with their own labels. Ritu Beri would go on to helm Parisian house Jean Scherrer, as did her maximalist classmate Manish Arora at Paco Rabanne, while JJ Valaya dove back into the textiles and traditions of royal India. But bringing in a shift in design language was Rajesh Pratap Singh, whose artisanal approach to design, along with clean lines, intricate detailing (especially the pin tuck), and experimentation in fabric heralded a new wave in India—one that would influence many for years to come.

Questions of a contemporary Indian fashion identity were also on Tarun Tahiliani's mind. Tahiliani started Ensemble with the goal of altering the practice of the best Made in India pieces being sent abroad, while locals were resorting to cheap copies and export surplus. But his focus soon shifted to the need for design that married new proportions and forms with India's textile-rich heritage. "Traditional tailoring techniques were not known. This was a moment of transition from a textile society to a ready-to-wear society, but no one could cut a sleeve," Tahiliani said of his decision to study at FIT in New York. "I learned details of embroidery on the job, watching the *karigar* at work, but I couldn't sew or create a structured drape." In his first collection, he used handloom textiles, deftly working with them to create a texturally strong line of flamboyant skirts, jackets, long-layered kurtas, and layered separates with pin-tucked detailing, intricate *jaals* and trellises, semiprecious stones embedded into collars, and a flatter, finer embroidery rather than the coarse, thick version that was prevalent. "Craft tradition has been the basis of our work; our business is wholly dependent on *karigars*. They are the invisible hands guiding this industry forward."

OPPOSITE Sabyasachi, embroidered *lehenga*. Modeled by Padma Lakshmi. Photographed by Kristian Schuller for the May 2019 issue of *Vogue* India.

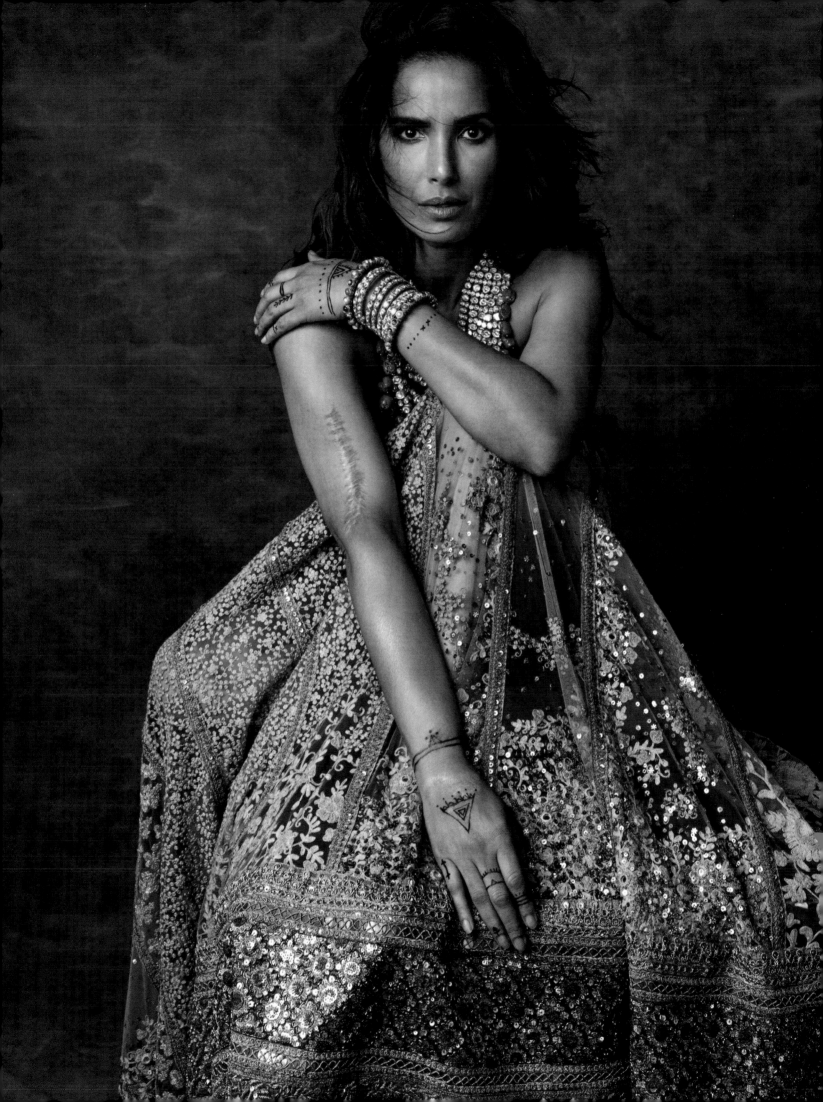

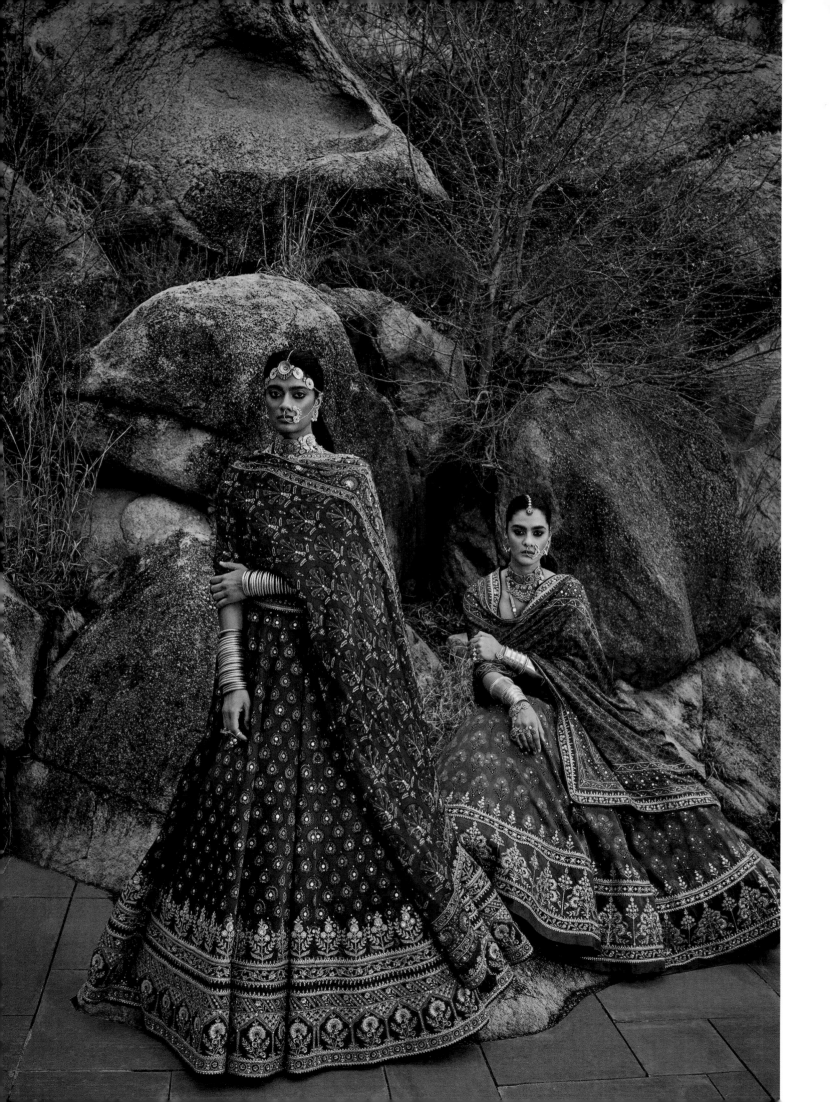

It requires empathy and a deep understanding to respect these human hands, Anita Dongre told me. Like Kumar, Dongre started her fashion career with block printing and *bandhani*, inspired by her home state of Rajasthan. "My signature has become combining different crafts—*gota-patti*, *bandhani* from Gujarat and Jaipur, *zardozi*, brocades from Benaras, hand-painting again from Jaipur—there are so many combinations. As we speak, I am working on a *bandhani* and block-printed collection, which goes to show that even thirty-four years later you can go back to the same combinations and look at them with a fresh perspective." Dongre was one of the first Indian designers to receive corporate funding, and today her group—which includes Anita Dongre Bridal, AND, and Global Desi—employs more than 2,500 people directly and has over a thousand points of sale.

Her motivation now is in using craft for change. The Anita Dongre label under its initiative Grassroot works with the women of the Self-Employed Women's Association (SEWA), an organization dedicated to empowering rural women across different craft industries. "We are now committed to providing work to over five hundred women. I can see the direct impact on the artisan, and marrying design with the craft of each cluster is incredibly complex but at the same time fascinating. We bring together their technical skills and consumer needs." For the launch of Grassroot in 2015, artisans walked the runway, and in her 2018 campaign, Dongre used Bachiben, one of SEWA's oldest members, the designer's way of putting a face to these largely invisible hands.

The complexity of the designer-*karigar* relationship is mired in a heavily skewed societal system. Conversations today raise questions on the value hierarchy in this dynamic, and the answer to "Who made my clothes?" is often murky. When Sabyasachi Mukherjee collaborated with H&M in 2021, the first Indian designer to do so, the most voluble criticism came from senior members of the crafts community, raising concerns about the future of artisanal crafts and the missed opportunities with this collaboration. Mukherjee's response: "Designed in India" should carry as much weight as "Made in India."

In 1999, when the Kolkata-based designer launched his craft-heavy label, with a strong design language, he believed that the energy and mood of Y2K India demanded a new iconography. "I work craft backward, you see. I make a commitment of doing different collections—one with Benarasis, one with *chikan*, one with *kantha*, one with Kanchipurams, one with block print—to support different clusters, and from start to finish we create our own textiles, fabrics, and prints; manufacture, advertise, and market them extensively; and then retail. You could say we are the fashion equivalent of farm to table," he said, laughing. "Over the years, we've aggregated over 6,500 *karigars* employed for the label directly and indirectly." In 2021, in the middle of a pandemic, Mukherjee's vision was validated when the brand closed the biggest corporate investment deal in Indian fashion; the funds, according to Mukherjee, will only make the crafts sector stronger, through plans for microfinancing, educational initiatives, and infrastructure development.

A large part of Mukherjee's success has centered on bridal couture, indisputably the most commercially relevant segment of the Indian fashion industry today. The wedding industry in India is pegged at $50 billion, the multiday, extravagant celebrations requiring elaborate looks for the bride, groom, and extended families, as well as a generous bridal trousseau. Mukherjee, Manish Malhotra, Abu Jani and Sandeep Khosla, Anita Dongre, Tarun Tahiliani, Gaurav Gupta, and Rahul Mishra are just a few of the bridal favorites, each bringing their focus on craft and tradition, all with a signature aesthetic.

While bridalwear commands a lion's share of the attention and the market, a new generation of designers birthed by the millennium brought purpose and a platform to

OPPOSITE Anita Dongre, *dupattas* and *lehengas* in natural dyes and *ajrak* hand-block prints with intricate hand-embroidery featuring *gota-patti* along with *dori*, sequins, and *zardozi*. 2021 *Ode to Bhuj* collection.

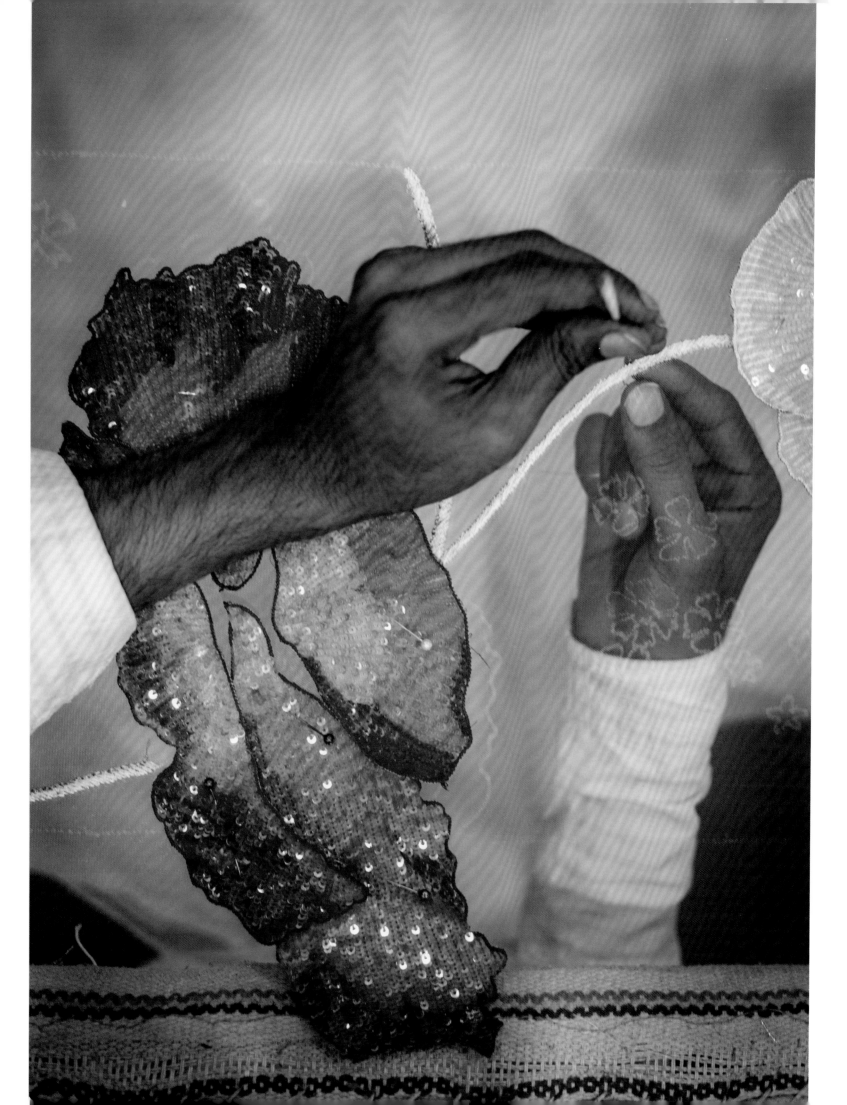

The fascination with craft in India stems from its scale; in no other country are artisans perpetuating centuries-old traditions in such a widespread and unregulated manner. As the Indian fashion industry expanded, it also brought into focus the different business models that bring the *karigar*'s work to the stage. In the Western tradition, the concept of ateliers is well understood; in India, there is often a hybrid approach; while most of the larger fashion houses have brought *karigars* and their skills in-house, others choose to adopt a decentralized model, employing clusters of entrepreneurial master craftspeople across the country.

When the pandemic hit in early 2020, the lockdowns were devastating for the artisan community. The Indian handloom and handicrafts sector is considered the second largest in the country, employing, some reports say, over twenty million, but the sector is largely disorganized and lacking infrastructure. The artisan's livelihood was devastatingly impacted. The cancellation of international orders, the downsizing of the Indian wedding and its grand budgets, the uncertainty of work, led many to flee urban centers back to their villages to look for new sources of employment. It prompted a series of important conversations on the transparency of design, on providing supportive frameworks, on creating new models of livelihood, with the artisans at the center, and ensuring the continuity of centuries-old traditions. A paradigm shift was clearly needed. In a series of interviews I conducted in May 2020, designers spoke about pivoting to network manufacturing (providing work in the *karigars*' own villages), creating a more transparent financial structure, and giving artisans the respect and dignity they deserve.

In a country where craft is revered in tone, but the craftsman is often forgotten, the realization that theirs is not a daily-wage job but a calling is the biggest change that needs to come about. How this pandemic affects the continuation of the crafts and traditions is yet to be seen, but it furthers the important conversations and questions on the changing dynamic between design and creation. "Design has a purpose to play," said Sanjay Garg of Raw Mango, who is appreciated for the responsible brand narrative he is building vis-à-vis the designer and the craftsperson. "A design intervention was needed, but I am an activist, too, and it needs a holistic approach."

It's the inherent hierarchy that is incredibly problematic for Kaul. "The systemic nature of who is the value creator and the value add needs to be defined and recognized. You cannot use a moral factor for profit, unless it's really reaching the *karigar*. The conversations around the Indian *karigars* and the business they help support need to be had."

For Kumar, who has six decades of experience and has seen the industry evolve, the relationship is clear. "You are not the designer; you have to put that away. You are the catalyst, putting two things together. What India has, that sets it so far apart from any other country, is a lineage of memory and skills, and that needs to be protected at all costs."

OPPOSITE A *karigar*, or artisan, works on a poppy motif embroidery for Rahul Mishra's Couture Fall 2022, *Tree of Life* collection.

DESIGN
PROFE

ABU JANI & SANDEEP KHOSLA

ALIA ALLANA

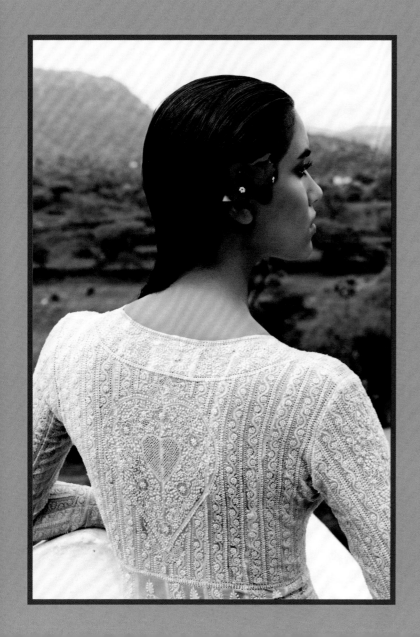

M uch before there was a fashion press, when boutiques were an informal preoccupation for wealthy women, Abu Jani and Sandeep Khosla—two esteemed figures in Indian fashion—dreamed of a modern revival of their country's textiles and embroideries. Their immense skill, innovations, and popularity led them to dress three generations of well-known Indian women.

ALIA ALLANA: *Sandeep, how do you and Abu conceptualize a collection together?*
SANDEEP KHOSLA: We work on everything together, almost. I'm much more fantasy. I am the ideas person, and he's a much more practical person. He understands that fantasy, and then he calms it down. That's how our partnership has worked so wonderfully. The beginning of every collection is rendered by Abu—he is a beautiful sketcher. He's done all our embroidery drawings for years.

Once, we were driving by the Old Fort in New Delhi, and I said, "Why don't we do this in embroidery?" He created a beautiful structure that we [then had] done in *resham*. Abu has a huge knowledge of embroidery.

White is our favorite color. Having said that, all colors are our favorites! Every fashion show we do, we will have a bright collection, we will have a jeweled collection. We don't like sad colors. We love pastels. We've introduced colors to the Indian palette. Some designers are still doing *ghagras* in maroon, which looks terrible against our skin.

AA: *Does Abu give interviews?*
SK: No, not at all, because people ask the same questions, such as "What is your inspiration?" and he's like, you just saw the collection and there is a press note.

AA: *How did you get into textiles?*
SK: It began at Mata Hari, our first shop. We were ghost-designing at that time. There were lots of rich women whose husbands would give them pocket money and tell them, "Come on, open a boutique," so they would hire people who would create something for them. We opened Mata Hari with eighty pieces, not one looking like the other; that was the kind of drive we had.

Very early in our career, when there was no fashion press saying that our work was gimmicky, it was all about the craft. We had carte blanche, and that's when we started doing silks. Those were the days of Hong Kong's synthetic polyester, around 1987. Not many people used pure fabrics. That's when we went to pure cotton. Abu and I had decided that we would not work with synthetics. We used to buy Gadwal saris that were pure cotton with real *zari* borders, and then we bought *tanchois*. That's how our romance with textiles started. Tarun Tahiliani saw us at Mata Hari and asked us to be a part of Ensemble.

AA: *Was Ensemble a seminal moment in Indian fashion?*
SK: Absolutely. Tarun was the first one, along with Rohit Khosla. Tarun had the means and the vision.

AA: *What was your collection like?*
SK: We did lovely dhotis with drapes, beautifully constructed tissue jackets, and, in those days, tissue was beautiful. It used to be thick. Today the material you get is not even a patch. *Jamdani* was a very big influence, which [weavers in] Benaras used to do beautifully at the time. Textiles, then, were cut so beautifully; the finishing was so beautiful.

OPPOSITE Abu Sandeep, kurta featuring Abu Jani–Sandeep Khosla's signature *chikankari* embroidery, designed and made by hand by women in Lucknow, Uttar Pradesh, in 2010.

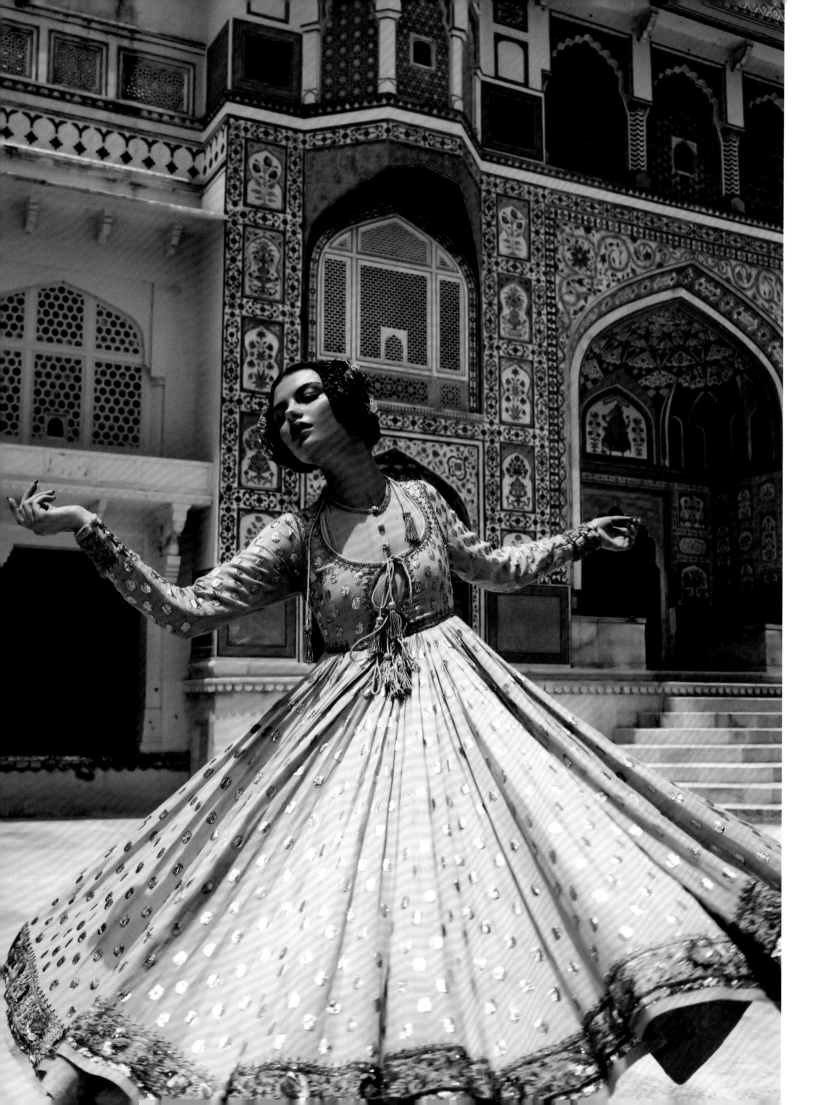

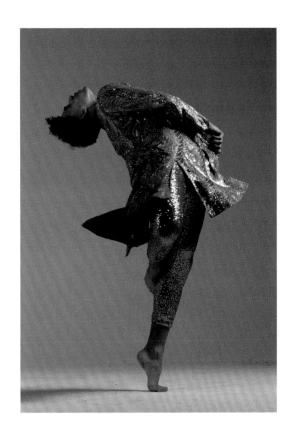

AA: *What do you think happened?*

SK: It became commercial. Agents came in between. The weavers were not directing themselves. The demand was faster than the supply. When we did *chikan*, we were the only ones.

AA: *How did you come across* chikan?

SK: We've always loved *chikan*. We had seen the movie *Pakeezah* [1972] with its sophisticated sets and costumes. *Chikan* is a craft we loved, and we had a passion to revive it. We went to a printer with a tablecloth, with silk on the border and chiffon in the center. He had two thousand blocks in his possession, but he never used them because in the early 1980s and 1990s they were just printing one block on top of another with no proportion, no neckline, no sleeve. Wherever it got cut, it got cut. He was not even going to match the back of it. It took us five days to print just the sample. He said that it would be impossible because we were doing it in chiffon and that it would tear because *chikan* goes through three hearty washes. Eventually it worked, but people hadn't seen printing like this before.

AA: *You've been credited with playing a role in* chikan's revival.

SK: It was on the edge of being common. People wore it to work. Our mission was to put *chikan* on the map, so that people would want to wear it to their weddings. From [the height of being used by] the Mughals, it went to nothing. Craft can only survive if there are people there to promote it. Thirty-five years ago, there was a new generation of rich people. When money changes hands, craft flourishes, and there is a new energy in the market because people are more willing to experiment.

AA: *Were some of your initial designs the outcome of experiments?*

SK: We started the whole crush [fabric] movement by fluke. Fortuny did his silk gowns in the early twentieth century, and then Mary McFadden had her pleated synthetic dresses in the 1970s and 1980s, but ours literally just happened. We stained the garment, we washed it, and opened it the next morning, and it looked crushed. I said, "Abu, let's keep it like this, let's not iron it," and then we made twenty more garments and crushed them, and that's how it happened.

A few days later, Abu Jani gave a rare interview and joined Sandeep Khosla and me in conversation.

AA: *What were your early influences?*

ABU JANI: India has so many inspirations that you need a lifetime in textile. We started with Benaras, Gujarat (*bandhani*), and then we did crushed fabric accidentally, which is Lucknow. The Nawabs used to do it to their sleeves, and women would crush their *dupattas* and add *ajrak* and *maika* that would make it glitter. It was very romantic to have those women in this little glitter. We then moved toward Kerala, because we loved white. There is a very fine cotton from Kerala called *muthu*; we did a white collection and then we did khadi because we always liked white in its pure state.

AA: *How were you exposed to this?*

SK: We've seen our mothers wear it.

AJ: In the Muslim households, the *dupattas* were like chadors. They drape very differently. Bohri women's *dupattas* are edged with *koran*, which is a silver wire wrapped at the edge.

OPPOSITE Abu Sandeep, *anarkali* made from handspun khadi embellished with Benarasi *gota* dots and hand-embroidered *zardozi* borders, 2002. The *anarkali* is a full-skirted silhouette, credited to the Mughal era.

ABOVE Abu Sandeep, "The Dance of Ecstasy" sherwani-style jacket embellished with crystals and sequins in three-dimensional peacock feather motifs, paired with sequin pants, 2005.

SK: And they do a crochet lace.

AJ: We introduced that crochet with our *chikankari*. There are some influences you have from home. My mom was very handy. She had a machine at home. She knit sweaters, wrapped gifts. I think it was just that. Even in Sandeep's family, his mother was very stylish in her dress, in beautiful woven saris and a big bindi. The thing is that when Sandeep and I started, we were like blank slates. We had no background, there was no fashion school, it was just excitement.

SK: And a lot of fantasy.

AJ: And overwhelming creativity that was bouncing between us.

AA: *And this manifested itself in modernizing textile and embroidery?*

AJ: Sandeep comes from a royal state, Kapurthala, full of palaces and royalty. He's seen architecture, beautiful structures, textiles, and jewelry. He's more of a revivalist than I am. I will execute it, but he's got a larger vision.

SK: We've never hesitated in spending money where experimenting was concerned. At one time we wanted to do a Roma collection, with beads and beads and beads. We made five blouses; one sold. We sold many skirts, but the blouses were too heavy; on the runway, they looked superb. That was half the battle won. There is a floral line, Dhaka, that we did twenty years ago; every time we reintroduce it in any format, it still sells.

AJ: Even Kutch embroidery. We saw it. It's ethnic and beautiful, multicolored with round mirrors. We asked, "How can we give it an Abu Sandeep take?" So, we used the mirrors but put *zardozi* on it. That was not just reviving it but reviving it in a more contemporary way, and that was our take.

AA: *It's impossible to not speak about your dedication to* chikan.

AJ: Sandeep immediately said that if we have to do *chikan*, it has to be on a luxurious fabric because we want women to wear their *jadau* jewelry on *chikan*. *Chikan* was an everyday textile. Our chiffons tore, our organzas tore, our georgettes were in smithereens, but we never gave up. It took us two years to get ten pieces; and then we collected twenty pieces and had our first exhibition. We had to invest to see how we could do it on fine fabric.

SK: Even students today, when you get them out of all these institutes, they know very little about textiles.

AJ: That's what pains me. See what your background is. Don't try to do what the German, Danish, or Dutch designers do—that contemporary kind of look. Experiment with certain elements like Issey Miyake did. He reinvented the kimono with his sensibility.

SK: We experimented with all kinds of embroidery and cuts. Whether it was a forty-eight-*kali* piece, dropping the length to the floor in twenty meters. We introduced Swarovski into the market when nobody could pronounce *Swarovski*.

AA: *About thirty years ago everybody wore handwoven textiles, but mechanization and globalization have changed attire massively in India. What do you make of this?*

SK: Every craftsperson is insecure in India, and then the city of Surat is doing computerized *chikan*. To the naked eye, a newbie doesn't know what *chikan* is. They don't know what the shadow stitch is. It's roughly done, but it's tidy on the back and they can't make it out. People are buying it as *chikan* because it's sold as *chikan*.

AJ: China makes computerized saris.

SK: Even the Benarasi saris are being machine-made. This will be the biggest challenge for the next ten years. When Abu says we will survive, we will survive; but I don't think the next generation will know what handloom is. They will not know what a real woven Benarasi sari is.

OPPOSITE Abu Sandeep, red georgette sari with a hand-embroidered gold and sequin peacock, 2013 *The Golden Peacock* collection.

ANAMIKA KHANNA

SHEFALEE VASUDEV

The search for design identity in a medium as visual, tactile, and influential as fashion is seldom immediate or absolute. Yet the fragments that determine that DNA, the dynamism of dialogues with consumers and critics, the shedding of delusions en route brand a designer's work. Kolkata-based Anamika Khanna found this identity through the Western gaze on Indian fashion. Through nuanced reflections on the global fashion scene where Indian design seemed alien, she realized she did not want to merely rejumble traditional opulence, heritage weaves, and the "more is less" echo of Indian fashion. So she formulated a design dialect by mixing embroidery, embellishments, handwoven materials, and a repertoire of artisanal techniques. With these distinct textiles, she created seductive, nonconformist silhouettes mixing representations from subcultures such as bohemianism and punk, among others, and experiments with classical Indian drapes. The first designer to pair saris with trousers, or as half drapes on the Indian fashion runway, she also placed intricately crafted capes on flowing or structured *lehengas*, reinterpreted dhotis, *salwars*, sherwanis, and *kediyus* with ingenious structuring, thus altering the flow, fall, and feel of Indian garments.

What has emerged in the years since Anamika Khanna launched her label in 2000 is Indian couture created on the axis of modern thought instead of just a fanciful closet of bridalwear.

And that's hardly all. Khanna's prêt-à-porter line AK-OK—cocreated with her twin sons, Viraj and Vishesh, and launched in 2020—gives life to millennial-style eclecticism. AK-OK is about a free-spirited whimsicality of ideas, colors, and prints, which open a conversation between the spectator and wearer beyond the binary East-West mindset in design. The casual charm of athleisure and such clever, artistic touches as hand-drawn scribbles, bold logos, reproductions of static on a TV screen, quirky graphics with hints of distressing, and appliqué work, to name a few, make AK-OK recognizably hers.

The designer, also a trained Bharatanatyam dancer, talks about her life in fashion by design.

SHEFALEE VASUDEV: *You did not formally train in fashion, yet it became your calling. Was there a particular moment that nudged you?*
ANAMIKA KHANNA: We were taught needlework at school. Besides the *kantha* embroidery of Bengal, I also learned the rather complex Kathiawadi stitch [*hurmicho*, also called the Sindhi stitch]. For an assignment, I found a *karigar* [artisan] to create an entire textile with the Kathiawadi stitch in shades of ivory and beige, and I felt that it laid the foundations of what I would eventually do. Much later, in 1998, I won the Damania Fashion Award for a garment I created using textured, embroidered borders and draping them as a top, held together with a belt. This show was my first exposure to fashion, and, during this period, I chanced upon a fascinating book on African Shoowa textiles. That's when I thought about making a career in the fashion world. It pushed me to the idea that I could create textiles not just by weaving but by embroidery as well.

SV: *Which techniques and embroideries essentially define your work?*
AK: Across twenty years, the vast repertoire of Indian embroidery techniques as a melting pot are a mainstay of our work. *Badla, tilla, zardozi,* varied techniques within *zardozi*, Parsi *gara*, and needlework of Bengal are just some. Instead of identifying textiles or embroideries as belonging to a region or a community, I call them Indian textiles, which include woven fabrics, appliqué, and embroidery.

SV: *Your silhouettes mix traditional garments with ideas from global cultural movements. Has this local–global blend been a conscious way to create brand identity?*

OPPOSITE Anamika Khanna, pearl mesh wedding veil, hand-embroidered lace blouse, silk organza threadwork sari with a *mukaish palla* and a gold *zardozi* border, 2021 Couture collection.

ABOVE Anamika Khanna, embellished silk jacket with tribal coins and hand tassels, 2018 *Festive* collection. Photographed by Bikramjit Bose for the September 2020 issue of *Vogue* India.

AK: When I took my brand to international platforms, I realized that we were almost treated as aliens in terms of design and dress. Structure and shape, X-shape straps [found in athleisure garments and swimwear], patternmaking, and silhouettes didn't really exist in our work. Our heritage of embroidery and textiles is so great that in my head I had thought there is so much to bank on. But I soon realized that I had no identity. What could I do to keep alive the heritage and the cross-cultural influences in India and make them my own? I was fascinated by how an Indian man wore the dhoti, for instance. There was lightness, movement, and inexplicably enough modernity. But nobody had ventured to make a dhoti to flatter a woman's body. So I actually draped a dhoti on a mannequin and started snipping at it, taking away the extras, adding zippers and some form. I even made cargo pants with pockets and belts from *salwars*, and saris with pockets. I got interested in the cape, because I wanted to add a layer on the shoulder in the *lehenga* ensemble. Later, the cape became a part of the Indian wardrobe. I made it Indian, Western, traditional, short, long, to be worn with a sari, or a dress, flowing or structured. The point is, if you are not "now," not modern, and don't push yourself into a nonethnic space, you would become irrelevant.

SV: *Often, a brand's inflection point is a collision between what a designer experiences personally and the demands of the market. What inspired your prêt-à-porter brand AK-OK?*
AK: For a long time, there was a demand for AK-OK–like clothes as I have been wearing them for years and putting them out there almost every day. But the beginning of this brand itself was an emotional journey. I had a bit of a health episode a few years ago; when I returned from the United States after treatment and wondered if everything would be OK, my sons would say that everything would be "A-OK, ma." Then one of them quipped, "Everything will be AK-OK!" That's how it started off. It is incredible. In terms of market demand, while the label was conceived for the young, millennial space, I quickly realized that the barrier of age did not exist anymore. AK-OK fits anywhere and is more about this mindset of freedom.

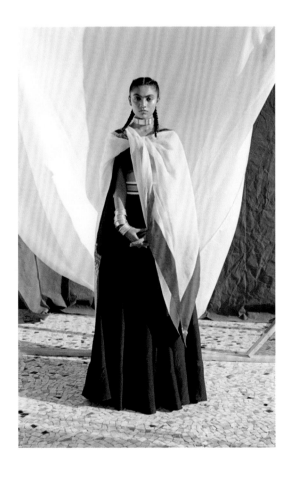

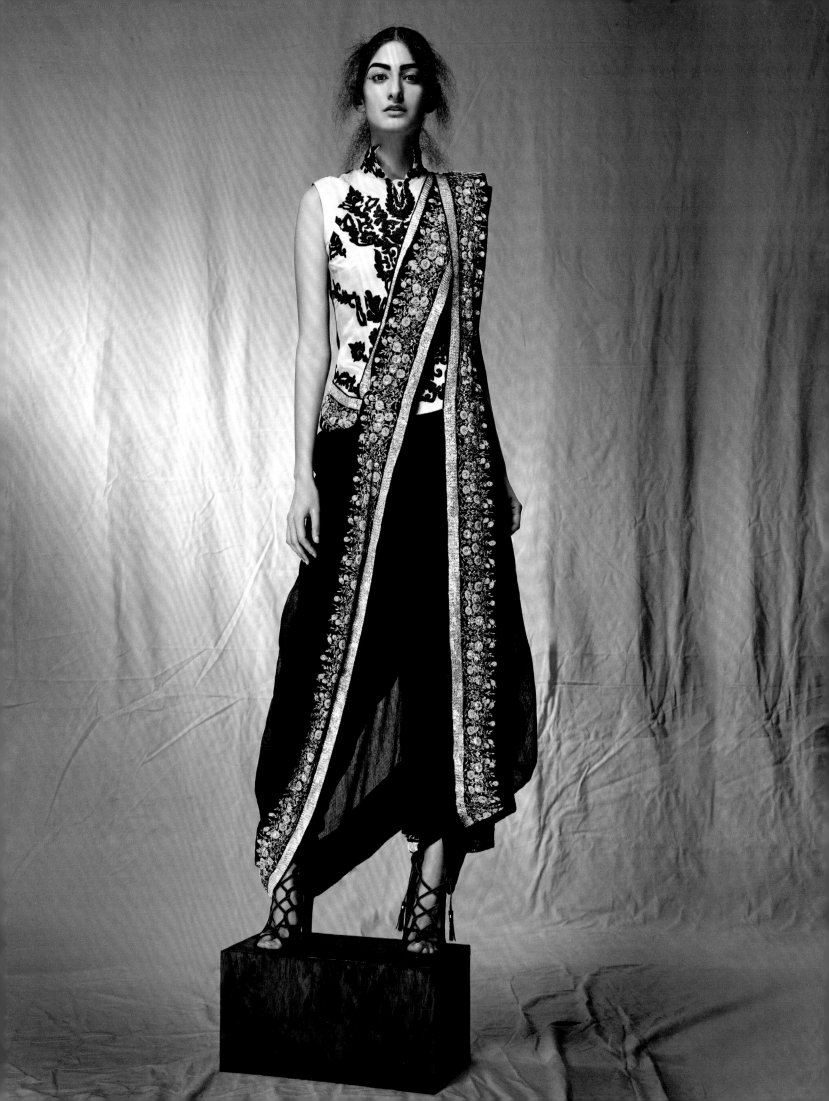

ANURADHA
VAKIL

PRIYANKA R. KHANNA

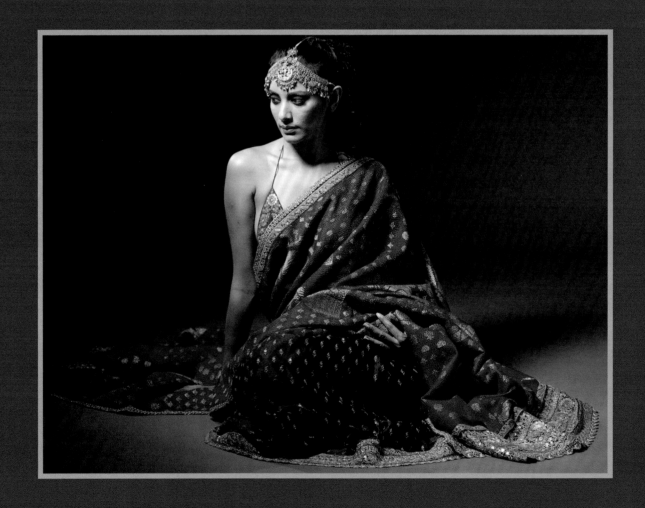

In the early 1990s, when Anuradha Vakil set up her label, the Indian fashion industry as we know it today was just taking flight, with the birth of multidesigner boutiques, the first Lakmé Fashion Week (1999), and an increased spotlight on the creative talents emerging from the country's design schools.

"Early on in my work life, I contemplated a serious decision—did I want to be a happy artist, or did I want to be in the press? It wasn't even a choice," Vakil tells me with a laugh over the phone from her studio in Ahmedabad.

In the quarter of a century that has passed since the start of her fashion career, Vakil has deliberately chosen to remain above the fray. She lives and works in Ahmedabad, a city with a deep cultural heritage and a strong textile history, far from the fashion and entertainment capitals of Mumbai and New Delhi. She's not on social media, and in the nearly fourteen years that I spent at *Vogue* India, she more often than not declined to be featured. Yet, Vakil is one of the country's most prolific designers, with a métier in craft that is unparalleled.

PRIYANKA R. KHANNA: *Mrs. Vakil, despite all the years I spent at* Vogue, *this is the first time I'm actually interviewing you at such length! Very little is known about you or how you started out.*

ANURADHA VAKIL: I think very early in my career I realized that my creative process is the most precious aspect of my work. I need solitude. I choose to be away from the noise. I don't believe I need to continue to tell the story of my life. I don't enjoy talking about my work. I would rather enjoy what I do and have that passion be reflected in my creations. I come from a different background; I had imagined my life quite differently. I have an MBA from the University of Michigan, but I was born an aesthete with a deep sensitivity to beauty. I don't know if it was a blessing or a curse, but I had to make everything around me beautiful. From a young age I was exposed to art and culture by my mother, and I believe that what you are exposed to as a child shapes your life and experiences.

PK: *You were raised in Ahmedabad and have continued to live there. How has the city impacted your journey?*

AV: I was born in London and moved to Ahmedabad at the age of two. The city has been a huge influence. It's a place that has been seen as the heart of India in terms of textile, though not necessarily the handcrafted kind. [Ahmedabad was often referred to as the Manchester of India, for the textile mills and trade that date back to the nineteenth-century British Raj.] Its proximity to Rajasthan has also influenced my work. Each collection was born out of the desire to work with craft embroideries, hand painting, vegetable dye *kalamkari*, the finest tie-dye, and *bandhani*. It was never a question of how I was going to come up with a new collection—I always had a wish list of techniques that inspired me.

PK: *And you've had new collections for twenty-five years! Let's rewind back to 1994.*

AV: There was no passion for textile crafts back then, and sadly there still isn't any today—really just a handful of people using these techniques. It requires education, a crazy love for craft, and patience. We, as a country, have so much, so why not [be inspired]? I started with Putapaka ikats and *telia rumals* from Andhra Pradesh. In Gujarat, we have *patolas* and the double ikats, but somehow the simplicity and contemporary design vocabulary—usually in monochrome—really attracted me. We work with a lot of craft centers and develop our own textiles: it's time- and labor-intensive. My *bandhanis* take two years minimum to plan; my custom pieces take at least three to four months, so it does involve a lot of organization.

OPPOSITE Anuradha Vakil, *odhana* and *lehenga* in antique gold woven brocades, hand-patched and hand-embroidered with *kantha* stitches and fine gold-silver borders, Fall 2007.

PK: *It's interesting that you say that you don't find a real passion there today. At this time in Indian fashion, the word* craft *is being constantly bandied about.*

AV: I'm a passionate lover of textiles and crafts, but also a responsible one. In the world of fashion, we tend not to want to repeat things. But we've always guaranteed our pool of craftsmen work, whether or not we could sell the pieces—that never entered my mind. Even twenty-five years ago, I would try to incentivize my craftsmen, so that the next generation was motivated to join their fathers' field. For me, the joy comes from this engagement. In my own way, I'm building bridges between fashion and craft, and that makes me happy … but that takes time.

PK: *Time, in this Insta-age, is always the issue.*

AV: I remember, when [filmmaker] Sanjay Leela Bhansali approached me for his film [*Saawariya*, 2007], I was a bit reluctant. I respected him as an artist, so I flew to meet him. I remember telling him that if I chose to do this film, I would need at least eighteen months to just do the textiles. And his response was, "That's why you are here!" If you know my clothes, you know that I follow the dictum of being governed by style and not fashion. Classic silhouettes, rooted in Indianness, that belong in contemporary India. Understated simplicity with a strong focus on saris—thankfully that particular drape and silhouette has survived today. The simplicity is key; there is not some cerebral process in terms of my collection. We did *angarkhas* twenty-five years ago, when no one was doing them, and are still doing them today.

PK: *You are often referred to as a textile revivalist. Do you agree with that?*

AV: It's a bit pretentious to think that one person can be a textile revivalist. I have tried to build bridges between fashion and textile craft. We undertake network manufacturing, we promise our centers work, and we employ a certain number of looms. There's a constant give-and-take, and there's a learning curve for both the designer and the craftsmen. That interaction is so exciting, although now I don't travel as much to the centers as I would like; but we ensure that we always keep them employed even if we have moved on creatively, so that they are also excited and involved.

We have done revival work with a number of centers—and in volume. For example, we continue the technique of *kalabuttu* embroidery; not many designers do this today, because it's very labor intensive and expensive. But I create what I want to create. It's about what I believe in, a technique. When I did [actor] Sonam Kapoor's wedding *lehenga*, I used my own motifs, very fine embroidery—it's not meant for impact, it's the finer things you need to see up close. Sanjay [Leela Bhansali] used to tease me: "Why are you putting effort on the inside of the *lehenga*? It's not going to show on-screen." But I said that I will know it's there. It is the attention to detail, a focus on craftsmanship.

PK: *What continues to motivate you?*

AV: I think I enjoy what I do. The wisest choice I made was not to be dictated by the market trends, not to look over my shoulder [at others]. The creative solitude has helped me rediscover myself, to not feel fatigue. I wake up recharged, jump out of bed, and run to my studio. The day I am not engaged, I will immediately shut the door. My husband teases me that whatever I've made has gone back into textiles. I have collected a great deal of Indian textiles and also have a huge passion for Victorian textiles, beaded textiles of French and English origin, ecclesiastical embroideries, and bohemian beads. It gives me such a kick when I chance upon these things! I see such an overlap between this region and Western Europe, in the design vocabularies. It gives me a deep sense of loss, however, to see the [diminishing of craft] in India, but it's not just India's story—it is happening all over the world.

OPPOSITE Anuradha Vakil, custom red and gold *lehenga* in a handwoven textile developed in Maheshwar, Madhya Pradesh, with embroidery employing the *kalabuttu* technique with real gold and silver threads, and centered around a stylized lotus motif. The garment took six months to create. Worn by actor Sonam Kapoor Ahuja to her wedding. Photographed by Signe Vilstrup / Tomorrow Management for the July 2018 issue of *Vogue* India.

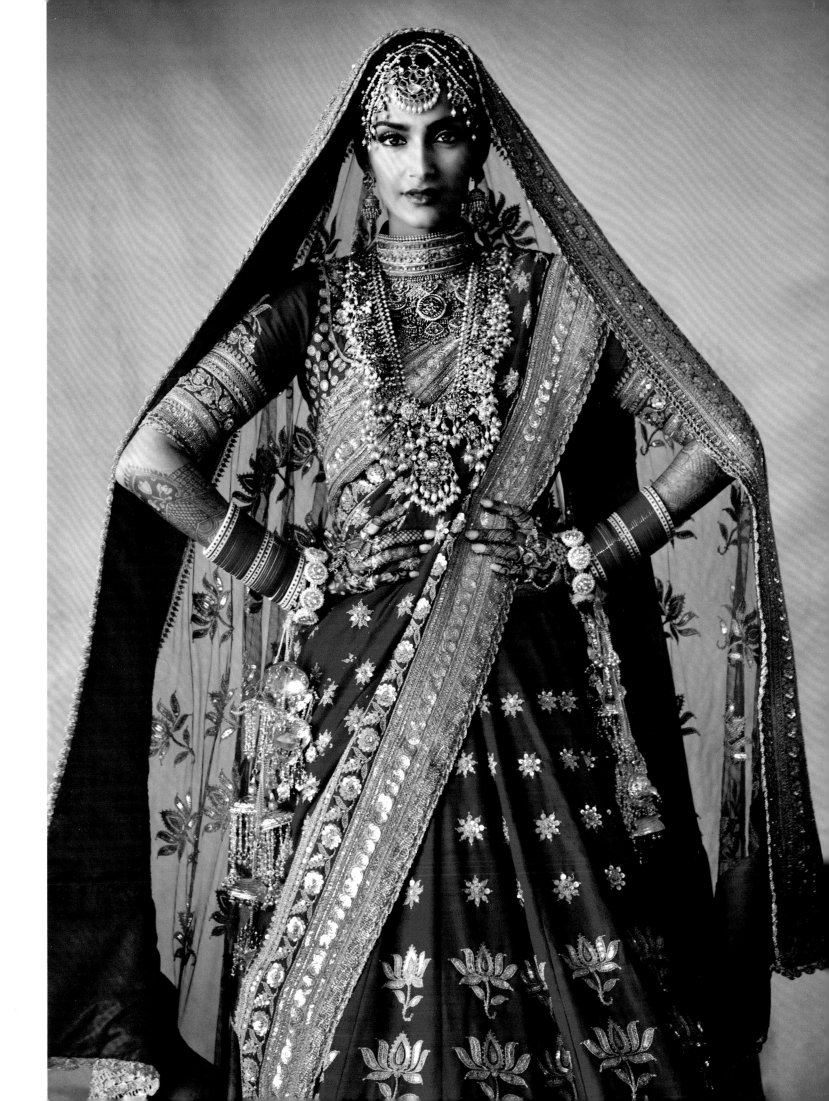

NOTEN

HAMISH BOWLES

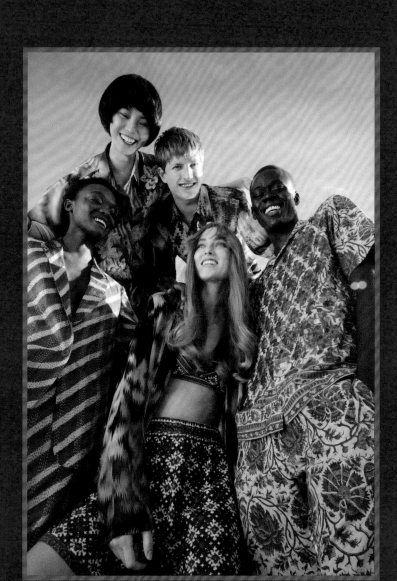

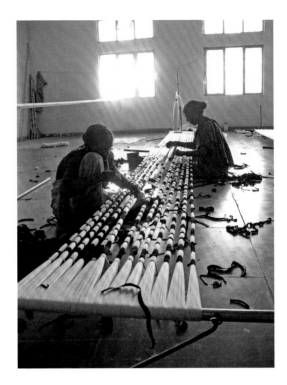

Dries Van Noten's very first collection—his 1981 graduation show from Antwerp's prestigious Royal Academy of Fine Arts—incorporated Indian sari fabrics and other textiles repurposed into the sort of generous bohemian silhouettes that have remained a leitmotif of his work. More than forty years later, the designer's High Summer 2022 collection was inspired by the Hindu festival of Holi, created using textiles made by specialist Indian artisans. The spirit of India has remained an enduring thread in his collections, notably in his Fall 1996 collection, inspired by the colors and imagery of Bollywood posters, and in his menswear show in Paris in 1986, staged in the Passage Brady, a hub of Indian subcontinent community life.

It was in 1987 that the designer first began working with Kolkata-based companies on his embroideries, relishing the artisanal quality of the work that he felt was so closely aligned to his own aesthetic vision. Since then, every season, whether the message of his collection be one of layered embellishment or austere minimalism, Van Noten has been sure to integrate the different specialist techniques of his various embroidery communities into his offering to ensure that the craftspeople are sustained even if the garments are not presented as part of his runway concept.

At the same time, India the country has cast a powerful spell. On his various travels through the subcontinent Van Noten has reveled in the visual cacophony of its cityscapes, and the joyous combinations of color, print, and weave in the clothing seen on everyone from the movie stars in Bollywood to the men and women in rural communities with their artfully draped garments. Van Noten's work places a primacy on textile surface design, and through the years and seasons has referenced such ancient Indian techniques as block printing, ikat weaving, resist dyeing, and various types of sequin, bullion, and thread embroidery, all practiced and perfected by generations of regional craftspeople.

On the pages of *The Telegraph* of India in 2009, Sabyasachi Mukherjee expressed his admiration for Van Noten's work, which he discovered as a student in his first year at the National Institute of Fashion Technology in New Delhi. In his piece, Mukherjee praised Van Noten for "his fearless mix of silhouettes, colours, and patterns" and his "subtle insanity." He continued, "I was amazed to see how an international designer had such a strong Indian sensibility." Perhaps no greater compliment could have been given to Van Noten, whose enduring love affair with India manifests in subtle or overt ways in each of his collections, and whose revered craftspeople have so informed his design sensibility. "What has been beautiful for me in my relationship with the Indian craftspeople who assist me in producing my collections over the years," Van Noten says, "is that, with time, there has been a great evolution in the expression of what we produce."

HAMISH BOWLES: *When did your passion for India begin?*
DRIES VAN NOTEN: The dream world of India has always fascinated me. In my collection during my final year of the academy, I used quite a bit of sari materials and Indian fabrics. I was working with a fabric supplier from Paris, and they had a small section of fabrics made in India that I really loved—the silks and the incredible colors and all those big checks. You felt the handcraft and the imperfection, and that for me was really important. I used sari materials and sari borders in that collection, which was also inspired by Catholic religious clothing. The clothes of the priests sometimes have really massive, quite heavy gold jacquard borders and insets and things like that, which I found back then in Indian saris—so there was that link.

When I started my own company around 1985, I had a very good friend who helped me with the company and who really loved India. She had a lover in India—so it was love not only for the country but also the man. Sometime after 1984, I joined her on a

OPPOSITE Dries Van Noten, looks featuring block printing, *kalamkari* (combination hand-painted and block-printed cotton textiles), and *kantha* (centuries-old tradition of stitching patchwork cloth from rags), High Summer 2022. Photographed by Bruna Kazinoti.

ABOVE AND PAGE 192 Ikat is a technique in which the yarn is first tie-dyed and then woven to create intricately detailed patterns in the fabric. The weave was featured in Van Noten's Spring 2010 collection. Photographs courtesy of Dries Van Noten.

trip to India. She really showed me the country in a very nice way, and we traveled to different parts and it was quite interesting.

The moment I started to work on my own collections, I tried to find a manufacturer who could make a few hand-embroidered scarves for me. At the time, India was making polyester wedding dresses for Russian markets with lots of fake pearls and fake diamonds. Quite a lot of their production was in hideous materials. The aesthetic at that time in India was strongly influenced by Bollywood, so everything was too bright, too brash, too gold, too glitzy. When I started to work with Indian artisans, I asked, "Can you make us a scarf that looks more like the maharajas and not so much like Bollywood?" It was really an education—for instance, when you have gold sequins, it can be a sequin that is not super shiny, but something more like brass, which has a patina. In what we called the *James Reeves* collection [Spring 2012], there were quite strong influences of Cristóbal Balenciaga, and we did some toreador jackets, but we did them all in white and in black bullion embroidery, made in yarn instead of the little wires and metal—a new version of bullion Indian embroidery! The embroiderers were very excited by that. It was really a mutual education. I taught them to see that there was something other than polyester on the market—to look at the beauty of their handspun silks, of a pashmina scarf. They needed to refresh their eyes a little bit to see again the beauty of those things because, like in so many countries in the 1960s and 1970s, everything had to be modern and new and plastic, and they lost a little bit of that connection with their own things, which now they definitely have found again. I still work with that original manufacturer.

Little by little, collections that we made were more embroidered, more sophisticated. At a certain moment they understood very well how to make things really beautiful in our eyes and not in the eyes of Bollywood. Then I changed my mind and said that maybe it would be interesting to look at Indian embroidery through their eyes instead and to use that Bollywood culture. So it's the *Bollywood* collection [Fall 1996] where we were really playing with turquoise jacquards, offset with glitter purple velvet with far-too-bright printed roses and big-size sequins and fuchsia with very bright gold elements. Everything was glittery and shiny, which we set off with very European tailoring to have a little bit of a balance. It was quite fun for us to work that way; but of course our colleagues were in a very minimal mood—it was the heyday of Jil Sander and Helmut Lang.

I learned a lot from India, and I think our manufacturers learned a lot from us. They went from low-quality embroidery and fast fashion to something that reaches at times the level of couture.

HB: *I remember you telling me that, while you have one manufacturer who is coordinating everything, different regions have different specialties of embroidery. Could you tell me a little about those techniques?*

DVN: The main manufacturer whom we've been working with from the beginning is a very clever guy and very conscious about things. Other people would just employ more and more craftspeople in their factories in Kolkata [formerly, Calcutta]—more and more workers living in the slums around the city. He really built up another system. We have a group of people working in the factory in Kolkata. Everyone has his own specialty and techniques—bullions, the hand machines, the handwork. Those people make the collection pieces in-house in Kolkata. The moment when we start to make the production, however, they take the bundles with all the fabrics, all the materials, the drawings, and everything with them to the villages where they distribute the work to all the workers in the area—approximately 200 to 300 kilometers from Kolkata. It is, in fact, a cottage industry. Every region, every village has a kind of specialty.

OPPOSITE Dries Van Noten, "sari" wrap ikat day dress, Spring 2010. Photograph courtesy of Dries Van Noten.

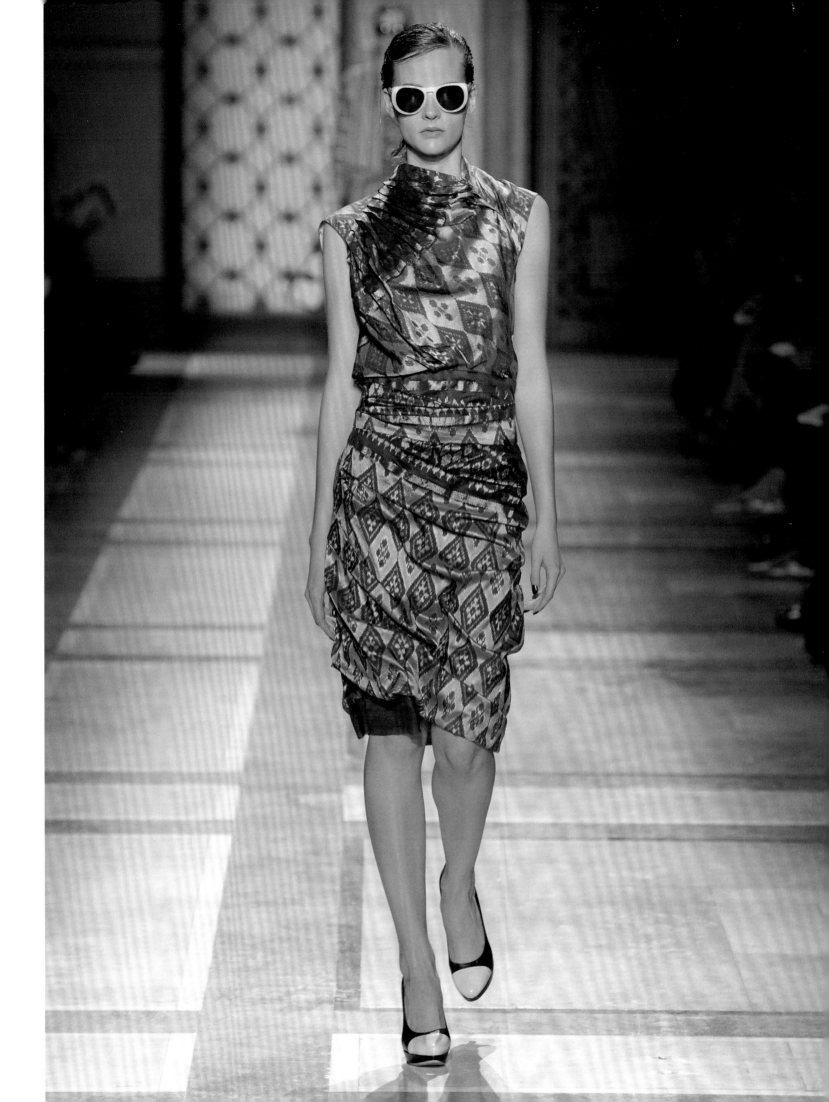

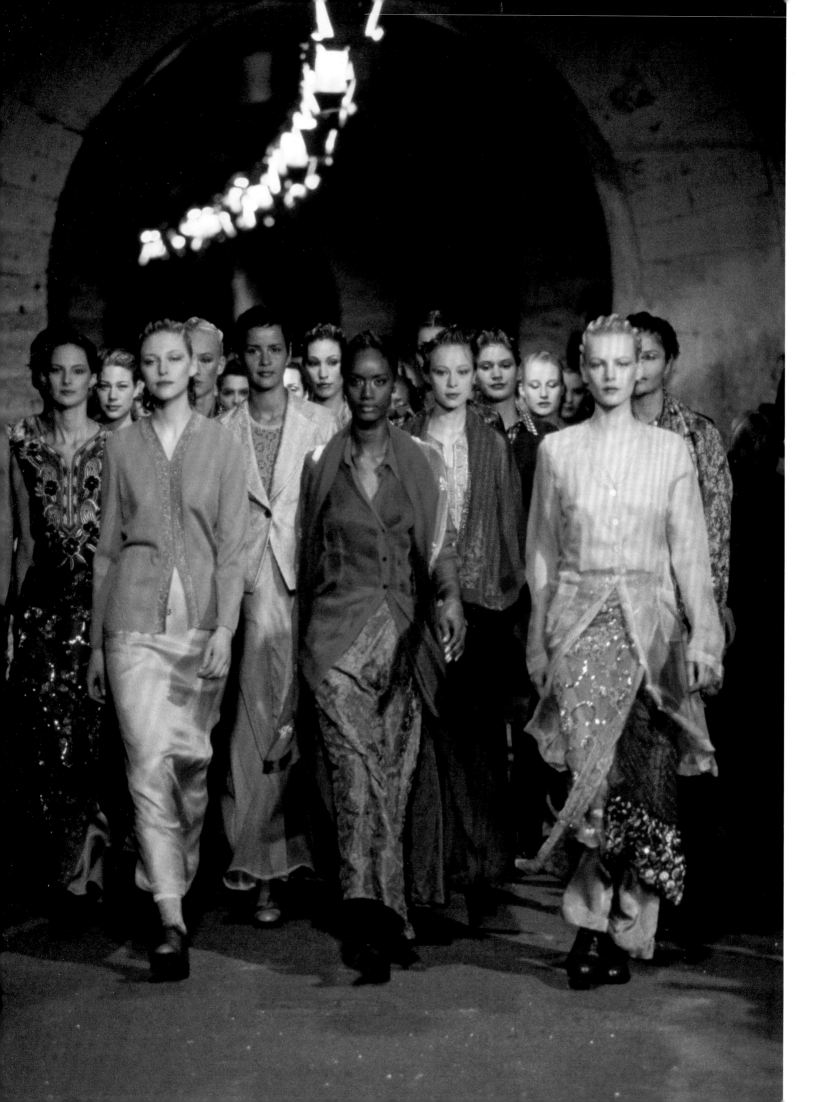

HB: *You have said that you are conscious of including elements of these various techniques in each of your collections.*

DVN: I think it would be a little bit selfish to only use those people when I need them, and when I don't need them "bye-bye" and "look out for yourselves," so I think that is strongly appreciated. We work in that way also with the weavers and printers that we are working with every season, even if we have a collection that is more about plain fabrics. We still have enough prints that those manufacturers know every season what business they are going to get from us. That is how we have always worked, and I think that is also the most correct way to build up a lifelong relationship, and of course is the only way of working in a very reliable way.

HB: *Are there any other collections apart from the Bollywood collection where you've very specifically looked at Indian culture?*

DVN: Indian culture is always on my mind and influencing me, because of course we embroider every season in India. Sometimes we try more to hide it so that you don't see it's made in India; sometimes it's really very clearly from there. For Spring 2010 we used sari fabrics that we draped around the body. The challenge was that we didn't spoil the fabric, so every garment was made out of a full sari. So the culture is always, in one way or another, in my mind.

Most of the embroidery is done by men in India; it is considered a very prestigious profession, and it goes from father to son. But the factory is organized by women. They have the lead in everything. They make the handwork on the garments while the stitching of garments is done by men. Ironing is done by men. Packaging and controlling are done by women. It's very strictly divided.

HB: *What has your experience of travel in India been? Have you spent a lot of time there yourself?*

DVN: In the beginning, no. It was only in the 1980s when I went there quite often, nearly every year for a week or two, traveling around. From the mid-1990s I didn't really go anymore. I went back I think a decade ago. It was quite a shock, going back. I loved it and I hated it at the same time. It changes so quickly. The area between Kolkata and the airport is all towers and big buildings and tech companies, but Kolkata for me is quite magical because—understanding that it's poor and life is difficult for many—there is a beauty that is really very special, there's an artistic eye about everything, there is a color in the light. For me it was really a revelation to walk around there, to see it, to discover things. When you go to the fruit markets in Kolkata, you see how even the poorest guy puts the fruit in his stall, you see all the lemons, you see all the oranges, you see all the fruit displayed in a beautiful way. It's a feast for the eyes. There is a beauty there that I think is really special. We went to Delhi quite often—we were fascinated. A lot of Mumbai. And then Rajasthan, of course. And then once or twice we went to Kashmir, when it was still possible to travel there, and to be there on a houseboat. It was very romantic.

OPPOSITE Finale of the Dries Van Noten Bollywood-inspired Fall 1996 runway show. Photographed by Marleen Daniëls.

JEAN PAUL
GAULTIER

HAMISH BOWLES

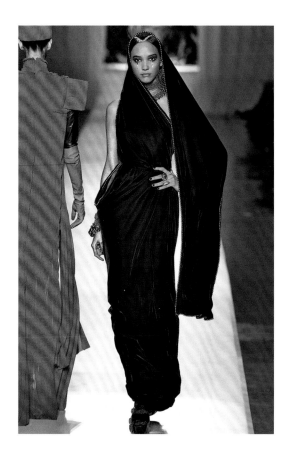

And inspired from that, I did the same in my collection, like an English dandy [Spring 1998 ready-to-wear]. I was always influenced by that. And of course, I should also say, the turban. I think that the first collection where I did skirts for men—some sarongs—I put some turbans matching the suits. I did the same thing for the sari. I had a pinstripe one with a matching turban."

As well as the forms of dress and textile, Indian jewelry has also inspired Gaultier, who notes "the color and the shock of the jewelry with enamel on the back and on the other side another material with the stone."

When Gaultier opened his haute couture house in spring 1997, he set up a small embroidery workshop of his own but also began working with Indian embroiderers "because they do that marvelously well. They do beautiful, beautiful embroidery." Gaultier remains in awe of India's craftspeople. "They surprise and surprise, and surprise, and surprise," he says.

He is also excited by the work of today's Indian fashion community. "You can feel the potential of the creativity they have," he says. "Because I think it's so different, their vision of beauty. It can be surrealistic … and I think they have big potential to do even more in fashion. I think they can bring something that is very interesting because it's a whole concept of life that is very different. It's a very different way to see life. We always expect surprise from them."

The other aspect of India "that truly surprised me," as Gaultier recalls, "was the first time I went there to make the fittings for the clothes for the French company that I was working for, the owner of the [production] company was using American technology. I was very surprised to see the incredible difference between the atelier where you went to work, which was very manual, and the owner with all this technology that I didn't even know about. And already in 1976, when you were in a plane over India, you saw millions of television antennae—more than anywhere else. I think it's a little bit strange, modernity and tradition. It was almost like something spiritual."

But ultimately, for Gaultier, it is the country's aesthetics that resonate. As he notes, "When you go to India, it's a shock when you see the beauty."

OPPSOITE Jean Paul Gaultier, maharaja-inspired ensemble of metallic silk, Fall/Winter 2007, Haute Couture. Modeled by Jon Kortajarena.

ABOVE Jean Paul Gaultier, sari-inspired evening dress of silk velvet, Fall/Winter 2017, Haute Couture. Modeled by Cora Emmanuel.

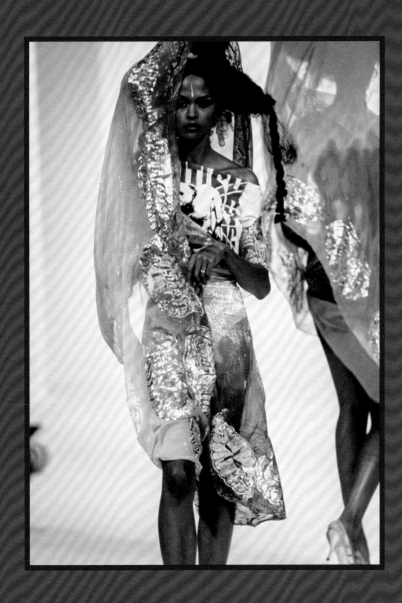

JOHN
GALLIANO

HAMISH BOWLES

"India has inspired, and continues to do so," designer John Galliano says. He was born in Gibraltar, the peninsula in the roiling strait that divides southern Spain from Morocco and somewhere that he remembers fondly as a place of sensory excitement. "Even my walk to school would inspire me," he confided to me in a profile for *Vogue* in 2009, "past the souks, smells, herbs, and Mediterranean colors. It was so vivid, so vibrant. My curiosity stayed with me, blossomed, as I became a traveler through life."

At the age of six, Galliano moved to London with his family. "I will never forget the change in colors, clothes, and culture," he said. "This seemed so much more important to me than the grayness and the climate—the idea that there was a whole new world out there that smelled like wet chalk. My taste for travel and adventure, my quest for beauty, had begun."

This sense of very different cultures colliding is something that has informed Galliano's work from the very beginning. His first collection after graduating from Saint Martins (where the garments that he designed for his final degree show were all bought by the prestigious London boutique Browns, and his first two customers were Diana Ross and Barbra Streisand), was based on a 1920s cartoon in *Punch*, the satiric British magazine, that was titled "Afghanistan Repudiates Western Ideals," giving the name to Galliano's collection. The cartoon depicted a fierce Afghan warrior crushing a European bowler hat, indignant at King Amanullah Khan's attempts to modernize his country along Western lines. Taking a fluid approach to geography and inspired by the melting pot of Hindu and Muslim cultures in the East End neighborhood of London where his studio was located, Galliano explored Indian subcontinental dress for this collection, using a palette of natural dyes and Madras cottons *and* appropriating draped dhoti trouser forms that he has returned to throughout his career.

In the vanguard of innovative London-based talent throughout the rest of the decade, in 1992 Galliano was emboldened to try his luck in Paris, where his collection titled *Olivia the Filibuster* for Spring 1993 featured what he described as "rocker saris," spangled with silvery stencils and dampened so that they clung to the models' bodies, models whom he saw as "marauders, like magpies, stealing from different cultures. The clothes were regal and street at the same time."

By 1995 Galliano's work and the global press attention that it drew had caught the eye of Bernard Arnault, who appointed the designer as creative director at Givenchy. For his debut haute couture collection for the house for Spring 1996, Galliano included a *passage* of evening dresses made from brocaded orange sari textiles that he sourced in the fabric shops serving the Indian community in London's Southall. A year later, Arnault gave Galliano the prize of Christian Dior. For both his eponymous house and Dior, research trips with the design team became an integral part of Galliano's design process. For these trips, Galliano and ten or so studio members (as well as his personal trainer) would immerse themselves in a country of choice for ten days or more. Sometimes half the studio would come for the first few days, then return while the remainder of the team replaced them. To inspire the Spring 2003 John Galliano collection, the designer chose India, and he and his team planned a trip through Rajasthan. The landing in New Delhi, Galliano recalls, "was such a culture shock. I'd never seen so many people and so much color, and I think I had to go to the hotel and lie down for a bit. It was such a life in front of you," he recalls, "and life on the street. Little motorbikes with whole families, and floating saris and kids hanging off and honking—but musically, you know. It was amazing." They traveled on to Jaipur and Udaipur and took a nerve-shattering small plane to visit the Taj Mahal. On these trips, as Galliano recalls, "there was stuff that was very prebooked, and then there was

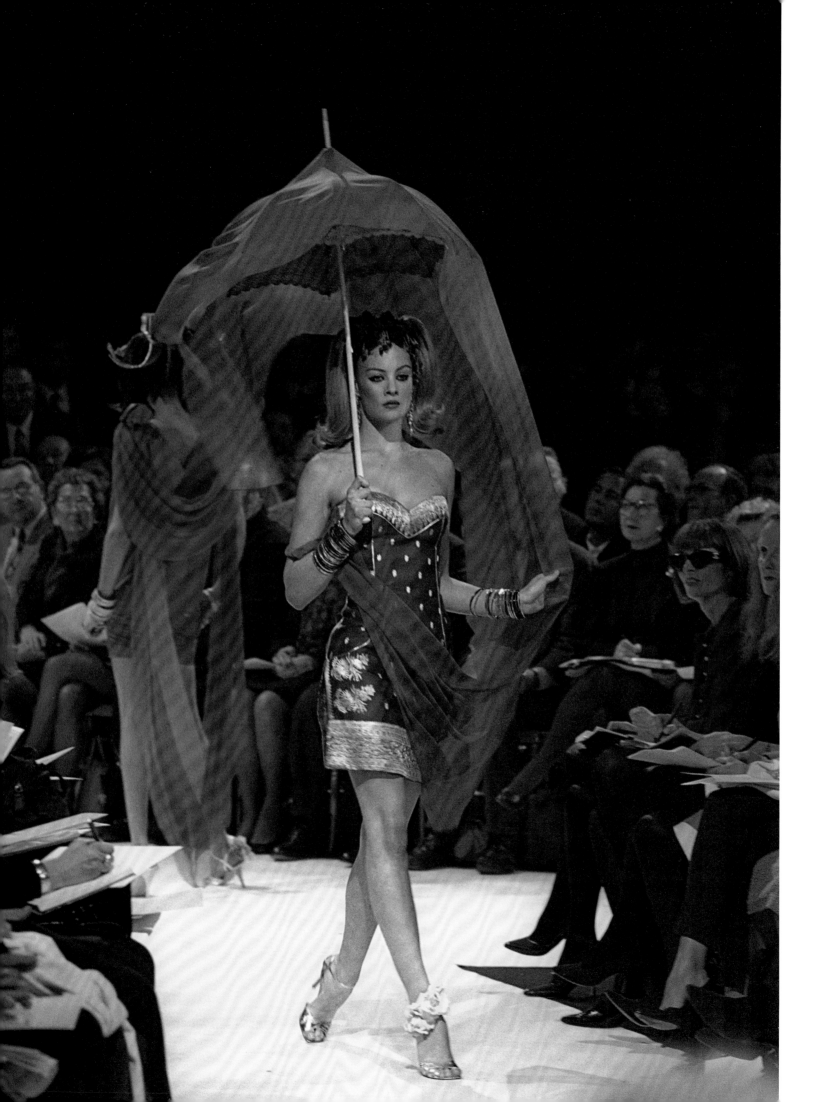

OPPOSITE John Galliano for Givenchy, cocktail dress of silk brocade and silk chiffon, Spring/Summer 1996, Haute Couture.

ABOVE Travel book assembled by John Galliano during his research trip to Rajasthan, India, in 2002 for the Spring 2003 John Galliano collection.

space to just be spontaneous and enjoy—eating from leaves with our fingers, open-air cinemas showing Bollywood films. It was fab, really fab. It had a big influence on quite a few collections. Color, embroidery, as well as the contacts we made with block printers, dyers, beaders—wonderful people."

The Galliano team's visit coincided with the Holi festival, which had such an impact on the designer's imagination that it became a key inspiration for his Spring 2003 John Galliano show. Backstage at that show, a cordoned-off set was created where the models, runway ready, could be powdered with the brilliantly colored pigments, with attention paid to making sure that the colored powders fell in all the ruffles and folds of the garments so that when the models moved onstage, the powder swirled in the air around them—a stunning coup de théâtre. Galliano himself took his bow covered in multicolored powders. "It's about time for a bit of joie de vivre," he told *Vogue* at the time.

During that trip, "We kept diaries and visual diaries and sketches throughout," Galliano remembers. "We kept every kind of receipt and details of where we ate and who we met." His practice was to create elaborate books of inspirational images that he would share with his design teams back in Paris, giving them some time to absorb the visual stimulation before he removed the books and they were left with their memories and impressions with which to build the collection.

In the same way, Galliano's memories of the country—the stunning surprise of driving past a country wedding and seeing a village full of women dressed in red saris, for instance, or on another occasion a gathering of women drawing water from a stream, each dressed in the most inspiring mix of vivid colors and prints such as marigold yellow with kingfisher blue, or magenta with green—would be transformed in his alchemical hands into clothes for both Dior and his own brand that helped to push fashion forward. Today, at Maison Margiela, the inspiration of India continues to resonate through Galliano's collections, although he is keenly aware that the more overt cultural appropriations that were unquestioned or went unchallenged in decades past are no longer part of the conversation.

For his Fall 2020 Maison Margiela *Artisanal* collection, for instance, John Galliano revisited his Fall 1986 *Forgotten Innocents* collection that included a section with models (including his muse of the moment Sibylle de Saint Phalle) whose high-waisted, diaphanous muslin dresses, closely based on early nineteenth-century examples, were also drenched in water just before they appeared, so that the dresses clung to their bodies. A scholar of fashion history, Galliano was taking as his reference *les merveilleuses*, the scandalous and fashion-forward society women of Napoleonic France who considered themselves dressed in imitation of antique statuary. The treatment also highlighted the exquisitely finely woven Indian muslins that were so prized at the time. For Margiela, Galliano reinterpreted these textiles—once woven in imperial Mughal workshops and coveted by the likes of Marie Antoinette and England's fashion plate Georgiana, the Duchess of Devonshire—in technologically advanced thermocollant vinyl.

At home in the French countryside, Galliano and his partner, Alexis Roche, now live with a collection of Indian miniatures and late nineteenth- and early twentieth-century portraits of princely rulers that have been gathered assiduously on various visits to India through the years.

"It's a country that has given so much," Galliano says, "their people so beautiful and so humbling."

OPPOSITE John Galliano, ensemble of silk mousseline and gabardine, Spring 2003. Modeled by Abbey Shaine. Photographed by Robert Fairer.

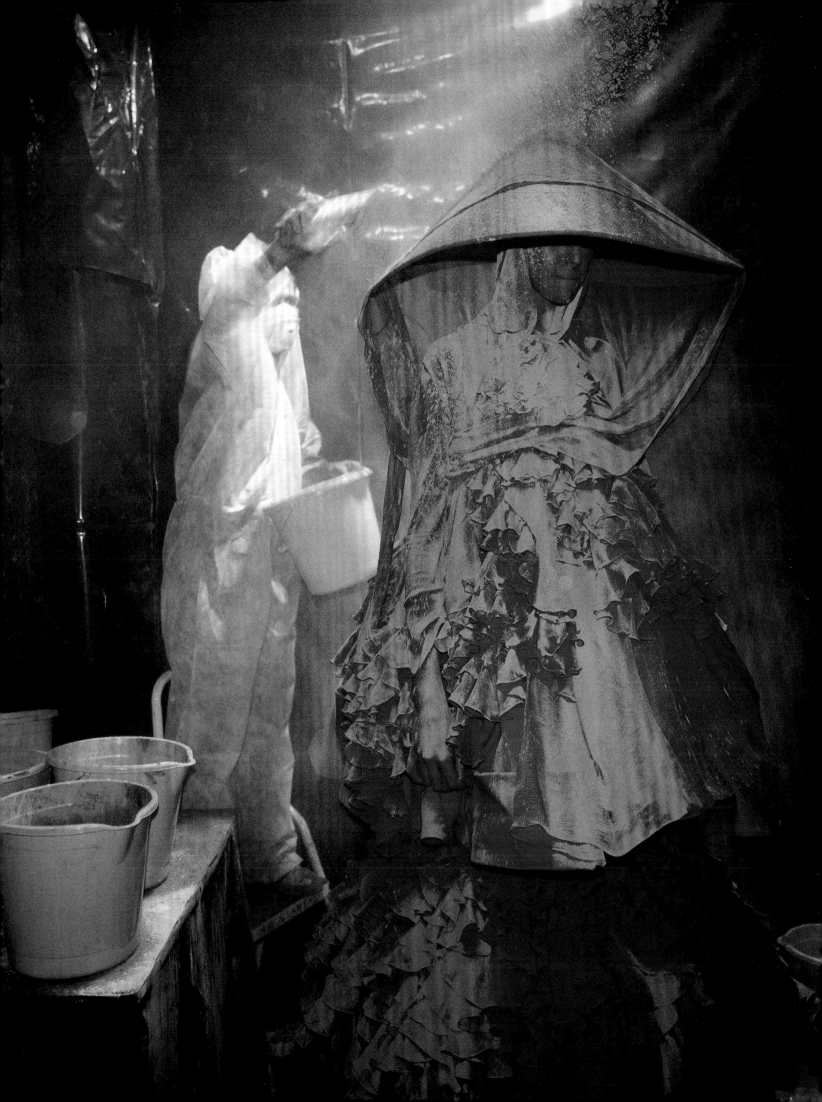

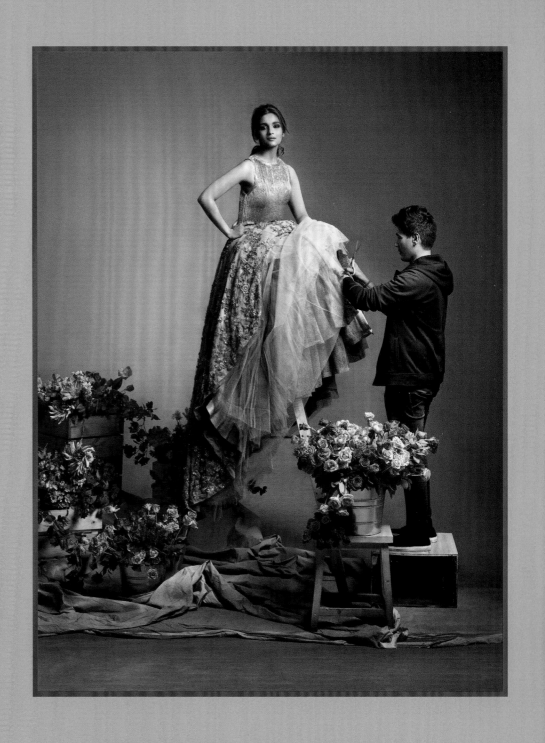

MANISH
MALHOTRA

ALIA ALLANA

M anish Malhotra's town car moves slowly in Mumbai's sputtering traffic. It is a wet afternoon, and despite the rain, a driver behind a three-wheeled auto rickshaw leans out, gesturing for Malhotra's attention. In a culture obsessed with cinema, three decades as Bollywood's leading stylist and designer to the biggest names in show business ensures Malhotra the sort of cultish fame usually reserved for stars. The car pulls into a leafy enclave in Bandra, the suburban neighborhood where Malhotra has lived since his childhood.

At historic Mehboob Studios, cameras are rolling, and Malhotra is on set to check on his loyal client Alia Bhatt, a talented actress who can fill any movie theater. He studies Bhatt's costume: striped shorts and a pink crop top. "Today's characters are very real," he says, somewhat apologetically. "Stylists just pick up clothes and put them together. I don't want to do that. Even earlier I'd cut clothes, restitch them. I gave them a new dimension, a new look, but today the game has changed."

As Bhatt performs a bedroom balcony scene, Malhotra reminisces about the "look" and his preoccupation with Bollywood's bygone glamour. For the past thirty-one years, Malhotra has defined fashion in Indian cinema. He possesses a remarkable ability not only to understand a character but also to translate the role into sartorial statements, which have been avidly studied and enthusiastically adopted by millions across the country. But in a transforming India, the look that Malhotra dreams of exists in couture, not cinema—at his atelier, and not on the silver screen. Bollywood continues to leave an imprint on his collections, one that can't be ignored as Malhotra re-creates the film industry's allure for the women he dresses, so that they feel like superstars—even if just for one day.

Malhotra was born in Mumbai to parents who migrated to India after the partition, the division of British India into India and Pakistan. His mother was a housewife, and his father ran a small business assembling air conditioners. Growing up, life was simple. There were few cars on the streets, denim was a rarity, and most boys and girls got outfits tailored for their birthday and Diwali. "You didn't live a life of plenty," he says.

Malhotra escaped his humdrum early life through cinema. He was seduced by actresses in crisp pleated saris that accentuated the bodice and tight-fitted blouses with low necklines. As a technological revolution gripped India and televisions transitioned from black-and-white to color, Malhotra studied cinematic fashion's exacting precision, seen in clean, soft threadwork on peach and powder blue, prints in chiffon, and the sheerness of fabric draped in pastel colors. "The colors, the costumes have seeped into me. I observed the lifestyle in films where the actors went to five-star hotels for lunch, and I was like, oh my God. I was so taken in by that," he says.

On the other side of town in the early 1980s, in one of South Mumbai's colonial-era bungalows, a group of aspiring designers came together under one roof at the city's first multibrand boutique, Ensemble. It was a world away from Malhotra's suburban life, one that he accessed through cover stories in magazines. But reading glossies and watching movies does not a career make, and Malhotra got a job as a salesboy at a boutique called Maharaja. Dissatisfied, he brought two tailors home and worked from his bedroom on his first piece—a stonewashed denim kurta paired with a white *salwar* that he took to Equinox, a boutique. "It was quite a disaster," he says, but Malhotra was hired immediately to dress the store's mannequins.

The designer's struggle in fashion reflected a bigger issue: an India that wrestled with extreme income inequalities, where who you were and where you came from could be a barrier to entry. "Fashion was very elitist. There was a big divide between town and the suburbs, and discrimination made this division deeper. I thought I didn't belong in the metropolis, culturally and economically. So, I chose cinema and went in to change

OPPOSITE Manish Malhotra fits actor Alia Bhatt in a custom fringe blouse and embellished *lehenga*. Photographed by Tarun Vishwa for the December 2015 issue of *Vogue* India.

fashion." He sourced fabrics from local markets, ran after tailors, pursued artisans, and delivered final products to actresses just before the cameras rolled, in pieces that varied from shockingly short, bright chiffon dresses with high slits; cycling shorts; and sports bras to patchwork crop tops and miniskirts paired with knee-high boots in looks that soon became instantly recognizable.

Malhotra was never *just* a stylist, often blurring the line between design and styling. "I opened T-shirts and blouses. I altered everything, adding darts, a zipper. Through observation, I'd ask a tailor, 'Why is the dart on the blouse standing like this, why isn't it here?', and they taught me ways to modernize something as simple as a blouse." In his early years, Malhotra stunned audiences with his colors: a mint green Punjabi set embellished in gold *zari*; a purple *kameez* studded with stones and crystals with golden floral embroidery; or a cherry-red fitted *lehenga* and long blouse that dictated what many brides would wear for seasons to come. Through cinema, Malhotra paid homage to eras gone by: Mughal, disco, the 1980s, hippies, haute couture, and the partition.

Despite India's liberalization policies that opened new markets, there were restricted cues on what progress looked like. Fashion in the 1990s was an expression of an active participation in the culture of globalization, and Bollywood actresses were role models triggering trends, influencing style. In that decade, Malhotra masterminded the looks in every blockbuster, putting women in the tiniest clothes and galvanizing cinema and society through his off-the-shoulder crystal tops and nude metallic bikini-blouses that revealed more than they concealed under sequined saris. From the chiffon sari to a copper wedding *lehenga*, Malhotra's signature touches fed his reputation, and modernization brought with it the opportunity to inhabit another existence.

"People were adapting to these new styles. My peplum cut in lime and tangerine ... I don't know if the actresses really believed in it, but they saw that it was working and the people loved it. So, every heroine wanted it," he says. But while Malhotra influenced fashion trends and despite his reputation as a magician of the costume closet, his work remained confined to Bollywood. "I once met a businessman from Surat and he said, 'You don't know how many copies of your chiffon kurta we've sold.' But I could never cash in on it because I didn't have a brand, because I didn't have a business. There was also no time, and I didn't have the bandwidth or the knowledge about the business of fashion."

In 1999, Malhotra took the leap and launched his first ready-to-wear collections for Reverie, a local boutique, and then with Sheetal Design Studio. "People asked, 'How can he enter the mainstream? He's a costumer, he's a stylist.' Then the clothes started selling because all the actors were wearing them," he says. The rest is fashion history.

In 2005, Malhotra launched his eponymous label. Though he makes clothes for both men and women, his main preoccupation remains femininity expressed through glamour—namely to re-create the magic of cinema in everyday life. The results over the years are floral *lehengas* embroidered in *zardozi* and *maroli* with bottle green butterfly blouses, *dori* work on fawn and crimson, an ebony *lehenga* with vintage gold embroidery accented with rust gold fringes that string the hem. The treat remains the blouses, which undergo radical transformations from the "Israr" bodice constructed with a sheer back in an icy mint color with silver and ivory embroidery to the rectangular midriff-baring "Noor" choli.

Starting with a tailor working from his bedroom, Malhotra has expanded to eighteen workshops with 250 embroiderers in offices dotted across the suburbs. "I hope that by next year I have everything in one place; that's been my dream for sixteen years," he says.

For now, his atelier in Goregaon has metal racks that hold outfits for storied actresses and reigning heroines. Around the studio, master cutters smooth out yards of

ABOVE Promotional photograph for the Bollywood movie *Kabhi Khushi Kabhie Gham* ... (2001), featuring looks designed by Manish Malhotra.

OPPOSITE Manish Malhotra, *lehengas* with intricate *zari* hand-embroidery from the 2020 *Ruhaaniyat—A Celebration Called Life* collection.

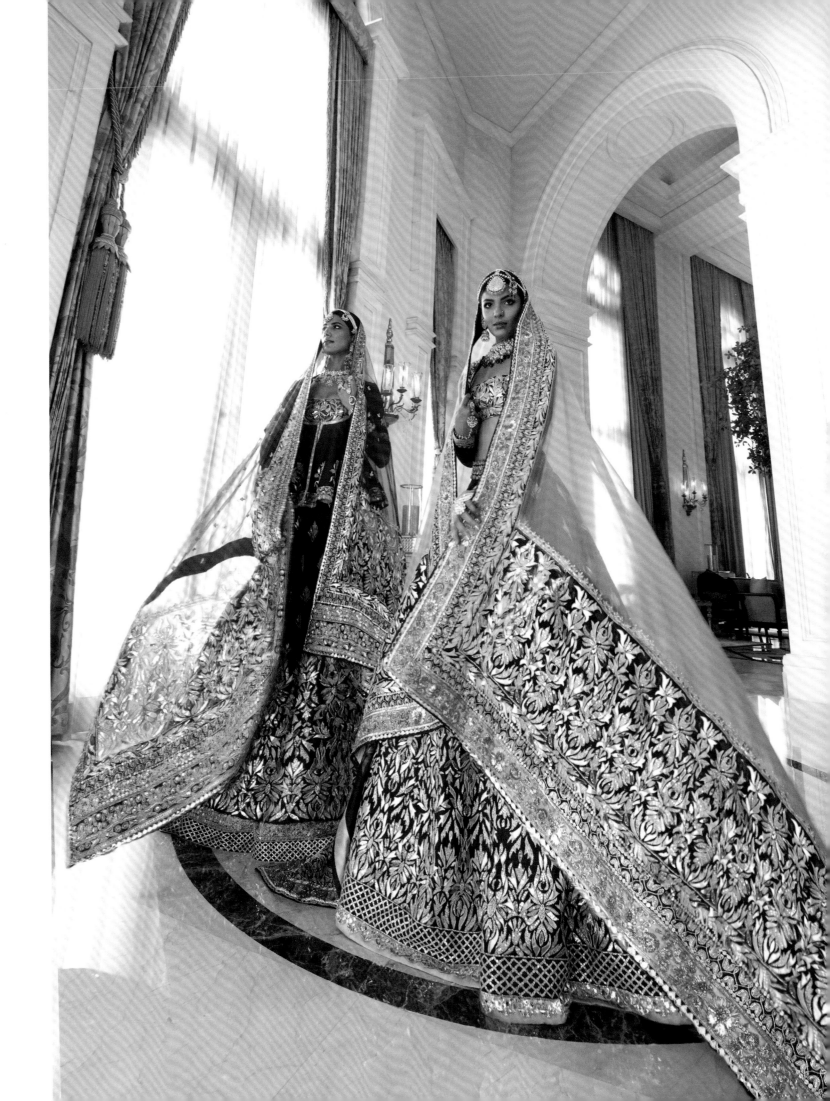

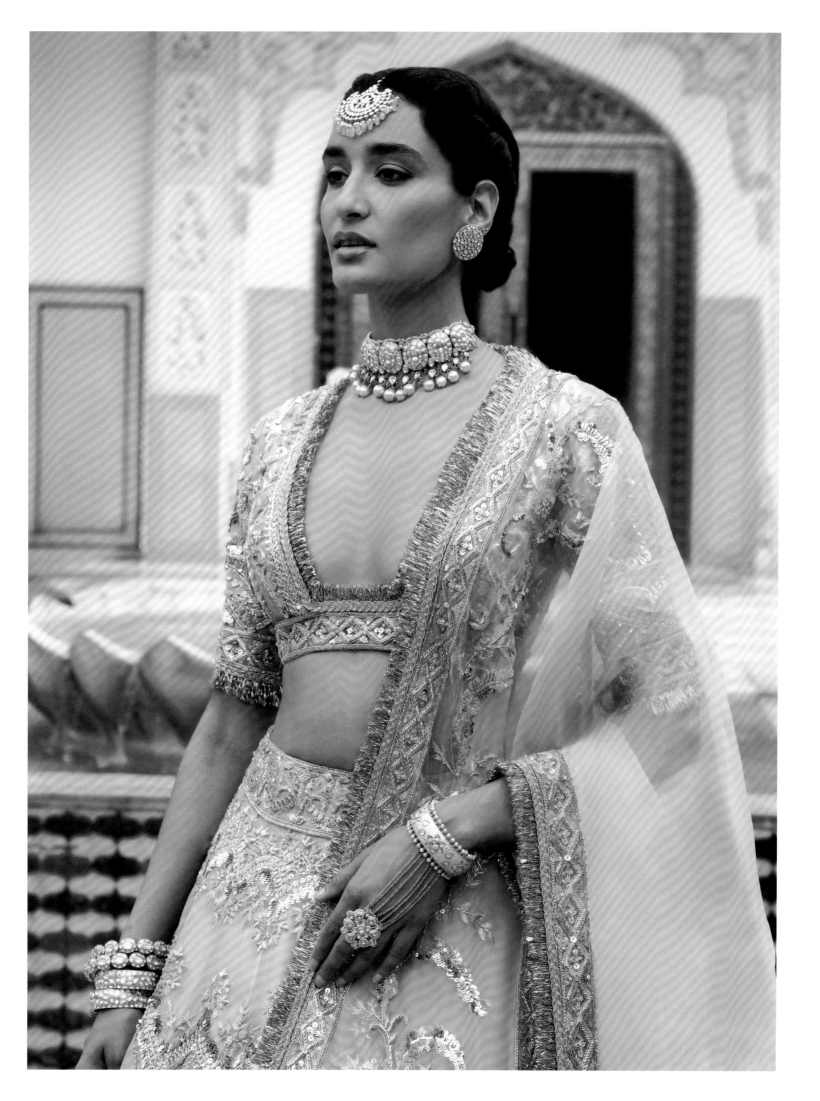

fabric on the cutting table. Once the cut is perfected, the fabric is moved over to sewing, where rows of men sit at their machines working to music. In a far corner, embroiderers hunch over wooden frames feverishly stitching sequins, of which there can never be too many in a Malhotra design. The atelier displays skills in sequin work paired with intricate *salli* embroidery that adds glitter and shine to a moss green sari from the *Taban* collection, in one of the house's most sought-after looks. When Malhotra walks into the design room, a team of young designers quickly surrounds him, each with a notebook. Malhotra inspects three pieces: a rainbow sequined gown with a feather cape, an embroidered green mermaid skirt with feathers, and a shaded blue Mijwan *chikankari lehenga* with an electric blue embroidered corset. "We need color and sequins," he says, the hallmarks of his look.

For days, Malhotra tells me, he labored over an idea of a barely-there blouse, backless yet snug. Inspired by the symbol, he called it "Infinity," and it was to be worn by Bhatt on the red carpet. One turn in the spotlight, and the Internet went wild. The blouse with *chikankari* embroidery was the handwork of Kashmiri artisans from Mijwan and was Malhotra's modern reinterpretation of Mughal embroidery. "I'm known for glamour, sequins, and over-the-top designs, but I'm also committed to craft, and that often gets missed out," he says, pointing to his color-blocking kurtas with *badla* and *tilla* work, which takes over a month to perfect.

In these Instagram-driven times, the game, the players, and the stakes have changed. Malhotra was once regarded as the gatekeeper with direct access to the stars' wardrobes, but today an algorithm can decide what's hot and what's not. "Likes don't necessarily mean business. Social media does get you the eyeballs—after that it's the strength of the product," he says.

While Malhotra's pieces continue to be more at home in the glamour of the aughts than the track pants and tank tops of today's world, he has fervently taken to social media and has also been part of a reality TV show, searching for fashion's next influencer. "Recently, a twenty-one-year-old bride was surprised that I design for films. She didn't know that, and it made me feel good. We've diversified so much, and now social media has made me into an influencer," he says. On any given day, Malhotra juggles three different jobs: tomorrow he'll be at another shoot, styling a rising star in cinema; he'll watch over the new collection and its online debut; but he's most excited about editing his first movie script, which will soon be produced by a big Bollywood production house. "As I've always said, cinema is my first love," he says, flashing his megawatt smile.

OPPOSITE Manish Malhotra, *lehenga* with *badla*, *zari*, and sequin embellishment, 2021 *Nooraniyat* collection.

ABOVE Manish Malhotra, embellished kurta. Modeled by actor Taapsee Pannu. Photographed by Bikramjit Bose for the May–June 2021 issue of *Vogue* India.

NAEEM
KHAN

HAMISH BOWLES

NAEEM
EMBROIDERIES

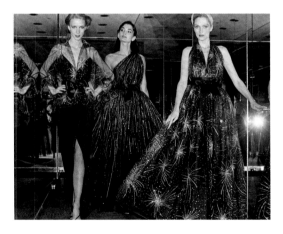

OPPOSITE Naeem Khan, evening dress with "firework" sequin embroidery inspired by Khan's work with Halston, Pre-Fall 2022.

TOP Khan's twenty-first birthday party, hosted by Halston.

CENTER Painting of Halston's "firework" embroidery, ca. 1980.

BOTTOM Karen Bjornson, Margaret Donohoe, and Dianne deWitt in "firework" sequin looks. Designed by Naeem Khan for Halston, Fall 1980.

Naeem Khan, born into a family of master craftsmen in the village of Bareilly in Uttar Pradesh, recalls his first childhood memory: the sound of hand-cut twenty-four-karat gold and sterling silver sequins tumbling to the floor of the embroidery workshop that had been established by his grandfather Shamshuddin.

Thanks to the global vision of Khan's father, Sharfuddin, those workshops would later embellish the sleekly flamboyant evening clothes designed by Halston, milliner turned fashion force who crowned First Lady Jacqueline Kennedy with the legendary domed hat worn to husband John F. Kennedy's 1961 inauguration, and whose clothes came to define the look of the Studio 54 era. Those Khan embroideries coruscated across that legendary disco dance floor, worn by such style icons as Liza Minnelli, Lauren Bacall, and Elizabeth Taylor, as well as the designer's own celebrated *cabine* of models, the Halstonettes. Khan was there for the fittings and the fun, for he learned his craft as an assistant to Halston, whose fabled studio in the Olympic Tower was the apex of the New York fashion world from the mid-1970s to the early 1980s. Khan has declared Halston his "guru," explaining that "the way he cut, molded, manipulated, and draped fabric has remained a touchstone."

Both Halston and his friend and sometime collaborator Andy Warhol pushed Khan "to think outside the box," and when Khan established his eponymous label in 2003, he asserted his place in the fashion system through a vision that blended his Indian heritage and mastery of the country's embroidery arts with a passion for the glamour embodied in the work of his mentor. This marriage was exemplified in the strapless champagne chiffon gown created for First Lady Michelle Obama to wear to the 2009 State Dinner for India's then Prime Minister Manmohan Singh and reached its apotheosis in the finale of his Fall 2019 collection when Khan reunited a trio of those fabled Halstonettes—Karen Bjornson, Pat Cleveland, and Alva Chinn—who walked wearing silver-sequined sheath dresses that pulsated with Studio 54 allure.

In Khan's autobiographical work, as in his fashion, the artisanship of India is married to a dynamic sense of modern American glamour.

HAMISH BOWLES: *Tell me about your family's history with embroidery and how that all began.*

NAAEM KHAN: In India, the embroidery business is predominantly run by communities. My grandfather started making embroideries in the 1930s and began with a small workshop of a hundred people. He was a worker at first—then he quit his job and started a factory with thirty to forty people, which became one hundred. He was making traditional Indian embroideries for the royal families in India. Then my father, who did not want to do this, left his little village at the age of nineteen and went to Mumbai, where he started his own business of making saris. Not knowing anybody and going door-to-door was the way he built his business. When I was growing up, he had two thousand people working for him.

If you were anybody important, and you wanted a trousseau for your wedding, you came to my father. I grew up watching all this, going with my grandfather to the factory, playing with spools of thread, lying underneath these yardages of saris that were being embroidered by hundreds of these men ... my vision of all this is so incredibly vivid.

My family became one of the most prominent embroidery families in India, and when I left for the United States, Halston was very intrigued by what we did. I became his assistant, and I started designing and going with him to Warhol's Factory. I learned from Halston the art of making glamorous things, lifestyle, draping ...

Then I started my own brand, and it has been an incredible journey—including making clothes for First Lady Michelle Obama. For example, the first State Dinner

dress for the Prime Minister of India that I made for her has so much history of mine. I used a very simple shape, which was very clean and Halstonish, but the embroidery I took from Warhol's *Flowers*. Then I sewed on sequins of pure silver—the same technique of my grandfather. The memory I had of hundreds of men beating metal into these flowers—tick-tack, tick-tack—and that's how that first State Dinner dress was made. It was part of my DNA. It was Halston, me, and my grandfather in that one dress.

HB: *How would Halston have known about your family business? And what would you say gave your father's work its edge? What set him apart from other embroiderers in the country?*
NK: My father is a very organized businessman, and he wanted to grow his business internationally. I came here to New York with him to go to school, and he came here to show his work to different designers. He went on appointments with Oscar [de la Renta], Bill Blass, Halston. The only one I went to was Halston because it was a Saturday, and Halston was busy during the week. I had no idea who this man was, and I went there and got a job as an assistant. So what makes my dad different from the rest? He had great vision and an organized business. He could produce thousands of dresses to the quality that Halston wanted.

HB: *What about Lesage and the fact that your father could create embroideries very similar to those? What are the characteristics that could only be done in India and only by your family?*
NK: It was a global organization where all the sequins were cut in Austria, all the crystals and beads were being sourced from Austria and Japan. Even the threads we were using were German. We were not using Indian materials, because India was not organized at that time. We really studied everything, from the size of the beads to their facets. With Halston this is what changed, what made us different from any of the Indian manufacturers. We had the techniques, but we certainly didn't have the materials. Then we did a big study on Lesage. The Indians were very used to stitching everything by the crochet needle—there are two types of stitching, one is *ari* and the other one is *zardozi* [everything by single needle]. With Halston we did everything single needle. And it was a modern take—like Warhol in art. Warhol would come in [to Halston] and then we would have the flower design to work with and we would sit there with Joe Eula [the illustrator who documented each of Halston's collections], me, Halston, Warhol and try to figure it out. And then with Halston, we had to establish how the light hit. We figured out that when the light hits from the top, the beads don't shine, but if the light hits from the side, at an angle, suddenly it becomes a different dress. So at the Olympic Tower we installed these photography lights on tripods that were hitting from the sides, and when Karen and Alva would come out and do their thing, it was as though the whole garment was shining like it was diamonds. We were actually looking at it like theater. That is what set us apart. Our family knew how to put it together, so it was our ideas from the United States, modernizing it, looking at Lesage, looking at Bob Mackie—who was big at that time and the only competition that Halston had in the stores—looking at how the beadwork shines when Liza [Minnelli]'s onstage. These were all techniques we developed in New York and passed on to technicians in India to have the embroideries made.

HB: *Tell me a little bit about the atmosphere at Halston when you were there. What was the process for creating collections, and how did the embroideries fit in with that?*
NK: It started with my family in India sending swatches of ideas. In the beginning they needed to be trained in a certain way—to understand that Halston liked more angular or more modern styles, not the traditional Indian ones. Then Halston and I would have

ABOVE Naeem Khan, evening dress of abstract hand-sewn copper sequins, inspired by stone walls, Fall 2011. Modeled by Karlie Kloss. Photographed by Steven Klein for the October 2011 issue of *Vogue*.

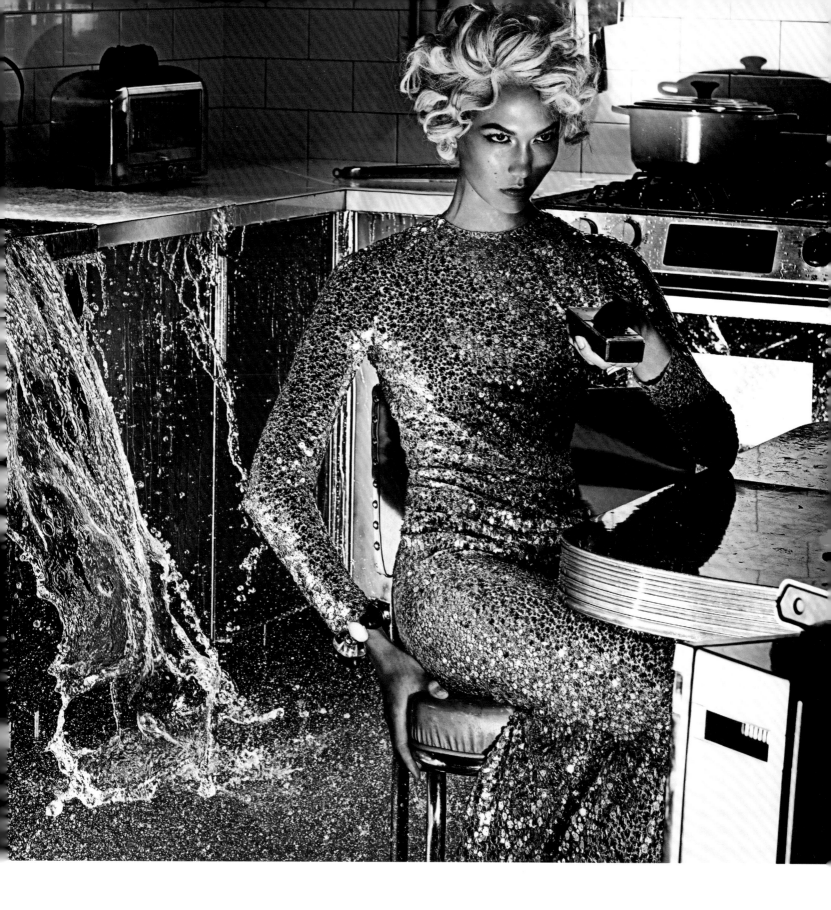

a meeting—he would have the idea that he wanted something geometric, and I would sit there with a spirograph and take paint, spin it, and create patterns with it, put it on the copier, blow it up, put it on the mannequin, and we knew from the embroideries what would happen if I placed the beads at certain angles. Then I would sit with him, and he would sketch out these five looks with geometric beading. He would say, "OK, jumpsuit with a kimono jacket," and then I would sit there and draw every line, show it to him, get the approval, and then we would have couriers who would take it on the plane, hand carry it to India every season.

HB: *What made you decide to found your own brand? Tell me how you took that Halston knowledge and brought it to your own brand.*
NK: I was tired of that life at Halston, which was very exhausting. Between the drugs, Studio 54, the craziness, the drama of the business … one day I just quit, and he was very upset because nobody else would do what I was doing. After eight years of doing this with him, I needed my own life. And I had met my wife and we just wanted to run away, so I basically left and went to Los Angeles. And I started my own brand thinking I'm so great, and within eight months I had lost every penny I had made.

HB: *What was your aesthetic vision for your first brand Riazee?*
NK: Riazee was super commercial, but there was a problem in that business because I was selling everything at such a good price. Then recession came, and people were a little more price-conscious, and we saw the margins of profit were dipping. I asked myself, "Why not start Naeem Khan and now triple the price for it?" I'd rather do a smaller business with a higher margin. So I started designing a little more forward-thinking, more "designer." [Riazee] was just designed like sportswear for the retailer. For Naeem Khan it became a collection where you buy things that were not all embroidered, you could combine things and present them on the runway like Valentino would do.

HB: *You have a community of eight hundred artisans?*
NK: Well, they fluctuate between six and eight hundred, depending on the season. In India most embroidery workshops work the same way, so if I have a hundred people who are my permanent people, then you have the other seven hundred on a contractual basis. You can change your executives, but I can't lose my artisans!

HB: *Are there embroiderers specializing in different kinds of embroidery?*
NK: There are two different types of stitches predominantly used in India. One is a single needle stitch, and the other is a crochet stitch. When I'm designing, in order to keep my artisans working, I have to design with both those techniques.

HB: *Would you say there was the hand of India in what you are doing?*
NK: In everything. Because I've never given up what I'm known for. There were many times I used to think, "Oh, I'm sick and tired of this glamour. Why can't I do suits?" But I always got resistance from the retailers. My design is driven by what the consumer needs. They come to me for super-high glam, and India plays a role in it because everything I design has the color sense of India or is inspired by India, or from reading some book on the Mughal dynasty because I also love history, and I love culture. But being part of such a family, I feel I owe something to them for all the success I have had. There is a thing in me that means I need to maintain that even though I live in America, and I make these modern clothes. I want to keep this embroidery art alive and make sure that these craftspeople are respected and have business from me—whatever I can do.

OPPOSITE Naeem Khan, evening dress of champagne tulle with sterling silver sequin embroidery, inspired by Andy Warhol's *Flowers*. Worn by First Lady Michelle Obama, standing next to her husband, President Barack Obama, for the state dinner in honor of Indian Prime Minister Manmohan Singh and his wife, Gursharan Kaur, in 2009.

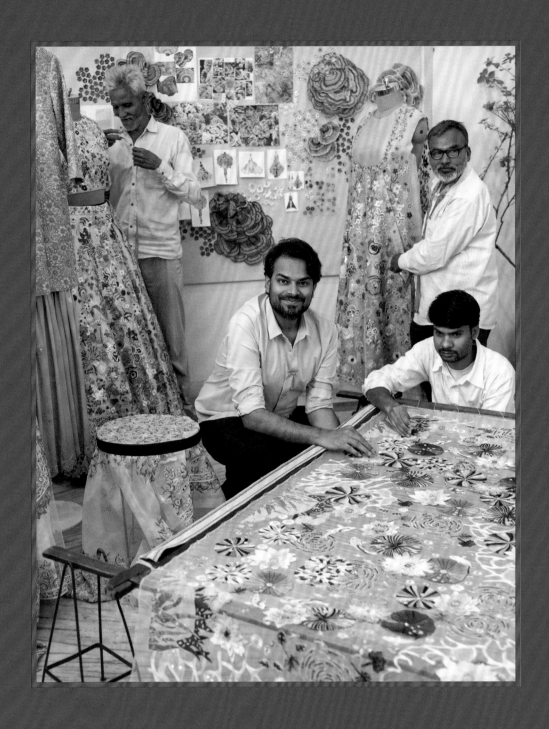

RAHUL
MISHRA

SUZY MENKES

The first time I saw the work of Rahul Mishra was when he won an International Woolmark Prize at Milan Fashion Week in 2014. I was impressed by his use of subtle textures and colors. The Indian designer has come a long way since his early focus on hand embroidery—as evidenced by the fact that he has been accepted by the French haute couture federation to show his Indian creations during the Paris season.

When I talk to the designer now, I realize how intensely personal his approach is, whether he is talking about his passion for the work of human hands—he has supported his hand embroidery workers during the pandemic—or explaining how he guides his daughter, Aarna, to understand nature's power. For Mishra, as with so many Indian creatives, his skills are a part of his life. He told me about his childhood and its creative rhythm, which speaks of age-old concepts.

"When I was young, my grandmother would spin her own yarn out of white cotton and get it woven by a local weaver," Mishra said. "With that fabric, she would make saris for herself, block-printed with a homemade indigo dye. It was part of the culture in India at the time, as our mothers would make things like curtains and pillow covers at home, and decorate them with different kinds of techniques such as appliqué, crochet, and hand painting. Despite all the modernization today, local craft and handloom of India continues to hold those aspects of our heritage and some values that my wife, Divya, and I wish for our daughter to grow with and understand from a young age. Aarna gets very little screen time in a day and, instead, we engage with her in activities such as cooking, gardening, painting, and sport such that she isn't influenced so much by media and is able to develop independently from it. We want her to grow as a child who is curious about natural processes and phenomena such as the power of transformation that nature holds—the way a seed grows into a plant, the way the five elements of nature interact with one another. Her wonderment makes us [in turn] wonder so much more and, with her, we learn so much every day."

I asked him to take me back to his own early days.

"Before studying design, I was a science student," he said. "I had primarily wanted to do filmmaking, and it was almost by chance that I got into apparel at India's National Institute of Design. I showcased a collection using the *mundum neriyatum* handloom textile from Kerala at Lakmé Fashion Week in Mumbai. Then, later on, I went to study at Istituto Marangoni in Milan."

At what period did he concentrate on India's local crafts, which he says are "deeply ingrained" in his heart? The creator realized that designs needed to be relevant to international markets to be sustainable there. That premise defined his modern approach to both textiles and design—and led to the milestone moment when the late Italian *Vogue* editor Franca Sozzani praised his work for the Woolmark prize.

How did Mishra grow a business in India, where he now has a thousand people working with him, in spite of the COVID-19 situation? His dream—impossible as it sounds—is to eventually employ a million artisans and in the next decade to reach ten thousand customers. Add to that aim: creating a zero carbon footprint culture in new headquarters that will create its own power and have rainwater harvesting, waste management, and recycling facilities. But all this, as he told me, depends on people.

"I have always shared a deeply personal relationship with my artisans," the designer said. "Since its inception, the intention of our brand has been to 'collaborate' with the weavers and embroiderers—not just to employ them. Even today, I spend my time interacting with the tailoring and embroidery team, talking about our families and taking their feedback. We laugh and celebrate together, like family, and take care of one another, like family too."

OPPOSITE Rahul Mishra with craftsmen, The Karigar Project. Photographed by Aman Kumar for the June–July 2021 issue of *Harper's Bazaar* India.

Mishra maintains that his workers "are in a way, my first critics," explaining that during the lockdown they discussed the concept of creating "couture" in the time of crisis. The conclusion was that—however indulgent the clothes—the detail and extravagance were a necessary way to support the workers.

"We have the philosophy of the three *P*s when creating a product: purpose, process, and people," according to Mishra. "That translates as identifying the need for another outfit and a suitable creative process. Thus, handlooms and hand embroidery generate work—and make the products special."

I had been fascinated by a recent digital couture show in Spring 2021 that Mishra called *The Dawn*. The images, taken in Rajasthan, stood out dramatically from previous collections—not least because of the white background of a marble dump yard in multicolored India. "A retrieval of color to a world drained of natural resources, abundance, and animation through years of piling marble dust," the designer explained. "After a year of lockdown and watching nature flourish during the lack of human activity, I contemplated the world as it would exist if humans continue to damage the environment. When the last tree is felled, fungi would blanket the dead trees and birth a new flush of life."

I asked Mishra if living in India meant that the power of human hands is both exceptional and alive. "Handcraft is at the core of India's cultural heritage," said Mishra, who added that before industrialization, all the local craft traditions employed large communities of people "not just to keep food on their tables, but to contribute to their success and prosperity."

Mishra explained that in 2004 he had visited the Sabarmati and Kochrab ashrams, favored by Mahatma Gandhi, for a course on design concepts and concerns. And this was where he had learned the real meaning of Gandhi's talisman: "Recall the face of the weakest man you have seen and ask yourself if this step you contemplate is going to contribute to them gaining their *swaraj* [self-reliance]. It is important for us to understand what mass production of fashion is doing to the environment and how we must return to the rhythm of slow production so as to conserve our resources." He continued, "Processes of handcraft allow us to explore our philosophies of slow fashion where fewer resources are used over a larger period of time and more people are empowered in the process. The clothes that emerge out of this also hold greater value as they are touched by hundreds of personal stories and souls in the process."

India today has millions of people dependent on craft, making it a primary responsibility of creative directors and designers to support their work. Per Mishra: "As Gandhi once said, 'There is no beauty in the finest cloth if it makes hunger and unhappiness.' I believe that machines have done a great disservice to people not only by creating unemployment, but also by enabling fashion that lacks the beauty of human touch. It's not just about keeping handicraft alive and celebrating it; it's also about empowering communities of craftsmen with purposeful design. And I believe that with the right rhythm we can cultivate the kind of luxury that is sustainable, mindful, and still exciting."

OPPOSITE Rahul Mishra, three-dimensional hand-embroidered "Mushroom" drop shoulder ocher long dress. Individually engineered in unique patterns with hand embroidery, the dress features hundreds of mushroom forms hand-tacked to its surface. Couture Spring 2021, *The Dawn* collection. Photographed by Hormis Anthony Tharakan.

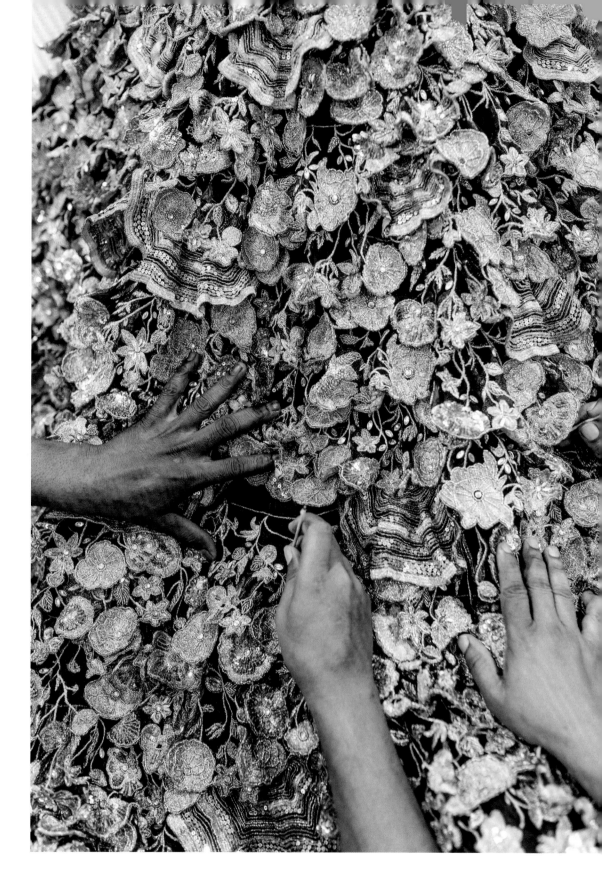

OPPOSITE Rahul Mishra, three-dimensional hand-embroidered "Gold Foliage" cape, featuring tens of thousands of embroidered leaves individually hand-tacked on tulle, paired with hand-embroidered "Mushroom" leggings. Couture Fall 2022, *Tree of Life* collection. Photographed by Valerio Mezzanotti.

ABOVE Rahul Mishra, three-dimensional hand-embroidered "Botanical" evening dress (detail), embroidered with gold *zari*, *resham* threads, metallic sequins, *kundan*, and metal cords to articulate the nervous system of a tree. Couture Fall 2022, *Tree of Life* collection. Photographed by Team Rahul Mishra.

RAW
MANGO

SARAH FEE

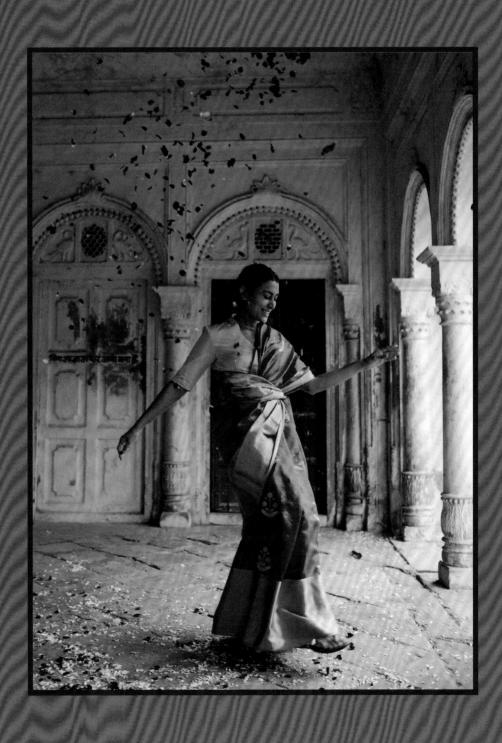

A Zoom call from Toronto—not an ideal first encounter—was how I met renowned designer Sanjay Garg, founder of Raw Mango, whose creativity draws on a deep sense of India's place, people, colors, textures, and traditions. But we instantly connected over a Naga palm-leaf raincoat that Garg had hanging on the wall behind him. Garg's animated praise of its ingenious silhouette and technique instantly conveyed his insatiable curiosity, his well-known indifference to urban runways, and the myriad inspirations during his journey as a "doctor" of design. Excerpts from our conversation offer further insights into Garg's search to define "a new aesthetic vocabulary," as he poetically puts it.

SARAH FEE: *Let's start at the beginning, how your early life shaped your journey.*
SANJAY GARG: You don't always know what the big moments are, at the time they happen. ... I started life in a tiny village, Mubarakpur in Rajasthan, which still has no post office. People hardly had phones or cars. I studied in the only village school. Becoming a doctor or engineer or accountant was the usual way—and I never knew that design could be studied. But when I went to Jaipur to continue schooling, I was introduced to a friend of my mother's, and that connection opened worlds to me—to seeing and to studying design. Still, I followed the expected path and did a master's in commerce. But then I made a decision that I had to follow my heart and give design a try, so I went to Craft College and NIFT [National Institute of Fashion Technology] in New Delhi.

SF: *So why textiles and fashion in particular? Why not another medium?*
SG: That is a good question. ... I never really separated them. I don't like labels or to be locked in. Fashion was for me a medium of expression, but never alone—I was doing everything at once: we were doing photos and video and dance. We created music and objects. For the tenth anniversary of Raw Mango, we created new music albums.

In this country, we live craft; we don't separate craft from art. Terra-cotta, leaf plates, handlooms, it's all still happening. In Hindi there's only one word for it: *kala*. It can be dance, music, or poetry ... textiles are part of it, too. There's one word, and we don't really separate art from craft, in a way.

SF: *You have said that the sari will always be your first love and that you want to make the sari the hero. Can you tell us more about that?*
SG: I've always wanted to be more like a graphic designer. To me the sari is both two- and three-dimensional. It's flat—like graphic artwork—but when it's worn it becomes sculpture on the body. Material to me was never just about design, it's about expression, a way of living life. And that's what I express through different media.

I always believe that India needs to come up with something that is its own ... there is no individuality in just following global brands. I ask myself, "How can I make a contribution?" India has a one-thousand-year-old skill set available; we have so many textiles, techniques, fibers, material, and motifs to offer the world. But I always ask, "How can the sari be a modern garment?" Not just for special occasions—for weddings or for local identity—it can be the new T-shirt, something cool for the young.

It's about changing the context, moving away from the sari being only a garment for the intelligentsia or the rural classes or solely being worn for special occasions and toward a confidence that any woman can wear it anywhere, anytime. That's modern and powerful.

SF: *So how do the sari and fashion come together?*
SG: The word *fashion* is a problem in many ways ... it really changes according to the times. And if the sari doesn't continue to change, it will die like an old language. The sari was

OPPOSITE Raw Mango, "Gulfam" Chanderi silk sari with gold *zari* floral embroidery and orange *meenakari* and "Pali" silk satin blouse, 2019 *Radha* collection. Photographed by Bikramjit Bose.

never frozen [in time], there weren't always petticoats or a blouse, it could be thirty-three or forty-eight inches wide and three to nine meters long and worn in so many different styles. So my idea is that it will only survive if everyone finds how the sari represents them in 2022 or beyond. Maybe they want to wear it with a sweatshirt or a jacket or a sexier blouse.

Classifying it as purely modern or purely traditional is also a problem. The sari, until today, has always been a modern garment.

SF: *Where do you consider yourself in relation to the so-called fashion world?*
SG: When I started, I was a rebel. I didn't want to use fashion models, photo shoots, or runway shows. But we did a lot of visual communication, and from the beginning we had women from across the country of all colors and ages and body types wearing our saris. We worked on palettes, developed a blouse and petticoat and a pullover sari, and did all kinds of draping.

I don't see myself as a fashion designer; I feel more like a doctor. The patient comes to the doctor, and the doctor solves the condition, and that's what design is to me. It's total design, from the table to the lighting to the doorknobs in the shoots. It's the graphic qualities, the music, the objects ... it's expression through all media. It is a journey. I will let you decide if what we do is fashion or not.

SF: *Where does the textile enter your creative process?*
SG: We have a long history of unstitched garments. I still design the textile first, before the silhouette. I study and look closely at the textile and then decide what silhouette it could take; I think about how it was used historically and what it could mean today in modern times. That's what gets me excited. I don't have weavers in Delhi, but I go to the centers of where weaving is being done today.

I've woven three hundred textile swatches myself. Weaving is like mathematics; it's like a drug. I remember sleeping and seeing it in my head or on the ceiling, how two colors can happen—the warp and the weft. I love it.

SF: *You were among the first to promote India's handwovens—as opposed to embroidery— and have worked with many kinds from across India, most notoriously Chanderi and Benarasi brocades. What is the newest textile you are working with?*
SG: *Mashru* ... I love the design and the weight of the fabric. The designs are hundreds of years old but still beautiful on the human body. But how to design with it today so it can survive and be modern? It's taken some time, but we've developed three kinds of *mashru*. One kind we launched in 2015, and the other is for our next collection.

SF: *Your collections are always conceptual. Where does the process start? For example, how did the line* Monkey Business *begin?*
SG: I think [a collection idea] first comes into my head as a kind of concept, then I think of the textile, then a woman, and finally a silhouette. Something is in my head that excites me, and I have to do it. I wondered why monkeys are not part of our visual vocabulary; monkeys are a symbol of India, and I see them all over Delhi. We have parrots and other things on our garments, but not monkeys. I had a lot of fun with this motif. It was meant a bit to upset the purists—people who don't want to alter so-called tradition—and to make us think of ways to keep tradition alive. Monkeys have adapted from the jungle to urban areas; they are intelligent and are a big tease. We shot on city rooftops to mimic how monkeys have come from the jungle to the city, ready for change—to keep design flowing and changing like language. This continuous dialogue keeps me going.

OPPOSITE Raw Mango, "Beloved" sari in Varanasi floral silk brocade with dense *zari* border, Summer 2022 *Chorus* collection. Photographed by Tenzin Dakpa.

PAGE 230 Raw Mango, "Roopa" organza sari with all-over peacock *butas* and "Parvati" striped silk blouse, Summer 2021 *Jhini* collection. Photographed by Rema Chaudhary.

PAGE 231 Raw Mango, "Anila" cotton sari with "Asta" shirt (left) and "Vani" cotton sari and "Vrini" shirt (right), 2017 *Cloud People* collection. Photographed by Ashish Shah.

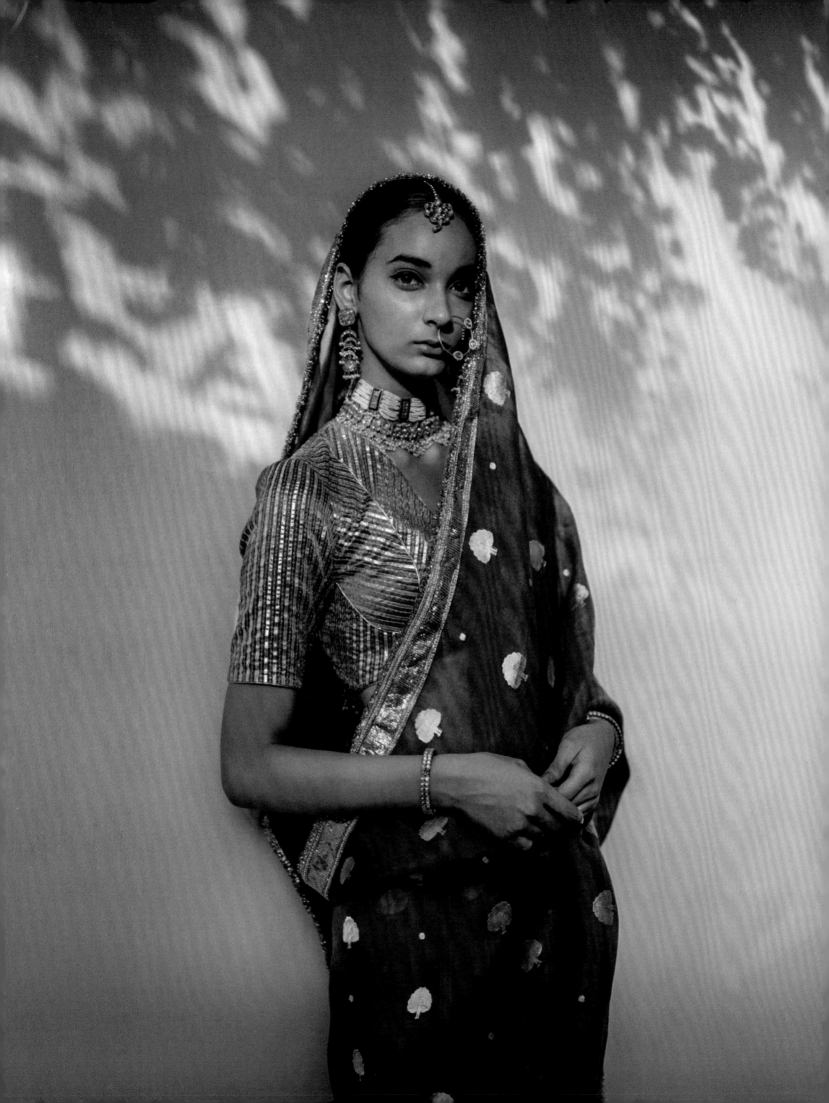

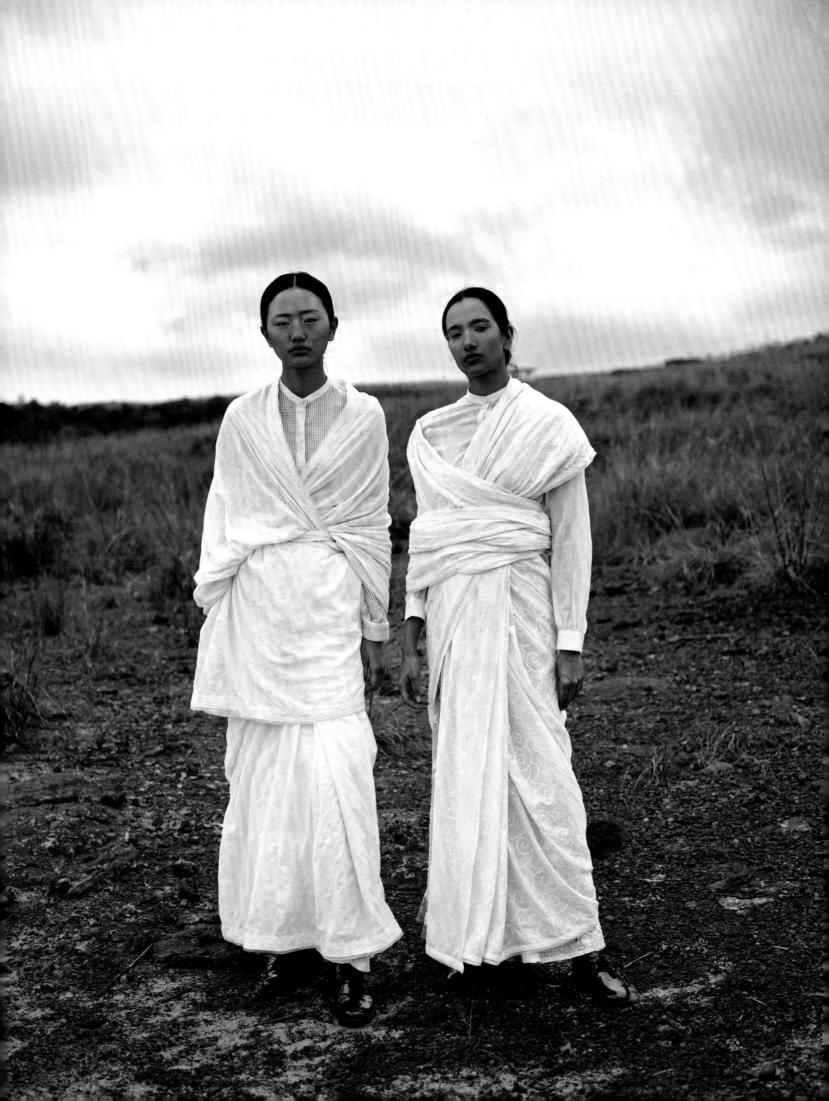

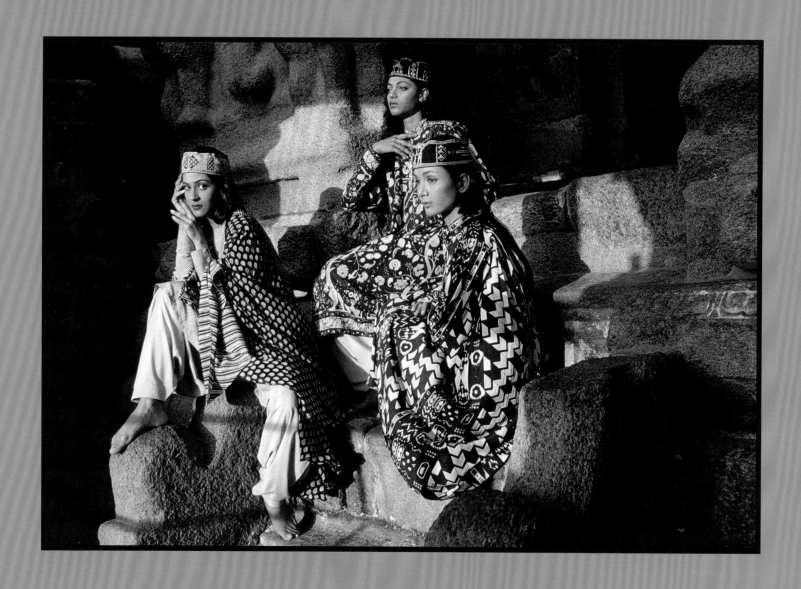

SUZY MENKES

RITU
KUMAR

"India had nothing, absolutely nothing," says Ritu Kumar, the celebrated designer and costume curator, of her country's fashion system at the end of the 1960s. "It was a complete desert when I started working," she says. "I was an art history student, and I came across this village where people were doing hand printing. It was a miracle that I found [the village] and its aesthetic. I knew how to draw, so I started making block prints for them."

At London's Victoria and Albert Museum where the young, artistic Kumar went to research Indian prints—because "there were none left in India"—she discovered "a complete vocabulary of classical designs. I wanted to put [them] in a space where [they] could be both modern and fit into people's aesthetic sense. So, it was much more a journey in aesthetics rather than just a journey looking for some old craft. I never really thought of myself as a fashion designer, because *fashion* was not a word we were familiar with. We had no production, so whatever I found was very precious. Everything related to Indian textiles—whether it be in printing or embroidering or tie-dyeing—was a huge discovery."

At the time, as Kumar recalls, "We really didn't have too much interaction with what the rest of the world was wearing. People didn't know what was going on in Paris. This was a time of toughness, post-Independence: the whole country was burning imported goods. You were very idealistic, you wanted to get India back to what it used to be. When we did get independence, we were in the mood to wear indigenous clothes. Imports had been banned—you were not allowed fabrics or anything from anywhere. I couldn't import a zipper or a single button, so in my initial years I had to innovate, to find loops and cords—things that knotted when you couldn't find a zipper—the kinds of things that perhaps were used thousands of years ago. Because of things like that, you had to create a completely different, organic feel. There were no retail spaces at that time—none."

In 1969, Kumar began making block-printed saris "from the authentic process. They had a completely new twist—so elegant and fashionable. [However] I didn't know where to put them. I went to a grocery store—one of the biggest— and started selling them there and they flew! Then I just couldn't stop the momentum." Kumar describes the craft revivalists like herself as "freedom fighters who went from village to village and found all the old crafts that were declining." She says, "We were sent into the field like doctors almost. We didn't know where we were going or what we were doing, but the discovery was so exciting. It was the generation that really got into more intellectual bohemia—that's when the Beatles came to India." In 1970, Kumar's work came to the attention of Judith Ann, whose father was in the Seventh Avenue fashion business in New York. "She convinced him that he should buy our dresses," Kumar recalls. "I'd never made a dress in my life, but I managed to find a cutter and a tailor who used to make dresses for the British ladies, and we made a dress." The label Ritu Kumar for Judith Ann sold for almost three decades.

Today, from Darjeeling in the Himalayan foothills to southern, techno-focused Hyderabad, Indian clothes look like art objects, and Ritu Kumar is proud of her part in helping Indian fashion survive. Her intriguing style has been to mix various Indian inspirations—using a deep historical knowledge of her country's handwork— and to find a vibrant and fresh way to present clothes from across the subcontinent. Now, in this millennium, a cultural aesthetic that has been ingrained over decades is currently subject to an evolution.

Fifty years ago, Ritu Kumar's early creations gave birth to an inventive vision that amalgamated different elements—all definitively Indian. Yet she feels that outside her own country, designers still find it difficult to define the range of Indian looks.

OPPOSITE Ritu Kumar, ensembles of hand-printed silk from the *Tree of Life* fashion tableau, a presentation about the revival of Indian craft, which was shown internationally. Photographed at the temples of Mahabalipuram, 1980s.

In explaining how and why Indian women choose their clothes, the designer says that "someone who is trying to export clothes to India has to work out a category of people and who wears what. I see the collections from Europe and America, but other countries have to understand how alien the concept of 'yellow and green are the colors of the season' is in India. It doesn't hit India at all—they have no idea, or interest." She explains that "colors in this country are worn according to religious festivals and for [special] occasions. You cannot meet somebody wearing black during Diwali [the Indian festival of light]. Black is not a color that we wear in India. Traditionally, it hasn't worked. People wear what suits the occasion, and we work toward fetes, seasons, movies, and theater. India loves theater, so clothes are always going to be a little over the top. Weddings are big, big expenditures: you need six outfits minimum and cannot repeat them." I ask her if that is good for business, and she maintains that it is, "particularly for the indigenous craftspeople."

Kumar believes that talent in India is ready to present itself—from the highly advanced skills to the legacy of the patronage of feudal lords, which she explores in her distinguished book *Costumes and Textiles of Royal India* (1999). "I speak here of things like embroideries and handwoven textiles," she says. "But perhaps even more important is the cultural aesthetic that has been ingrained over decades and is currently subject to a vibrant evolution. Those words typify our brand where we are now developing a global and modern persona on the foundations of revivalism and traditional craft."

For over fifty years, Ritu Kumar's work has been devoted primarily to reviving dying textile arts in various parts of India. But she has also developed an original meld of classic mixed with contemporary, something that she understood well in advance of the consumerism that dominated Indian society in the 1990s. "Before that, it was like seventeenth-century Europe, where you would go and get your fabric—from the weaver, from the embroiderer, or from the cotton industries in India—then make your dress."

I love listening to Kumar's descriptions of the textiles and the places where they are made: "delicate muslins" from Dhaka, "fine silk brocades" from Varanasi, "complex woolen weaves" from Kashmir, "intricate gold embroideries" from Lahore. "Indian clothing has a huge vocabulary," Kumar says. "I grew up wearing the *salwar kameez*—trousers and a top—which is what most Indian women wear today. But our mothers used to wear saris because they are 'figure streamed'—very forgiving—and it is attractive to wear six yards of gorgeous fabric. Alongside Western clothes there is now a huge influence of the younger generation wearing saris—in a sexier way, of course. In India we have been customizing for thousands of years. With five hundred years of textile tradition in every part of this country, and color and fabric that you can work with—nobody can ask for more."

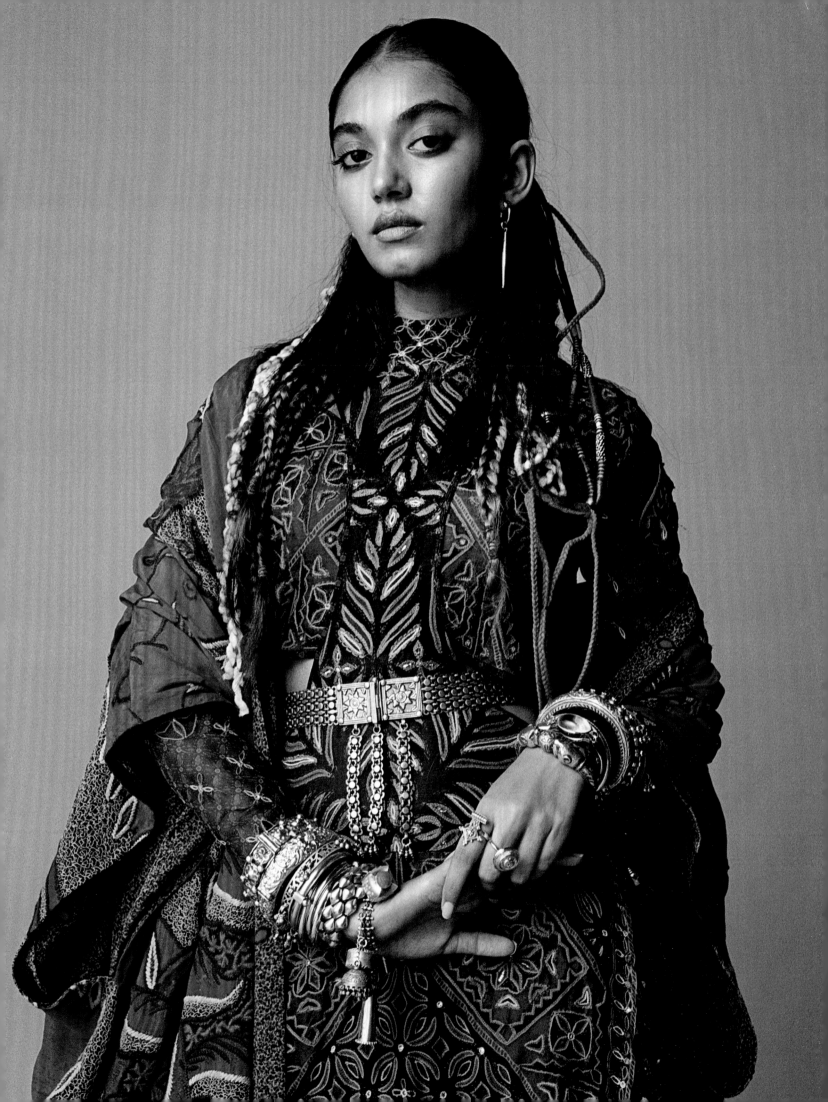

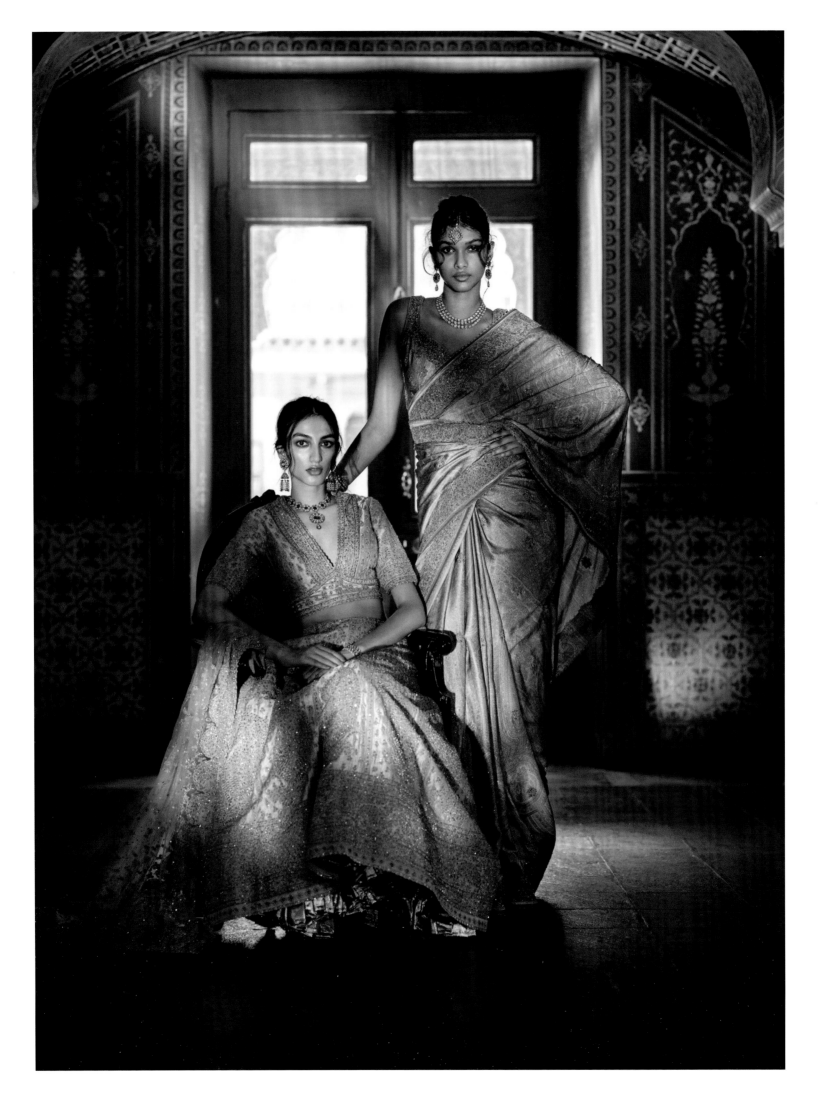

OPPOSITE Ritu Kumar, *lehenga* ensemble (*left*), consisting of a skirt, blouse, and shawl of hand-woven silk with hand block-printing and *zardozi* embroidery. Sari (*right*) of hand-woven silk that is hand screen-printed with *Jamawar* shawl motifs from Kashmir and embellished with *zardozi* embroidery, Fall/Winter 2021, RI Ritu Kumar collection. Photographed by Tarun Khiwal.

BELOW Ritu Kumar working on the revival of traditional *zardozi* bridal embroidery in Ranihati, a cluster of remote village huts, a few hours outside Calcutta (now Kolkata), early 1970s.

SABYASACHI
MUKHERJEE

SUZY MENKES

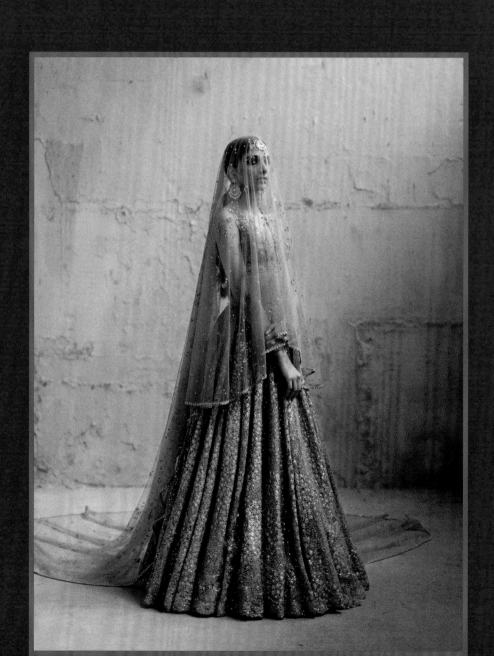

V ivid color, liquid silk, crisp stitches, dense embroideries, and fantastic patterns—everything in Sabyasachi Mukherjee's store in Mumbai tells a story. And not just about the power of Indian weddings. Although saris in their shimmering colors and intense decoration underscore the power of the Indian marriage and its demands, there is so much more—the store is a treasure trove, offering items from traditional Hyderabad pearl jewelry to pieces of fine china.

I remember my first visit, when I was captivated by those bright saris, with their patterns of birds, flowers, and temples. I asked the exceptionally creative designer how he keeps India's heritage alive.

"I am not just a 'designer'—I'm an Indian designer who has always believed that authenticity comes from being true to who you are, where you come from, and what you know," Sabyasachi replied. "As the world gets more homogenized, luxury seekers will want to explore diverse identities through authentic products and experiences. This almost evolutionary trend is going to be the driving force of the new frontier of luxury in the years to come, so I represent my collections as proudly Indian and reflective of my own experience. We are a land of many stories," he continued. "The dream is to be able to represent that richness and leverage it to create a luxury brand that has a value that cannot be matched in the world."

I asked the designer if it is remarkable to have embroiderers across the subcontinent: Bangladesh, West Bengal, Punjab, and Rajasthan. Since local crafts such as handlooms go back thousands of years, does this make his work noteworthy?

"If there is a superlative craft resource in India, you will find a Sabyasachi workshop there," he replied. "Our country has a diverse and pluralistic heritage. The idea is to explore these resources and amalgamate them to create products that can be made only in India."

Passionate as I am about the power and importance of the work of human hands, I asked the designer if he considered his embroideries from Kashmir or Rajasthan to be unique.

"I use machines for mechanical support, but I prefer to use the skills of the human mind and hand for embroidery," Sabyasachi said, explaining that India's long and rich legacy of embroidery has evolved into a glorious living tradition crossing continents, as it goes from *zardozi* and *ari*, to *kashida* from Kashmir, *phulkari* from Punjab, *gota* from Rajasthan, *chikankari* from Uttar Pradesh, *kantha* from Bengal, *shamilami* from Manipur, *kasuthi* from Karnataka, and *toda* from Tamil Nadu. As the designer puts it: "You can trace the history of India and its regional diversity through each stitch—artisanal embroidery isn't just refined into a perfected craft, it carries with it our stories and our heritage."

Thinking of the designer's work to promote Indian heritage, not including the treasures in his shop, I asked Sabyasachi if he should be seen as a so-called Renaissance man—someone intelligent and artistic, educated and sophisticated, imaginative and international.

"I come from Calcutta [now Kolkata]—the capital of British-ruled India and a vibrant hub of art, education, and culture," he replied. "It has witnessed economic devastation and Partition, but the cultural and intellectual grounding holds firm. It seeps into your system through a sort of osmosis. It's a city of renowned philosophers, poets, writers, freedom fighters, nation builders, filmmakers, musicians, and artists. Almost all of India's Nobel Prize laureates belonged to this city.

"Exploring thought is a way of life here," Sabyasachi continued. "Calcutta is known for its *adda* culture—salon-style conversations covering topics from the state of the nation to brewing that perfect cup of tea! I grew up with my art school mother and a

OPPOSITE Sabyasachi, hand-dyed tulle *lehenga* embroidered with paillettes and embroidered tulle veil, Sabyasachi Couture 2022.

motley crew of my bohemian friends—I've been swaddled in ideas and discussions about culture, education, art, entertainment, literature, and imagination for as long as I can remember."

Aware of the designer's early involvement with cinema, I asked him about Bollywood. "I worked in cinema when I was breaking into the fashion industry in India," he explained. "Films can be a great marketing tool because India, like America, is a celebrity-obsessed country. But I have to confess that I don't particularly enjoy making costumes because I enjoy working more independently and need my creative freedom."

The designer calls his philosophy the "personalized imperfection of the human hand." So I asked him about this battle against the digital world—just like that ongoing struggle between man and machine.

Sabyasachi pointed out that for crafts to survive, they need a market. As the world increasingly uses technology to create branded luxury, powered by marketing, the idea is to create authentic luxury that is slow and handmade. "I have always believed that authentic luxury will take over marketed luxury," he said. "What is created and crafted by human hands cannot be scaled. And that which represents the stories that make us—be it what was or what will be—is going to be the future pillar of luxury, alongside culture, art, and history. But I don't see this as a conflict between human and machine, or humanity and the digital world. The digital world offers a great marketing tool and has given brands like mine direct access to connect with our clients across the globe. But for me, luxury, pure luxury, is synonymous with the artisanal, and I am a big believer in creating something that is special, thoughtful, and timeless."

OPPOSITE Sabyasachi, handwoven half-pashmina and half-Benarasi saris with embroidered borders and printed blouses, 2015 *Sabyasachi Heritage Classics* collection.

PAGE 242 Sabyasachi, hand-dyed tulle *lehenga* with threadwork embroidery and embroidered tulle *dupatta*, 2022 *Sabyasachi Calcutta Rouge* collection.

PAGE 243 Sabyasachi, raw silk–embroidered *meenakari lehenga* with embroidered blouse and embroidered tulle *dupatta*, 2018 *Sabyasachi Heritage Bridal* collection.

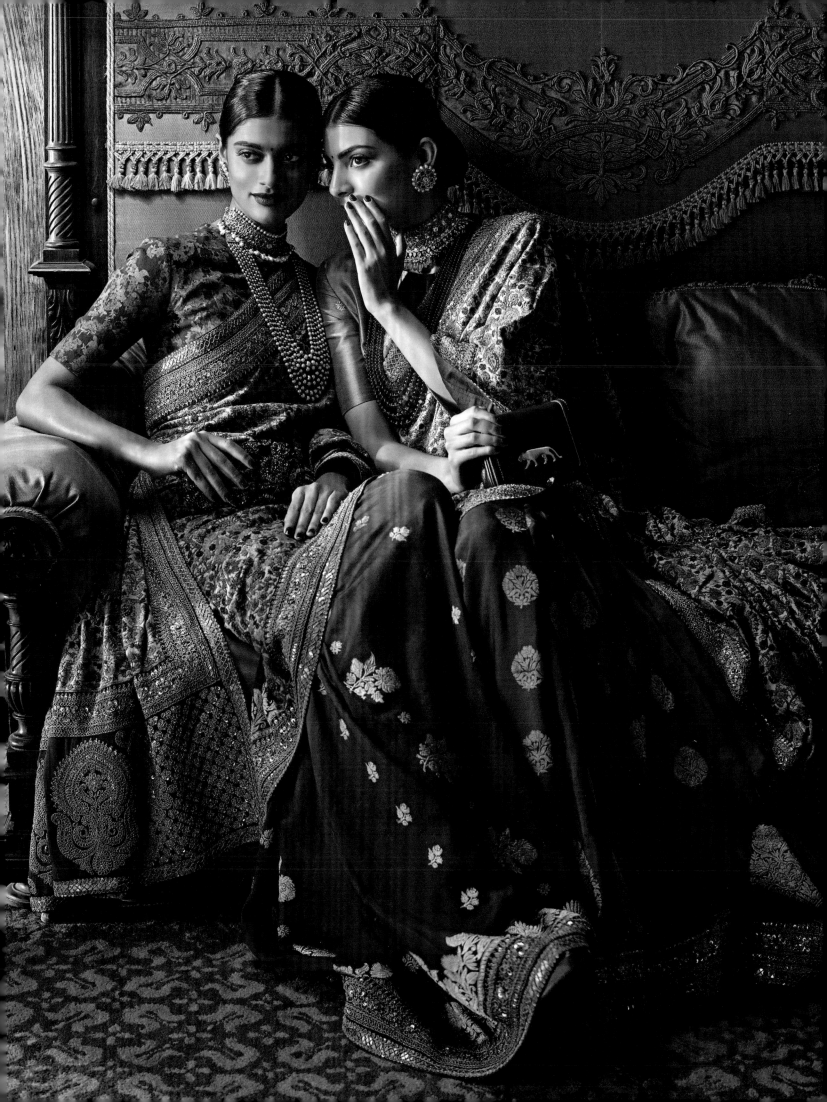

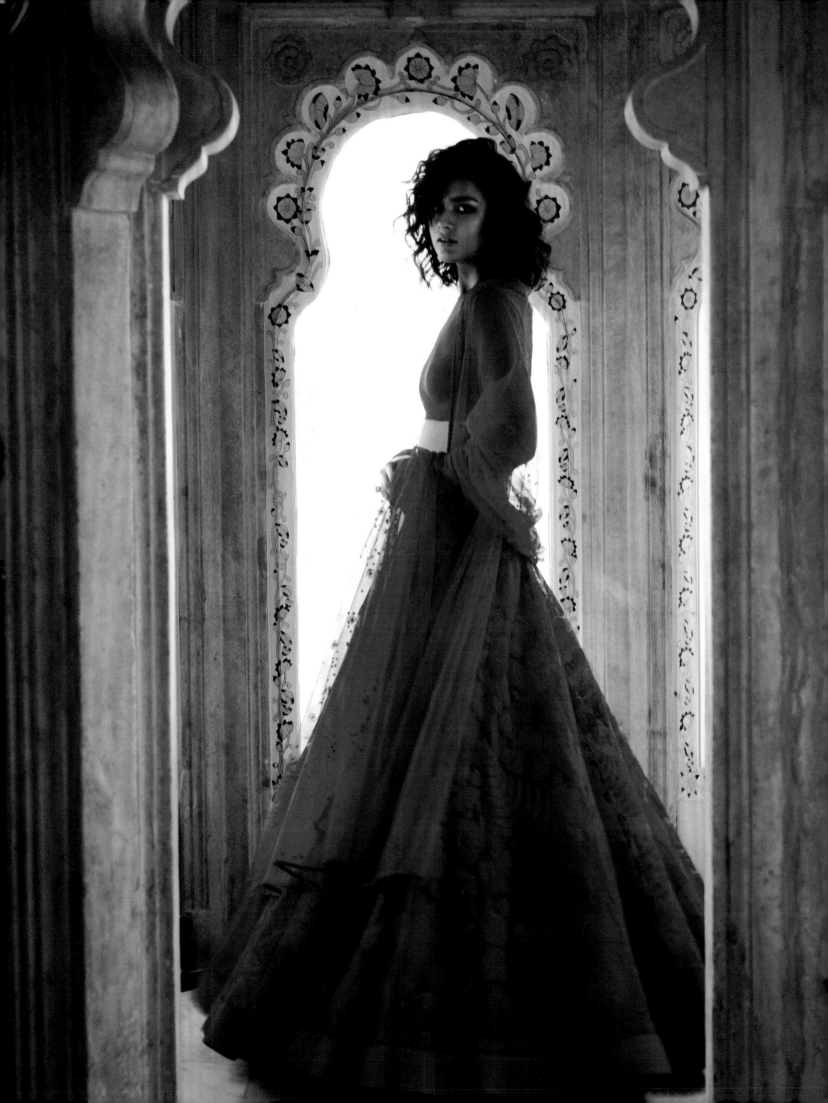

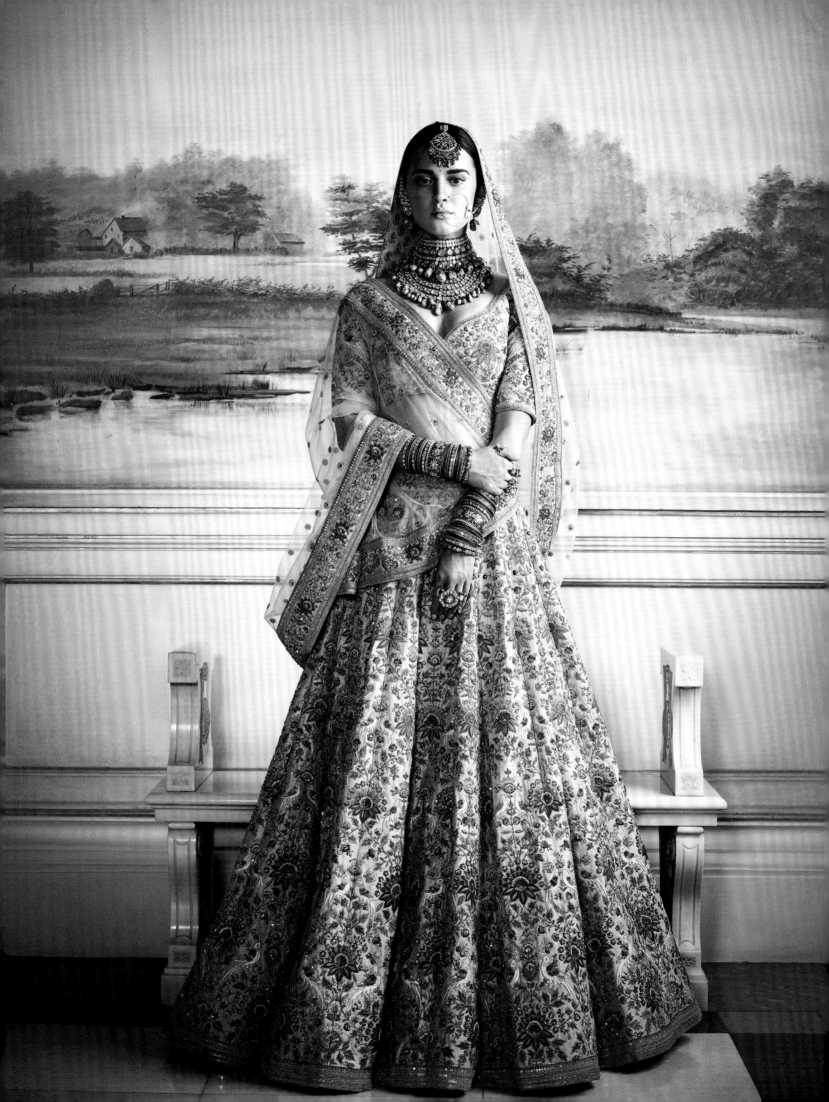

TARUN TAHILIANI

ALIA ALLANA

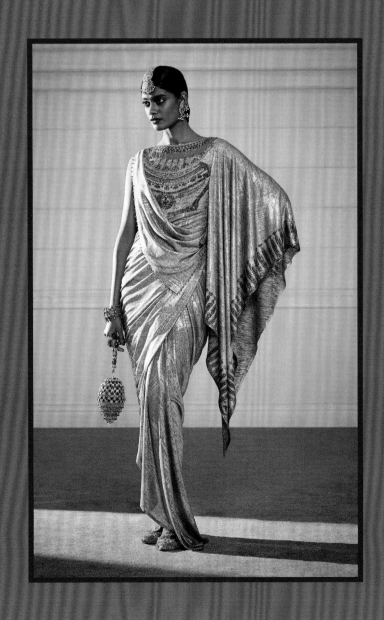

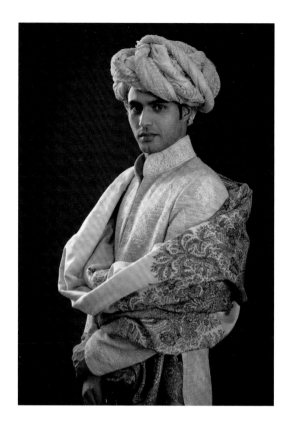

One evening in 1986, Tarun Tahiliani found himself at Coimbatore Central Prison performing in a play. That's when he first saw the embodiment of an idea that continues to drive him today. In front of him was the organizer of the event, a woman in white khadi. The fabric, devoted to freedom, was modernized into a Mao jacket with *boria* buttons, round fabric-covered buttons with a cotton core, and a *salwar*—artfully minimal with an Indian essence. Tahiliani had never seen anything like that. "It was exquisite," he recalls, mentioning that the garment was Asha Sarabhai for the Miyake Design Studio in Tokyo. The label wasn't available in India at that time; not much was. While acting was usually Tahiliani's escape from the tedium of a day job selling oil field equipment, that day it fortuitously changed the course of his life.

A year later, Tahiliani opened the doors of Ensemble, India's first multibrand boutique, with his wife, Sal, and the late designer Rohit Khosla. For an India that was opening up to the world, Tahiliani offered modern fashion possibilities rooted in tradition.

The conversation below is based on interviews that were conducted in New Delhi at the photo shoot for his new line, *The Reunion*, and in Mumbai at his October 2021 fashion show, his first since the beginning of the pandemic.

ALIA ALLANA: *India was known for its textiles, not its fashion, when you started Ensemble. How much did you know about the industry?*

TARUN TAHILIANI: I knew less than a dilettante did because frankly I started one fine day. What little I knew was through my mother's clothes, and I learned on the job, slowly but surely. The first thing I did for the first collection was go to Benaras with Martand Singh's famous book and visit the weavers mentioned in it, but I didn't know the difference between brocade and *tanchoi*. Through Singh's words, I began to discover my own journey. I went to different weavers in the countryside and asked if I could see what they did; in the process, I was learning.

AA: *Can you recall an enduring memory from that trip?*

TT: We had flown into Bhuj, and if you want pure drape—the Rabari men in those drapes, *safas,* and *kediyus* with shorts—there is very little that compares with that. It's all white, and as it gets dirty, it [becomes] beige with the *mitti* [soil]. That is the patina of dust in India. The men are statuesque, and the women are in billowing *dupattas*. There are women in one tribe in twenty-meter *lehengas* just tucked into a *nada* [string], and they have nine earrings, all in silver in graded sizes. I saw an old woman sitting in a store with Wayfarers. What an attitude. What mystique. In their sameness, the people were fiercely different.

AA: *What was fashion like when you started Ensemble?*

TT: When we began, people were seriously intimidated by the idea of coming to a place that made clothes look like they were displayed in an art gallery. People were used to going to exhibitions-cum-sales. It was like [shopping at] a bazaar versus high fashion, but back then all textiles were sold like that. Ensemble brought an international way of selling luxury to fashion.

In Mumbai we did a lot of very plain stuff in the beginning. We went to Benaras to shop, but except for the cut works that we could use, I was not equipped to do what I could do with brocade today. *Hakoba* was a simple fabric that had a sturdiness to it because of the embroidery. We tried to work with Maheshwari weaves, but everything frayed. We used a lot of Bhagalpur cotton because it was sturdy, and then we started playing with embroidery.

OPPOSITE Tarun Tahiliani, jersey metallic gold concept sari with jeweled printed bodice, embellished with diamonds and crystals, 2019 *Egypt* collection.

ABOVE Tarun Tahiliani, Mataka silk quilted sherwani with *jamewar* shawl, 2012 Couture collection.

AA: *What was the biggest challenge in the early days?*
TT: I realized that I loved this draped feeling that I saw in India, but there was no way to translate it into a pattern. Nobody here knew how to do it. Somebody could drape a dhoti on themselves, but if you said, "Find a pattern," it did not exist. If I drew something, the tailors gathered it up on the flat and I knew that was not correct. At that time, the only thing that had fit were the achkans for men and cholis for women.

That's when I realized I needed to study. If you look at the clothes of Ungaro or Chanel or what Dior had done—photographs of Dior cinching something—you can see that line on the drape, and there's a dress. Voilà. Magic.

AA: *But you remain committed to an Indian aesthetic.*
TT: I went inside the palaces of the Jodhpur family and saw the old *khandaans* and how they lived. It was not that the maharajas were not Westernized, but they still kept tradition. The women covered their heads, and I began to see this grace. I began to notice how different people wore textiles in different ways, and I realized that what defines us in India is that we could lavish any amount of care on a piece of textile.

AA: *Was fashion slow when you started in the industry?*
TT: I used to get *Jamawar* saris done in chiffon that would take a year or more with five Kashmiri [craftsmen] working on it. The saris were so exquisite and so weightless, and the artisans thought it was OK, that it was normal work. They were not spoiled by social media or by being entertained by soap operas.

AA: *You redefined what one could do with embroidery in Milan. How did that come about?*
TT: We took *chikan* to a new level when we started working with the Nawab of Kakori, Kazmi Sahib. He was principally interested in giving the women in his town of Kakori employment, and *chikankari* gave them a fantastic livelihood. At some point he was working with hundreds of women. Normally there were five to seven people to a piece until we started doing the separates, because we wanted one hand to do an entire yoke— it sits better that way.

This blew up after Milan. Milan forced us to try something new. I learned that an Italian woman wore her neckline at eleven inches, and an Indian woman wore it at six inches. Then the proportions begin to change, because when you change the neckline the rest of the garment begins to change. A friend, who ran a label and had a store on Bond Street in London, told me not to put embroidery all over because it has no value that way; people will think it's a textile. So, we didn't fill everything in, and it's so much more impactful and easier to wear.

AA: *After a period of exploring Western construction, you brought it to India in the shape of a concept sari.*
TT: For a lot of people, a concept sari is a sari with a zipper. That was never our idea. It's so that you can have different varieties of drapes on a structure and then you can attach the upper portion, which becomes the *pallu*. Sometimes it snaps in or, very often, it's left loose so that you can wrap yourself in a sari. With that we provide a foundation with draped corsets.

AA: *Your drapes kept evolving, with some becoming completely new silhouettes. Where did you encounter these?*
TT: One such place was the big Kumbh religious festival that happened in Allahabad. I must have seen images leading up to it, and by this time I was really into draping

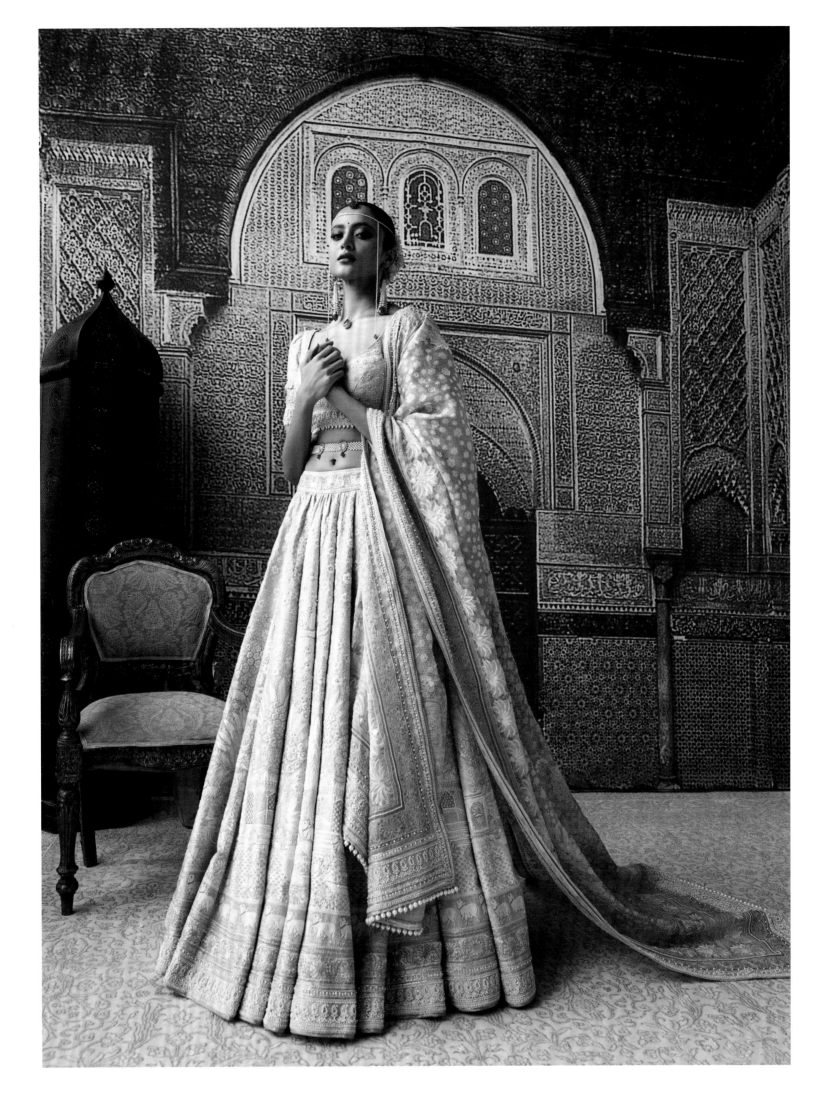

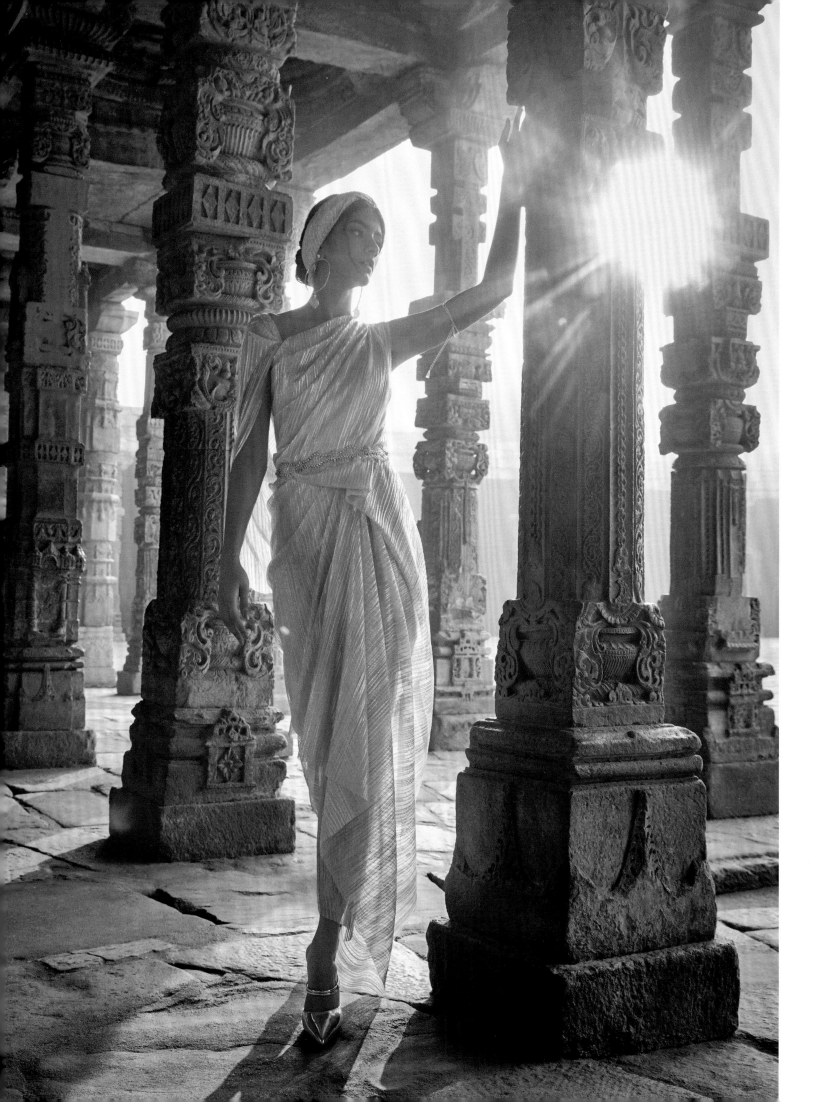

because unlike a sari, which is pretty much worn the same way and falls differently on different bodies, drapery at the Kumbh is unhinged. There is no single piece of cloth. Someone is wearing three meters, someone is wearing five meters, a lot wear a little dhoti with a shirt or with a lungi.

No matter what I thought, nothing prepared me for what I was about to see. That's when I really saw shapes and, if I take fabric, there are a million permutations and combinations of what I can do with it. The draping wasn't commercial—it was free, it was unfettered. When I see so much draping, the only place you can translate it is either a draped skirt or a concept sari.

AA: *How has your engagement with handloom changed?*

TT: For a while, I had stopped handloom. I did a lot of digital printing, because I didn't know what to do with the weavers. With handloom, in order to make it look stiff and big—which is what Indians traditionally like—they gum the fabrics and calender them to give more body and volume. I like the opposite. I like a thicker fabric that can drape like a jersey.

Now I'm finding these heavier weaves and we're learning what to do with them. The fact is that there are so many weavers in Bengal who are deriving sustenance and are improving, frankly. Maybe these things weren't so important to me before, but they are so important to me now, and we think we will use a foil jersey or a crinkle from abroad only because we can't get it in India. So now as a design house, it's not that I won't use things from abroad, because the stones come from abroad, but I'm committed to looking in India first for what we can do.

AA: *What made you return to Indian cloth?*

TT: I think I left it for a while because I didn't know what to do with it. During lockdown, I started devising my old things. I started doing strange things like boiling them. I take a lot of fabric and bury it in a mud pit in order to age it. I soak it. We soak fabric in vats of tea with different intensities. We antique it. The beauty of India is that these things look aged, and I'm after that patina of dirt and time.

AA: *Is it couture?*

TT: Going by the French definition of couture, there are legendary stories about how Shah Jahan's or Nur Jahan's clothes were stitched on their bodies every day. That was India; a lot of things were handmade. Traditionally people might all have worn *chikan*, then industrialization came in and people started to invent mechanized duplications of the handwork. India had *kani jamawar*, and they started to produce paisley shawls made on the looms in industrial England that were shipped back to India. I have beautiful net *pichwais* done in Germany for India. All this is beautiful and exciting and amazing, and it opens up something to a much larger market, to make things at a mass level for distribution, to get economies of scale no matter what the cost. But that's another story, for another day.

OPPOSITE Tarun Tahiliani, foil-crinkle tulle draped dress, Spring 2020.

ACKNOWLEDGMENTS

The exhibition *India in Fashion* and this associated publication have been immeasurably enriched by many people who have guided me at every turn with their profound enthusiasm for the subject and project. For their generosity in lending masterworks and sharing documentation, knowledge, and memories, I am indebted to all of them.

Naturally, I owe a tremendous amount to Nita and Mukesh Ambani, who conceived this project and invited me to curate it. They have helped to paint so vivid a picture of their beloved India. My profound thanks also to their daughter, Isha, for her support and passion for the subject.

I am grateful to Anna Wintour for her indulgence when this project has at times diverted my attention from my *World of Interiors* and *Vogue* lives.

Without the respected authors, this tome would not be possible. I extend my appreciation to the following scholars, journalists, and writers for their evocative words that illuminate the subject of this exhibition: Alia Allana, Frank Ames, Sonia Ashmore, Vandana Bhandari, Kimberly Chrisman-Campbell, Sarah Fee, Avalon Fotheringham, Sylvia Houghteling, Amin Jaffer, Priyanka R. Khanna, Ritu Kumar, Suzy Menkes, Caroline Rennolds Milbank, Alexandra Palmer, Aurélie Samuel, Laila Tyabji, Rujuta Vaidya, and Shefalee Vasudev.

A particularly rewarding aspect of this project has been to share the invaluable memories of designers about India, influence, and craft. I wish especially to thank John Galliano, Sanjay Garg, Jean Paul Gaultier, Abu Jani, Naeem Khan, Anamika Khanna, Sandeep Khosla, Ritu Kumar, Manish Malhotra, Rahul Mishra, Sabyasachi Mukherjee, Tarun Tahiliani, Anuradha Vakil, and Dries Van Noten.

The early support of Max Hollein and Andrew Bolton at The Metropolitan Museum of Art has been tremendous, and I extend particular gratitude for their unprecedented loan. I am also grateful to the Balenciaga Archive (Gaspard de Massé); Brighton Museum (Martin Pel); Direction du Patrimoine de Chanel (Julie Deydier, Odile Prémel); Leslie Chin; Christian Dior Couture–Dior Héritage (Solène Auréal-Lamy, Olivier Flaviano, Justine Lasgi, Soizic Pfaff); Cora Ginsburg, New York (Martina D'Amato, Titi Halle); The Costume Institute at The Metropolitan Museum of Art (Joyce Fung, Glenn Petersen, Anna Yanofsky); Dries Van Noten (Tatum Amadò, Jan Van Hoof); Fashion Museum, Bath (Rosemary Harden, Eleanor Summers); FIDM Museum (Kevin Jones); Francesca Galloway (Danielle Beilby, Mary Galloway, Christine Ramphal); Hamish Bowles Collection; Rahul Jain; Jean Paul Gaultier Archive (Daniel Menéndez Suárez, Clara Vergez); Cecilia Matteucci; MoMu Antwerp (Kaat Debo, Wim Mertens, Kim Verkens); Musée Yves Saint Laurent Paris (Madison Cox, Alice Coulon-Saillard, Elsa Janssen); Museum of the City of New York (Sheryl McMahan, Leela Outcalt); Gela Nash-Taylor; National Gallery of Victoria, Melbourne (Tony Ellwood AM, Katie Somerville); Palais Galliera (Miren Arzalluz, Laurent Cotta, Alexandre Samson); Peabody Essex Museum (Lynda Roscoe Hartigan, Rachel A. Miller, Petra Slinkard); Phoenix Art Museum (Helen Jean, Jeremy Mikolajczak); Enrico Quinto; Zandra Rhodes; Royal Collection Trust, London (Caroline de Guitaut); Royal Ontario Museum (John Basseches, Sarah Fee, Alexandra Palmer, Chris Paulocik, Nicola Woods); Sandy Schreier; Tatiana Sorokko; Mark Walsh; and York Museums Trust (Melanie Baldwin).

I would like to thank the following photo agencies, institutions, and individuals for their help in obtaining images for the catalogue: Amit Aggarwal; Bikramjit Bose; Annie Boulat; Francine Carpon; Sophie Carre; Cartier (César Imbert, Pierre Rainero); Chester Beatty Library; Charudutt Chitrak; Christian Dior Couture (Olivier Bialobos, Perrine

Scherrer); Cleveland Museum of Art; Condé Nast Archive (Cynthia Cathcart, Jasmine Kennedy, Ivan Shaw); Condé Nast India (Giselle D'Mello, Renuka Modi); Marleen Daniëls; Anita Dongre; Robert Fairer; Vanessa Fairer; John Fasal; Freer Gallery of Art; The Irving Penn Foundation; Maison John Galliano Archives (Sébastien Mandel, Brigitte Pellereau); Bruna Kazinoti; Anamika Khanna; Steven Klein; Karlie Kloss; Annie Leibovitz; Manish Malhotra (Ziyus Contractor); Steven Meisel; Rahul Mishra (Deshiv Puri, Adita Tiwari); Kate Moss; The Museum of Fine Arts, Houston (Shelby Rodriguez); Naeem Khan (Hailey Vollbrecht); Museu Nacional de Arte Antiga, Lisbon (Ana Kol, Tânia Olim); André Perlstein; Raw Mango (Salman Bukhari); Zandra Rhodes (Kelly Robinson); Sabyasachi (Manav Angelo Kashyap); Kristen Schuller; Ashish Shah; Brigadier His Highness Sukhjit Singh of Kapurthala (Cynthia Frederick); Prince Al Thani; Signe Vilstrup; and Tarun Vishwa.

I would like to extend my appreciation to Sidney Toledano, chairman and chief executive officer of LVMH Fashion, for allowing me unprecedented access to archives that facilitated my team's research, and for giving us permission to reproduce John Galliano's research notebook from his travels to India in 2002. My team and I further acknowledge the following institutions, scholars, and friends for their guidance and support: Fondation Azzedine Alaïa (Christoph von Weyhe, Olivier Saillard, Carla Sozzani); Hashim Badani; Chicago History Museum (Virginia Heaven); Eloise Clusellas; Rosemary Crill; Oriole Cullen; Fiona Da Rin; Peter D'Ascoli; William Dalrymple; Markus Dennig; de Young Museum (Krista Brugnara, Jill D'Allessandro); Christopher Donnellan; Drexel Historic Costume Collection (Clare Sauro); Brigid Gerstenecker; Maggie Gledhill; Priya Kapoor; Rta Kapur Chishti; Kent State University Museum (Joanne Fenn, Sara Hume); Maria Kublin;

Kyoto Costume Institute (Akiko Fukai); Los Angeles County Museum of Art (Sharon Takeda); Christian Louboutin; Christiane Mack; Marley Marius; Musée des Arts Décoratifs (Denis Bruna); Museum of Fine Arts, Boston (Emily Stoehrer, Allison Taylor, Theo Tyson); Alexis Roche; Kirat Young; Western Reserve Historical Society (Patty Edmonson); and Madison Williams.

My deepest thanks go to Patrick Kinmonth (Jack Henshall, Alexander Schnell Sramek, Philip Schnell Sramek) and Rooshad Shroff for their compelling exhibition design that has so eloquently brought the curatorial narrative to life.

I applaud Jacob Wildschiødtz and his team at NR2154 (Elina Asanti, Meryem Kettani, and Rachel Roth) for the elegance of their design, which perfectly reflects the subject of this book.

My sincere appreciation to the team at the Nita Mukesh Ambani Culture Centre for its tireless dedication to the project: Rajshree Bakshi, Devendra Bharma, Lydia Buthello, Piyush Chopra, Yashodhara Cran, Camilla Harden, Haresh Jiandani, Priyanka R. Khanna, Eve Lemesle, Pallavi Malhotra, Jay Modi, Sarosh Quraishi, Anupam Sah, Rishita Shah, Priya Tanna, and Rujuta Vaidya.

At Rizzoli, I wish to thank Charles Miers and Margaret Chace, for their enthusiasm and support for this project from the start; Philip Reeser, for guiding the book with his intelligence and insight; and Alyn Evans for her grace under fire during the book's production.

India in Fashion would not have been possible without the contributions of my indefatigable research associates, Molly Sorkin and Jennifer Park, who have brought their commitment, knowledge, and enthusiasm into play at every turn. For that, I am grateful.

GLOSSARY

Aari: Chain-stitch embroidery worked with a hooked awl, or *aari* tool. Famously worked by the Mochis of Gujarat

Abrawan: A very fine grade of cotton muslin, from the Persian meaning "running water."

Achkan: A form of knee-length, long-sleeved jacket worn by men. The jacket is fitted in the torso and sleeves, slightly flaring at the waist, with a center-front buttoned opening.

Alaballee: A grade of muslin, meaning "very fine."

Ajrak(h): A style of block printing worked in Sindh and Gujarat that combines mordant- and indigo-resist dyeing to form complex patterns.

Angarkha: A knee-length (or longer), long-sleeved, skirted or flared robe, fastened with ties and characterized by a central panel, or *purdah*, that covers the chest.

Bandhani: A tie-dye technique in which patterns are formed by binding small puckers of cloth.

Banyan: An informal, lightly structured robe or dressing gown worn by European men at home from the late seventeenth to early nineteenth centuries, also known as an Indian gown.

Benarasi brocades: Rich, finely woven silk fabric or silk saris from Benaras (now Varanasi), characterized by heavy use of *zari* or metal-wrapped threads.

Boteh/buta/buti: Paisley or mango-shaped motif; a floral sprig motif.

Bulbul chasm/chasm-i bulbul: Small woven diamond motif, from the Persian meaning "nightingale's eye."

Chakdar jama: Style of *jama* characterized by a skirt ending in four points at the hem.

Chanderi: A fine, glossy fabric woven of silk or mixed silk and cotton, typically with *zari*, named for the production center of Chanderi in Madhya Pradesh.

Chattai: Straw mat; pattern imitating the weave of a straw mat.

Chikankari: A style of whitework embroidery characterized by delicate patterns worked in a range of stitches on muslin. Famously produced in Lucknow, Uttar Pradesh.

Choli: Woman's form-fitting upper garment or blouse.

Chudi: Bangles; circular designs.

Dhoti: A wrapped garment that is passed between the legs and around the lower body. Can also refer to a style of sari drape.

Dochalla/doshalla: A pair of identical shawls that, when sewn back-to-back, form one reversible shawl.

Dupatta: Garment formed of a sheet of cloth and draped over the upper body.

Eri/eria/endi: Type of silk obtained from the *eri* silkworm, native to northeastern India. *Eri* silk is formed of shorter filaments and is spun rather than reeled.

Gara/garo: Style of silk embroidery characterized by a strong Chinese influence in the stitching and design.

Ghagra/ghaghra: An ankle-length full skirt, either gathered or paneled. The term is used interchangeably with *lehenga*.

Gharara: A style of *paijama* characterized by wide flares at the knees, worn by women.

Gota/gota-patti: Tinsel ribbon woven with metal; a style of appliqué that uses cut pieces of *gota*.

Himroo: A type of figured silk pattern using continuous supplementary wefts.

Ikat: A resist-dyeing technique in which the pattern is formed by tie-dyeing the yarns prior to weaving.

Jadau: A jewelry setting in which uncut gems (*polki*) are embedded in gold (*kundan*).

Jali: A lattice; a pattern that imitates a lattice; an embroidery technique in which threads are manipulated to form a lattice.

Jama: A style of skirted, long-sleeved robe characterized by a fitted bodice with cross-over chest panels fastened by ties at either side of the body. Worn by men and occasionally by women in various parts of India from at least the sixteenth century into the nineteenth.

Jamdani: A weaving technique in which muslin is patterned by discontinuous brocading of supplementary cotton wefts; muslin patterned by this technique.

Kaccho/kacho: A style of embroidery worked in northwest India and Pakistan, characterized by long floats of counted-thread satin or surface darning stitches, also known as *soof*.

Kalamkari: Technique of patterning cotton by the hand-drawing of mordants and resists; cotton textiles patterned by this method. From the Persian meaning "pen work."

Kali: A triangular panel, or gore, used to construct flared skirts.

Kamdani: A style of embellishment in which patterns are worked in *badla*, also known as *mukaish*.

Kameez: A style of long tunic, typically reaching to or below the knees, with slits at the lower side seams.

Kani: Twill-tapestry weaving technique in which the pattern is formed in a twill structure by double-interlocking multicolored wefts worked via small bobbins or *kani*. Famously used to pattern Kashmir shawls.

Kantha: A running stitch; a form of quilted and embroidered household textile traditionally made by women in Bengal.

Kediyus/kediyun: A long-sleeved short jacket with attached waist-length pleated skirt, traditionally worn by men in herding communities of rural Gujarat.

Khil'a/khil'at: Robes of honor; ceremonial garments given by rulers to acknowledge service and/or symbolize their authority over the receiver.

Kinkhwab/kamkhwab/kincob: A style of woven silk characterized by opulent *zari* brocading. Famously produced in Varanasi and Ahmedabad.

Kurta: A tunic.

Lehenga: Formal, ankle-length skirt worn by women for festive occasions. Traditionally worn with a *choli* (blouse) and *dupatta* (shoulder cloth). See also *ghagra*.

Lungi/lunghi: A form of wrapped garment that is draped around the waist to cover the lower body.

Madras (textile): A style of handloom cotton typically characterized by patterns formed of multicolored checks. Famously produced in southern India, named for the region of Madras (now Chennai).

Mataka/matka: Handloom silk fabric woven of spun (as opposed to reeled) silk waste (broken silk filaments), characterized by a coarse or rough texture.

Mashru: Cloth woven of silk warps and cottons wefts in a satin weave structure, characterized by a glossy silk face and matte cotton back.

Meenakari: Enamel-work.

Muga: Type of silk obtained from the *muga* silkworm. *Muga* silk is naturally golden-colored.

Mulmul khas: "King's muslin" or "special muslin," the finest grade of muslin. Famously produced in Bengal.

Mundum neriyatum/mundu set: Keralan style of woman's wrapped ensemble formed of two lengths of cloth, typically white with gold borders, draped around the lower and upper body respectively.

Muslin: Lightweight cotton fabric woven of finely spun thread, the finest qualities being sheer.

Nada/izarband: A drawstring for a lower garment, often with ornamented ends.

Odhani/odhni/orni/odhana: Woman's garment formed of a sheet of cloth draped over the upper body.

Paijama/payjama/pajama: Drawstring trousers.

Pakko/pakkoh: A style of embroidery worked in northwestern India and Pakistan, characterized by hard-wearing, closely packed arrangements of stitches, the name meaning "solid" or "permanent."

Palla/pallu/pallav: The decorative end of a sari, worn draped over the shoulder or head.

Panetar: Red-and-white bridalwear worn in western India.

Pashm: The fine, soft hair from the undercoat of the shawl goat, used to make pashmina.

Patka: Waist sash formed of a long, narrow, purpose-woven cloth, typically characterized by its decorative ends that are left hanging at the front of the body.

Patolo/patola: A distinctive style of double-ikat patterned silk from Gujarat, in which both the warp and weft are tie-dyed with the pattern prior to weaving. Famously produced in Patan.

Peshwaz: A long, open-fronted robe worn by women over *paijama* and sometimes a choli. Made out of both sheer and opaque fabrics, *peshwaz* were popular in courtly dress from at least the seventeenth into the nineteenth centuries.

Phulkari: Meaning "flower work," a style of counted-thread embroidery worked in floss silk on cotton using a surface darning stitch.

Resham: Silk thread; silk cloth.

Rumal: A kerchief, sometimes used as a headwrap; handkerchief; small cloth. From the Persian meaning "face wipe."

Safa: A turban, also known as a *pagri*.

Salwar/shalwar: A style of drawstring trouser with legs tapered at the ankles.

Sari: Woman's wrapped garment formed of an unstitched, uncut, purpose-woven length of fabric draped around the body. Design and patterning techniques vary across India, although most sari formats include vertical side borders and a decorative end (*palla/pallu/pallav*) for draping over the shoulder.

Shamilami: A combination of weaving and embroidery used to pattern textiles in Manipur.

Sherwani: A form of knee-length, long-sleeved jacket worn by men. The jacket is fitted in the torso and sleeves, slightly flaring at the waist, with a center-front buttoned opening.

Siddhaur: A *chikankari* embroidery stitch used to form *jali* motifs.

Sozni: A style of Kashmiri embroidery used to decorate one or both sides of pashmina cloth, using fine threads worked in close sympathy with the twill-structure of the pashmina ground.

Tanchoi: A brocaded silk satin, of Chinese origin, composed of two warps and multiple continuous pattern wefts in each pass.

Telia rumal: A style of *rumal* that is patterned via double-ikat (both warp and weft are tie-dyed prior to weaving). *Telia*, meaning "oily," refers to the sesame or castor oil used to treat the yarn, which gives the cloth a distinct scent and texture.

Tilla/tilladoz: A style of embellishment in which patterns are formed by couching spirals of metal-wrapped threads onto cloth, also known as *marori*.

Tinsel printing: Technique of block printing with an adhesive paste mixed or sprinkled with metallic powder.

Toda: An embroidery tradition from the pastoral women of the Nilgiris in Tamil Nadu, characterized by the use of red and black thread on a white cotton background.

Tasar/tussar/tusseh: A type of silk obtained from the *tasar* silkworm, native to India. *Tasar* silk is naturally golden-brown or gray in color.

Zardozi/zardosi: A rich style of embroidery or embellishment, worked using metal elements. From the Persian meaning "gold-work."

Zari: Metal thread.

OPPOSITE Jaeger, coat of mohair, Fall/Winter 1956. Modeled by Anne Gunning outside of the City Palace, Jaipur. Photographed by Norman Parkinson for the November 1956 issue of British *Vogue*.

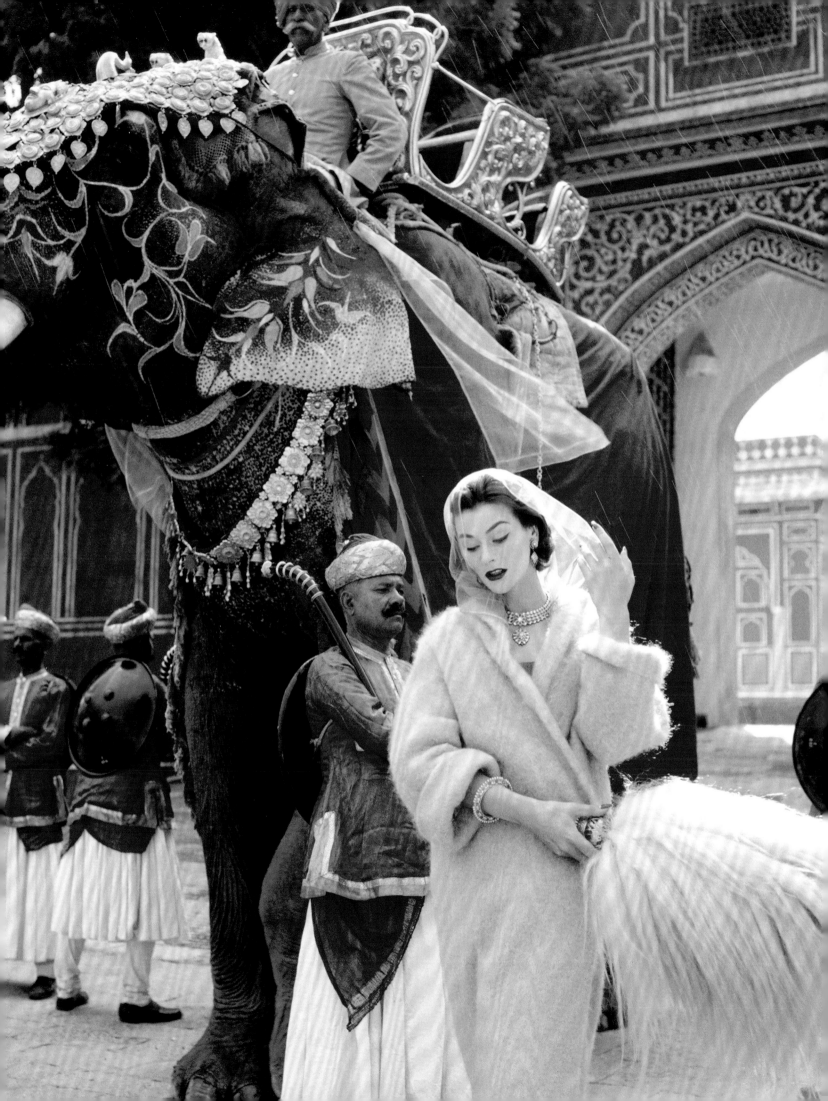

ALIA ALLANA is a reporter with *Fountain Ink* magazine where she covers international affairs, crime, and digital media. Allana began her career at the *Indian Express* in New Delhi in 2009. She studied international relations at the London School of Economics and was a recipient of the Mumbai Press Club's RedInk Awards in 2015 and 2017 for crime reporting, and in 2019 for reporting on Business and Economy; she also received the Society of Publishers in Asia award for reporting on women's issues in 2019 and on human rights in 2020. She contributed to Tarun Tahiliani's forthcoming monograph and has been published in the *New York Times* and the *Atlantic*.

FRANK AMES has been researching fine, rare, and historic textiles over the past forty years. This includes Middle Eastern/Islamic (including various carpets), European, and especially the early Kashmir shawls from Kashmir, Iran, and the Indian subcontinent. His latest book, *Woven Masterpieces of Sikh Heritage* (2010), represents a culmination of his research in this field, probing questions that continue to arise, especially as new and exciting shawl pieces are discovered or come on the market. The Metropolitan Museum of Art, the Musée Guimet, the TAPI Collection, the Museum of the Arab World, and the David Collection are just a few of the many institutions over the years that have acquired textiles and shawls from him. Ames is author of *The Kashmir Shawl and Its Indo-French Influence* (1986).

DR. SONIA ASHMORE is a design historian specializing in aspects of cultural exchange and trade between Britain and Asia. She has been published widely and contributed to a number of books for London's Victoria and Albert Museum (V&A), including *British Asian Style* (2010). Her book *Muslin* (2012) was the first publication to examine the global history of muslin and to showcase the V&A's substantial collections of this extraordinary fabric. As a research fellow at the V&A, she investigated the formation of the museum's nineteenth-century collections of South Asian textiles. Her broad research interest is in material and cultural exchange between Europe and Asia. She has taught and published widely on topics concerned with design and the decorative arts, and lectures and runs courses at the V&A. She is a trustee of Muslin Trust.

DR. VANDANA BHANDARI is a professor at the National Institute of Fashion Technology (NIFT) in New Delhi. Her teaching has focused on traditional Indian textiles, Indian dress, craft studies, fashion forecasting, and product development. Her research encompasses economic sustainability for craftspeople, craft-based studies, ethnographic studies on dress, and fashion in India. Bhandari is currently leading a national craft project titled USTTAD (Upgrading the Skills and Training in Traditional Arts/Crafts for Development) at NIFT. Her publications include *Textiles of Rajasthan: At the Jaipur Court* (2020), *Costume, Textiles and Jewellery of India: Traditions in Rajasthan* (2004), and *Jewelled Textiles: Gold and Silver Embellished Cloth of India* (2015).

HAMISH BOWLES is both editor in chief of the *World of Interiors* and global editor at large for American *Vogue*. He is recognized as one of the most respected authorities on the worlds of interior design and fashion history. Bowles has curated a number of exhibitions, including *Jacqueline Kennedy: The White House Years—Selections from the John F. Kennedy Library Museum* at the Metropolitan Museum of Art; *Balenciaga and Spain* at the de Young Museum; and *House Style: Five Centuries of Fashion* at Chatsworth. His publications include *YSL Lexicon: An ABC of the Fashion, Life, and Inspirations of Yves Saint Laurent* (2022); *The World of Federico Forquet: Italian Fashion, Interiors, Gardens* (2020); *Vogue: The Editor's Eye* (2012); *Stephen Jones & the Accent of Fashion* (2011); *Balenciaga and Spain* (2010); and *Vogue Living: Houses, Gardens, People* (2007). Bowles was educated at Saint Martin's School of Art and Design.

DR. KIMBERLY CHRISMAN-CAMPBELL is an award-winning fashion historian, curator, and journalist based in Los Angeles. She is the author of *Fashion Victims: Dress at the Court of Louis XVI and Marie-Antoinette* (Yale University Press, 2015); *Worn on This Day: The Clothes That Made History* (Running Press, 2019); and *The Way We Wed: A Global History of Wedding Fashion* (Running Press, 2020). She has written about fashion, art, and culture for the *Atlantic*, the *Washington Post, Politico,* and the *Wall Street Journal* and has appeared on NPR, the Biography Channel, and Reelz. She was a 2020–21 National Endowment for the Humanities (NEH) Public Scholar.

DR. SARAH FEE joined the Royal Ontario Museum in April 2009. She is responsible for the museum's renowned collection of approximately 15,000 textiles and fashion pieces that come from greater Asia and Africa, as well as eastern Europe. She has edited and written for numerous books, journals, and catalogues, including *Objects as Envoys: The Textile Arts of Madagascar* (2002); *Textile Trades, Consumer Cultures, and the Material Worlds of the Indian Ocean* (2018); *Textile History* journal; and *Cloth That Changed the World: The Art and Fashion of Indian Chintz* (2020). Her research has been supported by grants from the Smithsonian Institution, the Wenner-Gren Foundation, the Pasold Research Fund, and the Social Sciences and Humanities Research Council of Canada (SSHRC).

AVALON FOTHERINGHAM is curator for the South Asian textiles and dress collection at the Victoria and Albert Museum. She studied fiber and material practices at Concordia University in Montreal, and the history of design at the Royal College of Art in London. Before taking up the post of curator, she worked as research assistant for the 2015 exhibition *The Fabric of India* at the V&A. She is the author of *The Indian Textile Sourcebook* (2019).

DR. SYLVIA HOUGHTELING is an assistant professor in the Department of History of Art at Bryn Mawr College. Her research and teaching examine South Asian, European, and Islamic visual arts and material culture with a particular focus on the early modern period and on the textile medium. She holds an AB from Harvard University, an MPhil from the University of Cambridge, and a PhD from Yale

University. She was awarded a postdoctoral fellowship in the Department of Islamic Art at the Metropolitan Museum of Art. Her first book, *The Art of Cloth in Mughal India*, was published by Princeton University Press in 2022.

DR. AMIN JAFFER was a curator at the Victoria and Albert Museum for thirteen years. He authored *Furniture from British India and Ceylon* (2001), *Luxury Goods from India* (2002), and *Made for Maharajas: A Design Diary of Princely India* (2006). Jaffer was cocurator of the V&A's blockbuster exhibitions *Encounters: The Meeting of Asia and Europe 1500–1800* (2004) and *Maharaja: The Splendour of India's Royal Courts* (2009), and coeditor of the accompanying catalogues. His most recent publication is *Beyond Extravagance: A Royal Collection of Gems and Jewels* (2013), a multiauthored volume documenting a private collection of Indian jewelry spanning four hundred years. He lectures frequently in Europe, America, and India and contributes regularly to journals and major newspapers.

PRIYANKA R. KHANNA is an art, design, and fashion writer; author; and editor based in Mumbai. She worked in the public relations department at Hearst Magazines on publications including *O, The Oprah Magazine; Harper's Bazaar; CosmoGirl!*; and *Seventeen*. She returned to Mumbai to join the launch team of *Vogue* India, where she spent fifteen years, most recently as the fashion features director. She is currently a contributing editor at the *World of Interiors*. Khanna's debut novel *All the Right People* was published by Penguin Random House India in 2022.

RITU KUMAR is one of India's foremost designers, who has developed a unique style that combines the ancient traditions of Indian craftsmanship with contemporary innovations. With a background in art history, Kumar is involved with not only the research of traditional crafts but also their revival. She was awarded the Lifetime Achievement Award for fashion and her commitment to the revival and continuation of traditional craftsmanship. She currently serves on the board of governors for the National Institute of Fashion Technology and has been a member of the All India Handloom Board at the Ministry of Textiles.

SUZY MENKES is one of fashion's most informed, balanced, and respected voices. Menkes worked for the *International Herald Tribune* for twenty-six years and was a columnist for the *New York Times T Magazine*. In March 2014, she left her role as style editor at the *International New York Times* to join Condé Nast International as the international *Vogue* editor, reporting and contributing to all non-US *Vogue* websites. Menkes exited Condé Nast in July 2020. She is author of numerous books on fashion, including *The Royal Jewels* (1990) and *The Fashion World of Jean Paul Gaultier: From the Sidewalk to the Catwalk* (2001).

CAROLINE RENNOLDS MILBANK's work in fashion history has included stints as an auction house expert (Sotheby's and Doyle New York), appraiser, and consulting curator. She contributed essays to the catalogues of and curated the costume components of the exhibitions *Art and the Empire City: New York, 1825–1861* (Metropolitan Museum of Art, 2000) and *Noble Dreams, Wicked Pleasures: Orientalism in America, 1870–1930* (Clark Art Institute, Williamstown, Massachusetts, 2000). She was cocurator of the exhibitions *Elegance, Glamour and Style: Fashion and Its Photography* (The Bruce Museum, Greenwich, Connecticut, 1998) and *The Couture Accessory* (Museum of the Fashion Institute of Technology, 2004), the latter based on her book of the same title; and also selected the Worth evening gowns included in the exhibition *John Singer Sargent: Portraits of the Wertheimer Family* (Virginia Museum of Fine Arts, 2000).

DR. ALEXANDRA PALMER is the Nora E. Vaughan fashion costume senior curator and chair of the Veronika Gervers Research Fellowship in Textiles & Costume at the Royal Ontario Museum, and a cocurator of *BIG*, an exhibition in the Patricia Harris Gallery of Textiles & Costume. She is cross appointed and teaches in Fine Art History at the University of Toronto, the graduate program in Art History at York University, and the School of Graduate Studies at Ryerson University. She received her PhD in Design History from the University of Brighton. Palmer is author of *Dior: A New Look, A New Enterprise 1947–57* (V&A Publishing, 2009).

AURÉLIE SAMUEL was formerly director of collections at the Yves Saint Laurent museums in Paris and Marrakesh and, prior to that, the head of the textile department at the Musée Guimet. She is an art historian specializing in Indian culture. She is the author of *Yves Saint Laurent: Dreams of the Orient* (2018). Samuel is curating an exhibition on costume couture at the Mucem in Marseille that explores the dialogue between traditional costume and haute couture.

LAILA TYABJI is an Indian social worker, designer, writer, and craft activist. She is one of the founders of Dastkar, a Delhi-based nongovernmental organization, working for the revival of traditional crafts in India. In 2012, she was honored by the government of India with the Indian civilian award of Padma Shri.

RUJUTA VAIDYA is a fashion journalist and the former digital editor of *Vogue* India. Based in Mumbai, she is formally trained in fashion design from the National Institute of Fashion Technology and holds an MBA from the Indian School of Business.

SHEFALEE VASUDEV is a journalist and commentator on fashion and popular culture. She is currently editor at the *Voice of Fashion* at RISE Worldwide Limited and formerly at *India Today, Marie Claire, the Indian Express,* and *Mint*. She is author of *Powder Room: The Untold Story of Indian Fashion* (Random House, 2012).

FRONT COVER Anamika Khanna, pearl mesh wedding veil, hand-embroidered lace blouse, silk organza threadwork sari with a *mukaish palla* and a gold *zardozi* border, 2021 Couture collection.

OPPOSITE PAGE 1 Pauline Trigère, hooded halter pajamas of nylon, silk, and Lurex metallic threads. Modeled by Veruschka. Photographed in the Jas Mandir at Amber by Henry Clarke for the December 1964 issue of *Vogue*.

PAGE 2 John Galliano for Christian Dior, crystal headpiece and jewelry inspired by Princess Kishangarh, Fall 1997, Haute Couture. Modeled by Kate Moss. Photographed by Annie Leibovitz for the October 1999 issue of *Vogue*.

PAGE 4 Sabyasachi, printed *matka* silk embroidered *lehenga*, patchwork embroidered blouse, and embroidered tulle *dupatta*, 2022 *Sabyasachi Heritage Bridal* collection.

OPPOSITE PAGE 256 Nina Ricci, gold bead–embroidered satin evening dress with matching stole wrapped like a sari. Modeled by Dorothea McGowan. Photographed by Irving Penn for the October 15, 1961, issue of *Vogue*.

BACK COVER Kirat Young and Yves Saint Laurent during a studio fitting at 5 avenue Monceau for the presentation of the Fall/Winter 1977, Haute Couture. Photographed by André Perlstein.

First published in the United States of America in 2023 by Rizzoli Electa, a division of Rizzoli International Publications, Inc.
300 Park Avenue South
New York, New York 10010
rizzoliusa.com

PUBLISHER Charles Miers
ASSOCIATE PUBLISHER Margaret Chace
SENIOR EDITOR Philip Reeser
PRODUCTION MANAGER Alyn Evans
DESIGN COORDINATOR Olivia Russin
MANAGING EDITOR Lynn Scrabis

IN ASSOCIATION WITH
Nita Mukesh Ambani Cultural Centre
Reliance Industries Limited
Jio World Centre, G Block
Bandra Kurla Complex, Mumbai 400098
Maharashtra, India
nmacc.com

Editorial oversight and coordination provided by Molly Sorkin and Jennifer Park.

ART DIRECTION AND DESIGN NR2154
CREATIVE DIRECTOR Jacob Wildschiødtz
DESIGN DIRECTOR Elina Asanti
SENIOR DESIGNER Rachel Roth
PROJECT DIRECTOR Meryem Kettani

Excerpts from "A History of Indian Dress" by Ritu Kumar were originally published in her book *Costumes and Textiles of Royal India* (London: Christie's Books Ltd, 1999), © 1999 by Ritu Kumar.

ISBN 978-0-8478-7110-0
Library of Congress Control Number: 2022941765

2023 2024 2025 2026 / 10 9 8 7 6 5 4 3 2 1

Printed and bound in Italy

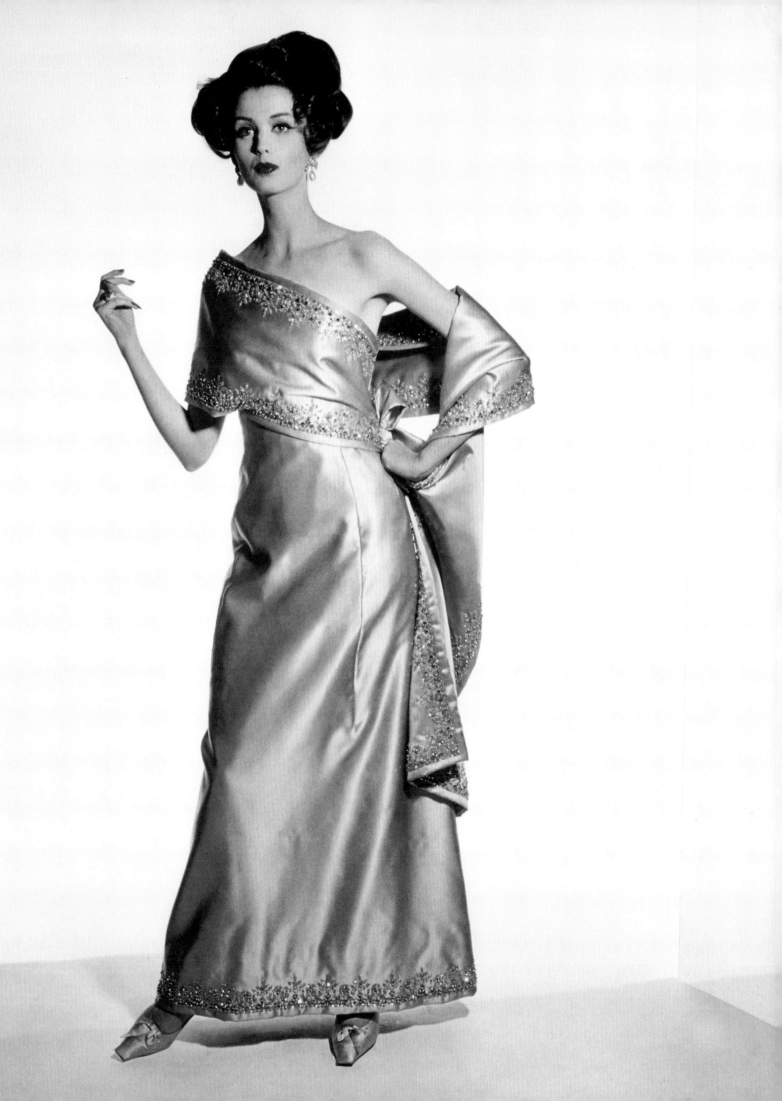